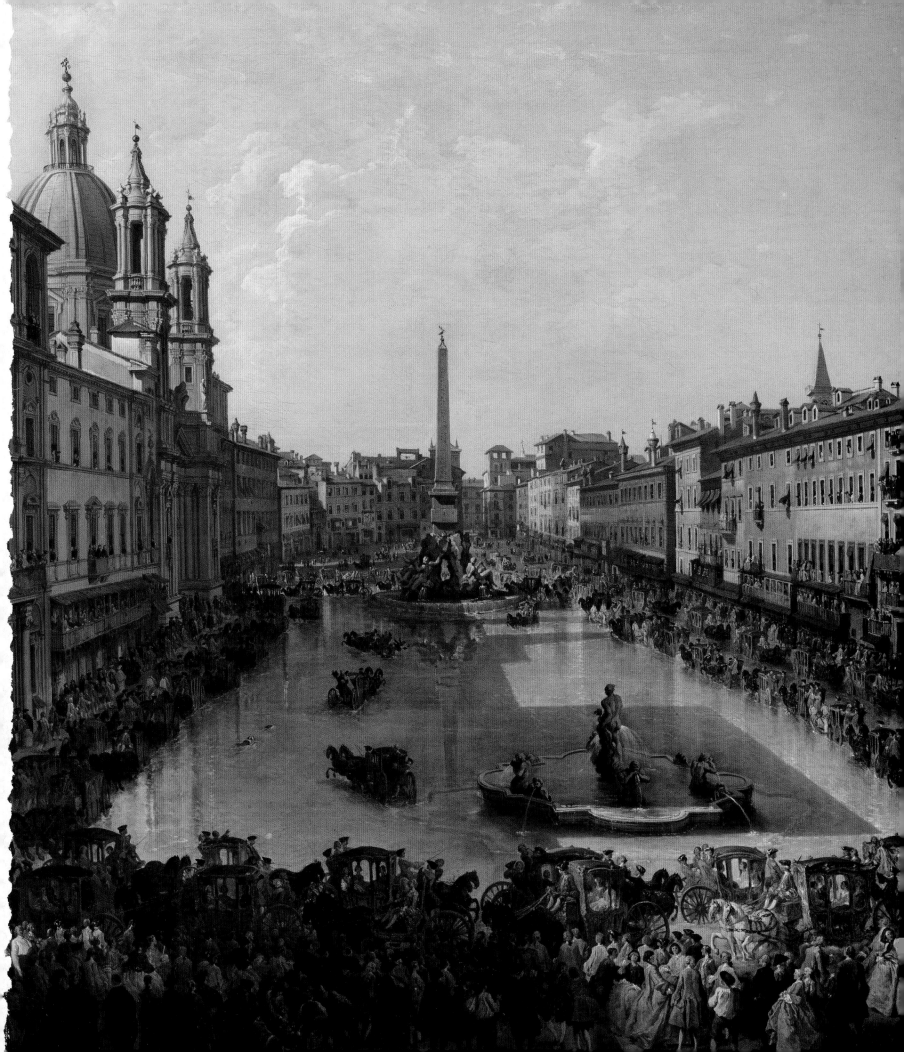

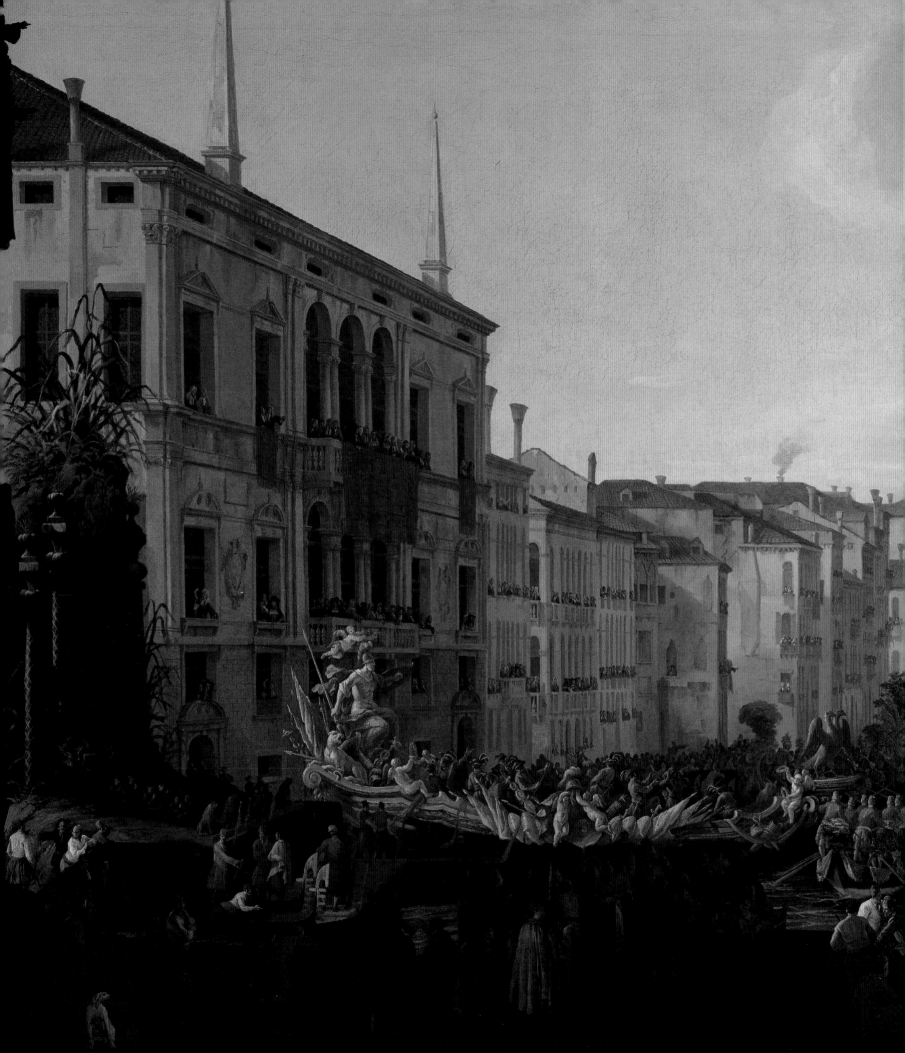

EYEWITNESS VIEWS

MAKING HISTORY IN EIGHTEENTH-CENTURY EUROPE

PETER BJÖRN KERBER

THE J. PAUL GETTY MUSEUM
LOS ANGELES

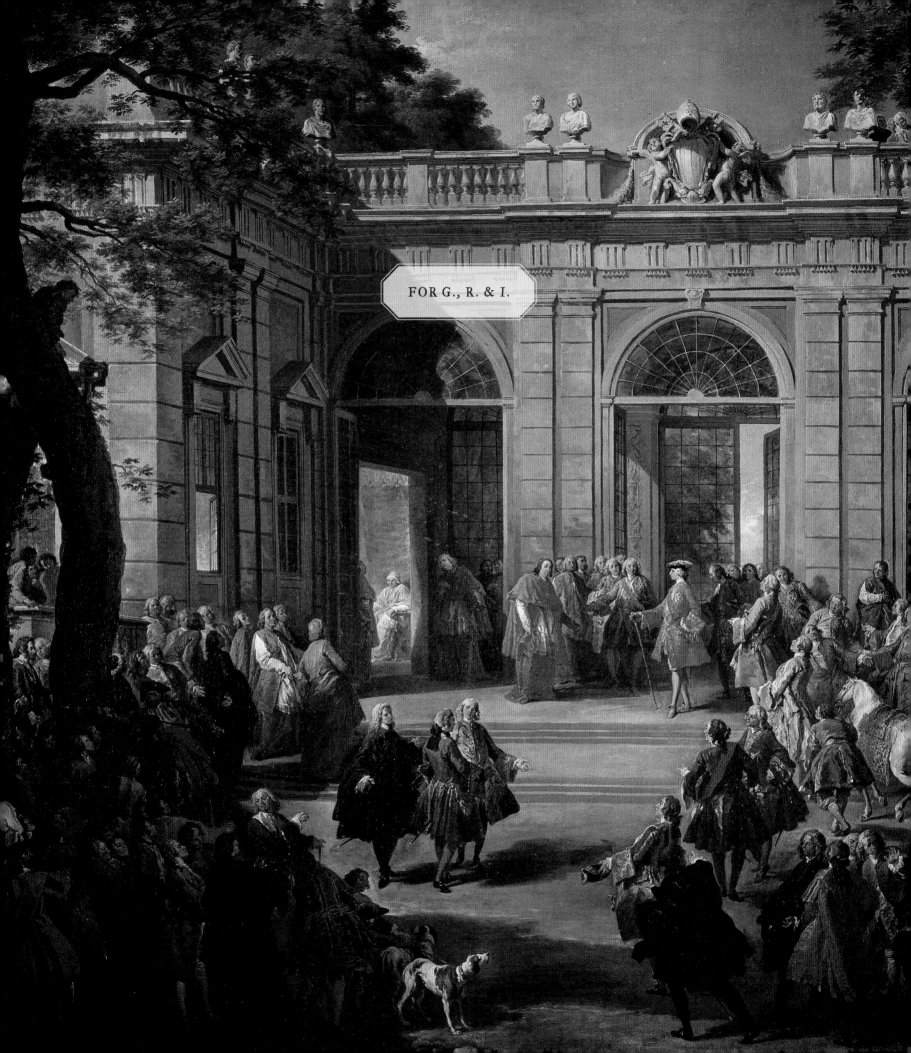

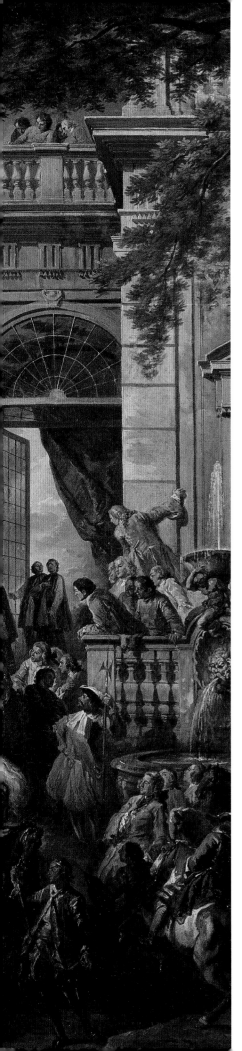

CONTENTS

This publication is issued on the occasion of the exhibition *Eyewitness Views: Making History in Eighteenth-Century Europe*, on view at the J. Paul Getty Museum at the Getty Center, Los Angeles, from May 9 to July 30, 2017; at the Minneapolis Institute of Art from September 10 to December 31, 2017; and at the Cleveland Museum of Art from February 25 to May 20, 2018.

The exhibition was organized by the J. Paul Getty Museum, the Minneapolis Institute of Art, and the Cleveland Museum of Art. It was supported by an indemnity from the Federal Council on the Arts and Humanities.

Published by the J. Paul Getty Museum, Los Angeles
Getty Publications
1200 Getty Center Drive, Suite 500
Los Angeles, CA 90049-1682
www.getty.edu/publications

Ruth Evans Lane, *Project Editor*
Mary Christian, *Manuscript Editor*
Catherine Lorenz, *Designer*
Elizabeth Kahn and Victoria Gallina, *Production*

Distributed in the United States and Canada by the University of Chicago Press

Distributed outside the United States and Canada by Yale University Press, London

Printed by Verona Libri in Italy

Library of Congress Cataloging-in-Publication Data

Names: Kerber, Peter Björn, author. | J. Paul Getty Museum, host institution, issuing body.
Title: Eyewitness views : making history in eighteenth-century Europe / Peter Björn Kerber.
Description: Los Angeles : J. Paul Getty Museum, [2017] | Includes bibliographical references and index.
Identifiers: LCCN 2016041795 | ISBN 9781606065259 (hardcover)
Subjects: LCSH: Narrative painting, European—18th century—Exhibitions. | Europe—In art—Exhibitions. | History in art—Exhibitions.
Classification: LCC ND1442.E854 K47 2017 | DDC 759.4/09033—dc23
LC record available at https://lccn.loc.gov/2016041795

FRONT COVER: Francesco Guardi, *The Meeting of Pope Pius VI and Doge Paolo Renier at San Giorgio in Alga* (detail, fig. 1)

BACK COVER, clockwise: Giovanni Paolo Panini, *King Charles III Visiting Pope Benedict XIV at the Coffee House of the Palazzo del Quirinale* (detail, fig. 205); Luca Carlevarijs, *The Regatta on the Grand Canal in Honor of King Frederick IV of Denmark* (detail, fig. 79); Bernardo Bellotto, *The Demolition of the Ruins of the Kreuzkirche* (detail, fig. 6); Francesco Guardi, *The Balloon Flight of Count Zambeccari* (detail, fig. 204); Antonio Joli, *King Ferdinand VI and Queen Maria Barbara of Braganza on the Royal Longboat at Aranjuez* (detail, fig. 153); Canaletto, *The Procession on the Feast Day of Saint Roch* (detail, fig. 189)

PAGE i: Giovanni Paolo Panini, *The Flooding of the Piazza Navona* (detail, fig. 140)

PAGES ii–iii: Luca Carlevarijs, *The Regatta on the Grand Canal in Honor of King Frederick IV of Denmark* (detail, fig. 79)

PAGE iv: Giovanni Paolo Panini, *King Charles III Visiting Pope Benedict XIV at the Coffee House of the Palazzo del Quirinale* (detail, fig. 205)

Illustration Credits

DIRECTORS' FOREWORD

When the rulers of eighteenth-century Europe put on a celebration, no effort or expense was spared: stunning architectural decorations transformed city squares and interior spaces, ornate coaches and boats transported kings and ambassadors, sumptuous liveries clothed their retinues, and specially composed music or spectacular fireworks entertained the crowds. While these breathtaking urban pageants were by their very nature ephemeral, they had a lasting impact on a genre of art that entered its golden age at the beginning of the eighteenth century: *vedute*, or view painting.

In order to record the grandeur and drama of these festivities, their patrons commissioned large-scale canvases that have few equals in their ability to bring a historical occasion to life across the centuries. It is therefore surprising that a full examination of topographical views with representations of contemporary events has never been attempted. In filling that gap, this book and the exhibition *Eyewitness Views: Making History in Eighteenth-Century Europe* make a much-needed contribution to our knowledge of one of the most visually dazzling and historically important aspects of eighteenth-century art.

Documenting events ranging from celebrations created in honor of royal visitors to civic and religious festivals and even fires or natural disasters, these paintings are among the most significant works produced by artists such as Canaletto, Giovanni Paolo Panini, Francesco Guardi, and Hubert Robert. Commissioned by or for crowned heads ranging from the Holy Roman Empress Maria Theresa to Kings Louis XV of France and Charles III of Spain, as well as multiple popes and doges, the depictions aimed to turn their eighteenth-century admirers into eyewitnesses of historical events from the recent past. Today, they allow us to experience and immerse ourselves in spectacular pageants that would otherwise be lost to us.

The J. Paul Getty Museum, the Minneapolis Institute of Art, and the Cleveland Museum of Art have collaborated to realize the first-ever survey of these magnificent works, resulting in an exhibition that considerably advances our understanding of both the art and the history of the eighteenth century.

We extend our profound thanks to Peter Björn Kerber for having conceived and organized *Eyewitness Views* and for having written the present companion volume. His vision for the project was truly interdisciplinary, combining a deep knowledge of the historical sources with a detailed analysis of the works themselves. In his research for the book and the exhibition, he was ably assisted by Akemi Herráez Vossbrink, Friederike Kroebel, and Laura Llewellyn.

The partnership and support of Patrick Noon, Chair of the Department of Paintings at the Minneapolis Institute of Art, and Betsy Wieseman, The Paul J. and Edith Ingalls Vigno Jr. Curator of European Paintings and Sculpture, 1500–1800, at the Cleveland Museum of Art, have been critical to the success of the exhibition. The

curators were supported by Richard Rand, Associate Director of Collections; Davide Gasparotto, Senior Curator of Paintings; Quincy Houghton, former Associate Director for Exhibitions; and Amber Keller, Acting Head of Exhibitions, all at the J. Paul Getty Museum. Under the direction of Exhibition Design Manager Merritt Price, Irma Ramirez and François Aubret created the exhibition's splendid design in Los Angeles.

At the Minneapolis Institute of Art administrative support was generously provided by Matthew Welch, Deputy Director and Chief Curator; Jennifer Komar Olivarez, Head of Exhibition Planning and Strategy; Rayna Fox, Executive Assistant to the Deputy Director and Chief Curator; Michael Lapthorn, Exhibition Designer; Tammy Pleshek, Public Relations Specialist; Kristin Prestegaard, Chief Engagement Officer; and Jennifer Starbright, Associate Registrar for Exhibitions.

Support within the Cleveland Museum of Art was provided by Heather Lemonedes, Chief Curator; Heidi Strean, Director of Exhibitions and Publications; Jeffrey Strean, Director of Design and Architecture; Mary Suzor, Director of Collections Management; Caroline Guscott, Department Director of Communications; Cyra Levenson, Director of Education and Academic Affairs; and their staffs.

We are tremendously grateful to several colleagues at Getty Publications who were instrumental in producing this elegant and beautiful book: editor Ruth Evans Lane for her guidance and diligence; book designer Catherine Lorenz for her creative vision; and photo researcher Pam Moffat for her detective work. Publisher Kara Kirk, editor in chief Karen Levine, production manager Karen Schmidt, and senior production coordinators Elizabeth Kahn and Victoria Gallina all made important contributions to the book's genesis.

The landmark exhibition that occasioned this volume would have been impossible without the generosity of lenders across North America and Europe. The directors and owners of these public and private collections are especially deserving of our heartfelt gratitude. We also acknowledge the indemnity provided by the Federal Council on the Arts and Humanities.

Timothy Potts
Director
J. Paul Getty Museum

Kaywin Feldman
Nivin and Duncan MacMillan Director and President
Minneapolis Institute of Art

William M. Griswold
Director and President
The Cleveland Museum of Art

ACKNOWLEDGMENTS

The seeds for this project were sown at the Philadelphia Museum of Art in spring 2000. Having spent an entire day immersing myself in the riches of the exhibition *Art in Rome in the Eighteenth Century*, I came away with an appreciation of the superb qualities of Settecento history painting and view painting, an awareness of the symbiotic relationship between these two genres, and a yearning to adopt them both as a field of scholarly endeavor.

Undertaking a study on a subject falling halfway between art history and history—as Francis Haskell so aptly put it in *Patrons and Painters*—runs the risk of disappointing readers interested in either field, but it leaves the author in no doubt about the value of the attempt or the enjoyment that can be derived from making it, whatever the deficiencies of the result may be.

I am deeply indebted to the many friends and colleagues who generously contributed their expertise, intellectual support, and practical assistance to my research and the exhibition: Brian Allen, Ian Archer, Alexis Ashot, Adriano Aymonino, Katharine Baetjer, Malcolm Baker, Liliana Barroero, Reinhold Baumstark, Charles Beddington, Emily Beeny, Sylvain Bellenger, David Boaretto-Sarti, Amanda Bradley, Jean-Marie Bruson, Dawson Carr, James Clifton, Jeffrey Collins, Roberto Contini, Howard Coutts, Alberto Craievich, David Dearinger, Thomas Gaehtgens, Mercedes González de Amezúa, Michael Hall, Andreas Henning, Roman Herzig, Clare Hornsby, Jeremy Howard, Yuriko Jackall, Susan Jenkins, Ian Kennedy, Antje-Fee Köllermann, Bożena Anna Kowalczyk, Heather Lemonedes, James Macdonald, Patrice Marandel, Louis Marchesano, Manuela Mena Marqués, David Marshall, Gudrun Maurer, Rebecca Messbarger, Gudula Metze, the late Olivier Michel, John Moore, John Morton-Morris, Patrick Noon, Carlo Orsi, Carole Paul, Joseph Rishel, Francis Russell, Scott Schaefer, Andreas Schumacher, Paolo Serafini, John Somerville, Gudrun Swoboda, Jennifer Thompson, Felix Thürlemann, Oliver Tostmann, Letizia Treves, Aidan Weston-Lewis, Betsy Wieseman, Veronika Wolf, Karin Wolfe, Martha Wolff, Jonathan Yarker, and several anonymous collectors. The book also benefited enormously from Susan Tipton's pioneering study of ambassadorial reception paintings.

Neither the exhibition nor this book would have been possible without the staunch support of Timothy Potts, Richard Rand, Davide Gasparotto, Quincy Houghton, Amber Keller, Betsy Severance, and Kanoko Sasao at the J. Paul Getty Museum, as well as Kaywin Feldman at the Minneapolis Institute of Art and William Griswold at the Cleveland Museum of Art. Anne Woollett, Scott Allan, and Jill Hortz, my colleagues in the Paintings Department, never ceased to encourage and help me along the way. Maureen Cassidy-Geiger, Anne-Lise Desmas, and Laura Llewellyn read the manuscript and made numerous essential suggestions. Stéphane Loire and Catherine Whistler kindly allowed me to read drafts of their forthcoming collection catalogues. Akemi Herráez Vossbrink and Friederike Kroebel provided invaluable research assistance.

I am enormously grateful to my thaumaturgic editor, Ruth Evans Lane, for her keen eye and sage counsel. Mary Christian and Greg Dobie improved the text in manifold ways. Catherine Lorenz brought tremendous empathy, acuity, and flair to the book's design, Pam Moffat tirelessly tracked down its images, and Elizabeth Kahn and Victoria Gallina seamlessly managed its production.

My greatest debt of all, however, is to a triumvirate of mentors and scholarly role models who have inspired and guided my work on eighteenth-century art from the very beginning: Steffi Roettgen, Edgar Peters Bowron, and Christopher Johns. Words cannot adequately express the depth of my gratitude for their advice, encouragement, and friendship.

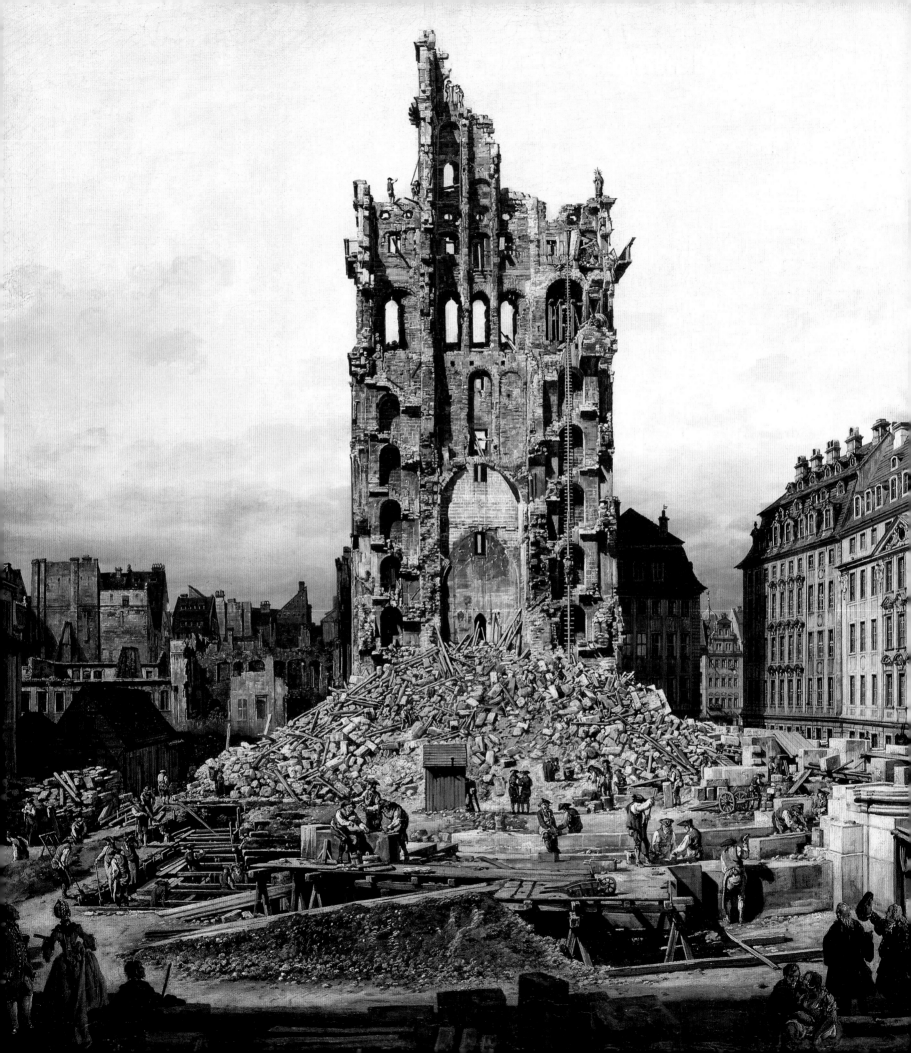

CHAPTER I
THE VIEW PAINTER AS EYEWITNESS

In the Venetian lagoon, a third of the way from the city to the mainland, lies the small island of San Giorgio in Alga, home to a monastery with a modest church and not much else. On 15 May 1782 it was awoken from its existence of tranquil insignificance by a seminal event in the history of the Serene Republic: the visit of Pope Pius VI (r. 1775–99), who was received by the doge on San Giorgio in Alga because the island marked the city's watery boundary (fig. 1). Pius VI was the first pontiff to visit Venice since 1177 and the only head of state to be received with the full pomp due to a personage of his rank; all other rulers and princes arriving in the city over the course of the eighteenth century traveled incognito, a ceremonial convention allowing them to assume a different name and avoid the strictures of protocol.

To mark this momentous occasion, Pietro Edwards, the Republic's inspector of public paintings, commissioned a series of four view paintings from Francesco Guardi (each of which exists in at least two versions) recording the key moments of the pope's five-day visit (figs. 2–4).[1] The agreement with the painter stipulated that he had to "take the views on the spot," most probably by making rapid sketches that formed the basis for the four compositions executed in his studio.[2] They exemplify what Ernst Gombrich has described as the "eyewitness principle," the deliberate construct of an artist representing what an eyewitness would have seen from a specific viewpoint at a specific point in time.[3] Artists and patrons leveraged this construct precisely because they realized that such images were, in Peter Burke's words, "in a sense historical agents, since they not only recorded events but also influenced the way in which those events were viewed at the time."[4]

The present book examines eighteenth-century view paintings depicting contemporary events. Many of these works, which simultaneously record an occasion and its topographical setting, are milestones in the careers of the century's leading view painters such as Guardi, Canaletto, and Giovanni Paolo Panini, who were spurred to create works of extraordinary artistic quality for a number of reasons: the opportunity to serve a prestigious clientele of kings, princes, and ambassadors; generous financial rewards and follow-up commissions; the inspiration of events characterized by lavish pageantry and a vibrant atmosphere; and, in many cases, the chance to work on a monumental scale that the regular tourist-driven market for view paintings rarely allowed.

In the absence of an established shorthand, the term *reportorial view* is used here to describe this type of painting.[5] Among its chief characteristics—which apply frequently but not always simultaneously—are the role as a permanent visual account of a transitory moment, the inclusion of recognizable likenesses of people participating in the event, the patronage of the event's protagonists or organizers, and the conscious shaping of the historical record. In order to develop a new understanding of the political and cultural agendas explicitly or implicitly expressed in such works, this study will

FIG. I
Francesco Guardi (Italian, 1712–1793).
*The Meeting of Pope Pius VI and Doge
Paolo Renier at San Giorgio in Alga*, 1782.
Oil on canvas, 51 × 67 cm (20¹⁄₁₆ × 26³⁄₈ in.).
Private collection

undertake a detailed analysis of a limited number of representative works, beginning with one of the earliest examples of the type, Luca Carlevarijs's *The Reception of the French Ambassador Henri Charles Arnauld, Abbé de Pomponne, at the Doge's Palace* of circa 1706–8, which is placed in the context of paintings documenting ambassadorial entries (chapter 2). The subsequent chapters will investigate thematically related groups of works such as views showing unique events staged for prominent visitors (chapter 3) and representations of recurring civic and religious celebrations (chapter 4).

As its chronological parameters, this study adopts the eight decades of the golden age of European view painting from the beginning of the eighteenth century to Francesco Guardi's late works of the 1780s, which coincided with the end of the ancien régime. During this period, view paintings enjoyed an unprecedented surge in both quality and popularity. In the finely spun web of dynastic and political alliances that characterized eighteenth-century Europe, pictures as well as artists moved with ease from court to court, from capital to capital. Crowned heads across

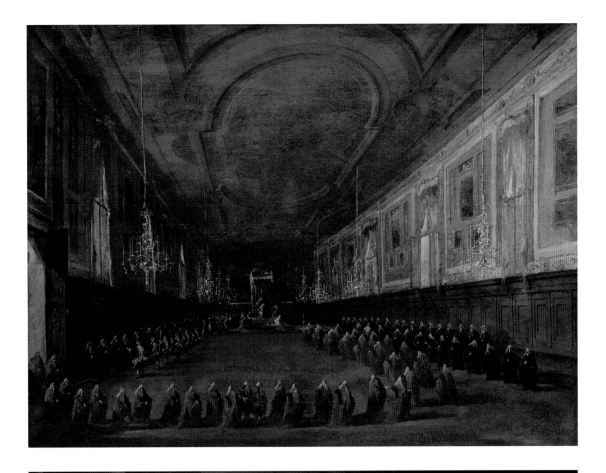

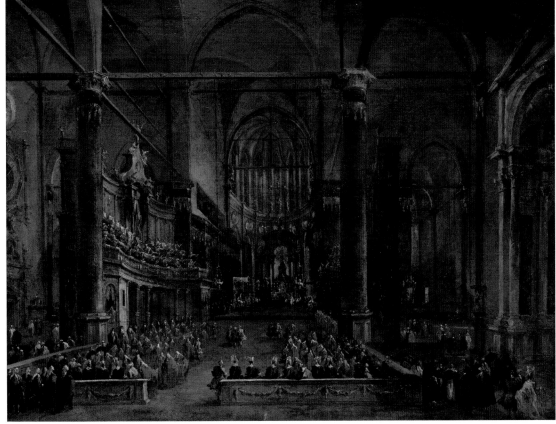

FIG. 2
Francesco Guardi (Italian, 1712–1793).
Pontifical Ceremony in Ss. Giovanni e Paolo,
1782. Oil on canvas, 51 × 69 cm (20 3⁄16 ×
27 1⁄16 in.). Cleveland Museum of Art,
Gift of the Hanna Fund, 1949.187

FIG. 3
Francesco Guardi (Italian, 1712–1793).
*Pope Pius VI Descending the Throne to Take
Leave of the Doge in the Hall of Ss. Giovanni
e Paolo*, 1782. Oil on canvas, 51 × 69 cm
(20 3⁄16 × 27 1⁄16 in.). Cleveland Museum of Art,
Gift of the Hanna Fund, 1949.187

FIG. 4
Francesco Guardi (Italian, 1712–1793).
*Pope Pius VI Blessing the Crowd in Campo
Ss. Giovanni e Paolo*, 1782. Oil on canvas,
50 × 67 cm (19⅞ × 26¼ in.). National Trust,
Upton House, NT 446812

the continent—from the Holy Roman Empress Maria Theresa to kings, electors, popes, and Venetian doges—delighted in seeing events staged either in their presence or in their honor commemorated in masterpieces by the group of artists selected for this study—Carlevarijs, Canaletto, Panini, Claude Joseph Vernet, Bernardo Bellotto, Antonio Joli, Francesco Battaglioli, Guardi, and Hubert Robert.

As a consequence of this concentration, works prized primarily for their historical value rather than their artistic qualities—for example, battle paintings—are outside the scope of the present study. Its geographic trajectory follows in the footsteps of the same group of artists. Although predominantly Italian by birth or by training, they dominated the production of view paintings of the highest artistic level in nearly every major European capital from Venice, Naples, and Rome to Vienna, Munich, Dresden,

Warsaw, Paris, Madrid, and London. The precepts of the reportorial view were carried to most of these cities by itinerant artists such as Joli or Bellotto, but this rarely resulted in the flowering of a local school of view painters once the Italians had moved on (chapter 5). By contrast, Guardi and Panini did not venture beyond views of and events in Venice and Rome, respectively, although the latter trained Robert, who went on to document incidents in Paris such as the fire at the opera house (see figs. 176, 177).

Reportorial views played a crucial role in the nascent genre of *vedute* as a whole due to a fortuitous confluence occurring in Venice: a constant stream of affluent foreign visitors encountering the city's highly distinctive topography, and Carlevarijs's rapidly developing ability to capture it in compelling view paintings.[6] A French ambassador, Joseph Antoine Hennequin de Charmont (ca. 1670–1731), was among the first to realize the potential this created and commissioned what could either be described as a view of the Molo and the Doge's Palace with his official entry or a view of his official entry against the backdrop of the Molo and the Doge's Palace (see fig. 37). A few of Gaspar van Wittel's (1652/53–1736) Venetian views—most significantly, *The Molo from the Bacino di San Marco* of 1697—slightly predate Carlevarijs's earliest works, but the former's compositions are purely topographical and do not record specific events.[7]

Shifts in Meaning

Whether a reportorial view painting was and is understood primarily as a view of a specific site or as a depiction of an event taking place at that site is most often determined by what knowledge of the occasion or the site has been preserved. As the event tended to be more relevant to a painting's patron and those who knew him or her than to successive generations, many works that changed hands saw their meaning shift from the reportorial to the topographical. This happened even to the works of Panini, who was probably more adept than any other artist at integrating vivid likenesses into his reportorial views:[8] immediately after the death of one of the most senior French ecclesiastics in Rome, Claude François Rogier de Beaufort-Montboissier, abbé de Canilliac, in 1761, a pair of paintings showing him during a visit to Saint Peter's Basilica and as a participant in a specific ambassadorial ceremony in Saint Peter's Square that had taken place only five years earlier were catalogued as "the interior of the church of Saint Peter's with many figures" and "Saint Peter's Square with coaches and figures."[9] By the time their next owner, Jacques Onésyme Bergeret de Grancourt, died in 1785, the paintings had become simply "the interior and exterior of Saint Peter's in Rome."[10]

Such a blurring of the boundaries between a painting's topographic and narrative functions could also be a calculated decision taken by the artist or patron. When Bellotto returned to Dresden after the end of the Seven Years' War (1756–63), he painted one of the city's main churches, the Kreuzkirche, for the second time. His homage to the monumental facade had become a record of the past, replaced by a present in which the artist documented the building's demolition (figs. 5, 6).[11] During the war, Bellotto had spent two years in Vienna, where Maria Theresa commissioned a pair of views of Schönbrunn Palace from him. The view from the garden side emphasizes the imposing architecture, the refined layout of the parterre, and the bucolic location outside Vienna,

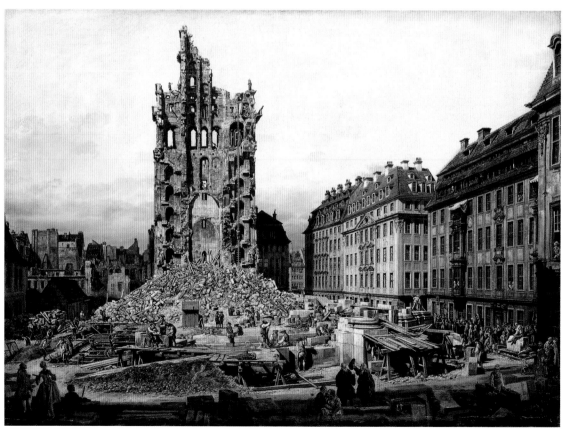

FIG. 5
Bernardo Bellotto (Italian, 1721–1780). *The Kreuzkirche in Dresden*, ca. 1751. Oil on canvas, 196 × 186 cm (77³⁄₁₆ × 73¼ in.). Dresden, Gemäldegalerie Alte Meister, inv. 616

FIG. 6
Bernardo Bellotto (Italian, 1721–1780). *The Demolition of the Ruins of the Kreuzkirche*, 1765. Oil on canvas, 80 × 110 cm (31½ × 43⁵⁄₁₆ in.). Dresden, Gemäldegalerie Alte Meister, inv. 638

FIG. 7
Bernardo Bellotto (Italian, 1721–1780). *Schönbrunn Palace, Garden Side*, 1759–60. Oil on canvas, 134 × 238 cm (52¾ × 93¹¹⁄₁₆ in.). Vienna, Kunsthistorisches Museum, inv. GG 1667

FIG. 8
Bernardo Bellotto (Italian, 1721–1780). *Schönbrunn Palace with the Arrival of the Courier from the Battle of Kunersdorf*, 1759–60. Oil on canvas, 135 × 235 cm (53⅛ × 92½ in.). Vienna, Kunsthistorisches Museum, inv. GG 1666

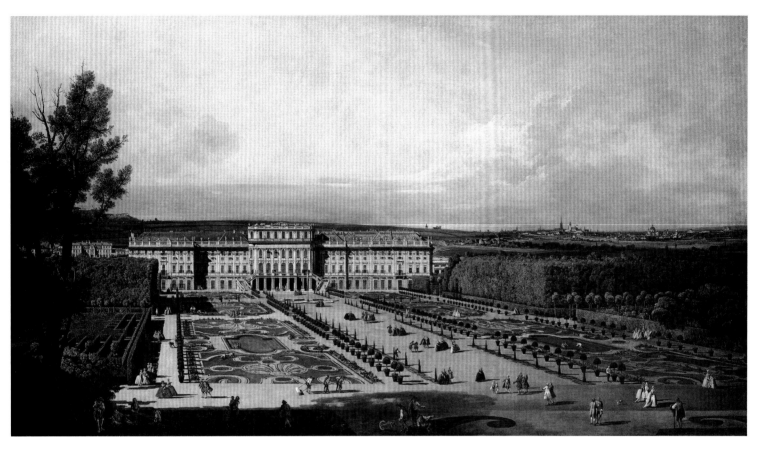

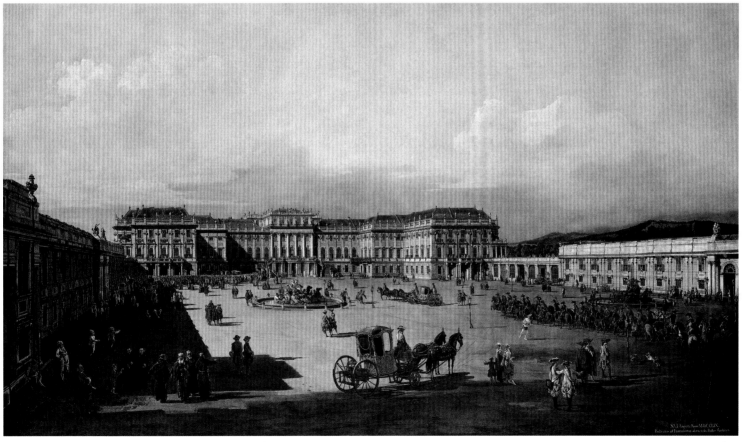

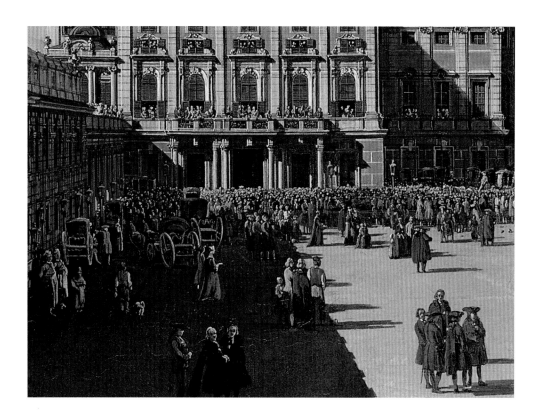

FIG. 9
Detail of fig. 8. Bernardo Bellotto,
*Schönbrunn Palace with the Arrival of the
Courier from the Battle of Kunersdorf*, 1759–60.
Vienna, Kunsthistorisches Museum

visible in the background (fig. 7). In the pendant, showing the palace from the courtyard side, a coach sweeps around the fountain and heads toward the left wing, where a dense crowd has gathered below the balcony (figs. 8, 9). An inscription at bottom right provides the historical context: on 16 August 1759, Count Joseph Kinsky reached Vienna with the news of a victory in the Seven Years' War.[12] Four days earlier, the allied Russian and Austrian forces had inflicted a punishing defeat on the Prussian army at Kunersdorf. Visible on the balcony in a blue dress, Maria Theresa leans over the balustrade as she waits to receive word of triumph or defeat. With equal legitimacy, the painting can be read as a rendition of the imperial summer palace or as the testimony of a critical moment in the Seven Years' War.

Chronicling seminal events in the lives of rulers and other members of the European elite was a task that brought view painters a level of recognition and prestige they had previously been lacking. In pushing beyond their genre's boundaries, they entered territory occupied by history painters and portraitists. The compositional and narrative techniques of Joli's interior scene of the abdication of Charles III as king of Naples in favor of his son Ferdinand in 1759 (fig. 10) parallel those employed, for example, by the portraitist Martin van Meytens in his depiction of the coronation banquet of Joseph II in 1764 (fig. 11).[13] In Rome, Panini and the history painter Pierre Subleyras (1699–1749) each memorialized the presentation of the Order of the Holy Spirit to Prince Girolamo Vaini by the French ambassador, Paul Hippolyte, duc de Saint-Aignan, on 15 September 1737 (figs. 12, 13).[14] The central group with the recipient kneeling in front of the ambassador, who holds out the blue riband known as the cordon bleu, is common to both compositions, but it is integrated into entirely different settings. Panini provides a view into the sumptuously decorated choir of the

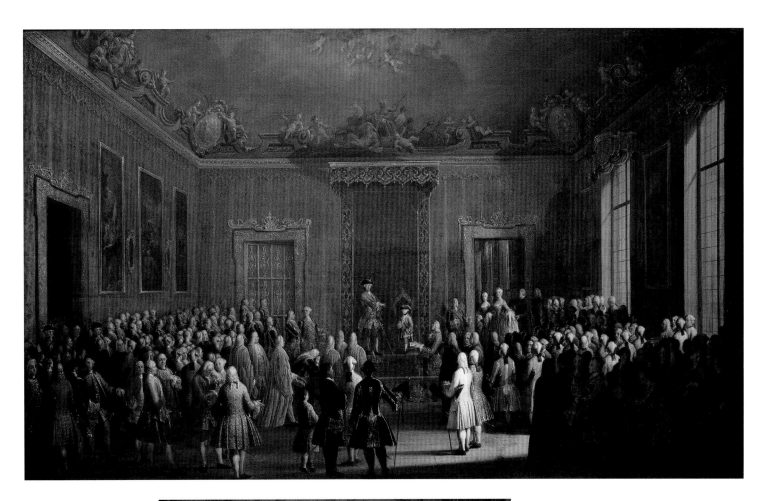

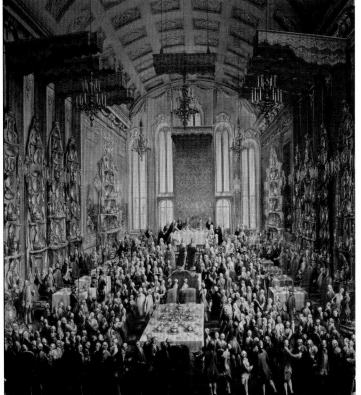

FIG. 10
Antonio Joli (Italian, 1700–1777). *The Abdication of Charles III as King of Naples in Favor of His Son Ferdinand*, ca. 1759. Oil on canvas, 77 × 126 cm (30⁵⁄₁₆ × 49⁵⁄₈ in.). Madrid, Museo del Prado, inv. P07696

FIG. 11
Martin van Meytens (Swedish, 1695–1770). *Coronation Banquet of Joseph II at the Römer in Frankfurt*, 1764. Oil on canvas, 360 × 320 cm (141¾ × 126 in.). Vienna, Schloß Schönbrunn

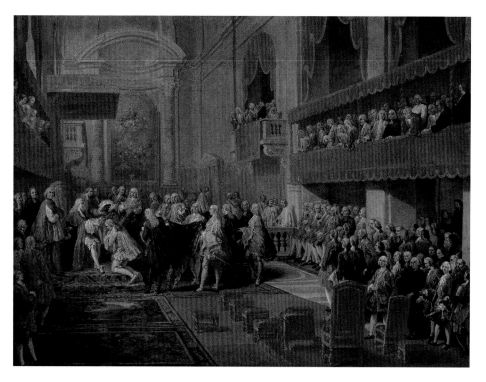

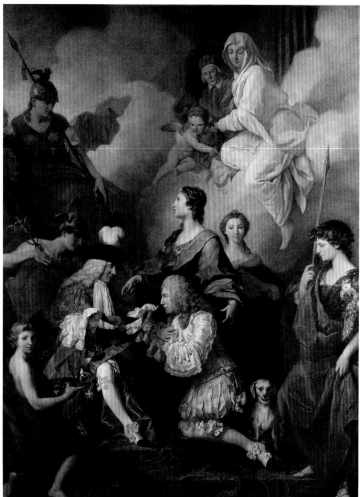

FIG. 12
Giovanni Paolo Panini (Italian, 1691–1765).
*The Duc de Saint-Aignan Presents the Order
of the Holy Spirit to Prince Girolamo Vaini*,
ca. 1737–45. Oil on canvas, 72 × 98 cm
(28⅜ × 38 9/16 in.). Caen, Musée des
Beaux-Arts, inv. 102

FIG. 13
Pierre Subleyras (French, 1699–1749).
*The Duc de Saint-Aignan Presents the Order
of the Holy Spirit to Prince Girolamo Vaini*,
1737. Oil on canvas, 332 × 224 cm (130 11/16 ×
88 3/16 in.). Paris, Musée National de la Légion
d'Honneur, Gift of La Société d'entraide de
la Légion d'Honneur, inv. 01054

French national church in Rome, San Luigi dei Francesi, where the duc de Saint-Aignan is seated under a dais; Subleyras takes the same event and transposes it into an allegorical realm: in a space vaguely defined by fluted columns, a congregation of classical deities—Minerva and Mercury—and personifications—including Religion and Nobility—attends the ceremony.

Whereas Panini's canvas exemplifies the qualities of verisimilitude, dramatic conviction, and precise observation that made him the premier view painter of eighteenth-century Rome,[15] Subleyras deploys the tools of his own genre with equal virtuosity. In other cases, history and view painters both took pains to create an impression or even an illusion of realism and authenticity. Agostino Masucci's monumental canvas—the figures are nearly life size—showing the wedding of Prince James Francis Edward Stuart and Princess Maria Clementina Sobieska in 1719 suggests that the viewer can step into the painter's shoes as a guest at the ceremony, disguising the fact that Masucci had no way of knowing what it actually looked like because it had taken place some fifteen years earlier (fig. 14). By the same token, certain views that purported to faithfully

FIG. 14
Agostino Masucci (Italian, ca. 1691–1758). *The Solemnization of the Marriage of James III and Maria Clementina Sobieska*, ca. 1735. Oil on canvas, 244 × 342 cm (96¹⁄₁₆ × 134⅝ in.). Edinburgh, Scottish National Portrait Gallery, inv. PG 2415

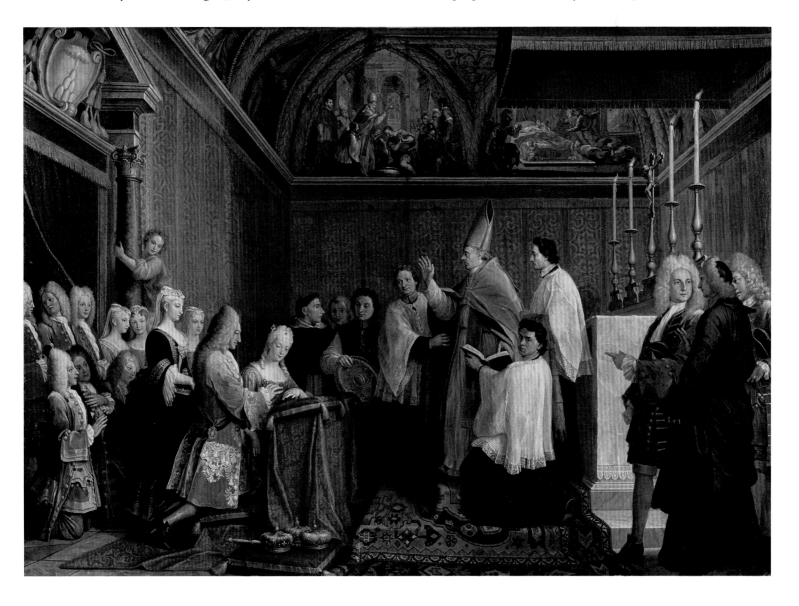

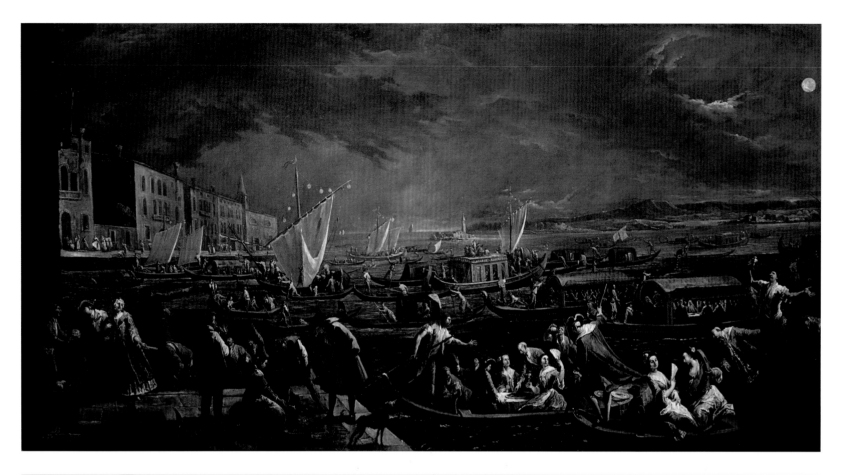

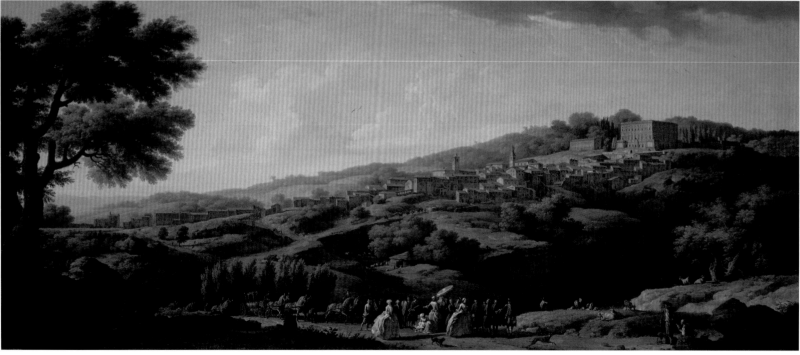

reproduce a topographical setting manipulated the scene's architectural features in order to invest it with a sense of grandeur that the event's actual site had been lacking (chapter 6).

View painters could find themselves in competition with history painters even when recording recurring events rather than unique occasions (chapter 5). As Canaletto was producing his night scene of the festival of Saint Martha (see fig. 165), he was probably aware of a large canvas of the same subject by Gaspare Diziani (fig. 15).[16] While the scale of the figures and the prominence of the buildings on the waterfront of the Giudecca Canal immediately reveal the differences in approach, the goal of bringing the festival to life through a wealth of anecdotal details is shared by both artists.

The role of landscape in reportorial view paintings was limited by the fact that noteworthy events typically occurred in urban settings. Perhaps the most impressive of the exceptions is Vernet's imposing view of Villa Farnese at Caprarola, north of Rome, in which the landscape occupies a significant proportion of the composition (fig. 16).[17] The canvas commemorates the visit of Elisabeth Farnese, Queen of Spain, to one of her ancestral homes in 1745. It was commissioned by the Spanish ambassador, Cardinal Troiano Acquaviva d'Aragona, who used the property as his country residence and appears in the foreground next to the queen. To indicate his status as an eyewitness, Vernet sits at left in the shade of a tree and sketches the scene.

Similarly, nature takes precedence over architecture in Guardi's depiction of Doge Paolo Renier (r. 1779–89) greeting Pope Pius VI at San Giorgio in Alga (see fig. 1).[18] Emphasizing the remoteness of the island in the Venetian lagoon's expanse of water and sky, with a fragment of the city's silhouette visible at left to indicate the location, helped Guardi demonstrate that the pope was treated with the greatest possible honors during his visit to Venice in 1782. The doge had traveled out to the small island in order to await Pius VI at the point where, in the city's unique topography, he was considered to enter Venice. The figures of the two protagonists are minute but distinctly identifiable by their dress and called out by compositional means, especially the gangway leading the eye toward them (fig. 17). They are equally small in the reportorial view of

FIG. 15
Gaspare Diziani (Italian, 1689–1767). *The Feast of Santa Marta*, ca. 1750–55. Oil on canvas, 167 × 329 cm (65¾ × 129½ in.). Venice, Ca' Rezzonico, inv. 115

FIG. 16
Claude-Joseph Vernet (French, 1714–1789). *The Visit of Elisabeth Farnese, Queen of Spain, to Villa Farnese at Caprarola*, 1746. Oil on canvas, 133 × 309 cm (52⅜ × 121⅝ in.). Philadelphia Museum of Art, Purchased with the Edith H. Bell Fund, inv. 1977-79-1

FIG. 17
Detail of fig. 1. Francesco Guardi, *The Meeting of Pope Pius VI and Doge Paolo Renier at San Giorgio in Alga*, 1782. Private collection

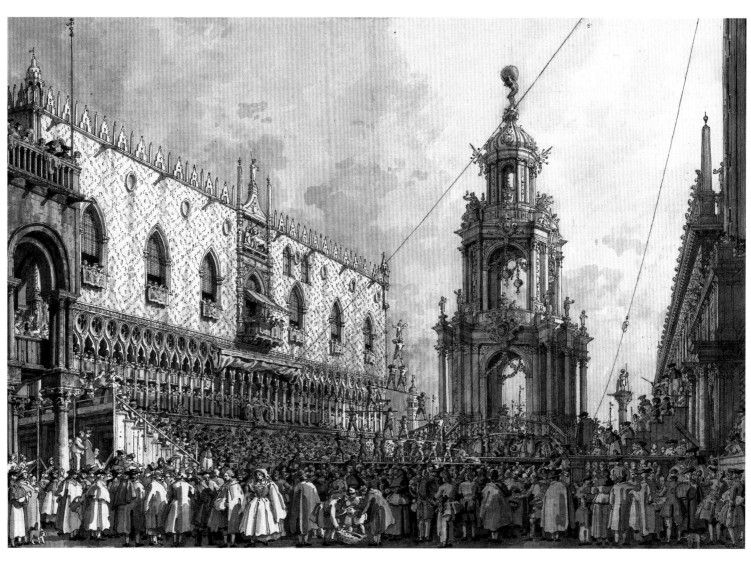

FIG. 18
Canaletto (Italian, 1697–1768). *The Giovedì Grasso Festival in the Piazzetta*, 1763–66, pen and brown ink with gray wash over graphite and red chalk heightened with white gouache, on laid paper, 386 × 555 mm (15 3/16 × 21 7/8 in.). Washington, D.C., National Gallery of Art, Wolfgang Ratjen Collection, Paul Mellon Fund, inv. 2007.111.55

FIG. 19
Giovanni Battista Brustolon (Italian, 1712–1796), after Canaletto (Italian, 1697–1768). *The Giovedì Grasso Festival in the Piazzetta*, 1763–66, etching and engraving on laid paper, 460 × 610 mm (18 1/8 × 24 in.). Los Angeles, Getty Research Institute, inv. 86-B1723

the pope giving his final blessing to the Venetian populace on Pentecost Sunday from a temporary benediction loggia erected in front of the Scuola di San Marco (see fig. 4).[19] Decorated to imitate the facade of Saint Mark's, this temporary structure was designed to offer space for the doge and the members of the Venetian Senate to participate in the ceremony literally on the same level as the pontiff instead of being passive recipients of his blessing down in the square.[20]

The emphasis is not, as it would have been in a reportorial composition by a history painter or portraitist, on the interaction between the protagonists but on the event's political significance and its setting. Guardi had employed the same technique in a series of twelve views known as the Festivals of the Doge, which were based on a series of engravings by Giovanni Battista Brustolon after drawings by Canaletto. The series includes the ceremonies connected to the election of a new doge (see chapter 6) as well as annual festivals in which the doge participated, such as the celebrations held on Giovedì Grasso, the Thursday of carnival, in the Piazzetta (figs. 18–20). The doge is but a tiny figure on the balcony of the Doge's Palace (fig. 21); the true protagonist of this and the other depictions in the series is the Serene Republic, embodied by its rituals and traditions.

FIG. 20
Francesco Guardi (Italian, 1712–1793). *The Giovedì Grasso Festival in the Piazzetta*, ca. 1775. Oil on canvas, 67 × 100 cm (26⅜ × 39⅜ in.). Paris, Musée du Louvre, Gift of Mrs. Barbara Hutton, inv. 321

FIG. 21
Detail of fig. 20. Francesco Guardi, *The
Giovedì Grasso Festival in the Piazzetta*, ca. 1775.
Paris, Musée du Louvre

Engravings, whether they formed the basis of a painting or reproduced one, were the most effective way to preserve its specific meaning. Panini's reportorial view of the Roman celebrations staged in 1729 by Cardinal de Polignac in honor of the birth of the dauphin, engraved in 1735 (see chapter 4), was invoked forty years later by the Parisian astronomer Joseph Jérôme Lefrançois de Lalande (1732–1807) in his Italian travel journal. When Lalande ended his description of the Piazza Navona by recalling the "famous celebration" and specifically referred to Panini's painting, he assumed that his readers would be familiar with it from the engraving.[21] A crucial difference between engravings and paintings of events is that the former rarely portray specific personalities, whereas the latter frequently combined stock figures drawn from a repertoire preserved in sketchbooks with recognizable likenesses of the patron and other protagonists; as their sources for these, view painters drew upon portrait engravings or even caricatures (see especially chapters 2 and 4).

The significance of the figures is one of the key characteristics that lifts reportorial view paintings out of the plethora of views produced in the eighteenth century. Rather than being a generic staffage whose chief purpose is pictorial effect, the figures in compositions documenting particular occasions fulfill two distinct roles: one group, usually smaller in number but often appearing in the foreground, portrays specific personalities; the other, the majority, stands in for the viewer and creates the impression of being an eyewitness to the event. Guardi's rendition of the Corpus Christi procession in Piazza San Marco, belonging to the Festivals of the Doge series based on a Brustolon engraving after a Canaletto drawing, is a case in point (fig. 22).[22] The composition and Guardi's fluid brushwork join forces to seduce the eye into accepting a carefully

16

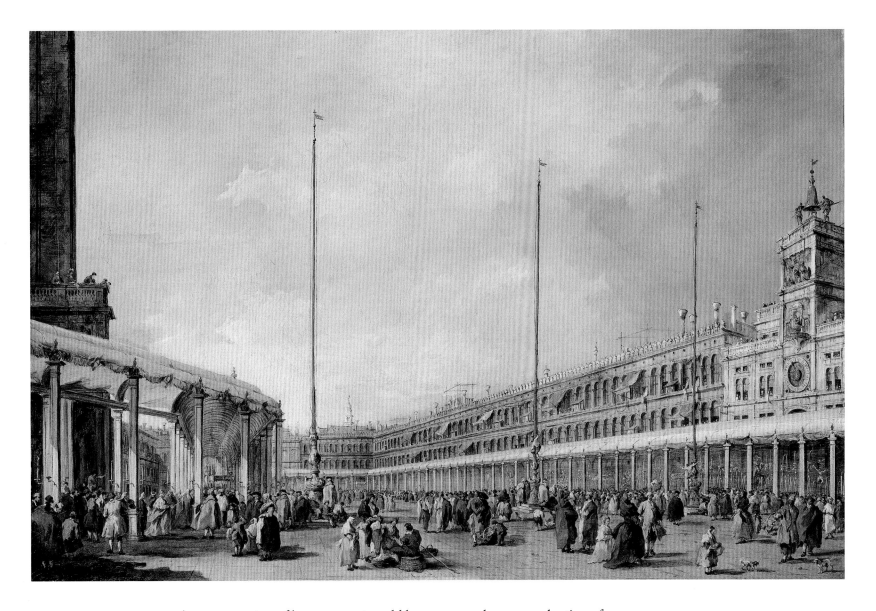

constructed representation of how an event could have appeared as a reproduction of reality—plausibility trumps mimicry. Doge Alvise IV Mocenigo (r. 1763–78), identifiable by his ducal hat and ermine shoulder cape, walks in the procession underneath the temporary colonnade at left. Behind him, a group of spectators is shown from the back, transplanting the viewer's perspective into the painting itself. The aspect of spectatorship is further emphasized by figures looking down into the piazza from the Loggia of the Campanile, from the windows of the Procuratie Vecchie, and from the balconies of the clock tower.

In this and in nearly every other work discussed in this study, such figures invite us to join them as participants in the events that inspired some of the greatest achievements of European view painting. By reconstructing their meaning and context through contemporary eyes, through the understanding of the spectator of the day, this book aims to demonstrate how reportorial *vedute* purposefully shaped the viewer's recollection and thereby determined the perception, memory, and historical record of many of eighteenth-century Europe's formative events.

FIG. 22
Francesco Guardi (Italian, 1712–1793).
Doge Alvise IV Mocenigo in the Corpus Christi Procession in Piazza San Marco, ca. 1775.
Oil on canvas, 67 × 98 cm (26⅜ × 38⁹⁄₁₆ in.).
Paris, Musée du Louvre, inv. 322

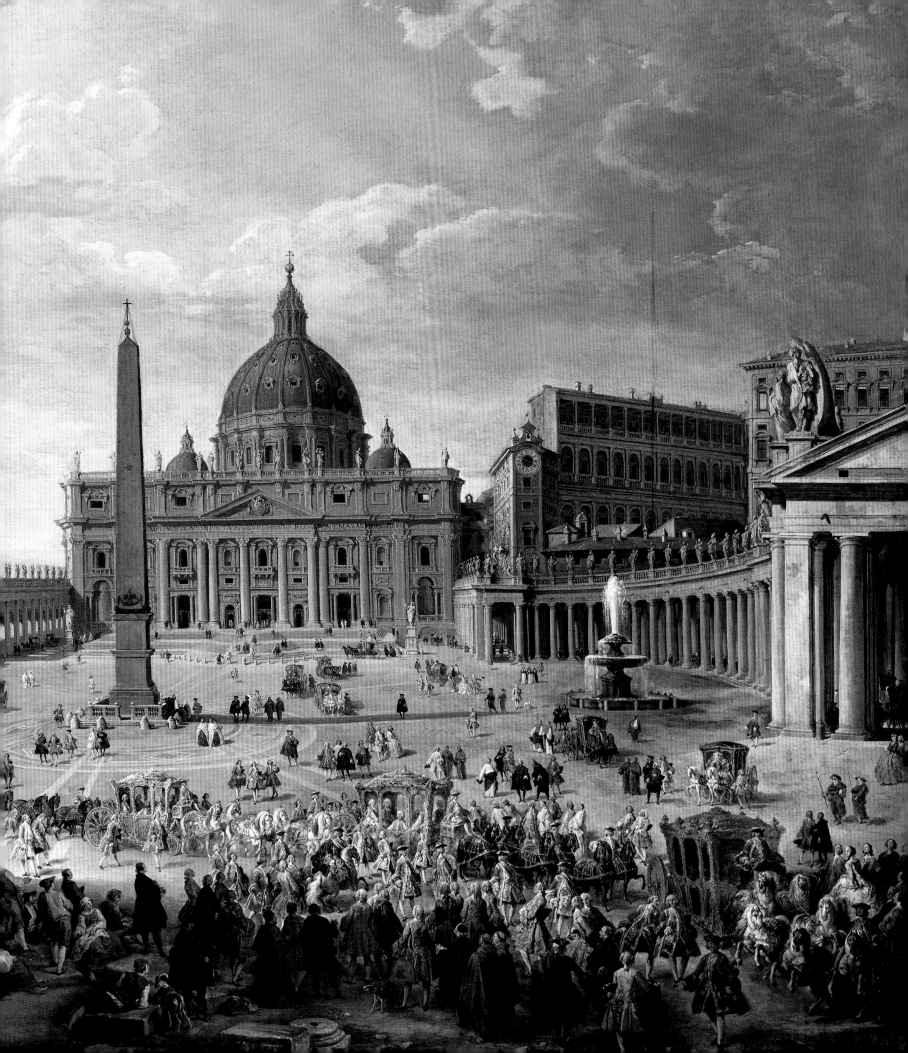

AMBASSADORIAL PATRONS
MAKE THEIR ENTRANCE

Stepping off a gondola onto the Molo on 10 May 1706, Henri Charles Arnauld, abbé de Pomponne (1669–1756),[1] made his official entry as the new French ambassador to the Most Serene Republic of Venice. Knowing that the day was going to be one of the most significant occasions in his entire career as a diplomat, Pomponne had commissioned Luca Carlevarijs to record the scene in a large canvas (fig. 23).[2] While the quay in front of the Doge's Palace and the Piazzetta had always been the traditional disembarkation point for prominent visitors to the city,[3] Pomponne's journey ending on the Molo had not in fact begun in Paris but only a few miles away, at the Palazzo Della Vecchia, located on the northern side of the island near the church of the Madonna dell'Orto. This was the ambassador's official residence, which he had occupied since his arrival in Venice in June 1705.[4] It was far from uncommon for the official entry of a new ambassador to be delayed by a year or more after his arrival. This gave the embassy time to prepare an opulent ceremony that demonstrated the power and wealth of the crown it represented. In formal terms, the meticulously staged entry was the beginning of an ambassador's tenure in a foreign capital; in practice, the event often became its high point—or even its only memorable moment. This was all the more likely if there was precious little actual diplomatic business to be conducted, as was usually the case in eighteenth-century Venice.

A French ambassador to Vienna, Berlin, or Saint Petersburg might negotiate a treaty, an alliance, even a joint declaration of war against another power. Such an embassy would be measured and remembered by its strategic outcomes. The Republic of Venice, having settled into scrupulous neutrality and lapsed into political insignificance, offered a diplomat little scope for displaying negotiating prowess or taking decisive action that might alter the course of history. Before setting out for Venice to take up his post as ambassador in 1723, Jacques Vincent Languet de Gergy (1667–1734) may have found it rather discouraging to read in his instructions from the French foreign ministry that with "the Republic playing so small a part and having so little influence in the principal affairs of Europe, the residency of an ambassador of the king seems to serve the maintenance of the ancient union between the crown and this Republic rather than the negotiation of any significant affairs."[5] During a visit to the city on the lagoon in 1728, the baron de Montesquieu (1689–1755) mercilessly pointed out that there was "nothing quite as useless as a French ambassador to Venice, like a merchant in a field hospital,"[6] while Charles de Brosses (1709–1777) observed in 1739 that "the job of ambassador is quite sad here."[7] One of the post's most astute occupants, François Joachim de Pierre, Cardinal de Bernis (1715–1794), professed in 1753 that he was "much at ease that I do not have anything more important to occupy me. Europe is not happy unless the ambassadors have nothing to do."[8] In sum, an ambassador to the Serene Republic was a representative in the most literal sense: representation was his chief responsibility because he often had no other raison d'être.

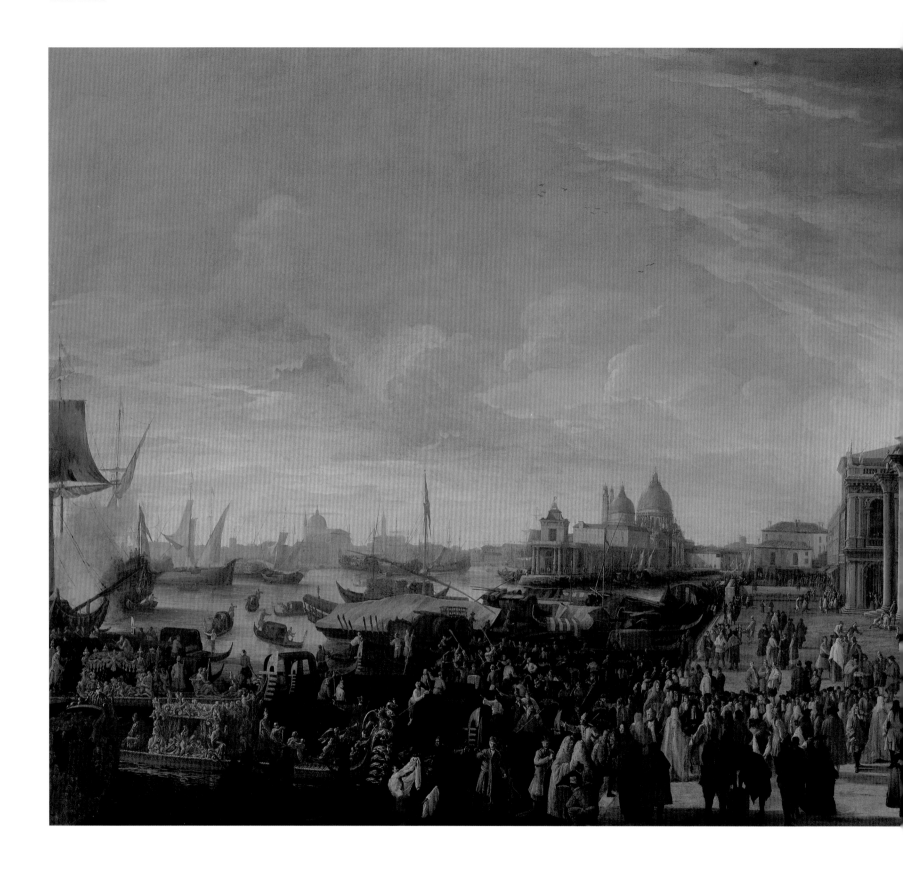

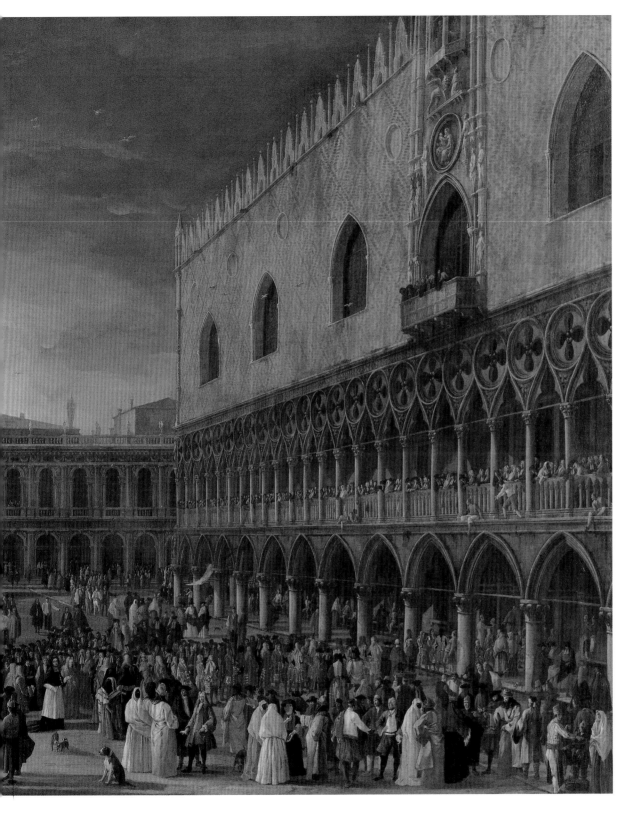

FIG. 23
Luca Carlevarijs (Italian, 1663–1730).
*The Reception of the French Ambassador
Henri Charles Arnauld, Abbé de Pomponne,
at the Doge's Palace*, ca. 1706–8. Oil on canvas,
130 × 260 cm (51³⁄₁₆ × 102³⁄₈ in.). Amsterdam,
Rijksmuseum, inv. SK-C-1612

In 1705, however, the role of French ambassador in Venice had not yet descended into complete political insignificance. Pomponne's appointment came in the middle of the War of the Spanish Succession (1701–14). His diplomatic mission was to convince the Venetian government to abandon its policy of strict neutrality and support the French side against Austria.[9] While the Venetian navy was a shadow of its former self, the city still occupied a strategically important position close to the port of Trieste, Austria's only access to the Adriatic. Moreover, the Venetian territories on the mainland formed a buffer zone between Austria and the Po valley, one of the major theaters of the war during the years 1701–6. The elaborate ceremony staged in May 1706 was therefore not merely the eager attempt of an ambitious diplomat to dazzle the host government; it was also a mating ritual. By putting the sophistication and enormous resources of his nation on conspicuous display, the ambassador hoped to persuade the Serene Republic that the kingdom of France was a more desirable suitor for Venice's political affections than its Habsburg rival.

The ceremony's ostensible purpose was the presentation of the ambassador's credentials to the doge. The fact that the day's program was dictated by the Venetian side and followed a tightly regimented, established protocol presented a challenge in that it left Pomponne with little scope to distinguish his entry from those of other ambassadors of the past and present.[10] A knight of the Order of the Golden Stole (an honor awarded to senators who had distinguished themselves as ambassadors or through other exceptional services rendered to the Republic)[11] was traditionally chosen by the Senate to accompany the ambassador from his residence to the Doge's Palace in the morning. In this case, the Senate selected Alvise II Pisani, who had become a friend of Pomponne's while serving as Venetian ambassador to France from 1698 until 1702. Pomponne and Pisani boarded the latter's gondola and were rowed to the Piazzetta in a waterborne procession with the embassy's parade gondolas, which by custom remained empty.[12] Upon arrival at the Molo, the ambassador processed into the Doge's Palace through the waterfront entrance and was conducted up the Scala dei Giganti for his audience with the doge and the Signoria (the six senior advisers to the doge plus the three chief judges of the Quarantia tribunal).

Relying on his artistic instincts as a view painter, Carlevarijs took advantage of the day's most visually arresting moment against the backdrop of an iconic urban setting. At the same time, he employed his powers of observation to capture a wealth of detail that held great political and personal significance for Pomponne. It is this aspect of the canvas that makes it a canonical example of reportorial view painting and deserves to be analyzed in depth.

At right, the imposing mass of the Doge's Palace is seen in steep recession. As the symbol and center of the republic's government, the building stood for its continuity and solidity, even in times of diminished external power. Other landmarks included in the view are, from left to right, the church of the Redentore on the Giudecca, the Bacino di San Marco studded with masts and sails, the entrance to the Grand Canal with the Dogana and the church of Santa Maria della Salute, the library, and the twin columns in the Piazzetta surmounted by Saint Theodore and the lion of Saint Mark. The splendor of Venice serves as a stage set for the quasi-theatrical performance of the official entry.

Smoke still lingers over the ships at left as they have just fired a cannon salute to mark the ambassador's disembarkation.[13] The excitement of the Venetian population is palpable; every available spot between the loggia arcades of the Doge's Palace is filled with curious onlookers. A few particularly daring ones have even climbed over the balustrade in order to get a better view of the procession that stretches from the waterfront to the building. At its head, the ambassador's twelve footmen in their gold-colored liveries with silver braids have already reached the palace, followed by his four *valets de chambre* in scarlet liveries.[14] The embassy staff did not travel in the procession of gondolas and took a quicker route from the residence in order to be lined up on the Molo in time for the ambassador's arrival.[15] Farther back, each of the high-ranking foreigners is accompanied on his left by one of the sixty-five senators chosen for the ceremony by the doge, resplendent in their red togas. At the water's edge, a senator solicitously helps one of the last guests step on land from a gondola. Singled out in the center of the procession is the ambassador, dressed in a black cassock underneath a rochet, the white, lace-trimmed clerical tunic, and a black mozzetta, the shoulder cape worn by senior clerics and canons (fig. 24). Next to him, Alvise Pisani is identifiable by the gold brocade stole worn over his red senatorial robes.

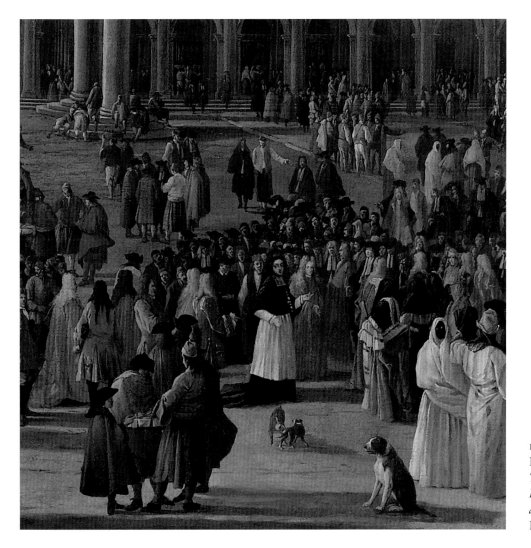

FIG. 24
Detail of fig. 23. Luca Carlevarijs,
*The Reception of the French Ambassador
Henri Charles Arnauld, Abbé de Pomponne,
at the Doge's Palace*, ca. 1706–8. Amsterdam,
Rijksmuseum

Cloaked in Gallican Independence

During the preparations for the ceremony, Pomponne's vestments had given rise to a diplomatic tussle between the French and Venetian sides when Pisani demanded that Pomponne "must wear the rochet covered by the mantelletta according to the custom of Italian abbés."[16] The mantelletta, a knee-length cloak, open in front and fastened at the neck, with vertical side slits instead of sleeves, was customarily worn by bishops when traveling outside their dioceses and by prelates without episcopal rank.[17] According to the *Caeremoniale episcoporum* (the Church's ceremonial manual), covering the rochet (which was understood as a sign of ecclesiastical jurisdiction) with the mantelletta signified acceptance of a higher authority's jurisdiction. By wearing this vestment, a bishop thus acknowledged that he had no jurisdiction outside his diocese.[18]

In insisting on wearing a mozzetta rather than a mantelletta over his rochet, Pomponne followed a celebrated precedent. In an assertion of Gallican independence against Roman convention, Georges d'Aubusson de la Feuillade (1609–1697), archbishop of Embrun, had appeared in this dress at his official entry as French ambassador in Venice in 1659. Such was the commotion this had caused that the history of Venice written by Giovan Battista Nani (1616–1678), Venetian ambassador to Paris from 1643 to 1668, recounted in detail that in accordance with the custom of French prelates appearing before the king, Feuillade had arrived without a mantelletta, his rochet uncovered.[19] Pomponne would almost certainly have read Nani's book in preparation for his embassy, alerting him to the controversy and perhaps also to the possibility of creating a stir that would be approvingly noted in Paris.

In a detailed account Pomponne sent to Louis XIV less than a week after his entry, he invoked Feuillade as one of the precedents before explaining the significance of his sartorial decision in comparison to the custom of the papal nuncio (the Holy See's ambassador) in Venice:

> The subject of this dispute was that in Rome and the rest of Italy, the uncovered rochet is the mark of a free jurisdiction, whereas the mantelletta is a sign that the prelate does not have any jurisdiction, or that it is suspended or eclipsed, as it were.... The papal nuncio in Venice wears the rochet uncovered around the city and, when visiting the Collegio, until he reaches the feet of the two statues of the giants on the stairs by which one ascends to the Sala del Collegio because he exercises a jurisdiction in the city, but he puts on the mantelletta at the feet of these statues in order to show that he does not exercise any jurisdiction with regard to the Signoria and the body of the Republic. The Venetians also regard this custom as the mark of a particular respect offered by an ecclesiastical minister to the prince [i.e., the doge].[20]

The arrangements described in Pomponne's report continued to be observed by later papal nuncios and can be seen in Joli's *The Courtyard of the Doge's Palace with the Papal Nuncio Giovanni Francesco Stoppani and Senators in Procession* of circa 1742 (fig. 25).[21] The painting shows Stoppani's departure after the presentation of his credentials to the doge on 17 April 1741,[22] and since he has passed the twin statues at the top of the

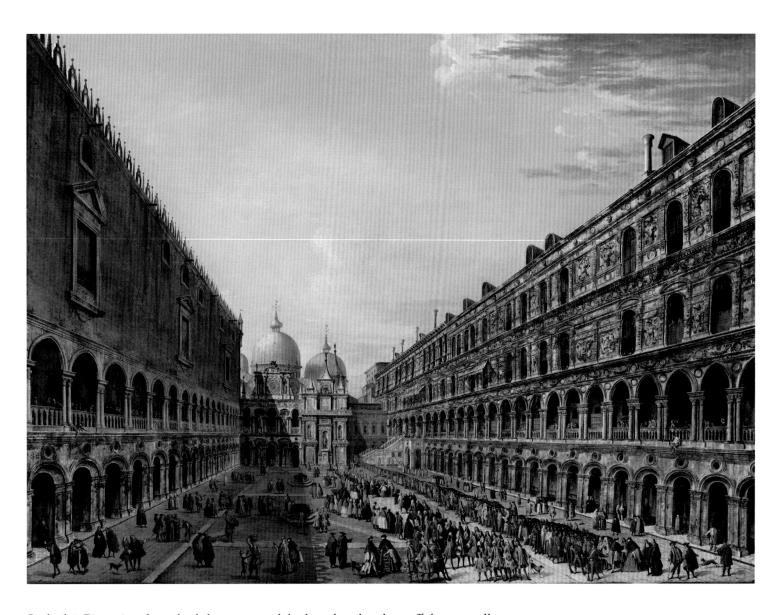

Scala dei Giganti and reached the courtyard, he has already taken off the mantelletta (fig. 26). Escorted by Marco Foscarini as knight of the Order of the Golden Stole, the nuncio is the only figure in the painting to appear in the mozzetta, whereas every one of the other clerics processing out of the Doge's Palace behind him wears a mantelletta covering his rochet—while all of them were bishops, they were outside their dioceses.[23]

In the eyes of the Venetians, however, Pomponne had no right to claim this privilege for himself. Whereas a papal nuncio possessed ecclesiastical jurisdiction by virtue of his office and the holders of the post had at least the rank of a bishop, Pomponne could not assert any jurisdiction whatsoever. Although commonly referred to as the abbé de Pomponne, he was neither an abbot nor a bishop.[24] His sinecure as abbot of Saint-Médard in Soissons, one of the oldest Benedictine abbeys in France, was held *in commendam* (in trust), a mechanism that entitled the holder to the income from the benefice without requiring him to govern the abbey community, join the order, or even be in residence.[25]

FIG. 25
Antonio Joli (Italian, 1700–1777). *The Courtyard of the Doge's Palace with the Papal Nuncio Giovanni Francesco Stoppani and Senators in Procession*, ca. 1742. Oil on canvas, 161 × 222 cm (63⅜ × 87⅜ in.). Washington, D.C., National Gallery of Art, Gift of Mrs. Barbara Hutton, inv. 1945.15.1

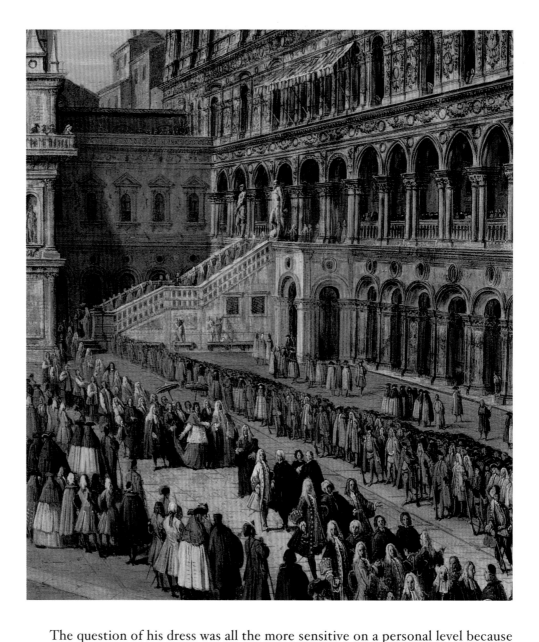

FIG. 26
Detail of fig. 25. Antonio Joli, *The Courtyard of the Doge's Palace with the Papal Nuncio Giovanni Francesco Stoppani and Senators in Procession*, ca. 1742. Washington, D.C., National Gallery of Art

The question of his dress was all the more sensitive on a personal level because Feuillade, the ambassador who had set the precedent of wearing the mozzetta, had been an implacable foe of the leading Jansenist theologian Antoine Arnauld (1612–1694), Pomponne's great-uncle, who had guided his education and instilled in him the movement's rigorous religious principles.[26] Being seen as less successful than Feuillade in asserting a ceremonial privilege would have been anathema to Pomponne, and he was determined to match his predecessor by appearing at his official entry clad in a mozzetta and uncovered rochet. At the same time, Pomponne was a skilled diplomat well versed in the art of the possible and did not want to offend the doge and the Signoria. He therefore sought and found another precedent in Jean François d'Estrades (1647–1715), French ambassador to Venice from 1676 to 1678, who like him had been merely an abbé.[27] To justify his compromise, Pomponne went so far as to send Louis XIV an excerpt from the Serene Republic's ceremonial records describing Estrades's dress on the day of his audience with the doge.[28]

The compromise consisted of appropriating the custom of the papal nuncio, who held a much higher ecclesiastical rank but as a foreign ambassador was Pomponne's equal in political terms. The Venetian authorities fully understood the significance of this decision and painstakingly recorded in their official report what he had worn where and when: "Dressed in a black cassock and mozzetta and uncovered rochet" for the journey from his residence to the Doge's Palace and the procession across the Molo, "the ambassador took the mantelletta and covered the rochet" upon reaching the Scala dei Giganti and appeared in this dress before the Signoria. Upon his departure, he removed the mantelletta at the stairs and returned to his residence wearing the mozzetta.[29] Pomponne's own report similarly noted that he left his palace wearing "the ceremonial habit with mozzetta, uncovered rochet, and hat" and "paused at the feet of the statues of the giants to put on the mantelletta" before entering the Sala del Collegio.[30]

Pomponne's appearance left a lasting impression in Venice. Almost fifty years later, when Giovanni Grevembroch (Jan van Grevenbroeck, 1731–1807) compiled an album of eighteenth-century Venetian costumes, *Gli abiti de veneziani di quasi ogni età con diligenza raccolti e dipinti nel secolo XVIII*, he chose Pomponne as an example of a French ambassador, showing him in the same black cassock (without the rochet and mozzetta) as in Carlevarijs's painting and specifically referring to his official entry of 1706 in the inscription (fig. 27).[31]

Waterborne Politics

At the beginning of a letter to Louis XIV dated 15 May 1706 that accompanied the report of his official entry, Pomponne wrote of the ceremony: "I have endeavored to render it as dazzling as I possibly could."[32] Probably the most important means of accomplishing this goal was the procession of gondolas, one of the few elements under the control of the French side. The Serene Republic's sumptuary laws dictated that all other gondolas in Venice—even those of the richest patrician families—had to be black. They also expressly forbade the use of gilded, painted, and carved ornaments as well as colored fabrics.[33] The ambassador's resplendent vessels therefore provided an incomparable opportunity to display his nation's magnificence and affluence to the Venetians, who avidly watched the cortege as it made its way to the Doge's Palace and showed themselves impressed by the opulence of the ceremony, which was widely acknowledged to be grander than any previous ambassadorial entry.[34]

As the Venetian architect Tommaso Temanza (1705–1789) noted, the sculptor Michele Fanoli (1659–1737) "received much applause for the figures and carvings on the gondolas of the Abbé de Pomponne, Ambassador to Venice for the King of France."[35] The allegorical figures decorating the vessels were expressly designed to deliver political statements. In Carlevarijs's painting, the parade gondolas are clustered into the bottom left corner of the composition (fig. 28). Their iconography was explained in sonnets distributed to the ceremony's attendees[36] and described in detail in Pomponne's report to the king, which emphasized that the ambassador himself had devised the allegorical program. The first two vessels represented "the glory of France under the happy reign of His Majesty on land as well as on sea." On the first gondola, a trumpeting figure of

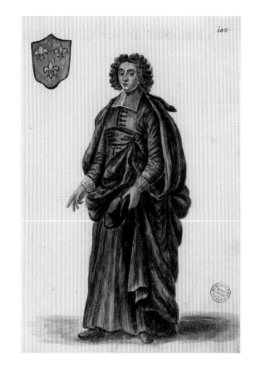

FIG. 27
Giovanni Grevembroch (Jan van Grevenbroeck) (Italian, 1731–1807). *Ambasciadore francese*, in *Gli abiti de veneziani di quasi ogni età con diligenza raccolti e dipinti nel secolo XVIII*, ca. 1753, Venice, Museo Correr, ms. Gradenigo-Dolfin 49, vol. 2, fol. 102

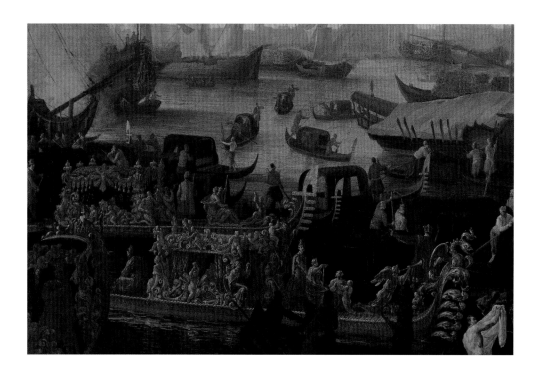

Fame preceded a personification of France holding a commander's baton, with History at her feet recording the events of the reign of Louis XIV in a book held by a putto. The cabin, hung with crimson velvet draperies, was supported at its corners by figures representing the king's virtues of Religion, Piety, Magnanimity, and Liberality.[37] The dual arms of Louis XIV are visible on the side of the cabin, separated by a putto: the gold fleur-de-lis of France in a blue shield on the left, and the gold chains of Navarre in a red shield on the right.[38]

The cabin of the second gondola, seen in Carlevarijs's depiction to the left and behind the first one, was hung with green velvet and surmounted by the Sun King's radiant symbol. On its prow the allegorical figures of Neptune and Thetis, riding in a shell-shaped chariot drawn by dolphins and guided by a merman, represented the king's naval power, together with the four tritons at the corners of the cabin. But after the effusive discussions of the first two gondolas, Pomponne's report suddenly became succinct when describing the vessel that bore the coat of arms of his family, a chevron flanked by twin palm fronds with a pyramid of six mounds underneath, in gold on a blue ground:[39] "The third gondola is also decorated with figures and other ornaments, and its cabin covered in a blue velvet with gold braid," matching his heraldic colors.[40]

It was anything but an accident that Carlevarijs depicted this gondola at the painting's extreme edge, in deep shadow and sharply foreshortened. By contrast, the first and second gondolas are illuminated by bright sunshine and seen laterally to display their decorations to best advantage and legibility. In emphasizing and de-emphasizing the same elements of the ceremony, Pomponne's report and Carlevarijs's canvas reflect the fact that they were both statements of intention as much as documentary records. At the end of Pomponne's embassy in December 1709,[41] the painting and a pendant showing the ambassador's first audience (untraced) were shipped to France and installed either in his *hôtel particulier* in Paris or in his château at Vic-sur-Aisne.[42]

FIG. 28
Detail of fig. 23. Luca Carlevarijs,
*The Reception of the French Ambassador
Henri Charles Arnauld, Abbé de Pomponne,
at the Doge's Palace*, ca. 1706–8. Amsterdam,
Rijksmuseum

Artistically and financially, the construction of the parade gondolas for an ambassadorial entry was an enormous undertaking and one of the reasons why a new ambassador's official entry often took place long after his arrival. Pomponne's immediate predecessor, Joseph Antoine Hennequin de Charmont, arrived in Venice in September 1701 but only staged his entry on 30 April 1703.[43] Following the end of Pomponne's embassy in 1709, the post of French ambassador in Venice remained vacant until 1723. The reason was a diplomatic dispute—also the cause of Pomponne's quite abrupt recall—over the role of the Venetian cardinal Pietro Ottoboni (1667–1740) as cardinal protector of France in Rome, which violated the Serene Republic's policy of strict neutrality. After relations had recovered, the next ambassador, Jacques Vincent Languet de Gergy, arrived in December 1723, yet he waited almost another three years before celebrating his official entry on 5 November 1726.[44]

The imperial ambassador Giovanni Battista Colloredo (1656–1729), who had arrived in Venice in 1715, explained five years later that he would not be able to stage his entry until he received the necessary remittances from Vienna; in 1723, he confessed to his cousin Girolamo (Hieronymus) Colloredo (1674–1726), governor of Milan, that he had been forced to borrow money at usurious interest rates because he had just started commissioning his equipage—the parade gondolas, liveries, and other items necessary for an official entry—when Vienna, already in arrears for fifteen years on another stipend granted by the previous emperor, decided to reduce his stipend by a third.[45] Colloredo was finally able to celebrate his official entry on 4 April 1726.[46] At the end of the year he returned to Vienna. By the middle of the century some French ambassadors were no longer able to shoulder the escalating costs and omitted the ceremony altogether.[47] Cardinal de Bernis wrote to Paris on 22 September 1753 that he was in no rush "to make such a considerable expense" even if the king were to partly cover the outlay. He left the decision to the secretary of state for foreign affairs but warned that "a considerable amount of time is required to prepare it."[48]

The lion's share of the outlay for an official entry was taken up by the parade gondolas. In 1708 the imperial ambassador, Filippo Hercolani (1663–1722), had complained bitterly to Emperor Joseph I (r. 1705–11) that he would have to spend "50,000 florins out of my own pocket just to float through Venice in gilded gondolas."[49] As the expenditure list for Hercolani's entry sent to Vienna by his successor, Colloredo, shows, more than half of the total amount was spent on the gondolas, which cost 28,863 florins, dwarfing the 11,933 florins for the liveries and 8,808 florins for food, drink, and candles for a series of festive receptions held at the embassy.[50] By comparison, the annual rent for Palazzo Coccina, his large and prestigious residence on the Grand Canal, came to approximately 2,000 florins.[51] Even though many ambassadors paid for their parade gondolas out of their own pockets, upon their return home or transfer to their next post they had no choice but to leave them behind. The "Inventory of the household and gondolas of the imperial ambassador in Venice" compiled on the occasion of Hercolani's departure in March 1714 specified the arrangements he had made for storing his gondolas near the Ponte del Megio in Santa Croce.[52] In 1754, the incoming imperial ambassador, Philipp Joseph von Orsini-Rosenberg (1691–1765), wrote to the Austrian chancellor of state, Wenzel Anton von Kaunitz, to protest against a request from

Vienna to avoid any expenditures on new gondolas and liveries for his entry, explaining that the ones he had inherited from his predecessor would have to be replaced because they had been damaged beyond repair by the city's saline humidity.[53]

Recycled Opulence

Even if the ambassadors of the three major powers who maintained embassies in Venice—the Holy Roman Empire, France, and the Holy See—were engaged in a game of one-upmanship for the most magnificent gondolas, there were limits on the resources and time that could be invested in designing and constructing the vessels. Taken together, these factors resulted in a mixture of profligate showmanship, judicious recycling, and a second-hand market—something that did not escape the attention of eagle-eyed, competitive observers: five days after the new imperial ambassador Giuseppe Bolagnos (d. 1732) had celebrated his official entry in 1729, his French colleague Gergy wrote to Louis XV to point out that "as beautiful as this ambassador's gondolas may be," Bolagnos had bought the hulls and allegorical sculptures from his predecessor, Colloredo.[54] As was customary for foreign ambassadors in Venice, the Frenchman had participated with his own parade gondolas in the naval procession staged in honor of his colleague.[55] Gergy was, of course, anything but a disinterested observer; the primary purpose of his letter was to reassure the king that the newly arrived political rival had not been able to out-shine the magnificence on display during his own entry celebrated three years earlier.

Bolagnos had indeed recycled many parts of Colloredo's gondolas, but he had also replaced many of the allegorical sculptures and refurbished the cabin interiors. Gergy

FIG. 29
Luca Carlevarijs (Italian, 1663–1730).
The Reception of the Imperial Ambassador Giambattista Colloredo at the Doge's Palace, ca. 1726. Oil on canvas, 132 × 259 cm (51¹⁵⁄₁₆ × 101¹⁵⁄₁₆ in.). Dresden, Gemäldegalerie Alte Meister, inv. 553

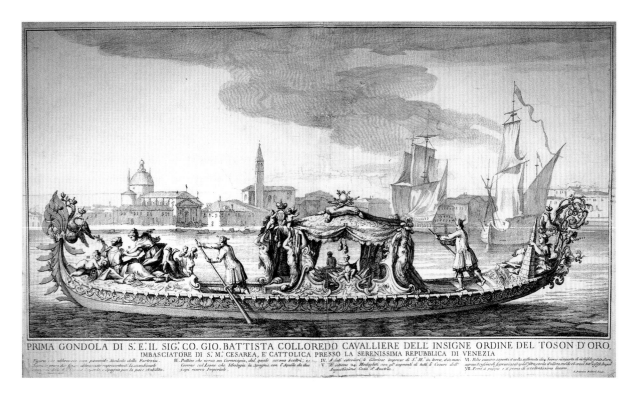

PRIMA GONDOLA DI S: E: IL SIG: CO. GIO. BATTISTA COLLOREDO CAVALLIERE DELL' INSIGNE ORDINE DEL TOSON D'ORO.
IMBASCIATORE DI S: M: CESAREA, E CATTOLICA PRESSO LA SERENISSIMA REPUBBLICA DI VENEZIA

was quite familiar with the imperial parade gondolas because he had witnessed Colloredo's entry in 1726, and his own vessels had sailed next to the Austrian ambassador's in the Bucintoro ceremony on Ascension Day (see chapter 6), but he may also have resorted to an aide-mémoire. After the enormous effort of funding his official entry, Colloredo had been determined to create a detailed visual record of the event that represented the culmination of his diplomatic career. In addition to paintings by Carlevarijs (fig. 29) and Canaletto (see fig. 50), he commissioned a set of large engravings of his three parade gondolas by Antonio Faldoni after Carlevarijs for wider dissemination.[56] A comparison between the engraving of Colloredo's first gondola (fig. 30) and the same vessel in Canaletto's painting of Bolagnos's entry (fig. 31) shows that while the *ferro di prua,* or prow-head (an ornamented steel blade that protects the prow in collisions

FIG. 30
Antonio Faldoni (Italian, ca. 1690–ca. 1770), after Luca Carlevarijs (Italian, 1663–1730). *First Gondola of the Imperial Ambassador Colloredo,* 1726, engraving, 420 × 695 mm (16 9/16 × 27 3/8 in.). Venice, Museo Correr

FIG. 31
Detail of fig. 52. Canaletto, *The Reception of the Imperial Ambassador Giuseppe Bolagnos at the Doge's Palace,* ca. 1729. Private collection

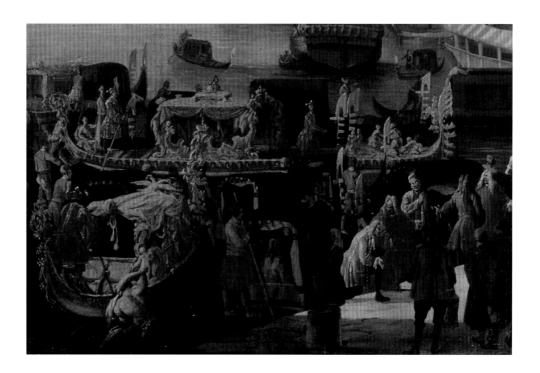

FIG. 32
Detail of fig. 29. Luca Carlevarijs,
*The Reception of the Imperial Ambassador
Giambattista Colloredo at the Doge's Palace*,
ca. 1726. Dresden, Gemäldegalerie
Alte Meister

and helps to balance a gondola), the metal scroll at the stern known as a *risso* (Venetian dialect for *riccio*), and the four female herms at the corners of the cabin had all been reused, the allegorical figures on the prow and stern were entirely new.[57]

On 21 May 1729, the same day that Gergy wrote to Louis XV to point the finger at the imperial ambassador for cutting a few corners, Bolagnos dispatched his own report of his official entry to Emperor Charles VI in Vienna. Having assured the emperor of the richness and splendor of the embroidered fabrics, carving, and gilding on all three imperial gondolas, he emphasized that "in addition to the artful disposition of the statues and figures as well as the beauty of the ornaments, the metal prow-heads and stern scrolls of all three gondolas were tooled to ultimate perfection and nothing to equal them has ever been seen in Venice. Various gilded leaves made them appear even more beautiful and earned them universal admiration."[58] While impossible to verify for anyone reading the report in Vienna, the claim was not entirely truthful: the first gondola's splendid prow-head with four flamelike, upward-curving tongues, interlaced with gilded leaves, had in fact been seen before and is clearly recognizable both in Faldoni's engraving and in Carlevarijs's painting of Colloredo's entry in 1726 (fig. 32). The same distinctive prow head appears on the first of three parade gondolas, decorated with the imperial double-headed eagle, that are seen traversing the Bacino di San Marco in front of the Molo and the Doge's Palace in a canvas by Michele Marieschi (1710–1744) (fig. 33).[59]

Gergy's critical remarks notwithstanding, the reuse of existing parade gondola components had been common practice at the French embassy as well. The elaborate prow head in the shape of a dragon that graced the first gondola at Pomponne's entry in 1706 (see fig. 28) had been made for the entry of the French ambassador Michel Jean Amelot de Gournay (1655–1724) in 1682, when it was recorded in an engraving by Jérôme Trudon after Louis Dorigny (fig. 34).[60] An accompanying inscription explained the iconographical role the dragon had played in 1682: "On the prow are two embracing

FIG. 33
Michele Marieschi (Italian, 1710–1744). *The Bacino di San Marco with the Parade Gondolas of the Imperial Ambassador in Front of the Palazzo Ducale*, ca. 1735. Oil on canvas, 106 × 134 cm (41 ¾ × 52 ¾ in.). Private collection

FIG. 34
Jérôme Trudon, after Louis Dorigny (French, 1654–1742). *First Gondola of the French Ambassador Amelot de Gournay*, 1682, engraving, 236 × 450 mm (9 5/16 × 17 11/16 in.). Paris, Bibliothèque Nationale de France, Département des Estampes, Réserve QB-201 (59), fol., p. 53

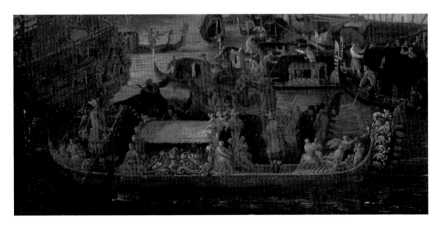

FIG. 35
Detail of fig. 37. Luca Carlevarijs, *The Reception of the French Ambassador Joseph-Antoine Hennequin, Seigneur de Charmont, at the Doge's Palace*, ca. 1703–4. Private collection

figures who represent Justice and Peace…with their putti around them in order to support them against the venom of Discord represented by the figure of a dragon, which serves as the gondola's armament and prow head. A third putto, which is that of France, holding a shield with a sun on it, chases away this animal of division."[61]

The dragon prow head, singled out for praise in the inscription on the 1682 print,[62] was preserved at the embassy and fitted to a new parade gondola for the Charmont entry in 1703 (fig. 35). The sculptural program of Charmont's gondolas reflected the current political situation. In a pointed reference to the accession of Louis XIV's grandson Philip V to the Spanish throne in 1700, the first gondola's prow showed "the union of Spain with France represented by two women in royal dress [and] a child representing the new century."[63] This group was preceded by a trumpeting figure of Fame in place of the putto pursuing the dragon of discord, thus breaking the iconographical link from the gilded wood figures to the polished steel prow head and converting the latter from a narrative into a purely decorative element.

Pomponne's entry in 1706 saw the prow head's next outing. The figure of Fame remained the same, while the group of Spain and France had now been replaced by France with History at her feet, and the cabin was entirely new (see fig. 28).[64] This was not the end of the dragon's distinguished service in the Bacino di San Marco, merely the end of its service for France. Incoming ambassadors keen to commission a new equipage for their official entry were not above selling off their predecessor's in order to raise funds.[65] It is therefore surprising but not implausible that we encounter the same prow head yet again almost four decades after it had first decorated a parade gondola. Carlo Gaetano Stampa (1667–1742), titular archbishop of Chalcedon, took up his post as papal nuncio in Venice in September 1720.[66] Celebrating his official entry comparatively quickly, on 15 July 1721, he may have felt that there was no harm in purchasing an exquisitely made and heraldically neutral second-hand component for his gondola, since this saved both time and money—or he may not even have been aware of the dragon prow head's prior history. The remainder of his gondola's iconography was

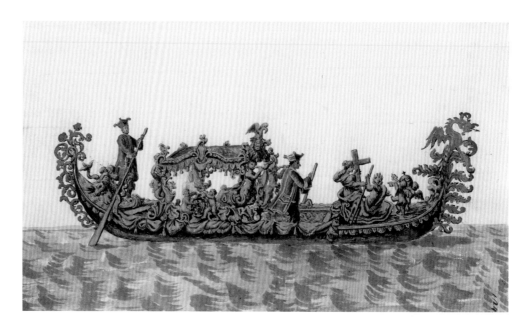

FIG. 36
Giovanni Grevembroch (Jan van Grevenbroeck) (Italian, 1731–1807). *Gondola reale*, in *Gli abiti de veneziani di quasi ogni età con diligenza raccolti e dipinti nel secolo XVIII*, ca. 1753, Venice, Museo Correr, ms. Gradenigo-Dolfin 49, vol. 4, fol. 124

appropriately ecclesiastical. Behind the dragon, two putti play with a papal tiara and the crossed keys. They are followed by an allegory of Religion with her cross riding in a shell piloted by Neptune, perhaps an allusion to the role of the Catholic faith in the maritime polity of Venice (fig. 36).[67]

Originality and Modularity

The artistic practices of appropriation, adaptation, and emulation employed during the design and construction of the parade gondolas for ambassadorial entries had a parallel in the creation of the paintings documenting these events.[68] When Carlevarijs received the commission for the earliest painting of this type, the Charmont entry of 1703 (fig. 37),[69] he decided to base the view of the Molo and the Doge's Palace from the Riva degli Schiavoni on an engraving by the French printmaker Israël Silvestre (1621–1691) in which the cupola of Santa Maria della Salute was yet unbuilt (fig. 38).[70] Three years later, when asked by Pomponne to record his entry, Carlevarijs was able to refine both viewpoint and perspective (see fig. 23). His position is slightly farther back, with an additional window visible on the facade of the Doge's Palace. A shift in the angle creates significantly more space on the quay to depict the procession, and the ambassador now occupies a central position halfway between the water's edge and the arcades. The view of the Bacino is less cramped, and the church of the Redentore on the Giudecca is no longer disguised by sails and masts. Carlevarijs also corrected some minor errors, such as the roundel above the central window and balcony of the Doge's Palace, which now contains the relief of the Virgin and Child missing in the Charmont version. Yet the most important improvement, aided by the considerably larger size of the canvas, was that Carlevarijs provided far more detail where it mattered most to his patron: in the likenesses and dress of the protagonists and in the accurate depiction of the gondolas.

Ambassador and artist, respectively planning an official entry and its depiction, found themselves faced with a similar challenge. Neither wanted their effort to be merely a repetition of a previous one, yet their desire for originality was constrained by the ceremony's immutable urban setting and fixed protocol. It is not a coincidence that the written reports ambassadors submitted to their governments emphasized the same aspects of the ceremony as the paintings: their own attire, the liveries of their retinue, and the allegorical sculptures and opulent textiles of the gondolas. These were the aspects that changed from entry to entry, were under the control of the ambassador rather than the Venetian government, and allowed him to set himself apart from his predecessors and from the entries staged by the representatives of other powers.

For the remainder of the painting, Carlevarijs quickly developed a modular system that was not dissimilar to the way the gondolas were refurbished and adapted for each new entry. Anecdotal details such as the two dogs sniffing each other in front of the ambassador (see fig. 24) draw the viewer into the scene as a participant in the event and create a sense of witnessing reality. Lifelike as the staffage figures and animals may seem, they were neither observed on the day nor specific to any given setting. For example, a male figure in a blue suit with a white shirt, looking into the distance, right foot forward, right arm akimbo, and left hand resting on his sword hilt, stands on the Molo at the entries of Pomponne, Montagu, and Gergy in 1706, 1707, and 1726, on the deck of

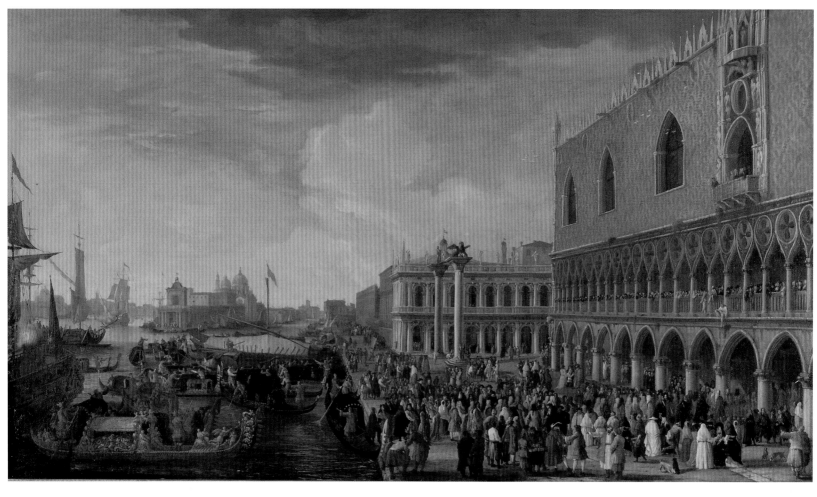

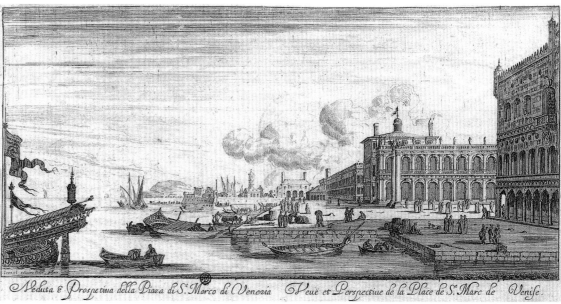

FIG. 37
Luca Carlevarijs (Italian, 1663–1730). *The Reception of the French Ambassador Joseph-Antoine Hennequin, Seigneur de Charmont, at the Doge's Palace*, ca. 1703–4. Oil on canvas, 89 × 158 cm (35 1/16 × 62 3/16 in.). Private collection

FIG. 38
Israël Silvestre (French, 1621–1691). *Veduta e Prospetiva della Piaza di St. Marco di Venezia*, 1660s, engraving, 116 × 247 mm (4 9/16 × 9 3/4 in.). Lyon, Bibliothèque municipale, inv. F17SIL004095

FIG. 39
Detail of fig. 23. Luca Carlevarijs,
*The Reception of the French Ambassador
Henri Charles Arnauld, Abbé de Pomponne,
at the Doge's Palace*, ca. 1706–8. Amsterdam,
Rijksmuseum

FIG. 40
Detail of fig. 46. Luca Carlevarijs,
*The Reception of the British Ambassador
Charles Montagu, 4th Earl of Manchester, at
the Doge's Palace*, ca. 1707–8. Birmingham
Museums & Art Gallery

FIG. 41
Detail of fig. 51. Luca Carlevarijs,
*The Reception of the French Ambassador
Jacques-Vincent Languet, Comte de Gergy,
at the Doge's Palace*, ca. 1726. Musée National
du Château de Fontainebleau

FIG. 42
Detail of fig. 183. Luca Carlevarijs,
The Bucintoro Departing from the Molo, 1710.
Los Angeles, J. Paul Getty Museum

FIG. 43
Luca Carlevarijs (Italian, 1663–1730). *The
Entry of the Venetian Envoys Extraordinary
Alvise II Pisani and Andrea da Lezze at the
Ducal Palace in Milan* (detail), ca. 1711. Oil
on canvas, 130 × 163 cm (51 3/16 × 64 3/16 in.).
Vicenza, Palazzo Leoni Montanari, Banca
Intesa Sanpaolo collection

FIG. 44
Detail of fig. 62. Luca Carlevarijs,
*The Entry of the Venetian Ambassadors
Extraordinary Nicolò Erizzo and Alvise II
Pisani in London*, ca. 1708–10. Munich,
Bayerische Staatsgemäldesammlungen

FIG. 45
Luca Carlevarijs (Italian, 1663–1730).
Studies of Two Gentlemen, ca. 1700–1705.
Oil on canvas, 20.1 × 16.6 cm (7 15/16 × 6 9/16 in.).
London, Victoria and Albert Museum,
inv. P.65-1938

a barge at the Bucintoro festival in 1710, in the courtyard of the Ducal Palace in Milan
at the entry of the Venetian envoys in 1711, and (having changed into a brown suit) on
the steps leading from the Tower of London down to the Thames at the arrival of the
Venetian envoys in 1707 (figs. 39–44).[71] The careful composites of Carlevarijs's animated
crowd scenes were drawn from a repertoire of figure types that he kept in several albums
of oil studies and drawings, one of which includes the well-traveled gentleman (fig. 45).[72]

Such was the success of the prototype Carlevarijs had created in the canvas for
Pomponne that for the next two decades he enjoyed an undisputed monopoly on depic-
tions of ambassadorial entries in Venice.[73] Writing in 1732, two years after the artist's
death, Vincenzo da Canal noted that Carlevarijs was "employed until the end of his life
by local patrons as well as by ambassadors and foreign princes [to paint] the occasions
of public entries and solemn regattas."[74]

The next commission occurred in 1707, when Charles Montagu, 4th Earl of Man-
chester, later 1st Duke of Manchester (ca. 1662–1722), celebrated his entry as Her

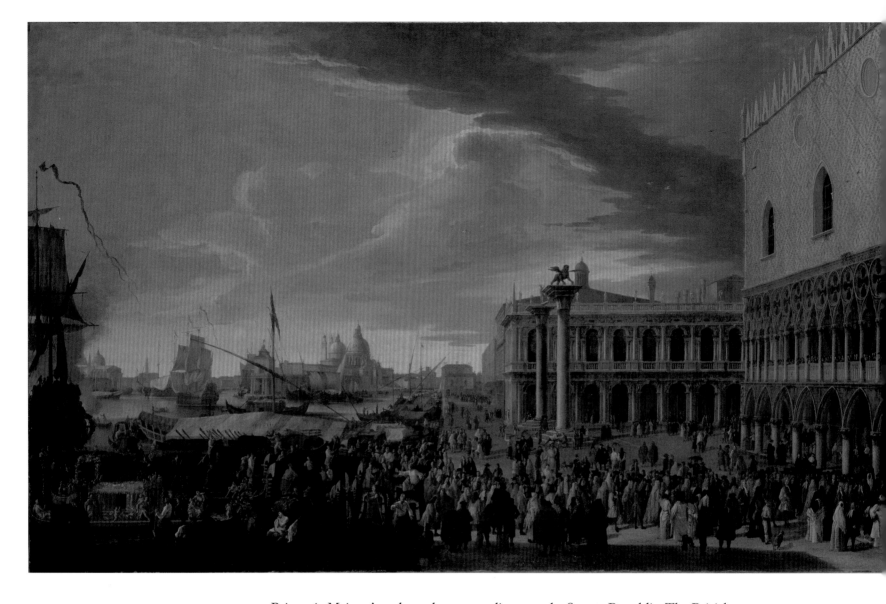

FIG. 46
Luca Carlevarijs (Italian, 1663–1730). *The Reception of the British Ambassador Charles Montagu, 4th Earl of Manchester, at the Doge's Palace*, ca. 1707–8. Oil on canvas, 132 × 264 cm (51 15/16 × 103 15/16 in.). Birmingham Museums & Art Gallery, inv. 1949P36

Britannic Majesty's ambassador extraordinary to the Serene Republic. The British government considered Venice too politically irrelevant to justify a regular ambassador there, employing a consul to look after its commercial interests. However, the current situation in the War of the Spanish Succession did warrant an attempt to persuade the Serene Republic to give up its neutrality and join Great Britain, the German-speaking states, and the Dutch Republic in the Grand Alliance against France. Hence Montagu's mission was precisely the opposite of Pomponne's, and staging a dazzling official entry that surpassed the Frenchman's from the previous year was a crucial way to impress upon his hosts the fact that London would be an even wealthier and more powerful ally than Paris. On 16 September 1707 Montagu reported to London that he was going to "make my entry next Wednesday, and I have my first audience the day after. The method here is so different from other courts, that till this is over one can make no proposition to them, which has made me make all the dispatch I could possibly."[75] Short on time but not on funds and familiar with the ceremony from a previous mission to the Republic in 1697–98, Montagu had planned ahead and commissioned his parade gondolas from

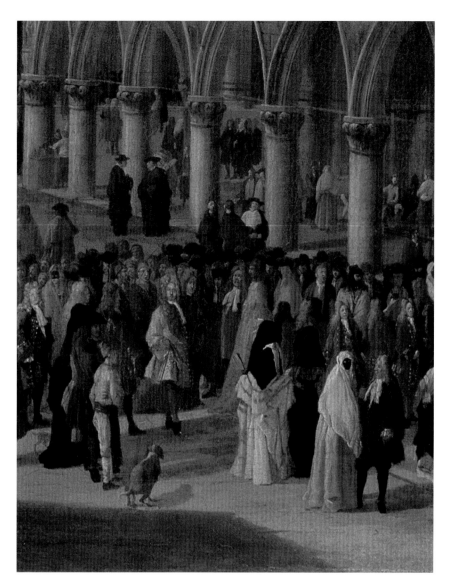

Venetian craftsmen before he even left London.[76] Having arrived at the end of June, he was therefore ready to make his official entry on 22 September 1707. The Venetians, ever appreciative of beautiful fabrics, particularly noted his "richly colored dress."[77]

The political rivalry with Pomponne did not prevent Montagu from commissioning the painting of his entry from the same artist, nor did it prevent Carlevarijs from reusing his established composition (fig. 46).[78] The viewpoint has subtly shifted once again, reducing the visible part of the Doge's Palace from eleven to ten arches. In his elegant, richly embroidered suit, the ambassador has paused and turned to strike a pose and directly engage the viewer (fig. 47). Next to him, Giovan Francesco Morosini, the knight of the Order of the Golden Stole, seems to be encouraging him to resume the procession, gesturing toward the Ducal Palace with an outstretched arm. Montagu's painstaking preparations had evidently included bringing an engraving by John Smith (1652 or 1654–1742) of his portrait by Sir Godfrey Kneller (1646–1723) with him from London (fig. 48). Carlevarijs based Montagu's likeness and pose on this sheet from 1693 but updated the attire to record what his fashionable patron wore on the day of his entry.

FIG. 47
Detail of fig. 46. Luca Carlevarijs, *The Reception of the British Ambassador Charles Montagu, 4th Earl of Manchester, at the Doge's Palace*, ca. 1707–8. Birmingham Museums & Art Gallery

FIG. 48
John Smith (British, 1652 or 1654–1742), after Sir Godfrey Kneller (British, 1646–1723). *Charles Montagu, First Earl of Halifax*, 1693, mezzotint, 336 × 247 mm (13¼ × 9¾ in.). London, National Portrait Gallery, Purchased with help from the Friends of the National Libraries and the Pilgrim Trust, 1966, inv. NPG D35216

FIG. 49
Detail of fig. 46. Luca Carlevarijs,
*The Reception of the British Ambassador
Charles Montagu, 4th Earl of Manchester,
at the Doge's Palace*, ca. 1707–8. Birmingham
Museums & Art Gallery

The first of Montagu's parade gondolas (fig. 49) was decorated with a steel prow-head showing Saint George, the patron saint of England, vanquishing the dragon, while on the prow, a personification of England was accompanied by Abundance disgorging her horn of plenty. Carlevarijs also alluded to Great Britain's naval power: compared to Pomponne's entry, the prominence of the ship that has fired a cannon salute at the painting's left margin has been considerably increased. Its stern displays the new royal coat of arms introduced after the Acts of Union next to the red ensign of the British navy.

Montagu's mission turned out to be just as fruitless as that of his antagonist Pomponne in the opposite camp. By 2 March 1708 he had already resigned himself to this: "It is our good fortune that this State cannot contribute much either to our good or prejudice; for I have had so little to do that I have made it my business to know the true state of their affairs. Their government is merely an outward show, and their neutrality has been suffered, I imagine, knowing they are not in a condition of being serviceable in any manner."[79] When Montagu returned to London in October 1708,

taking Carlevarijs's painting with him, he may have reflected on the fact that while his political mission had been futile, his stay in Venice bore rich artistic fruits: he persuaded the prominent painters Giovanni Antonio Pellegrini (1675–1741) and Marco Ricci (1676–1730) to move to London and engaged the star singer Nicola Grimaldi (1673–1732), known as Nicolini, for the opera in London, where he was to appear in the title role in Handel's *Rinaldo* in 1711.[80]

A New Competitor: Canaletto

The next time that Carlevarijs was asked to reprise his successful formula for diplomatic entries was in 1726 for the ceremony of the imperial ambassador Colloredo (see fig. 29).[81] The elderly artist's work now showed a certain amount of fatigue, but such was his reputation for the depiction of the procession in front of the Doge's Palace that Colloredo gave the commission to him rather than to the rapidly rising star of Venetian view painting, by whom he had already acquired a canvas two years earlier: Giovanni Antonio Canal, called Canaletto (1697–1768).[82] Colloredo did, however, also order a painting of his official entry from the younger view painter, but one of a very different nature (fig. 50).[83] The canvas offers a sweeping view of the Bacino di San Marco from the Dogana at left to the

FIG. 50
Canaletto (Italian, 1697–1768). *The Bacino di San Marco with the Reception of the Imperial Ambassador Giambattista Colloredo at the Doge's Palace*, ca. 1726. Oil on canvas, 141 × 230 cm (55½ × 90⁹⁄₁₆ in.). Upton House, National Trust, inv. NT 446806

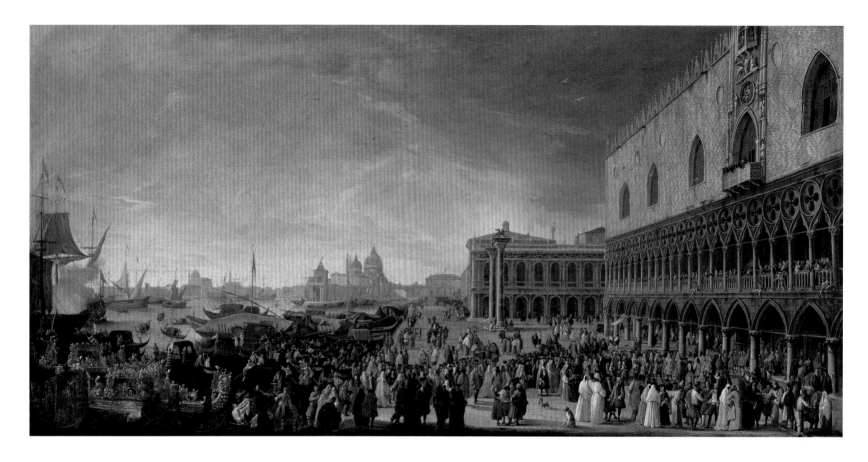

tightly cropped facade of the church of San Giorgio Maggiore on the right. Almost lost in the melee of vessels crowding the water near the Molo are the three gilded parade gondolas in front of the Doge's Palace. In combination with the procession of senators in their red togas discernible on the Molo among the crowd of spectators, the occasion is clearly identifiable as an ambassadorial entry—Colloredo's entry, as the painting's early provenance makes clear. The two paintings by Carlevarijs and Canaletto provide different viewpoints of the same event, literally and figuratively: where the former portrayed the ceremony with the spectacular urban setting as its backdrop, the latter created a portrait of the city embracing and almost engulfing the ambassador's arrival.

Carlevarijs's monopoly was decisively broken only a few months later. For his entry on 5 November 1726,[84] the new French ambassador Gergy decided to hedge his bets and commission paintings of the same scene from both Carlevarijs and Canaletto. However, the new balance of power was already evident in that he asked the former for a cabinet size (fig. 51)[85] and the latter for a monumental canvas that matched the width and considerably exceeded the height of Carlevarijs's largest works for Pomponne, Montagu, and Colloredo (fig. 52).[86] When developing his composition, the young and ambitious Canaletto therefore found himself in a position not unlike that of an arriving ambassador preparing his entry: constrained by the expectations set by multiple precedents, obliged to follow the ceremony's rigid protocol, yet keen to make his mark and display his inventiveness.

The appropriation and emulation of successful compositions portraying the unique topography of the city on the lagoon was a hallmark of eighteenth-century Venetian

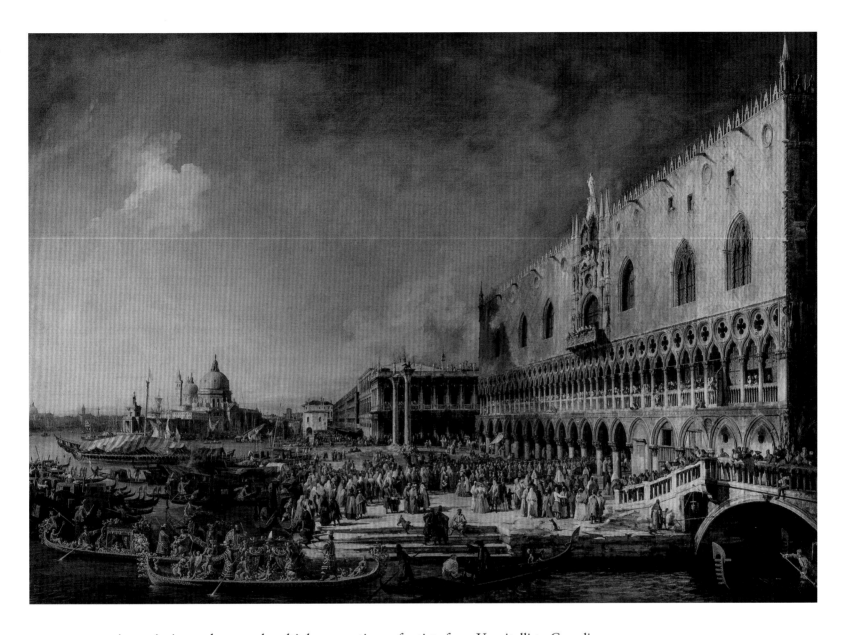

view painting and spanned multiple generations of artists from Vanvitelli to Guardi. Carlevarijs had availed himself of this practice in 1703, when he adopted the view of the Molo from Silvestre's engraving, and now it was Canaletto's turn to try to surpass Carlevarijs's prototype. In the eighteenth century, this process was not considered a failure, but rather a primary feature of artistic creativity, as was memorably expressed in a characterization of Handel's borrowing practices attributed to the composer William Boyce (1711–1779): "He takes other men's pebbles and polishes them into diamonds."[87] Sir Joshua Reynolds espoused the same principle in his Sixth Discourse, delivered to the Royal Academy in 1774: "The true and liberal ground of imitation is an open field; where, though he who precedes has had the advantage of starting before you, you may always propose to overtake him: it is enough however to pursue his course; you need not tread in his footsteps; and you certainly have a right to outstrip him if you can."[88]

As he examined the prototype established by Carlevarijs, Canaletto identified a crucial flaw: the sumptuous parade gondolas on which the ambassadors expended

FIG. 52

Canaletto (Italian, 1697–1768). *The Reception of the French Ambassador Jacques-Vincent Languet, Comte de Gergy, at the Doge's Palace*, ca. 1727. Oil on canvas, 181 × 260 cm (71¼ × 102⅜ in.). St. Petersburg, Hermitage, inv. ГЭ-175

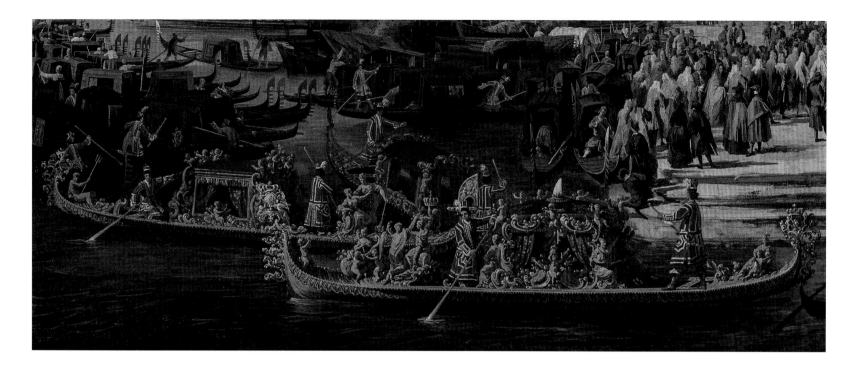

enormous effort and resources, were marginalized in the bottom left corner of the composition. He quickly came to the conclusion that, as the most important visual expression of his patron's sophistication and political principles, the gondolas deserved pride of place. In order to achieve this, Canaletto pulled back the viewpoint to the other side of the Rio di Palazzo, the canal leading to the Bridge of Sighs. His view encompasses the entire facade of the Doge's Palace, the Ponte della Paglia, and the Rio di Palazzo, thereby creating the opportunity to move the parade gondolas into a far more conspicuous foreground position at the mouth of the canal. Their gilded allegorical sculptures and polished steel prow-heads—showing a cartouche of three lilies surmounted by a crown—are sparkling in the sunlight (fig. 53). Gergy, accompanied by Nicolò Tron as the knight of the Order of the Golden Stole, occupies a central position. Like Montagu, he has stopped and turns toward the viewer, holding a plumed hat in his right hand. Upon his departure from Venice in October 1731, Gergy shipped the Carlevarijs, the Canaletto, and a pendant to the latter showing his participation in the Bucintoro festival (see chapter 6) back to Paris, where they are listed in his estate inventory of 1734.[89]

On Gergy's heels, the imperial ambassador Giuseppe Bolagnos, keen to surpass his French colleague, commissioned a similarly sized canvas from Canaletto on the occasion of his official entry on 16 May 1729 (fig. 54).[90] With the benefit of an extra two years of experience as a view painter under his belt, Canaletto moved the viewpoint a little closer again (the arch of the Ponte della Paglia on the right has been reduced from half to less than a quarter) in order to get closer to the gondolas. The spectacular prow-heads, one with upward-curving tongues interlaced with gilded leaves, the other showing the imperial double-headed eagle, may have been inherited from Bolagnos's predecessor, Colloredo, but Canaletto gave them an entirely new prominence (fig. 55). The ambassador's report to Charles VI is clear evidence of the immense pride he took in his parade

FIG. 53
Detail of fig. 52. Canaletto (Italian, 1697–1768). *The Reception of the French Ambassador Jacques-Vincent Languet, Comte de Gergy, at the Doge's Palace*, ca. 1727. St. Petersburg, Hermitage

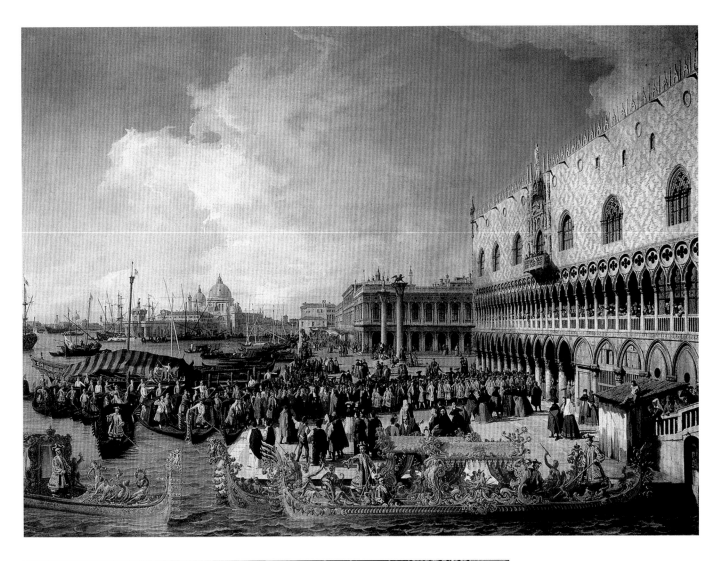

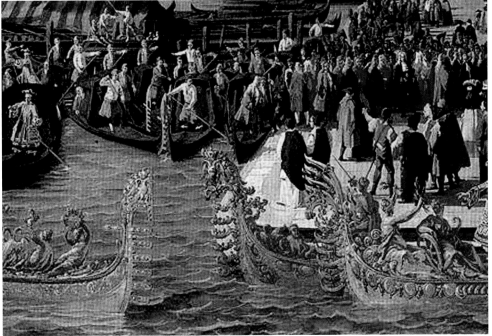

FIG. 54
Canaletto (Italian, 1697–1768). *The Reception of the Imperial Ambassador Giuseppe Bolagnos at the Doge's Palace*, ca. 1729. Oil on canvas, 184 × 265 cm (72 7/16 × 104 5/16 in.). Private collection

FIG. 55
Detail of fig. 54. Canaletto, *The Reception of the Imperial Ambassador Giuseppe Bolagnos at the Doge's Palace*, ca. 1729. Private collection

gondolas, making it plausible that he asked the painter to place additional emphasis on them. The vessels are described by Bolagnos with an attention to detail matched by Canaletto's depiction of them: the cabin of the first gondola, closest to the viewer, was furnished with crimson and gold draperies and bore a carved and gilded eagle on the roof, while the second, slightly offset immediately behind it, had turquoise draperies. The third vessel, seen at far left, shows a glazed cabin covered in crimson velvet. Placed behind it at a right angle to the picture plane is the *negrona*, the black gondola intended for the ambassador's everyday use, identifiable here because its two oarsmen have the same livery as the gondoliers in the three gilded vessels. Once again, the verbal and visual records of the official entry are of equal precision: the gondoliers each wear a scarlet *justaucorps* (knee-length coat) with silver trim and blue cuffs over a blue velvet vest. Trousers and a beret made of the same blue velvet with silver trim complete the gala livery.[91] Seeking out Bolagnos and the knight of the Order of the Golden Stole, Andrea Corner,[92] on the quay underscores the ultimate outcome of Canaletto's revision of the Carlevarijs prototype: the ceremony's true protagonists are now on the water.

The Embarkation at the Rialto Bridge

On the day of an official entry, the ceremonies came to an end with the departure of the ambassador and his party from the Molo, once more accompanied by the knight of the Order of the Golden Stole and the senators. Upon arrival at his residence, "he does again regale the Company with all sorts of Refreshments; after which, he conducts the Cavalier [i.e., the knight of the Order of the Golden Stole] to his Gondola, giving him the right hand. During those two days, the whole Town is in mask, and there is Musick all night in the Ambassador's House, where all who will come, are entertain'd with Wine, Coffee, and all sort of Refreshments, so that crouds of Masks go and come continually."[93] This account of the standard ambassadorial protocol was written by Christian Cole (1673–1734), who served as secretary to the British ambassador Montagu from 1707 to 1708, then as British chargé d'affaires from 1708 to 1714, and as minister resident in 1715.

Cole also described the final step in the accreditation process, the delivery of the Senate's response to the ambassador: "The Ambassador's Speech is by the Sage of the Week reported to the Senate with the Answer, which the College has prepared for the Senate to consider on. When this Answer, or any other, is approved of by the Senate, the College sends a Secretary to the Ambassador, to know when his Excellency will come to the College to receive the Senate's Answer to his Speech. He appoints generally the next morning, and then he is rowed, with all his Retinue in Gondolas, to the Place of St. Mark."[94]

After he has paid his respects to the doge, listened to him reading out the response, and received a transcript, "the Ambassador goes down . . . the Stairs of the Giants; then, and only at that time, he walks over the Place of St. Mark, and so thorough all the Merceria, which is a long Street full of Shops, down to the Rialto Bridge, where he takes his Gondolas and goes home. At other times he goes from the Palace directly to his Gondola."[95] Bolagnos described the same procedure in his report to Charles VI: "This morning . . . in order to receive the response to the credentials of Your Imperial Majesty

and to my speech to the College, I went to the latter with the same formalities and public display of gondolas and staff in gala livery...and having received both responses...I returned with the same formalities and entourage, walking from Piazza San Marco all the way through the Merceria to the Fondaco dei Tedeschi, where I embarked with my whole cortege to return to my palace."[96] These arrangements were also recorded by the papal nuncio Stampa in a letter to the Cardinal Secretary of State in Rome, noting specifically Bolagnos's journey on foot through the Merceria and his gilded parade gondolas awaiting him at the Fondaco dei Tedeschi.[97]

The subject of a painting by Canaletto showing three gilded parade gondolas at the Rialto Bridge awaiting a group of well-dressed gentlemen who are descending the steps toward the water has hitherto been identified as the embarkation of the Saxon crown prince Friedrich Christian (1722–1763) (fig. 56).[98] However, the teenage heir was

FIG. 56
Canaletto (Italian, 1697–1768). *The Embarkation of an Ambassador at the Rialto Bridge*, ca. 1740. Oil on canvas, 99 × 130 cm (39 × 51³⁄₁₆ in.). Seattle, Paul G. Allen Family Collection

FIG. 57
Attributed to Pietro Longhi (Italian, ca. 1701–1785). *Reception of Crown Prince Friedrich Christian at the Border of the Republic of Venice*, 1739. Oil on canvas, 78 × 106 cm (30 11/16 × 41 3/4 in.) Warsaw, Royal Castle, inv. FC-ZKW/1130

handicapped and unable to walk without assistance. Due to what was diagnosed at the time as "palsy," he needed to be supported while standing up and was carried by necessity in a sedan chair. In a depiction of his arrival at the Venetian border in 1739, attributed to Pietro Longhi (1701–1785), Friedrich Christian's medical condition is portrayed with both sympathy and accuracy (fig. 57). Even when allowing for flattery and artistic license, it is impossible to reconcile the figures in Canaletto's painting with the prince's situation, which was well known to contemporary observers in Venice such as Lady Mary Wortley Montagu (1689–1762): "He has been lame from his Birth, and is carry'd about in a chair, thô a Beautifull B[oy] from the Waste upwards."[99]

Canaletto's painting does not show Friedrich Christian but an ambassador and his retinue who, having walked through the Merceria after receiving a response from the Senate, are about to board their parade gondolas at the Rialto Bridge (fig. 58). No red senatorial togas are visible. In the Serene Republic's diplomatic protocol, all other journeys that involved a full deployment of parade gondolas had the ambassador's party departing from the Molo, and they were accompanied back to his residence by the knight of the Order of the Golden Stole and a group of senators.

The requirement for the ambassador to travel on foot from the Doge's Palace to the Rialto after receiving a response from the Senate, designed perhaps to remind him of his status as a petitioner (with faint echoes of a walk *from* Canossa), applied equally to the representatives of Great Britain, the Holy Roman Empire, and France. The report on the abbé de Pomponne's official entry closes with a description of his return journey after receiving the Senate's response on 13 May 1706:

The secretary [of the Senate] accompanied the ambassador to the door of the great hall between the Sala del Collegio and the chapel, after which the ambassador departed on foot, and instead of boarding his gondolas at the Piazza San Marco, he walked through the whole of the Merceria.... The ambassador walked at the end [of his cortege], accompanied by his secretary. In this order, he went to the bottom of the Rialto Bridge, where he boarded his gondolas.[100]

On stylistic grounds, Canaletto's canvas with the arrival of an ambassador's party at the Rialto after the walk through the Merceria may be dated to the years around 1740. As no ecclesiastics are present, a papal nuncio's entry can be excluded. Great Britain was represented in Venice by residents (who did not receive the same ceremonial privileges) from 1713 until 1737, when diplomatic relations were broken off in protest against the Serene Republic's cordial (though unofficial) reception of Charles Edward Stuart, called the Young Pretender.[101] The arrival of Robert d'Arcy, 4th Earl of Holdernesse (1718–1778), as ambassador extraordinary on 17 October 1744 marked a normalization,[102] but he did not have time to celebrate an official entry because he laid down his functions at the end of April of the following year.[103]

Charles François de Froulay (1673–1744), the French ambassador from October 1733 until February 1743, celebrated his official entry on 21 April 1738.[104] If he commissioned the canvas from Canaletto, the embarkation at the Rialto Bridge may have been selected instead of the traditional scene in front of the Doge's Palace because of Froulay's fraught and adversarial relationship with the government of the Serene Republic,

whose state inquisitors had lodged an official complaint about his scandalous liaison with a Venetian nun.[105] The composition privileges an iconic location that symbolizes the city's role as a trading hub rather than its political institutions. The chosen moment was also the only opportunity to depict an ambassador's parade gondolas without the presence of red-robed senators. A comparison of the gondolas and liveries to Frou-lay's report describing his official entry would permit a conclusive identification, but although he mentions the document in a letter of 13 May 1738 to the foreign ministry, the report itself is lost.[106] The most distinctive of the vessels used by Froulay's predecessor, Gergy, the third parade gondola with its red lacquer hull seen in both of the paintings he commissioned from Canaletto (see figs. 52, 185), does not appear in the Rialto Bridge scene but could have been replaced or refurbished in the interim.[107]

An alternative candidate for the painting's patron is the imperial ambassador Pio di Savoia, in office from June 1732 until December 1743. He had celebrated his entry relatively quickly, in December 1732, so that the moment shown would have to be the return to the Rialto after a later inquiry to the Senate. Cole's description of the ambassadorial protocol mentions that the same procedure that applied to the receipt of the Senate's response at the end of the accreditation process also applied to "any other" answer given by the Senate.[108] It is therefore conceivable that the Canaletto depicts Pio di Savoia's embarkation after receiving the response to an important inquiry made to the Senate in the late 1730s or early 1740s. The red and blue liveries seen in the painting could have been worn either by the imperial ambassador's gondoliers or by their French counterparts, since both embassies used red as the primary color with blue and silver as accent colors for their frequently redesigned liveries. The description of Pio di Savoia's parade gondolas deployed for his official entry in 1732 broadly agrees with the vessels depicted here, with the exception of the third gondola's roof, which is said to be covered in green velvet but has a gold color in the painting.[109] The gondolas and their sculptural decoration are not, however, rendered with the same degree of accuracy evident in the paintings of the late 1720s, because Canaletto's style had by now begun to take on a more calligraphic character.

Choiseul and Panini in Rome

While the departure of an ambassador at the end of the weeklong series of ceremonies that comprised an official entry, with no visible presence of the host government, was an extremely unusual subject for paintings commissioned by foreign representatives in Venice, a young and ambitious French ambassador in Rome, Étienne François, comte de Choiseul-Stainville (1719–1785), made the very same choice for the depiction of his official entry commissioned from Giovanni Paolo Panini (1691–1765). The composition exists in two versions that show the same scene but have traditionally been dated two years apart. The larger version is signed and dated 1756 (fig. 59).[110] The slightly smaller rendition has consistently been dated to 1754 (fig. 60).[111] In its signature, the last digit of the date is illegible but has been interpreted as 1754, based on a misunderstanding of the event shown. Choiseul had arrived in Rome on 4 November 1754,[112] yet his official entry did not take place until 28 March 1756, followed by his first public audience with Pope Benedict XIV (r. 1740–58) on 4 April 1756.[113]

FIG. 59
Giovanni Paolo Panini (Italian, 1691–1765). *St. Peter's Square with the Departure of the Duc de Choiseul*, 1756. Oil on canvas, 158 × 221 cm (62³⁄₁₆ × 87 in.). Private collection

FIG. 60
Giovanni Paolo Panini (Italian, 1691–1765). *St. Peter's Square with the Departure of the Duc de Choiseul*, 1756. Oil on canvas, 152 × 195 cm (59¹³⁄₁₆ × 76¾ in.). Berlin, Gemäldegalerie, inv. 80.2

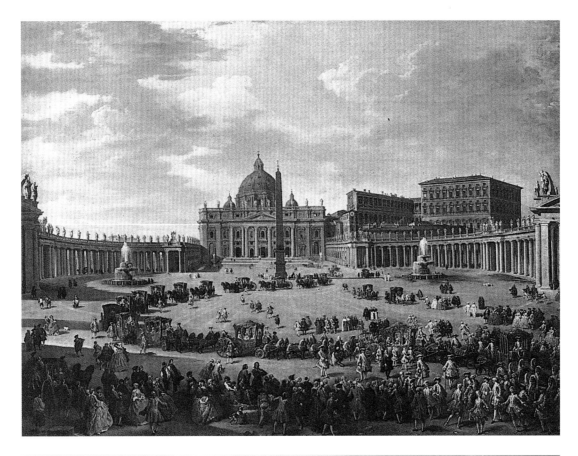

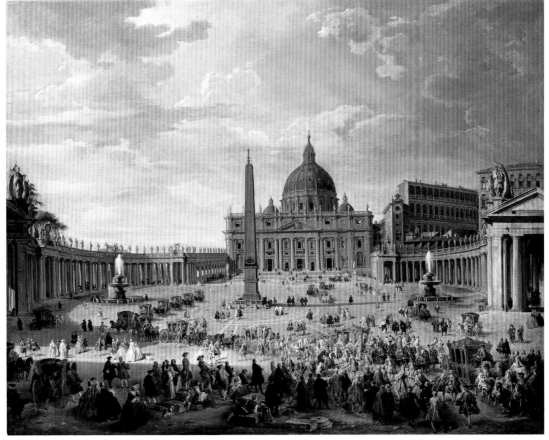

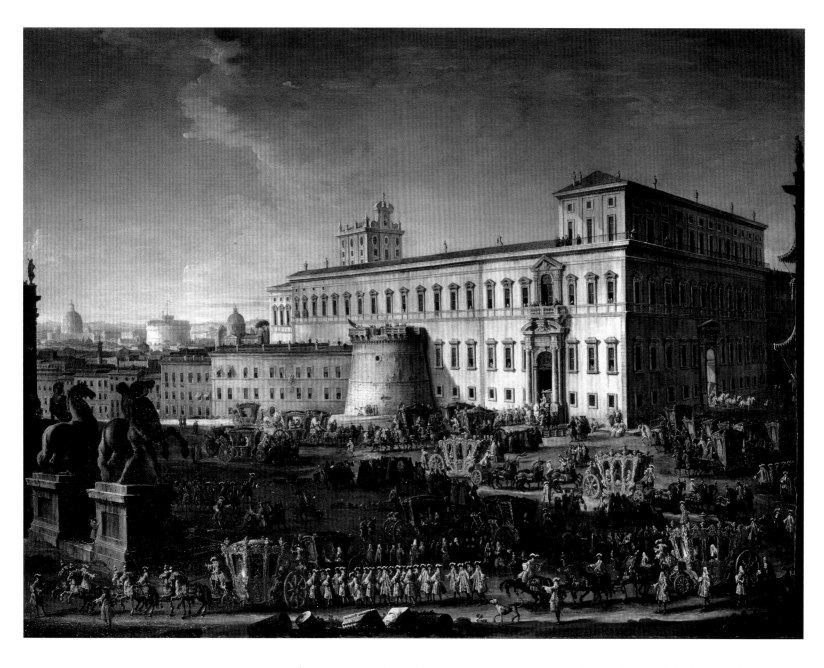

FIG. 61
Antonio Joli (Italian, 1700–1777). *The Departure of the Venetian Ambassador Alvise IV Mocenigo from the Quirinal Palace*, ca. 1754. Oil on canvas, 204 × 276 cm (80⁵⁄₁₆ × 108¹¹⁄₁₆ in.). Venice, Palazzo Mocenigo, inv. M. 127

The assumption that the canvas may relate to an earlier audience with the pope in late 1754 is mistaken for several reasons. The audiences for new ambassadors took place at the Quirinal Palace, the official papal residence, not at the Vatican Palace. A painting by Antonio Joli records the departure of the Venetian ambassador Alvise IV Mocenigo after his audience with Benedict XIV at the Quirinal Palace in February 1748 (fig. 61).[114]

The preparation of the sumptuous coaches and liveries for the ambassador's cortege was an expensive and time-consuming undertaking that could not have been accomplished within a few days or weeks of Choiseul's arrival in November 1754. The enormous importance of the splendor of the ambassadorial coach is demonstrated by the consequences of its absence. Having arrived in London on 4 March 1707, the Venetian ambassadors extraordinary Nicolò Erizzo and Alvise II Pisani delayed their official entry and urgently awaited audience with Queen Anne (r. 1702–14) until the gilded

parade coach specially commissioned in Paris for the occasion had been delivered after shipping delays caused by the War of the Spanish Succession, in addition to inclement weather in the English Channel. On 15 April, they wrote to the Venetian Senate: "once the coach has arrived, we will request the entry and audience"; on 29 April, they anxiously reported that "our coaches are fatally held up over there [i.e., at Rotterdam] by the sea" because the merchant vessels were waiting for the warships due to escort their convoy to England.[115] When the coach had still not arrived by 13 May, they resolved to arrange, at considerable expense coming out of their own pockets, for a replacement to be made by local craftsmen. This turned out to be unnecessary after all when, on 27 May, the convoy with their shipment from the United Provinces finally arrived in London.

It was only with the coach in place that the necessary "decorum of the representation" had been secured and Erizzo and Pisani felt able to request a date for their official entry.[116] In his detailed account of the day's events, the embassy's secretary, Giacomo Busenello, reported triumphantly that "the rich, noble, and resounding coach of their Excellencies Erizzo and Pisani elicited the applause and, it can be said, even the stupefaction of London, which does not easily grant its admiration to the magnificence of foreigners."[117] Even a more impartial observer, the imperial ambassador Johann Wenzel von Gallas, admiringly noted the Venetians' "very splendid" coach in a letter to the emperor in Vienna.[118] In Carlevarijs's depiction—subsequently produced in Venice—of the event, the long-awaited coach was given due prominence (fig. 62).[119]

The cavalcade of coaches in Panini's painting executed for Choiseul includes an element that is specific to the official entry of an ambassador and would not have been seen on any other occasion: an empty coach containing only a cushion on which the ambassador's credentials, to be presented to the pope, were displayed.[120] A report dispatched to the French foreign ministry immediately after the event noted: "The coach called the vanguard preceded the [first] passenger carriage; it was drawn by six magnificent horses and carried a large square cushion of blue velvet trimmed with silver and decorated with silver tassels."[121] Panini turned this coach toward the viewer to make the cushion inside clearly visible (fig. 63).[122] An empty vanguard coach at the front of the procession also appears in Joli's painting of the Venetian ambassador's official entry (fig. 64).

Choiseul himself traveled in the next coach, accompanied by several high-ranking ecclesiastics wearing purple mantellettas over their white rochets (fig. 65). The ambassador, seated by the window, appears—as the Roman newspaper *Diario ordinario* informed its readers in one of the reports it published on the week's events—"with the cross of the Order of the Holy Spirit, called cordon bleu, with which he was recently decorated by his Most Christian Majesty [i.e., Louis XV]."[123] Having received the order in January 1756, the ambassador wears its blue sash from right shoulder to left hip.[124] This makes a date prior to 1756 for the painting highly unlikely.[125]

Coming as the result of intense behind-the-scenes machinations lasting for almost a year, the award of the Order of the Holy Spirit was a personal triumph for Choiseul. In his correspondence with the French foreign minister, Antoine Louis Rouillé (1689–1761), he delicately broached the subject for the first time in February 1755.[126] Evidently he also mentioned his desire to Benedict XIV, who employed a diplomatic back channel—the regular correspondence with his friend Cardinal Pierre Guérin de Tencin

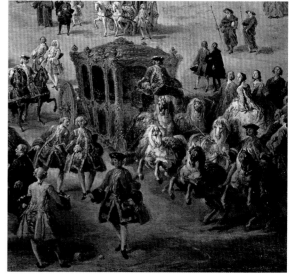

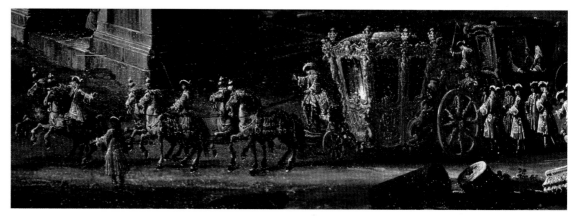

FIG. 62
Luca Carlevarijs (Italian, 1663–1730). *The Entry of the Venetian Ambassadors Extraordinary Nicolò Erizzo and Alvise II Pisani in London*, ca. 1708–10. Oil on canvas, 140 × 252 cm (55⅛ × 99³⁄₁₆ in.). Munich, Bayerische Staatsgemäldesammlungen, inv. 14560

FIG. 63
Detail of fig. 60. Giovanni Paolo Panini, *St. Peter's Square with the Departure of the Duc de Choiseul*, 1756. Berlin, Gemäldegalerie

FIG. 64
Detail of fig. 61. Antonio Joli, *The Departure of the Venetian Ambassador Alvise IV Mocenigo from the Quirinal Palace*, ca. 1754. Venice, Palazzo Mocenigo

FIG. 65
Detail of fig. 60. Giovanni Paolo Panini, *St. Peter's Square with the Departure of the Duc de Choiseul*, 1756. Berlin, Gemäldegalerie

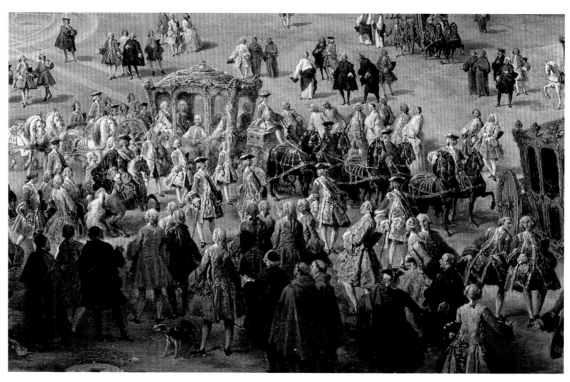

(1680–1758), archbishop of Lyon, who forwarded French translations of all his letters to Versailles, as the pope was well aware—to discreetly voice his support only a week later.[127] The next ally Choiseul enlisted in his quest was even more influential: the marquise de Pompadour (1721–1764). In June, the king's mistress pledged that she would "procure" the order for him.[128] This unlikely alliance of altar and boudoir could not fail to convince Louis XV. On 1 January 1756, he duly wrote to Benedict XIV that although the Order of the Holy Spirit was customarily awarded in recognition of long-term service to the French crown, he was making an exception for Choiseul (still in his thirties and on his first diplomatic posting) in order to fulfill the pope's wish.[129]

In successfully maneuvering for the Order of the Holy Spirit, Choiseul secured a crucial building block in his strategy of creating a visual legacy that would match those of the previous ambassadors Polignac, Rochefoucauld, and Nivernais, all considerably senior to him and recipients of the order either prior to or during their embassies to Rome. In the absence of a royal wedding or the birth of an heir to the throne, which had provided his three predecessors with opportunities not only to stage dazzling celebrations in Rome but to have them commemorated by Panini in equally dazzling canvases (see chapter 4), Choiseul instead turned his official entry into a spectacle of similar magnitude. He clearly had the ambition to return to Paris with a painted reportage to equal or surpass theirs, and it is likely that his decision to delay his official entry until 1756 was at least in part motivated by a firm resolve to appear in his canvas with the cordon bleu resplendently draped across his chest.

The specific moment shown in Panini's painting was carefully chosen to support the desired statement. The two detailed eyewitness accounts recording the day of Choiseul's public audience with the pope—one published in the *Diario ordinario*, the other written by the marquis de Middelbourg and sent to Versailles—agree that the ambassadorial cavalcade did not in fact traverse Saint Peter's Square (or even cross the Tiber) on that day.[130] As Choiseul did not have the opportunity to have spectacular ephemeral architecture constructed for a festival, he appropriated Rome's most recognizable urban space instead. By employing Saint Peter's as the backdrop, the composition also conveys the prestige of the young ambassador's first diplomatic posting at first glance. Furthermore, the setting provides sufficient breadth and depth for the cavalcade to unfurl in all its splendor, as a comparison with Joli's cramped depiction (still indebted to the artificial serpentine arrangement found in seventeenth-century engravings of coach processions) in the awkwardly shaped Piazza del Quirinale makes clear.

The scene is not, however, a fiction. As the final leg of the series of events that comprised the official entry of an ambassador to the Holy See, the protocol required a visit to Saint Peter's. The *Diario ordinario* noted that on 5 April, the day after the public audience with Benedict XIV, Choiseul went to the Vatican Basilica "with the same noble retinue and a cortege similar to the one with which he had gone to his first audience with His Holiness."[131] While four previous French representatives in Rome had also commissioned major works from Panini, the depiction of Choiseul's departure after the visit to Saint Peter's allowed Panini to create a particularly meaningful pairing of pendant canvases. In 1730 he had painted his first interior view of Saint Peter's, showing the visit of Cardinal de Polignac (fig. 66).[132] The composition had become a staple

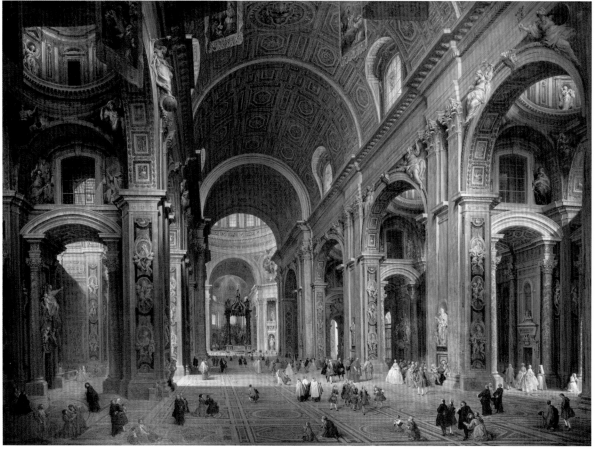

of the artist's production and exists in over twenty versions that reflect the gradual changes to the interior's sculptural decoration. Not only is the canvas of Choiseul's visit to the basilica among the finest of these (fig. 67),[133] but the familiar view is accorded a new context by becoming part of a chronological sequence—the visit is followed by the departure—and of a juxtaposition of interior and exterior views of the same iconic monument.

Adjustments for a New Patron

The views of Saint Peter's Square and the basilica's interior each existed in two paired versions. The first, slightly larger pair was commissioned by Choiseul and appeared in his estate sale in Paris in 1786 (see figs. 59, 67).[134] The smaller pair is set apart in multiple ways: in the view of the square, the viewpoint has been shifted to the right so that the obelisk now appears to the left of the basilica's cupola (see fig. 60). The cavalcade and many of the figures have been rearranged, and numerous pentimenti further testify to the fact that this composition, while depicting the same event, was developed independently.

The smaller interior view also differs from its larger version in practically all of the figures (fig. 68).[135] In the area near the first pillar on the right, Choiseul's painting shows the ambassador with his retinue and a cardinal, while the smaller canvas guides the viewer's attention to a hitherto unidentified cleric wearing the blue riband of the Order of the Holy Spirit around his neck (figs. 69, 70).[136] The decoration as well as the ecclesiastical bands at the collar establish his nationality as French, while the purple

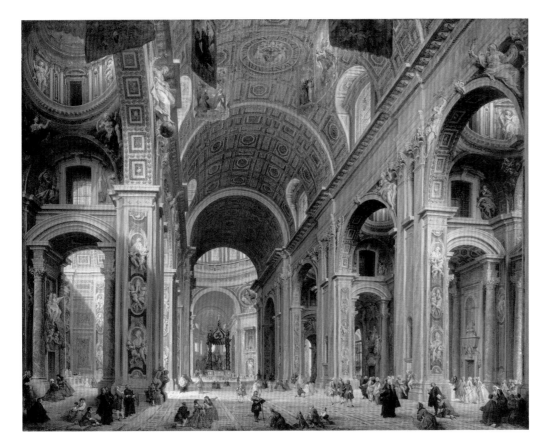

FIG. 66
Giovanni Paolo Panini (Italian, 1691–1765). *Interior of St. Peter's with the Visit of Cardinal de Polignac*, 1730. Oil on canvas, 150 × 225 cm (59 1/16 × 88 9/16 in.). Paris, Musée du Louvre, inv. 413

FIG. 67
Giovanni Paolo Panini (Italian, 1691–1765). *Interior of St. Peter's with the Visit of the Duc de Choiseul*, 1756–57. Oil on canvas, 164 × 236 cm (64 9/16 × 92 15/16 in.). Boston, Athenaeum, purchase, 1834, inv. UR12

FIG. 68
Giovanni Paolo Panini (Italian, 1691–1765). *Interior of St. Peter's with the Visit of the Abbé de Canilliac*, 1753–54. Oil on canvas, 155 × 197 cm (61 × 77 9/16 in.). Washington, D.C., National Gallery of Art, Alisa Mellon Bruce Fund, inv. 1968.13.2

mantelletta with a red lining, worn over a lace rochet he gathers up with his left hand, indicates that he is a senior prelate or bishop but not a cardinal. The only French cleric present in Rome at this time who had been awarded the cordon bleu but not the cardinalate was Claude François Rogier de Beaufort-Montboissier, abbé de Canilliac (1699–1761).[137] As an auditor of the Rota, the highest tribunal of the Church, he was the senior French representative in Rome after the ambassador.[138] The painting may be dated to the period between June 1753, when Canilliac received the Order of the Holy Spirit,[139] and August 1754, when the statues of Saint Teresa of Avila by Filippo Della Valle and Saint Vincent de Paul by Pietro Bracci were installed in the first two niches on the right.[140] Panini's *Ancient Rome*, commissioned by Canilliac in 1758, includes a similar likeness of him with the blue riband and badge, wearing a purple cassock and rochet but a mozzetta instead of the mantelletta (fig. 71).[141]

The identification of Canilliac as the protagonist of the smaller of the two interior views raises the question of whether he also commissioned its pendant with the cavalcade in Saint Peter's Square (see fig. 60). A comparison of the ambassadorial coach reveals a crucial adjustment Panini made when he painted this scene for the second time: in Choiseul's version, the ambassador is clearly visible by the window, while the man next to him is in shadow and partly hidden by a window frame (fig. 72). In the smaller version, by contrast, the second passenger on the rear banquette has greatly increased in prominence (see fig. 65). This larger, fully visible, and well-lit figure is once again identifiable by the Order of the Holy Spirit worn in the clerical style: he is the abbé de Canilliac, who was one of the senior clerics invited to travel in Choiseul's coach, as the *Diario ordinario* recorded.[142]

Canilliac's estate inventory, taken on 5 April 1761, lists seven paintings by Panini including "the interior of the church of Saint Peter's with many figures" and "Saint Peter's Square with coaches and figures."[143] Displayed in the gallery of Canilliac's Roman residence, they flanked Panini's *The Decoration of the Piazza Farnese for the*

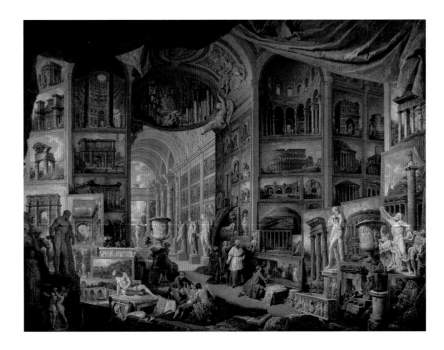

Celebration of the Marriage of the Dauphin.[144] Listed immediately after them are Canilliac's versions of *Ancient Rome* and *Modern Rome* (Paris, Musée du Louvre).[145] The interior and exterior views of Saint Peter's, today in Washington and Berlin, were acquired by Jacques Onésyme Bergeret de Grancourt (1715–1785) and are listed in his estate inventory of 1785.[146]

Choiseul and Canilliac fully understood the significance of documentary view paintings and deployed them as effectively as any of the ambassadors who commissioned works of this type from Carlevarijs, Canaletto, Joli, Marieschi, or Panini. While it has been suggested that the prominent role that the host city's political symbols and the splendor of its setting play in such compositions make it likely that the paintings of official entries were ordered by the local governments as gifts to the ambassadors,[147] a detailed analysis of the visual evidence in conjunction with contemporary reports and provenance records demonstrates that protagonist and patron were one and the same in almost every case.[148]

Foreign ambassadors were the first to recognize the image-making potential offered by the qualitative leap in Venetian and Roman view painting in the early decades of the eighteenth century that turned the viewer into a virtual eyewitness. Exploiting the opportunity to shape historical perception through carefully calibrated visual statements, ambassadors were able to expand the audience for their careers' most memorable moments across geographical and chronological boundaries. They created a new standard for recording spectacular occasions that artists and patrons soon began to apply to events ranging from religious festivals to civic celebrations and from royal visits to natural disasters.

FIG. 71
Giovanni Paolo Panini (Italian, 1691–1765).
Ancient Rome (detail), 1758. Oil on canvas,
231 × 303 cm (90 15/16 × 119 5/16 in.). Paris, Musée
du Louvre, inv. RF 1944-21

FIG. 72
Detail of fig. 59. Giovanni Paolo Panini,
*St. Peter's Square with the Departure of the
Duc de Choiseul*, 1756. Private collection

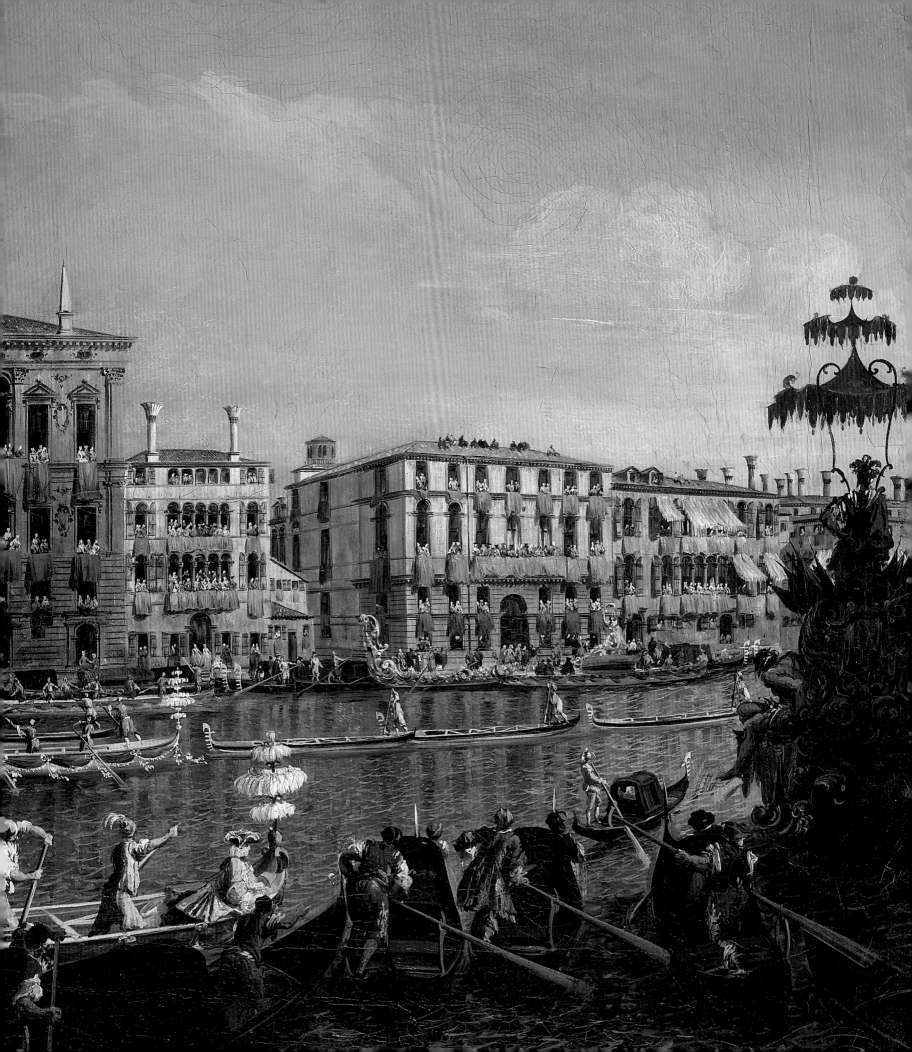

THE SPECTATOR
BECOMES THE SPECTACLE

☙·❧

"A Regata is intended after Easter for the Prince [of Saxony], which is said to be one of the finest shows in the World, and never given since the King of Denmark was here, which is 30 year ago. Many English and others of all Nations are expected to come to see it,"[1] the writer Lady Mary Wortley Montagu informed her husband in England from Venice on 16 March 1740. Since her arrival in September 1739, she had explored the city, mingled with the Venetian nobility and visiting foreigners, met old friends and made new ones, and held a regular salon, but her characteristic restlessness soon reasserted itself, and she was keen to move on to Florence and Rome. What kept her in Venice was the opportunity to experience a once-in-a-lifetime event: the special regatta organized on the occasion of the visit of crown prince Friedrich Christian of Saxony, eldest son of Augustus III, King of Poland and Elector of Saxony, on 4 May 1740.

Putting on lavish entertainments for the benefit of illustrious foreign guests was a time-honored tradition in Venice. With its former luster dulled by a combination of political irrelevance, military impotence, and economic stagnation, the Serene Republic still—or all the more—prided itself on its ability to put on a spectacle like no other. Many of them, such as carnival and the Bucintoro festival, recurred annually, but the very grandest of these occasions were the unique celebrations reserved for visiting foreign dignitaries. As a general rule, only crowned heads and their children warranted this level of effort and expenditure. Since the organizers as well as the honoree had a strong interest in documenting events of this nature, they had an enduring existence in printed reports, paintings, drawings, and engravings, often commissioned as gifts to the guests or dedicated to them. This chapter investigates the textual and visual records of events staged for prominent visitors to Venice and employs the former to illuminate the latter.

At the apex of the pyramid of honors a royal guest might receive stood the festive regatta. The *Forestiere illuminato* (Enlightened foreigner), a guidebook for visitors published by Giovanni Battista Albrizzi (1698–1777) in 1740, described the regatta as "one of the happiest entertainments the public customarily offers to foreign princes."[2] Giustina Renier Michiel (1755–1832), a granddaughter of the penultimate and niece of the last doge before the fall of the Republic, wrote in her history of the Venetian festivals she had experienced in her youth that the regatta was the city's "most interesting and imposing spectacle."[3]

The regular annual regatta, originally conceived as a training ground for and expression of Venetian naval prowess, had been held since the early fourteenth century and usually took place on 2 February, the feast of the Purification of the Virgin.[4] By the seventeenth century, a standard course of approximately eight kilometers had been established.[5] It ran from the Punta di Sant'Antonio, named after a church at the island's southeastern edge, through the Bacino and past the Molo into the Grand Canal. Having proceeded underneath the Rialto Bridge, the race continued up the Grand Canal

FIG. 73
Route of regatta, on Lodovico Ughi (Italian, act. ca. 1729). *Pictorial Representation of the Illustrious City of Venice*, 1729, etching and engraving on twenty joined sheets of laid paper, 148.5 × 264.2 cm (58⁷⁄₁₆ × 104 in.). Washington, D.C., National Gallery of Art, The Ahmanson Foundation, inv. 2010.66.1

FIG. 74
Canaletto (Italian, 1697–1768). *Regatta on the Grand Canal*, ca. 1733–34. Oil on canvas, 77 × 126 cm (30⁵⁄₁₆ × 49⁵⁄₈ in.). London, Royal Collection, inv. RCIN 404416

FIG. 75
Canaletto (Italian, 1697–1768). *Regatta on the Grand Canal*, ca. 1735–40. Oil on canvas, 150 × 218 cm (59¹⁄₁₆ × 85¹³⁄₁₆ in.). Barnard Castle, Bowes Museum, inv. 1982.32.2

to a turnaround point—marked by a pole in the water—at Santa Croce, a church that stood on a site opposite the modern-day railway station. Retracing part of their route, the contestants passed underneath the Rialto once more and reached the finishing line at the Volta di Canal, the waterway's sharpest bend (fig. 73). It was here that the *macchina della regata*, a temporary pavilion on a floating platform, was set up at the mouth of the Rio di Ca' Foscari, between Ca' Foscari and Palazzo Balbi. The *macchina* was constructed to a new design for every regatta, and its platform hosted the prize-giving ceremony after the races, of which there were typically four or five: the first for single-oared *battelli* (a type of light, open boat), the second for *battelli* with two oarsmen, followed by the third and fourth for gondolas rowed by one and two gondoliers respectively. On certain occasions, a race for female contestants was added at the end.

In the foreground of Canaletto's depiction of a regatta in 1734, a group of spectators are standing on gondolas and the platform of the *macchina*, partly cut off at left (fig. 74).[6] They are intently watching the single-oared *battelli* as they race toward the Rialto Bridge, barely discernible in the distance. The view is taken from Ca' Foscari, looking northeast along the longest straight stretch of the Grand Canal. On the left bank, the *macchina* is adjacent to Palazzo Balbi, with its pair of obelisks. Leading toward the dome of the church of Santi Giovanni e Paolo on the horizon, the procession of palaces on the right bank begins with Palazzo Nani-Mocenigo and progresses in the direction of the Rialto with Palazzo Contarini delle Figure, two Mocenigo palaces surmounted by obelisks, and the flank of Palazzo Corner-Spinelli catching the sunlight.

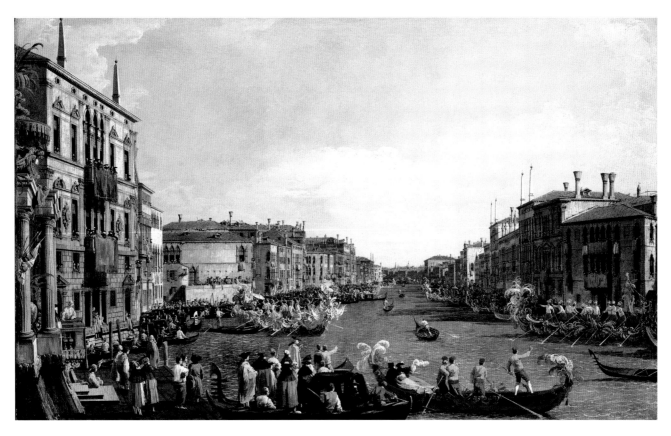

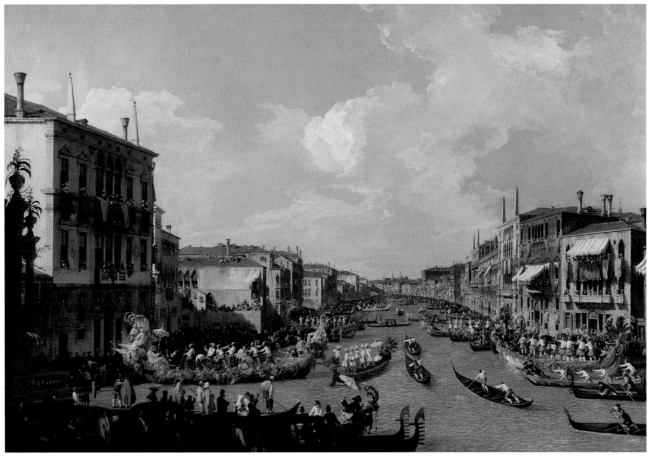

After this canvas had been engraved by Antonio Visentini (1688–1782) and published in his collection of Venetian views, the *Prospectus Magni Canalis Venetiarum* of 1735,[7] Canaletto painted a number of other regatta scenes,[8] the largest of which plunges the viewer into a crucial moment in the two-oared race (fig. 75).[9] Three gondolas have swung around the bend in a close formation and are trying to catch up with the leader, but a passenger gondola with a cabin has decided to traverse the canal and is in danger of blocking their paths, with its gondoliers straining every sinew to get out of the way in time. On the platform of the *macchina*, Canaletto added a detail he had omitted in the earlier versions: the colored flags awarded as prizes (fig. 76). The winner received the red flag (here inscribed "Primo"), followed by green, blue, and yellow. The first three finishers received prize money, while the fourth-placed contestant was given a live piglet, as the symbol on the yellow flag indicates.[10]

In addition to appearing in these evocative depictions of the regatta, the scene of the Grand Canal from Palazzo Balbi to the Rialto Bridge also became one of the artist's most successful topographical views,[11] yet it had not originated with Canaletto. As in the case of his first painting of an ambassadorial reception, he adopted the composition of a prototype by Luca Carlevarijs, known to him through an engraving by Giuseppe Baroni published in 1717 (fig. 77).[12] Once again, Canaletto sought to relieve his predecessor's typical overcrowding: while Carlevarijs showed only the first window of Palazzo Nani-Mocenigo at the right edge, Canaletto obtained a wider expanse of water at the bend in the Grand Canal by extending the viewing angle to include the building's whole facade. The additional space is used to highlight the drama of the regatta and the efforts of the contestants, squeezed into a corner by Carlevarijs. Both painters' compositional choices parallel those in their ambassadorial reception scenes, where the parade gondolas marginalized by the older artist were given pride of place by the younger (see chapter 2).

FIG. 76
Detail of fig. 75. Canaletto, *Regatta on the Grand Canal*, ca. 1735–40. Barnard Castle, Bowes Museum

FIG. 77
Giuseppe Baroni (Italian, ca. 1670–1731), after Luca Carlevarijs (Italian, 1663–1730). *Rappresentazione della regatta solenne fatta in Venezia sopra il Canal Grande nel di IIII. marzo M.D.CCIX per divertimento di sua maestà il Re di Danimarca*, etching, ca. 1717, 500 × 690 mm (19¹¹⁄₁₆ × 27³⁄₁₆ in.). Los Angeles, Getty Research Institute, inv. 1406-819

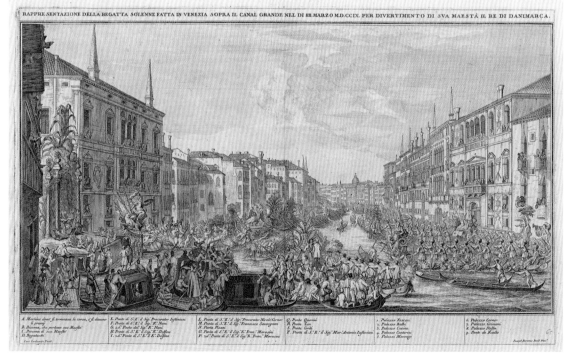

Contests between Oarsmen and between Noblemen

When Canaletto painted his first regatta scene, the canvas by Carlevarijs that formed the basis of Baroni's engraving had long left Venice. By 1713, it is recorded in the collection of King Frederick IV of Denmark and Norway (r. 1699–1730), who appears in it (fig. 78).[13] Unlike Canaletto, Carlevarijs provided his viewers with the opportunity to witness an event that entered the annals of Venice due to its protagonist's royal rank. Wearing a red coat, Frederick IV sits on the prow of a ceremonial barge in the central foreground. The painting ostensibly shows the king watching the regatta, but it is really he who has become the spectacle. The event thus fulfilled a dual function: the foreign visitor was entertained by seeing the race, while the Venetians were entertained by seeing the foreign visitor.

Frederick IV had arrived in Venice on 29 December 1708. In order to accommodate his large retinue of fifty-three people, Palazzo Foscarini at San Stae was joined to the neighboring Palazzo Savorgnan. The Senate delegated four noblemen to attend to him during his stay: Nicolò Erizzo, Giovan Francesco Morosini, Giovan Battista Nani, and Daniele Dolfin. After a wait for better weather, the special regatta organized in his honor finally took place on 4 March 1709, the king's penultimate day in the city. The Republic's official chronicle of ceremonies noted: "On 4 March, the day before his departure from this city, the aforementioned cavaliers [Erizzo, Morosini, Nani, and Dolfin] offered him a most noble regatta for his enjoyment. It was accompanied by twenty-six richly decorated *peote* as well as numerous *bissone* and other types of barges

FIG. 78
Luca Carlevarijs (Italian, 1663–1730). *The Regatta on the Grand Canal in Honor of King Frederick IV of Denmark*, ca. 1709. Oil on canvas, 135 × 260 cm (53⅛ × 102⅜ in.). Hillerød, Frederiksborg Slot

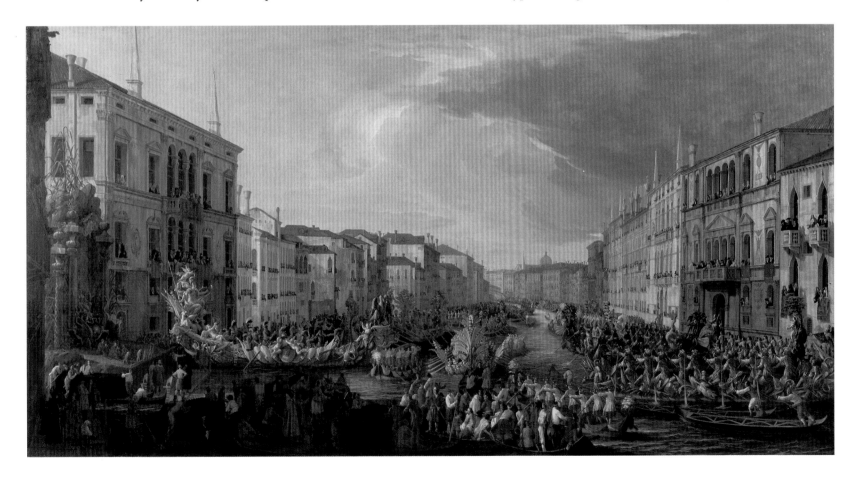

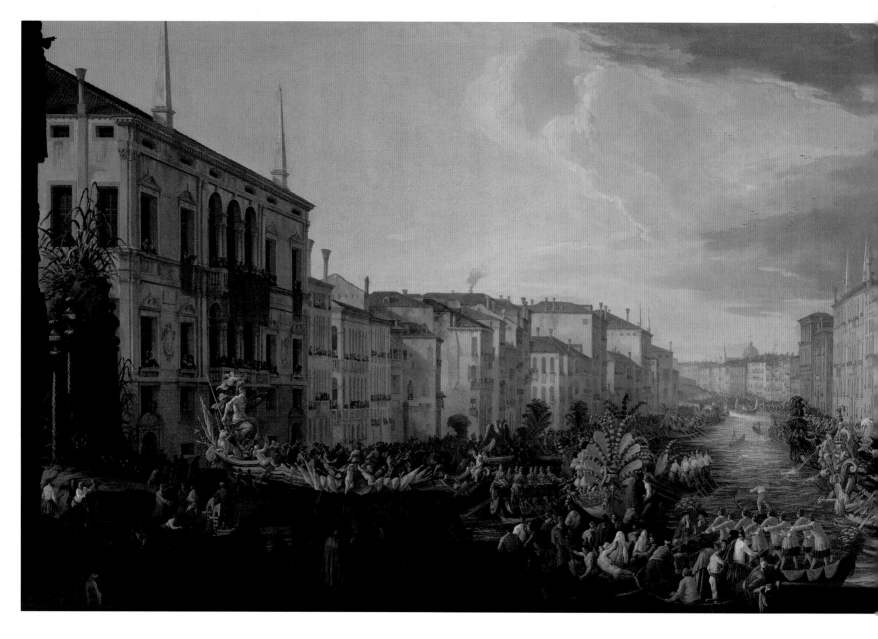

FIG. 79
Luca Carlevarijs (Italian, 1663–1730). *The Regatta on the Grand Canal in Honor of King Frederick IV of Denmark*, 1711. Oil on canvas, 135 × 260 cm (53⅛ × 102⅜ in.). Los Angeles, J. Paul Getty Museum, inv. 86.PA.599

FIG. 80
Detail of fig. 79. Luca Carlevarijs, *The Regatta on the Grand Canal in Honor of King Frederick IV of Denmark*, 1711. Los Angeles, J. Paul Getty Museum

that attracted universal admiration. The king was collected from his residence by the Excellent Cavalier Dolfin in a richly decorated *bissone*, in which he went along the Grand Canal accompanied by the twenty-six *peote* with great splendor and majesty."[14]

In addition to the canvas for the king, Carlevarijs painted a second version of the composition that differs only in some of the secondary figures (fig. 79).[15] In both paintings, the king is shown in the *bissona* (an eight-oared ceremonial barge of about twelve and a half meters in length)[16] provided by Daniele Dolfin, who sits next to him (fig. 80). Its eight oarsmen wear yellow and red, the colors of the house of Oldenburg, in recognition of the fact that the king traveled incognito as Count of Oldenburg, the German county from which his family originated. Soon after the event, a detailed description of the lavish ceremonial vessels constructed especially for the regatta was published under the title *La magnificenza veneta nella pomposa Comparsa delle Sontuose Peote, che scorsero il Canal Grande nella Regata seguita il dì 4 Marzo 1709. à divertimento di Sua Maestà*

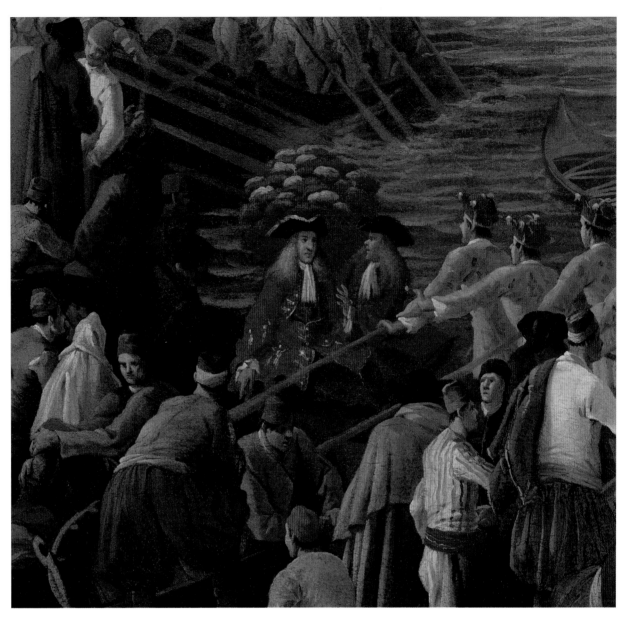

Federico IV. Rè di Danimarca, Norvegia, &c. Its anonymous author proclaimed that the *bissona* prepared for the king's use was "adorned all over with crimson velvet laced with gold fringes, which by being lowered into the water carried the treasures of the earth into the sea" and posited that upon boarding, the king might have been in doubt as to whether he was entering a barge or a royal chamber.[17] Carlevarijs's painting shows the costly fabric draped over the side of the barge, ready to be ruined by the seawater in an act of heedless extravagance.

Eager to witness the spectacle and catch a glimpse of the royal visitor, spectators are thronging every available window and balcony of the palaces lining the Grand Canal. In front of the *macchina*, a group of musicians contributes to the festive atmosphere. Their green costumes turn them into a living extension of the pavilion's ephemeral decorations of columns surmounted by coral-filled vases flanking the royal coat of arms topped by a crown. The entire structure is bedecked with reeds. In the center,

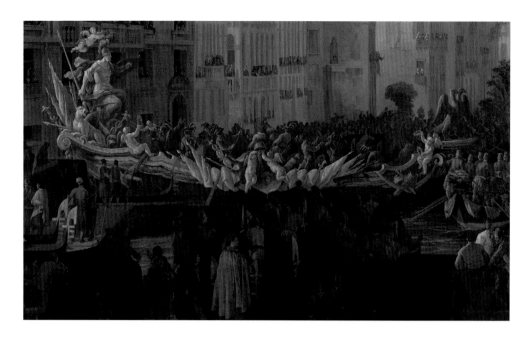

FIG. 81
Detail of fig. 79. Luca Carlevarijs,
*The Regatta on the Grand Canal in Honor
of King Frederick IV of Denmark*, 1711.
Los Angeles, J. Paul Getty Museum

FIG. 82
Giovanni Grevembroch (Jan van Greven-
broeck) (Italian, 1731–1807). *Pallade Guerriera*,
in *Gli abiti de veneziani di quasi ogni età con
diligenza raccolti e dipinti nel secolo XVIII*,
ca. 1753, Venice, Museo Correr, ms.
Gradenigo-Dolfin 49, vol. 4, fol. 131

FIG. 83
Vincenzo Coronelli (Italian, 1650–1718).
Peotta dell'Eccellentissomo S. Proc. Giustiniani,
in *Regatta nel Canale Grande di Venezia di IV.
marzo MDCCIX. ed altre feste solennizzate nella
venuta di Federico IV. Rè di Danimarca in questa
Metropoli*, Venice: Coronelli, 1709, fol. 41r

FIG. 84
Vincenzo Coronelli (Italian, 1650–1718).
*Machina a Ca' Foscari Nella Regatta 4. Marzo
1709*, in *Regatta nel Canale Grande di Venezia di
IV. marzo MDCCIX. ed altre feste solennizzate
nella venuta di Federico IV. Rè di Danimarca
in questa Metropoli*, Venice: Coronelli, 1709,
fol. 36r

FIG. 85
Detail of fig. 79. Luca Carlevarijs,
*The Regatta on the Grand Canal in Honor
of King Frederick IV of Denmark*, 1711.
Los Angeles, J. Paul Getty Museum

FIG. 86
Vincenzo Coronelli (Italian, 1650–1718).
Peotta dell'Ecc. S. Gio: Batista Nani C., in
*Regatta nel Canale Grande di Venezia di IV.
marzo MDCCIX. ed altre feste solennizzate nella
venuta di Federico IV. Rè di Danimarca in questa
Metropoli*, Venice: Coronelli, 1709, fol. 43r

fantastical sea creatures appear at the feet of an allegorical figure. The latter's subject cannot be determined in the painting, but *La magnificenza veneta* identifies the subject of the *macchina* as "the palace of Merit."[18]

The same report describes each of the ceremonial barges known as *peote* and names the Venetian noble families who commissioned them. The two most prominent vessels are placed almost parallel to the picture plane in the foreground. At left, the barge of Girolamo Giustiniani is recognizable by his family's heraldic animal, the double-headed eagle, on the prow and a statue of Minerva holding a spear and a shield on the stern (fig. 81).[19] Its design is credited to the Florentine scenographer Zenone Angelo Rossi (or Rosis, 1670–1750 or 1752).[20] The same Giustiniani barge is illustrated in Giovanni Grevembroch's *Gli abiti de veneziani di quasi ogni età con diligenza raccolti e dipinti nel secolo XVIII* with an inscription describing its subject as *Pallade Guerriera* (a reference to the role of Minerva or Pallas Athena as goddess of war), "the valiant daughter of Jove resplendent on the high prow" (fig. 82).[21] A collection of engravings published by

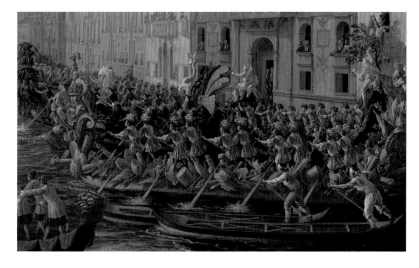

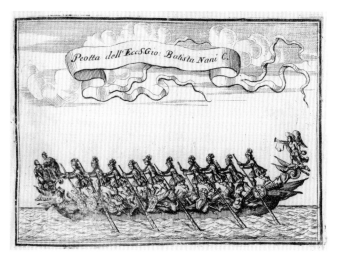

Vincenzo Coronelli includes the regatta's ceremonial barges as well as a frontal view of the *macchina* with the enthroned personification of Merit not visible in Carlevarijs's canvas (figs. 83, 84).[22]

La magnificenza veneta also provides an explanation for the two gilded figures of bearded men on the prow of the barge seen at right in the painting, which belonged to Giovan Battista Nani, another of the four patricians selected by the Senate as the prince's hosts (fig. 85).[23] They represent Denmark and Oldenburg and support a crown surmounting the coat of arms of Oldenburg with its two horizontal red bands on a yellow ground. On the barge's stern, the Danish royal coat of arms appears on a banner hanging from the trumpet of a figure of Fame. The red and yellow colors of Oldenburg are repeated in the oarsmen's liveries, a quasi-operatic reinterpretation of Roman military dress. The depiction of the Nani barge in Coronelli's suite of engravings differs from the painting in that the coat of arms held by the two men is that of Denmark rather than of Oldenburg (fig. 86). Since the printed description of 1709 also mentions

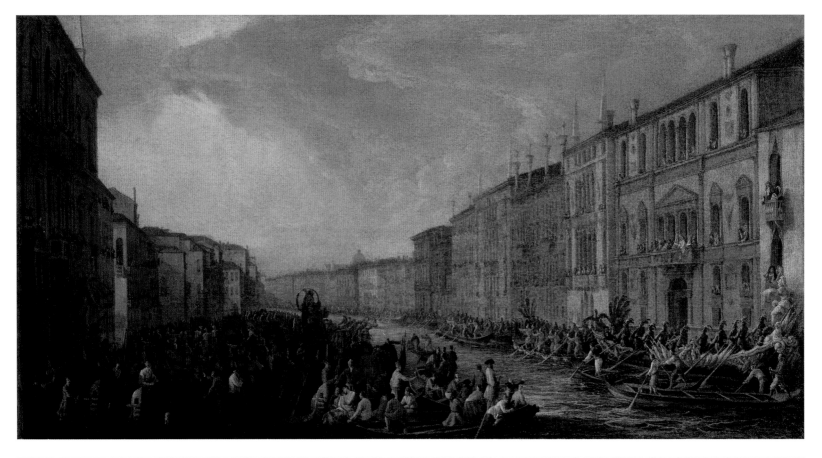

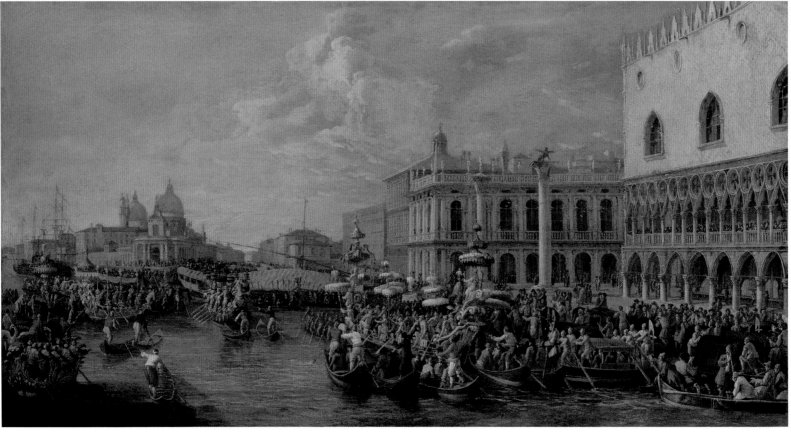

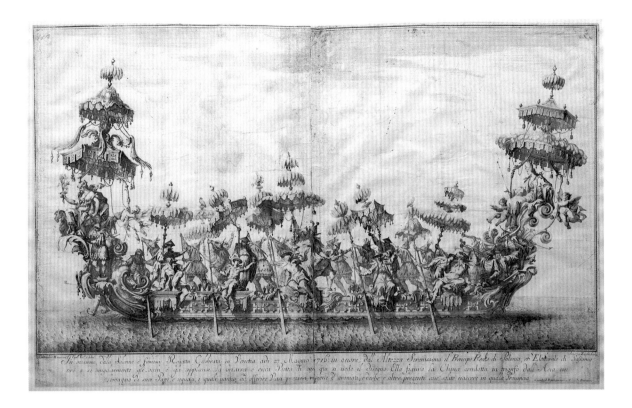

the "royal arms of His Danish Majesty" here,[24] it is possible that in this highly conspicuous passage of the painting (to which the artist drew attention through compositional means and lighting), intended for display in Denmark, Carlevarijs wanted to respect the king's incognito as Duke of Oldenburg and that he repeated this modification in the second version. It was not uncommon for painters of documentary views to amend the visual record in order to accommodate their patrons' preferences or simply to flatter them (see chapter 6).[25] A third painting of the 1709 regatta by Carlevarijs is taken from the same viewpoint but does not include the king and has switched the positions of many of the barges, with the Giustiniani barge with the statue of Minerva appearing at right and the Nani barge with Fame sounding a bannered trumpet at left (fig. 87).[26] As the group with the male personifications of Denmark and Oldenburg is now seen from the other side, the coat of arms is not visible.

The emphasis on the allegorical floats, a means for the Venetian nobility to display their wealth, sophistication, and taste in competition with other families, is even stronger in Carlevarijs's depiction of the next festive regatta, held on 27 May 1716 for crown prince Friedrich August of Saxony (1696–1763), later King Augustus III of Poland (fig. 88).[27] It shows an earlier moment on the regatta's route: the cortege of contestants, *peote*, *bissone*, and vessels carrying spectators passes in front of the Doge's Palace and is about to enter the mouth of the Grand Canal. The most lavish of the day's ceremonial barges, featuring fantastical three-tiered structures on the prow and stern that simultaneously invoke the doge's *ombrellino* (parasol) and Chinese pagodas, is seen in front of the twin columns at the entrance to the Piazzetta. As the inscription on an engraving by Andrea Zucchi records, this vessel was designed by the scenographer Alessandro Mauro[28] and represented "China led in triumph by Asia" (fig. 89).[29] The same barge was

FIG. 87
Luca Carlevarijs (Italian, 1663–1730).
The Regatta on the Grand Canal in Honor of King Frederick IV of Denmark, 1710–11.
Oil on canvas, 61 × 121 cm (24 × 47⅝ in.).
St. Petersburg, Hermitage, inv. ГЭ-216

FIG. 88
Luca Carlevarijs (Italian, 1663–1730).
The Regatta in Honor of Prince Friedrich August of Saxony Passing the Molo, ca. 1716.
Oil on canvas, 61 × 115 cm (24 × 45¼ in.).
St. Petersburg, Hermitage, inv. ГЭ-5538

FIG. 89
Andrea Zucchi (Italian, 1679–1740), after Alessandro Mauro (Italian, fl. 1709–48).
La China condotta in trionfo dall'Asia, engraving, 556 × 900 mm (21⅞ × 35⁷⁄₁₆ in.).
Venice, Museo Correr

described and the print was reproduced in a short section on regattas in Albrizzi's *Forestiere illuminato* of 1740.[30] This guidebook to Venice was dedicated to Augustus III's son and heir to the Saxon electorate, crown prince Friedrich Christian, on the occasion of his stay in the city from 21 December 1739 to 11 June 1740 during an extended tour of Italy.[31]

Marieschi's New Point of View

The festive regatta for the young Saxon prince, so eagerly anticipated by Lady Mary Wortley Montagu, took place on 4 May 1740 and was organized on a scale unseen since the one for Frederick IV of Denmark in 1709, as she had been told.[32] Johann Caspar Goethe (1710–1782), Johann Wolfgang's father, also visited Venice in 1740 but had already made arrangements to leave for Rome when he learned about the preparations for the regatta, leading him to lament that "if I have ever had the mad wish to be able to divide myself into two bodies, it was on this occasion as it would allow me to send one body to Rome and stay with the other one in Venice in order to enjoy so famous a ceremony."[33]

A canvas by Michele Marieschi, traditionally catalogued as showing an unspecified regatta on the Grand Canal, can be identified as a depiction of the race held for Friedrich Christian (fig. 90).[34] At the painting's right edge, a ceremonial barge with a triple-tiered *ombrellino* superstructure, reminiscent of the *peota* designed for the visit of the prince's father in 1716, floats into view. Such sumptuous allegorical *peote* typically appeared in the festive regattas organized for visitors of royal blood, and the only event of this nature to take place between the completion of Palazzo Civran Grimani, the fourth building from the left (with multiple figures sitting on the roof) in circa 1739[35] and Marieschi's death in 1744 was the regatta for Friedrich Christian.

Instead of the view down the long stretch of the Grand Canal toward the Rialto Bridge chosen by Carlevarijs and Canaletto, Marieschi depicted the Volta di Canal from the contestants' perspective as they reach the bend, with Palazzo Balbi straight ahead. He most likely developed this new composition because it allowed him to include prominently Ca' Foscari, the building on the left and Friedrich Christian's residence during his stay in Venice. According to one of the weekly reports dispatched to the prince's father, Augustus III, in Dresden by his governor Count Joseph Wackerbarth-Salmour (1685–1761), before the start of the regatta, Friedrich Christian "placed himself on a loggia of his palace, from where one looked out over the whole Grand Canal all the way to the Rialto Bridge on the left and Santa Maria della Carità [today the Accademia] on the right, which is the most beautiful viewpoint in the entire city."[36] In the painting, groups of well-dressed spectators—the prince presumably among them—have stepped out onto the first- and second-floor balconies fronting Ca' Foscari's loggias in order to enjoy the magnificent spectacle on the canal.

In the race for two-oared gondolas, three boats are neck and neck, with a fourth just behind them. A *bissona* with six oarsmen in yellow and dusty pink livery and a well-dressed passenger at the prow has ventured too far into the path of the race, leaving only a narrow passage for the competing gondolas. The floating pavilion seen between Ca' Foscari and Palazzo Balbi lacks the lineup of small colored flags for the winners because it was not the *macchina della regata* at the finishing line, which in 1740 was

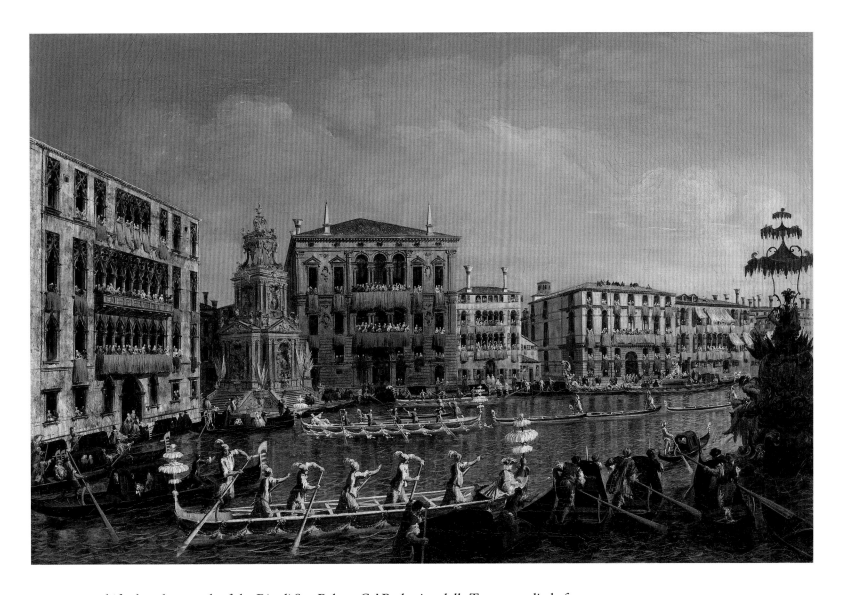

shifted to the mouth of the Rio di San Polo at Ca' Barbarigo della Terrazza, a little far-
ther up the canal toward the Rialto.[37] For the race in honor of Grand Duke Paul of Rus-
sia (1754–1801) in 1782, one of the few regattas in the eighteenth century that matched
the splendor of the race staged for Friedrich Christian's visit, five additional pavilions
were erected in various locations along the Grand Canal.[38] If this was also the case in
1740, the prominent position next to the royal guest's residence at the Volta di Canal
would certainly not have remained empty, and it seems likely that Marieschi's painting
shows such an additional structure at the mouth of the Rio di Ca' Foscari.

In Lady Mary's words, the regatta for Friedrich Christian "was really a magnificent
show, as ever was exhibited since the galley of Cleopatra."[39] The detailed account of the
event she sent to her husband elaborated:

> It is a race of Boats: they are accompany'd by vessells which they call Piotes and
> Bichones, that are built at the Expence of the nobles and strangers that have a
> mind to display their magnificence. They are a sort of Machines adorn'd with all
> that sculpture and gilding can do to make a shineing appearance. Several of them

FIG. 90
Michele Marieschi (Italian, 1710–1744). *The
Regatta in Honor of Prince Friedrich Christian
of Saxony*, ca. 1740. Oil on canvas, 56 × 85 cm
(22 1/16 × 33 7/16 in.). Private collection

cost £1,000 sterling and I beleive none less than 500. They are row'd by Gondoliers dress'd in rich Habits suitable to what they represent. There was enough of them to look like a little Fleet, and I own I never saw a finer sight.[40]

She went on to describe several of the most impressive *peote*:

Signor Alvisio Mocenigo's was the Garden of Hesperides. The whole fable was represented by different Statues.... Signor Paul Dona had the chariot of Diana, who appear'd Hunting in a large wood, the trees, hounds, Stag, and Nymphs all done naturally, the Gondoliers dress'd like peasants attending the chase, and Endimion lying under a large Tree gazing on the Goddess. Signor Angelo Labbia represented Poland crowning of Saxony, waited on by the Virtues and subject provinces.[41]

A Permanent Souvenir of Ephemeral Barges

Recorded in the crown prince's privy purse accounts is a payment for a set of watercolors by Antonio Joli showing some of the ceremonial barges that had so dazzled Lady Mary.[42] The *peota* with the Garden of the Hesperides (fig. 91)[43] shows Hercules on the stern, slaying the dragon underneath the tree bearing the golden apples, while on the prow, the three Hesperides sisters are garlanding a statue of Venus with flowers.[44] Two other contemporary sources discuss the iconography of the barges in more detail than Lady Mary: *L'Adria festosa*, a printed account of the events organized during Friedrich Christian's stay in Venice, and the prince's own manuscript diary. The former describes the barge as follows: "On the stern, the entrance to the Garden of the Hesperides with the tree of the Golden Apples is guarded by the watchful dragon, whom Hercules is about to slay with his club. On the prow, the three Hesperides sisters Aigle, Creusa, and Hesperethusa are worshipping a simulacrum of the goddess Venus erected on a pedestal. The whole *peota* is designed as a garden so lifelike that the flowers appear to be products of nature rather than art."[45] The prince himself mentioned in his diary that he saw a "*peota*...that represents the Garden of the Hesperides with Hercules killing the dragon on the stern and the three Hesperides sisters adoring Venus on the prow."[46] Among the other barges he described was a representation of the hunt of Diana with Endymion on the prow (fig. 92).[47]

The vessel appearing at right in Marieschi's painting (see fig. 90) shows an enthroned figure under a baldachin, seen from behind. Visible below are piled-up flags as well as a muscular male figure, possibly a bound prisoner. The ensemble matches a ceremonial barge described by Lady Mary as "the Triumphs of Peace, discord being chain'd at her Feet"[48] and in *L'Adria festosa* as "Peace Triumphant, holding a green olive branch in her right hand, with Discord, Disdain and Hostility overthrown and enchained and poles, flags, and military implements under her feet."[49]

L'Adria festosa not only provides more precise iconographic details than the descriptions by Lady Mary and Friedrich Christian, it also names the artists responsible for the designs of the barges, for example the one "representing Saxony crowned by Poland and courted by Virtue, with symbols and hieroglyphs of royal virtues, various scepters, crowns, and trophies, with the figures leading Saxony toward Poland dressed

FIG. 91
Antonio Joli (Italian, 1700–1777). *Peota with Hercules in the Garden of the Hesperides*, 1740, ink and wash on paper, 468 × 720 mm (18⁷⁄₁₆ × 28³⁄₈ in.). Dresden, Kupferstich-Kabinett, inv. C-1979-6

FIG. 92
Antonio Joli (Italian, 1700–1777). *Peota with the Hunt of Diana and Endymion*, 1740, ink and wash on paper, 468 × 720 mm (18⁷⁄₁₆ × 28³⁄₈ in.). Dresden, Kupferstich-Kabinett, inv. C-1979-8

PEOTA DI SVA. Ecc: Gio: Aluise Mocenigo Casa Vechia. ORTI ESPERIDI

Peota Di Sua Ecc Polo Dona. Diana Cacciatrice.

with rich emblems. The admirable work of the aforementioned Mr. Antonio Joli."[50] Those watercolors showing barges the artist had designed himself are signed "inventor and director Antonio Joli" (see fig. 91). The artists credited with the design of one or several *peote* were mostly scenographers and architects specializing in ephemeral decorations, such as Romualdo Mauro, Gaetano Zampini, Francesco Candolfi, Alvise Vancetta, Pietro Zangrandi, and Lorenzo Gamba.

One unexpected name, however, stands out: Giovanni Battista Tiepolo. He was responsible for "the *peota* of His Excellency Giacomo Soranzo of Rio Marin, which showed Muscovy and Poland joined on the stern for the benefit of King Augustus, seated on the prow underneath a royal baldachin formed of various plumes between military implements, which are scattered all over the *peota* with a variety of gilded foliage, accompanied by the principal rivers of the two kingdoms, the Vistula and the Volga.... The work was designed by the celebrated Giovanni Battista Tiepolo and executed under his supervision."[51]

Joli's set of watercolors produced for Friedrich Christian does not include this barge, but a working drawing executed in pencil and colored washes preserves an early stage of Tiepolo's design (fig. 93).[52] There are several differences between this sheet and the description of the barge in *L'Adria festosa*. The two main groups have traded places:

FIG. 93
Giovanni Battista Tiepolo (Italian, 1696–1770). *Ceremonial Barge for the Regatta in Honor of Prince Friedrich Christian of Saxony*, 1740, pencil and wash, 469 × 789 mm (18⁷⁄₁₆ × 31¹⁄₁₆ in.). Private collection

the personifications of Poland (a standing knight wearing a suit of armor) and Muscovy (a female figure seated at his feet) are located on the prow, while the baldachin and the figure of the king are lightly indicated in pencil on the stern. A river god holding a rudder, with water gushing out of the vase he leans on, is seated below the prow but cannot be identified as one of the two specific waterways; the second river god was presumably located on the vessel's other side. In its center, a boy holds two large fish, symbolizing the rich bounty the rivers yielded for the kingdom of Poland. He swings his leg over a curved cornice, a motif familiar from Tiepolo's frescoes such as the ceiling in Palazzo Clerici in Milan of 1739.[53]

While Joli's sheets record the final barges as they appeared in the regatta, Tiepolo's drawing includes only those elements he was responsible for. This evidently did not include the costumes for the oarsmen and musicians: the oars are suspended in space, and the position just underneath the stern structure, where the musicians appear in Joli's watercolors of other barges (see figs. 91, 92), remains empty. It was not unusual for a barge and its costumes to be designed by two different artists; such a division of labor had also occurred in 1716 for the regatta in honor of Friedrich Christian's father, Augustus III, with Gaspare Diziani contributing the costumes for the *peota* designed by Alessandro Mauro (see fig. 89).[54]

Lady Mary pronounced herself impressed with the results in their entirety: "Signor Soranzo represented the Kingdom of Poland with all the provinces and Rivers in that Dominions, with a concert of the best instrumental music in rich Polish Habits; the painting and gilding were exquisite in their kinds."[55] It appears that, just as Tiepolo had been uncertain how to represent some unfamiliar elements of the barge's rather complex iconographic program, the spectators struggled to comprehend every aspect of its meaning. Even the spectacle's addressee, Prince Friedrich Christian, who would certainly have been given an ample explanation of the waterborne parade floats by his Venetian hosts, identified the two rivers as the Elbe and the Vistula, described the group on the prow as "Mars under a laurel embracing a Pole," and understood the overall subject to be "the Triumph of Poland over the Tartars,"[56] while his governor Wackerbarth noted in his report to Augustus III that the *peota* represented the Triumph of Poland, with the Polish white eagle on the stern, oarsmen in Polish dress, and "a group of musicians in the Turkish taste."[57]

Chasing Bulls in Piazza San Marco

Discrepancies of this nature underscore the pitfalls of any attempt to reconcile the visual record represented by view paintings and related drawings or engravings too literally with the written accounts of contemporary observers found in letters, journals, and printed reports. This is equally true of another Venetian event that also existed in a recurring version, usually during carnival, as well as a much more lavish form put on to entertain particularly high-ranking foreign visitors: the bull chase.[58] Its special form, held in Piazza San Marco, was as rare as the ceremonial regatta and took place merely four times during the eighteenth century: in 1709 for King Frederick IV of Denmark,[59] in 1740 for Friedrich Christian, in 1767 for Duke Carl Eugen of Württemberg (1728–1793), and in 1782 for Grand Duke Paul of Russia.[60] Only one of

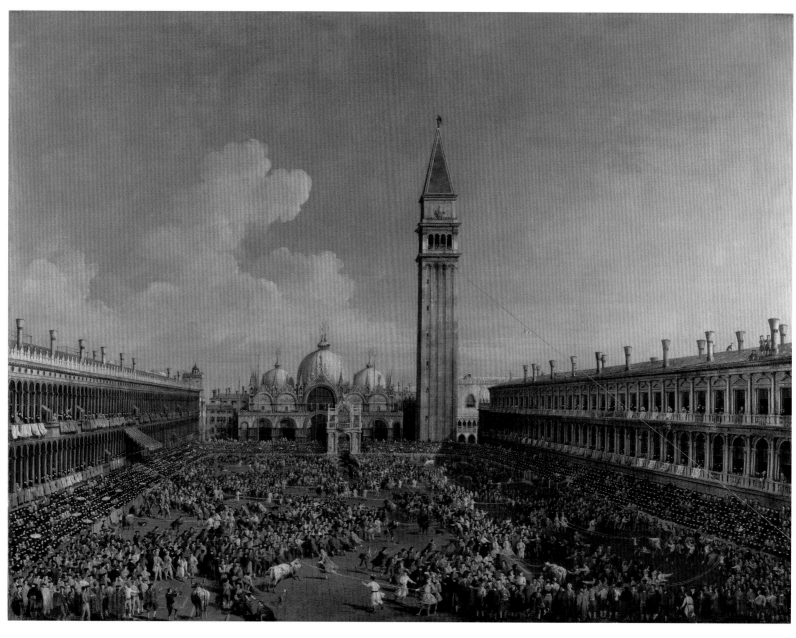

FIG. 94
Giovanni Battista Cimaroli (Italian, 1687–1771). *Piazza San Marco with the Bull Chase in Celebration of the Visit of Prince Friedrich Christian of Saxony*, ca. 1740. Oil on canvas, 153 × 203 cm (60¼ × 79¹⁵⁄₁₆ in.). Private collection

FIG. 95
Vincenzo Coronelli (Italian, 1650–1718). *The Bull Chase in Piazza San Marco in Celebration of the Visit of King Frederick IV of Denmark*, 1709, engraving. Venice, Biblioteca Nazionale Marciana, inv. 150.d.4

these events, the special bull chase held for the Saxon crown prince on 16 February 1740, was recorded in a view painting (fig. 94), while the other three are documented in engravings (fig. 95).[61] On each of these occasions, a tiered amphitheater was constructed around the perimeter of the square behind a sturdy wooden wall for the protection of the spectators. On its short sides in front of the basilica of San Marco and the church of San Geminiano, ephemeral triumphal arches or loggias were erected in honor of the foreign guests.

In the three engravings, the center of the square is populated mostly by the bull handlers known as *tiratori* (literally, bull pullers), who restrain the animals with ropes tied to their horns while large dogs are baiting and attacking them. The immense cruelty of this spectacle was pointed out by numerous foreign observers, including Johann Caspar Goethe, who attended the bull chase for Friedrich Christian and described it as "horrendous."[62] His account of the event mostly agrees with the large view painted by Giovanni Battista Cimaroli (1687–1771), which shows the square thronged with spectators:[63] "So many thousands of people entered the area inside the fence where the chase took place that it was almost a miracle that they did not lose life or limb, since one could barely see the bulls, and in fact some men and dogs were carried away near-fatally wounded."[64] In the foreground of the canvas, a man has been thrown to the ground by a bull and is bleeding from his forehead (fig. 96). Other spectators are trying to avoid the same fate by darting out of the beast's path. An account of the bull chase published in a chronicle of the year 1740 reported that the forty-eight bull handlers appeared in European, Asiatic, African, and American costumes and were accompanied by more than fifty dogs in a spectacle lasting three hours.[65] In the painting, the "Africans" are seen entering the arena from the triumphal arch, while the "European" bull handlers in the central foreground are dressed in the manner of eighteenth-century opera singers performing heroic roles (figs. 97, 98).

Serenaded by an orchestra with trumpets and tambourines placed directly underneath his window,[66] the prince watched the bull chase from an apartment in the

FIG. 96
Detail of fig. 94. Giovanni Battista Cimaroli, *Piazza San Marco with the Bull Chase in Celebration of the Visit of Prince Friedrich Christian of Saxony*, ca. 1740. Private collection

FIG. 97
Detail of fig. 94. Giovanni Battista Cimaroli, *Piazza San Marco with the Bull Chase in Celebration of the Visit of Prince Friedrich Christian of Saxony*, ca. 1740. Private collection

FIG. 98
Detail of fig. 117. Giovanni Michele Graneri, *Interior of the Teatro Regio in Turin*, ca. 1753. Turin, Museo Civico d'Arte Antica, Palazzo Madama

FIG. 99
Detail of fig. 94. Giovanni Battista Cimaroli,
*Piazza San Marco with the Bull Chase in Cele-
bration of the Visit of Prince Friedrich Christian
of Saxony*, ca. 1740. Private collection

Procuratie Vecchie on the left, its windows shielded by a striped marquee (fig. 99). He
noted in his diary: "120 bulls were hunted, each one led by two men. Twenty bulls at
a time were released. Several of these men were dressed in the heroic manner, repre-
senting Europe, several as Turks or Persians representing Asia; several as Moors rep-
resenting Africa, and several in a different barbarian dress representing America.
Furthermore, a man was going to make the flight, but the rope had been loosened and
he was unable to continue."[67]

Cimaroli's painting telescopes several stages of the spectacle into a single moment:
the entry of a group of costumed bull handlers through the triumphal arch, the unau-
thorized and dangerous presence of thousands of spectators (many of them masked in
Venetian carnival dress) inside the arena, the near-fatal accident of a man wounded by
a rampaging bull, and finally the so-called *volo,* or flight—the descent of an acrobat on a
rope from the top of the Campanile, which was also a regular feature of the carnival fes-
tivities in the Piazzetta (see fig. 20). It is only through Friedrich Christian's own testi-
mony that we learn of the fact that this last part of the spectacle, which took place after
the end of the bull chase, had to be abandoned because the rope had slackened. Both
Cimaroli and the author of *L'Adria festosa*, written as a celebratory narrative rather than
a news report, glossed over the mishap. In the painting, the rope is taut and the acrobat
has already descended about a third of the way down, while according to the publica-
tion, "the flight descended from the summit of the tall Campanile and presented His
Royal Highness with a bouquet of flowers."[68]

A Feast for Ears and Eyes

The third type of special event that the Serene Republic customarily staged for the benefit of royal visitors was concerts in the Ospedali, the city's famous girls' orphanages that trained their charges as singers and musicians.[69] Easier to organize, more frequently held, and certainly less dazzling than a regatta or a bull chase, these events did not have the same appeal for view painters and their patrons. Frederick IV of Denmark attended a concert led by Antonio Vivaldi at the church of the Ospedale della Pietà on 30 December 1708 and was the dedicatee of Vivaldi's twelve Violin Sonatas op. 2 of 1709. Three decades later, the Pietà, the Incurabili, and the Mendicanti—the orphanages' competition for public acclaim and bequests was fierce—organized special concerts in honor of Friedrich Christian, while Vivaldi composed concertos for him.[70] Such performances took place in the Ospedali's convent churches, where the girls were audible but not visible behind the latticework grilles of their choir lofts.

The concert held on 20 January 1782 for Grand Duke Paul of Russia and his wife, Maria Feodorovna, a Württemberg princess, took an entirely different approach. Traveling incognito as Count of the North, Catherine the Great's son had decided at short notice to add a visit to Venice to his European itinerary. Whereas Frederick IV and Friedrich Christian had both stayed in the city for months, the heir to the Russian throne allowed precisely one week, from 18 to 25 January 1782. The Venetian authorities scrambled to put together the expected program for visitors of his rank, including a regatta and a bull chase. Since there was no time for the grand duke to visit each of the Ospedali, and privileging one institution over the others was as unthinkable as asking the girls from one to perform in the church of another, the concert was organized on the neutral ground of the Casino dei Filarmonici, located in the short wing of the Procuratie next to the church of San Geminiano (on the side toward the Procuratie Nuove). An orchestra and choir of eighty-two of the most talented girls drawn from all four Ospedali was assembled, uniform new dresses were sewn, and the cantata *Il Telemaco nell'isola Ogigia* by Michele Mortellari to a libretto by Carlo Lanfranchi Rossi was selected and hastily rehearsed.[71]

Francesco Guardi was given the task of recording several of the frenetic week's events in a series of canvases.[72] Somewhat surprisingly, both the regatta and the bull chase appear to have been omitted from this commission, and none of his regatta scenes has been convincingly linked to the race staged on 23 January 1782.[73] However, a drawing by the artist may have been made on this occasion; it prominently shows a festival barge with a cabin with glass panes on all four sides, matching the vessels constructed to protect the grand duke and his wife from the elements on a cold winter day, as the Countess Giustiniana Orsini Rosenberg (1737–1791) noted in her detailed account of the Russian visit.[74]

While Carlevarijs, Canaletto, and Cimaroli had captured the breathtaking spectacle of these events in large-scale canvases, Guardi chose a format that aims less at impressing the viewer and more at drawing him in. The interior view of the concert in the Casino dei Filarmonici captures the atmosphere of the moment perhaps more effectively than a much larger canvas could (fig. 100).[75] The special arrangements made for this concert meant that the Ospedali's customary policy of hiding the girls from view had been temporarily suspended. Wearing their new black dresses with white

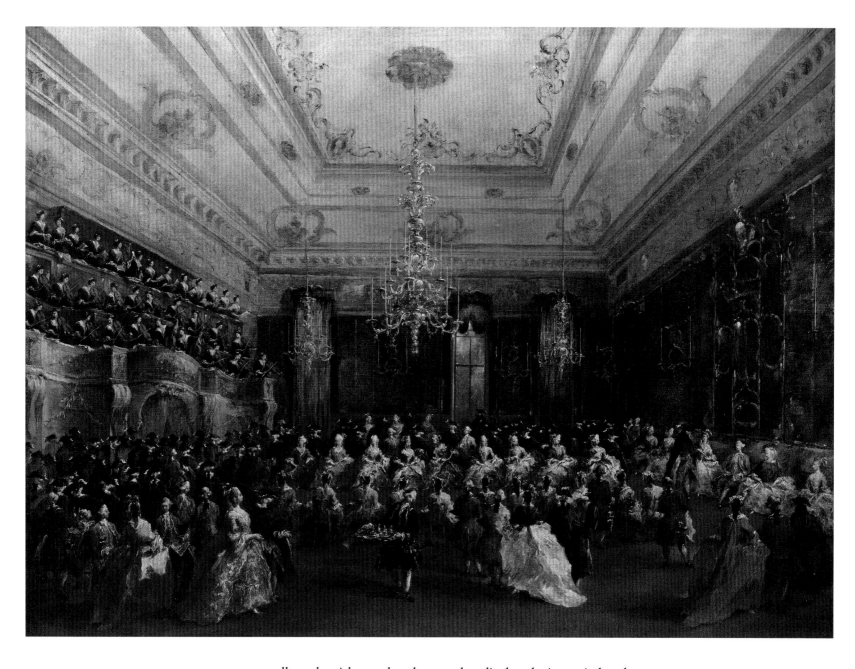

FIG. 100
Francesco Guardi (Italian, 1712–1793). *The Concert in Honor of Grand Duke Paul and Grand Duchess Maria Feodorovna of Russia*, 1782. Oil on canvas, 68 × 91 cm (26¾ × 35¹³⁄₁₆ in.). Munich, Alte Pinakothek, inv. 8574

collars, the girls are placed—or rather displayed—in serried ranks on a temporary cantoria erected against the wall at left, with the highest of three tiers occupied by the choir, the middle and bottom rows by the orchestra.⁷⁶

Most of the guests have turned their backs on this rare sight, staring instead at the Russian couple seated on the opposite side of the room, on an upholstered bench underneath a central mirror akin to a glittering cloth of honor. Exceptionally permitted to emerge from their existence as disembodied voices and become public performers, the girls from the Ospedali were yet again rendered effectively invisible. Giustiniana Rosenberg recounted the situation just as vividly as the painter evoked it on canvas: "The desire to approach the Counts of the North, to see them face to face, and perhaps also to be observed doing so, had encouraged even the most timid. In spite of the heat in the concert hall, the Counts of the North stayed until the end of the cantata, and even afterward

they remained for some time in the room in order to satisfy the affectionate eagerness of the spectators, whose eyes could not sate themselves on their countenances."[77]

Guardi's canvas reflects a marked shift in the nature of spectatorship. The same is already true for Carlevarijs's view of the regatta for Frederick IV from early in the century (see fig. 79) and for a painting by Giuseppe Zocchi recording a similar event that took place not in Venice but in Siena: the visit of Francis Stephen, Grand Duke of Tuscany (r. 1737–65, later Holy Roman Emperor) and his wife Maria Theresa of Austria, soon to succeed to the Habsburg dominions. In their honor, a special palio race was staged in the Piazza del Campo on 2 April 1739 (fig. 101).[78] Zocchi placed Maria Theresa and Francis Stephen in the center of the enclosure and of the composition, with much of the attention focused on the couple rather than on the horserace in progress around the perimeter of the square. Commissioned by Orazio Sansedoni (1680–1751), the painting depicts the event as it would have been seen from the easternmost part of the recently enlarged Palazzo Sansedoni. The viewer steps into the shoes of a spectator standing at a window of the palace, and once again the guests watching the entertainment have themselves become the entertainment for their hosts. In Siena as in Venice, the reportorial view transcends the depiction of architecture, ephemeral decoration, and pageantry to become a document of social behavior.

FIG. 101
Giuseppe Zocchi (Italian, 1711/17–1767). *The Palio Race in the Campo in Honor of Grand Duke Francis of Tuscany and Archduchess Maria Theresa of Austria*, 1740. Oil on canvas, 82 × 132 cm (32¼ × 52 in.). Siena, Banca Monte dei Paschi di Siena, Museo San Donato, inv. 381466

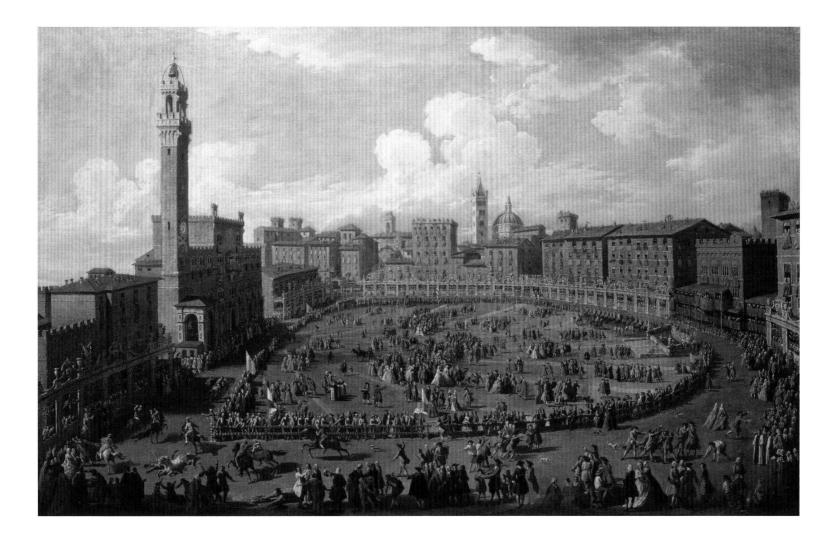

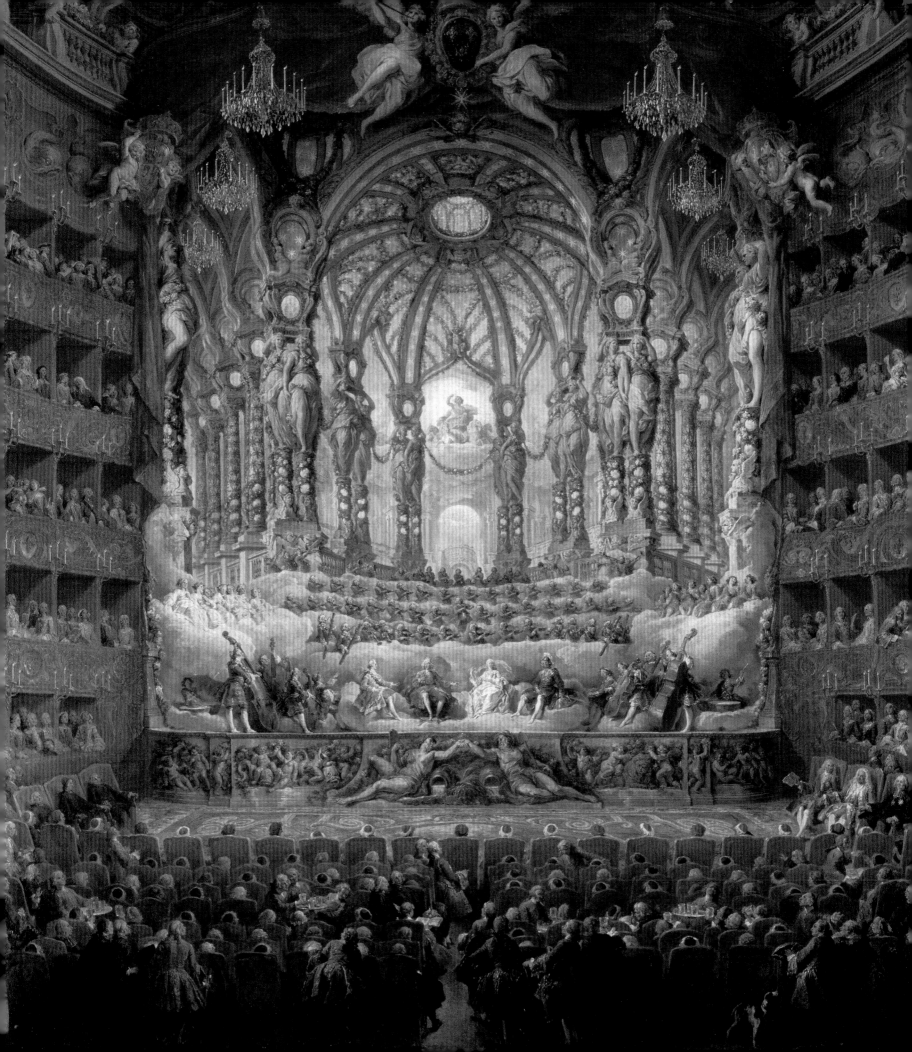

CHAPTER 4
PORTRAYING AND ENGRAVING
MAGNIFICENCE

༄·༄

The relationship between the designs for decorations erected for an event, their built appearance, and their visual records was ambiguous and did not always follow a logical sequence of design, execution, and documentation. This was especially true for the recurring religious and secular ceremonies that shaped the annual calendar of the population of eighteenth-century Europe and provided plentiful material for view painters and engravers. As the addressees and audiences of these events were far more numerous than those of ad hoc spectacles, their primary visual records were often engravings rather than paintings.

To the French antiquarian Pierre-Jean Grosley (1718–1785), who had visited Italy in 1758, such recurring events fulfilled the same role as the circus games of antiquity: "In Rome, all civil and religious ceremonies held with pomp and splendor are called functions: they supplant the spectacles for which the Roman people were once so ravenous."[1] One occasion in particular resulted in memorable transformations of the city's liveliest squares: the so-called Chinea festival at the end of June. The Chinea took its name from a white horse delivered to the pope every year on 28 June, the vigil of the feast of Rome's patron saints Peter and Paul, as a feudal tribute from the ruler of the Kingdom of Naples. Having been led through the streets of Rome in a procession to Saint Peter's, the animal was presented to the pope by the Neapolitan ambassador in Rome, an office that during the eighteenth century was invariably held by a member of the Colonna family.[2] The ceremony's most visible elements were the monumental set pieces erected in Piazza Ss. Apostoli or Piazza Farnese (fig. 102).[3] By day, they conveyed an allegorical program; by night, they served as launch platforms for fireworks. Like their siblings constructed for the regatta in Venice, the ephemeral structures were known as *macchine*. These transformations of the city's urban fabric often lasted for weeks rather than days as the construction of a *macchina* could take up to two months.[4] In some cases, the decorations created for one event remained in place for another occasion one or two months later.[5]

The established method of recording a Chinea *macchina* was through engravings that were commissioned by the Colonna family and distributed to thousands of recipients all over Europe in order to publicize the majesty of the ephemeral decorations and, by implication, of the Colonna name. These prints, however, were neither intended nor understood as faithful records of the structures as built but as interpretative images of their designs, with the architect credited alongside the etcher. Impressions of its print were typically pulled and dispatched by post well before the construction of the actual structure had been completed.[6] While the majority of the Chinea prints depict the *macchina* devoid of its urban setting,[7] *vedute* specialists such as Giuseppe Vasi (1710–1782) occasionally provided the full urban context, for instance in his etching of a Chinea structure erected in Piazza Farnese in 1745 (fig. 103).[8]

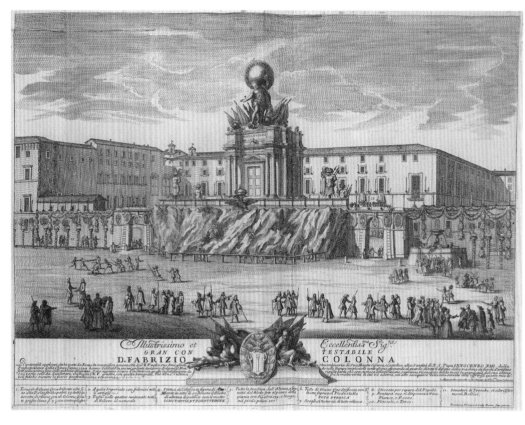

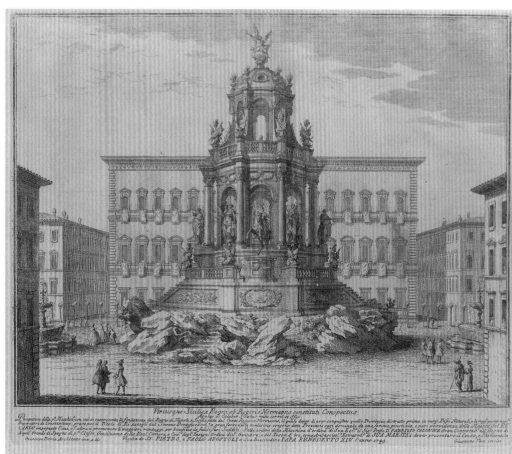

FIG. 102
Giovanni Girolamo Frezza (Italian, 1659–1741). *Macchina in Piazza Ss. Apostoli for the Chinea Festival of 1722*, 1722, engraving, 408 × 540 mm (16 1/16 × 21 1/4 in.). Los Angeles, Getty Research Institute, inv. 1387-207

FIG. 103
Giuseppe Vasi (Italian, 1710–1782), after Giuseppe Doria (Italian, act. 1725–1747). *First Macchina for the Chinea Festival of 1745. The Foundation of the Kingdom of Naples*, 1745, etching, 402 × 480 mm (15 13/16 × 18 7/8 in.). Los Angeles, Getty Research Institute, inv. 2862-452

The primary function of a Chinea print was to communicate the *macchina*'s allegorical or symbolic meaning, typically by way of a lengthy inscription describing the image. The text on Vasi's engraving from 1745 explains that the structure represents "the foundation of the Kingdom of Naples and Sicily by the Norman Count Roger, who after conquering these provinces, which had previously been appropriated by various indigenous princes and for the most part by the emperors of Constantinople, took the title of king awarded to him by the Roman Pontiff."[9] While the words underscore the medieval origin of the feudal ties between Naples and the papacy, the design's visual language emphasizes a continuity extending both backward and forward in time from the Middle Ages. Its most prominent feature was an equestrian statue of King Roger II of Sicily (r. 1130–54) dressed as a heroic Roman soldier, evoking the ideals of antiquity. To a contemporary observer, the figure of a mounted Roman soldier leaping into a chasm (represented by the simulated rocks) would have brought to mind the bravery of Marcus Curtius, a popular subject for view painters such as Joli and Panini (fig. 104).[10]

The Chinea *macchina* in Piazza Farnese in 1745 was constructed of papier-mâché and stucco over a wooden armature that had originally undergirded the structure celebrating the wedding of Louis Ferdinand (1729–1765), dauphin of France, firstborn son of Louis XV and heir to the French throne, to the Infanta Maria Teresa of Spain (1726–1746), sister of the future Charles III.[11] Its engraving by Louis-Joseph Le Lorrain (1715–1759) had been produced in advance, and the lettering claims that the event took place in May 1745 (fig. 105).[12] When Pope Benedict XIV decided on short notice to spend several weeks at Castelgandolfo, however, the French chargé d'affaires, the abbé de Canilliac, had to postpone his plans.[13] After the pope's return, the French celebrations in Piazza

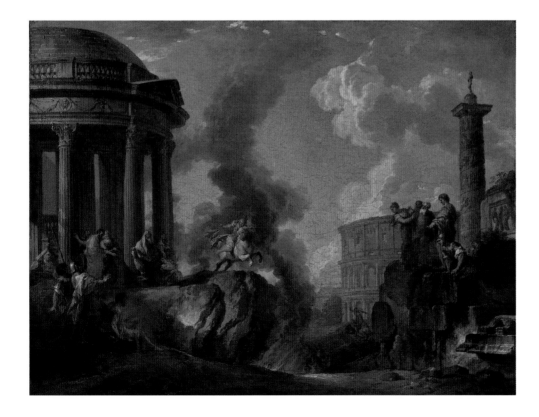

FIG. 104
Giovanni Paolo Panini (Italian, 1691–1765).
The Leap of Marcus Curtius, ca. 1730.
Oil on canvas, 74 × 98 cm (29⅛ × 38⁹⁄₁₆ in.).
Cambridge, Fitzwilliam Museum, inv. 207

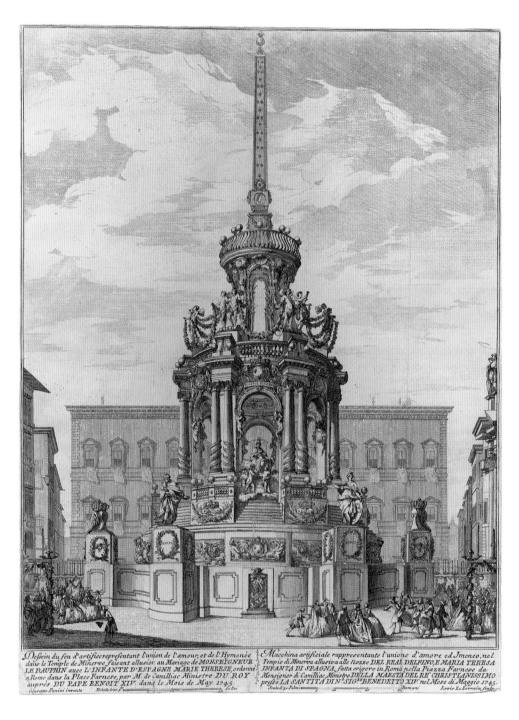

FIG. 105
Louis Le Lorrain (French, 1715–1759). *The
Decoration of the Piazza Farnese for the
Celebration of the Marriage of the Dauphin*, 1745,
etching, 570 × 430 mm (22⁷⁄₁₆ × 16¹⁵⁄₁₆ in.).
London, British Museum, inv. 1897,0113.211

Farnese were finally able to go ahead on 19 and 20 June,[14] a delay that created consider-
able logistical difficulties for the square's next scheduled occupant, the Chinea festival.

With only eight days left until the fixed date of 28 June, the Colonna pragmatically
decided to purchase the armature standing in Piazza Farnese from Canilliac.[15] The
family's architect, Giuseppe Doria (act. 1725–47) abandoned his original subject, the
twelve provinces of the two Sicilies, and designed a new *macchina* around the existing
armature. The print of the previously intended *macchina*, already produced by Miguel
de Sorelló (ca. 1700–1705), was discarded and an engraving of the new one commis-
sioned from Vasi (see fig. 103).[16]

The two-tiered circular edifice with eight arcades Doria inherited was rapidly transformed into an allegory of the foundation of Naples. The structure had begun its life as a temple of Minerva (see fig. 105); the goddess of wisdom and learning may have been chosen for the fact that the fifteen-year-old groom had yet to finish his education. In front of her statue, Cupid and Hymen, respectively the gods of love and marriage, are shown as two putti joining hands.[17] The iconography has been infelicitously described as "the wedding of Love and Hymen."[18] The French word *union* and the Italian *unione* in the lettering on Le Lorrain's engraving[19] refer not to a wedding between these two gods but to their accord in bestowing their protection upon the royal marriage. The mythological prototype invoked by the *macchina*'s design is the wedding of Perseus and Andromeda in Ovid's *Metamorphoses* (4:757–62). Having offered a sacrifice to three deities including Minerva, the Greek hero "claims Andromeda as the prize of his great deed, seeking no further dowry. Hymen and Love shake the marriage torch; the fires are fed full with incense rich and fragrant, garlands deck the dwellings, and everywhere lyre and flute and songs resound, blessed proofs of inward joy."[20] In what may be a further allusion to Ovid's description, the figures on the structure's upper level hold heavy garlands. They encircle a lantern surmounted by an obelisk embellished with a fleur-de-lis pattern above a medallion showing the dauphin in profile in the manner of Roman emperor portraits on ancient coins.

Engraving and Painting in Dispute

Neither the fleur-de-lis decoration, nor the garlands, nor a number of other details (such as the balustrade atop the lantern) of Le Lorrain's engraving appear in the second important visual record of the wedding celebrations, a painting by Giovanni Paolo Panini (fig. 106).[21] Although Panini's son Giuseppe is credited on the engraving as having designed the *macchina* and probably provided a preparatory drawing for the entire sheet, the canvas and the print are independent of each other. The absence of many ornamental details on the *macchina* in the painting permits two (not mutually exclusive) explanations: the canvas itself is unfinished, or it was intended to show the *macchina* in an unfinished state during the preparations for the event.

A third possibility is that the painting accurately reflects a *macchina* that was never brought to completion due to the interruptions, in which case the engraving would show an unexecuted version; this is obviated by the testimony of an observant contemporary commentator, the painter Pier Leone Ghezzi (1674–1755), who was also a perceptive and prolific caricaturist. His sketch of Giovanni Paolo Panini, dated 28 June 1745, bears the autograph inscription: "Giovanni Paolo Panini, Parmesan view painter who had the fireworks in Piazza Farnese constructed by order of Mons. Canilliac with the blunder of putting a spire on top of the temple of Hymen, as can be seen better in the print" (fig. 107).[22] The caricature shows a somewhat disgruntled-looking Panini senior, who presumably agreed to oversee the work of his relatively inexperienced son,[23] next to the top of the *macchina*'s lantern and the obelisk in its final state, complete with the portrait of the dauphin and the fleur-de-lis pattern. Benedict XIV is also reported to have carefully compared the print to the *macchina*. The pope came to Palazzo Farnese in order to satisfy his curiosity about the ephemeral decorations. He was given a luxury version of

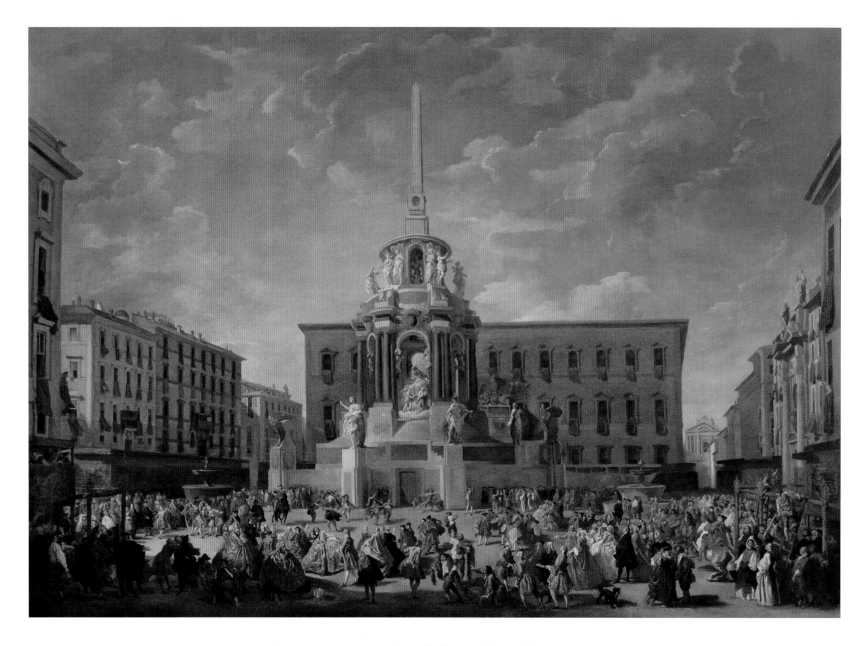

FIG. 106

Giovanni Paolo Panini (Italian, 1691–1765). *The Decoration of the Piazza Farnese for the Celebration of the Marriage of the Dauphin,* 1745. Oil on canvas, 166 × 238 cm (65⅜ × 93¹¹⁄₁₆ in.). Norfolk, VA, Chrysler Museum, Gift of Walter P. Chrysler Jr., inv. 71.523

the engraving, printed on silk, by Canilliac and went out on a balcony "with the print in hand, comparing many things to the *macchina* itself" for almost half an hour.[24]

A fourth possibility has been suggested: that the canvas was created as a large-scale sketch of the proposed design of the *macchina* and submitted by Panini to Canilliac for his approval.[25] This is extremely difficult to reconcile with the painting's considerable size, the prominent inclusion of an urban setting that both artist and patron knew well, the multitude of detailed figures, and especially with the absence of many of the *macchina*'s most important iconographic features.

The resolution of these questions is aided by a detailed account in the *Diario ordinario,* which allows the identification of the moment shown in the painting as the morning of 19 June, the first day of the celebrations. The sun is coming from the east and all around the square; workmen are putting finishing touches on the decorations. In the central foreground, several of them are unpacking heavy garlands from a crate (fig. 108),

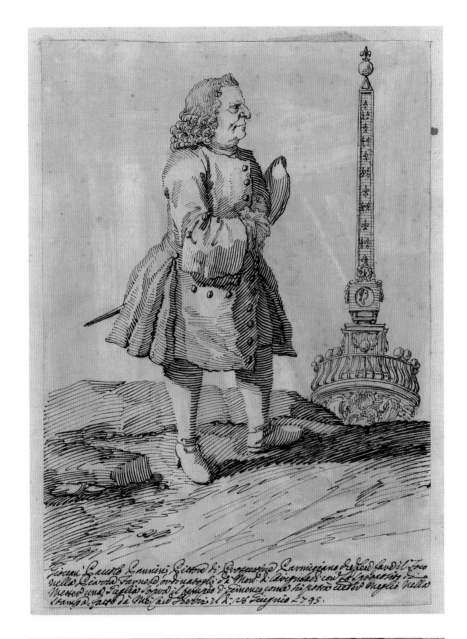

FIG. 107
Pier Leone Ghezzi (Italian, 1674–1755).
Giovanni Paolo Panini (Italian, 1691–1765),
1745, pen and brown ink on paper,
276 × 198 mm (10⅞ × 7¹³⁄₁₆ in.). Vatican City,
Biblioteca Apostolica Vaticana, ms. Ott.lat.
3119, fol. 91r

FIG. 108
Detail of fig. 106. Giovanni Paolo Panini,
*The Decoration of the Piazza Farnese for the
Celebration of the Marriage of the Dauphin*, 1745.
Norfolk, VA, Chrysler Museum

while others are installing torches in the candelabra mounted on scaffolds on either side of the square (fig. 109). The *Diario ordinario* reported: "On this first evening, the entire square was illuminated around its perimeter with a copious quantity of torches in double candelabra, painted in chiaroscuro and arranged with perfect symmetry and order between various festoons of greenery, which made their appearance even more beautiful."[26] A section of the finished scaffold is visible in Le Lorrain's engraving (fig. 110).

Slightly to the right of center, the abbé de Canilliac, identifiable by his clerical dress and the embassy's liveried footmen attending to him, observes the progress of the preparations (fig. 111). While the French, as the groom's side, were the main organizers of the celebrations in honor of the royal wedding, the bride's side was represented by Cardinal Troiano Acquaviva d'Aragona (1694–1747), who, as Spanish ambassador to the Holy See, outranked Canilliac in both ecclesiastical and diplomatic status. Accompanied by an entourage and several footmen, Acquaviva appears in the middle ground at left, wearing a black tricorne over his red zucchetto (skullcap) and a black cassock with the red stockings of a cardinal. Leaning on his walking stick, he looks up at the *macchina*. While it might seem plausible that the edifice itself is still unfinished and the workmen are about to add the missing decorative elements, the construction techniques employed for such ephemeral structures exclude this possibility. Their surfaces consisted of large pieces of canvas onto which the trompe-l'oeil architectural elements had already been painted before they were stretched over the armature.[27] Furthermore, finishing the surfaces at this stage would have required erecting and disassembling an impractically tall scaffold reaching the top of the obelisk.

Just like the views of official entries (see chapter 2), such paintings were almost invariably commissioned by the ambassador overseeing the celebration. A large-scale

FIG. 110
Detail of fig. 105. Louis Le Lorrain, *The Decoration of the Piazza Farnese for the Celebration of the Marriage of the Dauphin*, 1745. London, British Museum

FIG. 111
Detail of fig. 106. Giovanni Paolo Panini, *The Decoration of the Piazza Farnese for the Celebration of the Marriage of the Dauphin*, 1745. Norfolk, VA, Chrysler Museum

visual document would have been especially significant for Canilliac, who, as the interim head of the French embassy, without the rank of ambassador, was unlikely to ever again have the opportunity to stage a prestigious event. The previous chargé d'affaires, Cardinal Pierre Guérin de Tencin, had left Rome in August 1742 to take up an appointment as minister of state without portfolio. Until a new ambassador could be appointed, Canilliac was instructed by the foreign ministry to serve as chargé d'affaires because his current position as a judge at the Rota, the highest tribunal of the Church,[28] lent him the necessary stature: "since you are already auditor of the Rota, you could be regarded as sufficiently authorized to speak in the name of the king."[29] Benedict XIV, however, considered the additional role as the representative of a foreign power to be incompatible with the impartiality expected of a judge and vowed to Canilliac's predecessor, Tencin, now back in France, that "this will serve as a warning signal for future cases, and for as long as we live, we will not accept any auditor of the Rota as a diplomatic representative, which will also aid the cause of justice."[30] The somewhat prickly Canilliac lacked the diplomatic acumen to gain the trust of the down-to-earth pontiff, who characterized him as capable of "infuriating even the bronze statue of Saint Peter in Saint Peter's Basilica."[31] For the next three years, Benedict XIV preferred to work around the Frenchman and received him mainly to demand the prompt appointment of a new ambassador.[32] Given that the pope had only been in office since 1740 and was relatively young, Canilliac understood that his aspirations to the cardinalate would only ever be fulfilled through a nomination by the French crown,[33] and he must have looked at the royal wedding celebrations of 1745 as a unique opportunity to further these ambitions by impressing Louis XV.

Canilliac's successor, Frédéric Jérôme de La Rochefoucauld (1701–1757), archbishop of Bourges, had been designated as the new ambassador in June 1743 and was supposed to take up his post within a few months, but the campaigns of the War of the Austrian Succession (1740–48) made the customary land route through the Piedmontese and Austrian territories in northern Italy impossible. In June 1745, after insistent requests from the pope, the archbishop was dispatched in the greatest secrecy on board a Maltese vessel sailing from Marseille. Having successfully evaded the British navy operating in the Mediterranean, the ship reached Civitavecchia on 15 June, and La Rochefoucauld arrived in Rome two days later.[34]

La Rochefoucauld's unexpected arrival, combined with the celebration's postponement from May to June, meant that three days before the event conceived as an ostentatious display presenting his taste, organizational skills, and devotion to the royal family in the best light, Canilliac had to abruptly hand over the French embassy's reins to La Rochefoucauld. As the new ambassador was not yet formally accredited and could not officially participate, he visited Piazza Farnese incognito to see the *macchina* and later observed the fireworks from a private house nearby.[35]

The new ambassador's sudden arrival may in fact have been the reason why the canvas was never brought to the same level of finish as Panini's other large-scale reportorial views. Nonetheless, it was displayed in the gallery of Canilliac's Roman residence, the Palazzo De Carolis, until his death in 1761 together with the exterior and interior views of Saint Peter's (see figs. 60, 68) as well as the pair *Ancient Rome* and *Modern Rome*.[36] In his estate inventory of 5 April 1761, the painting is listed as "the French celebrations

held in Piazza Farnese with figures."[37] While the other four large Paninis in Canilliac's collection were all sent to France,[38] the Piazza Farnese view remained in Rome and next appears—described as unfinished—in the estate inventory of Francesco Panini (1738–1800), the painter's youngest son. If the abandoned commission was also unpaid for, the artist may have been able to reclaim it from Canilliac's estate.[39]

Recording a Musical Performance

Only two years after Canilliac had transformed Piazza Farnese, La Rochefoucauld—recently created a cardinal—found himself having to stage the celebrations for another royal wedding. After Maria Teresa had died soon after giving birth to her first daughter in 1746, Louis XV chose Maria Josepha of Saxony (1731–1767), a daughter of Augustus III, King of Poland and Elector of Saxony, as the dauphin's second wife. After the wedding at Versailles on 9 February 1747, the foreign ministry granted La Rochefoucauld 12,000 livres to stage celebrations in Rome, with the expectation that he would additionally spend a considerably higher amount out of his own pocket.[40] For the first time, the main celebrations were staged indoors—in the Teatro Argentina, the city's most modern and prestigious opera house, opened in 1732.[41] Once again, father and son Panini played a double role in creating and documenting a spectacular occasion. As in 1745, Giuseppe was put in charge of designing the ephemeral decorations,[42] while Giovanni Paolo was commissioned to record the event. His painting shows the theater's complete transformation, with each of the 160 boxes covered in damask and crimson velvet with gold ornaments (fig. 112).[43] The composition suggests the perspective from a box in the center of the first balcony, but in fact Panini brings the viewer much closer to the stage, as if hovering over the center of the stalls.

The canvas depicts the first of the three performances of a celebratory cantata that took place on 12, 13, and 15 July 1747. The *Diario ordinario* reported that the interior of the Teatro Argentina had been "turned into a hall with a new and truly majestic transparent stage set."[44] The term *hall* (*sala*) was also used by Benedict XIV, who could not attend the performance for reasons of decorum but visited the theater earlier in the day and noted: "Tonight and on the next two evenings, a solemn cantata will be given in Teatro Argentina, which has been adapted by the cardinal ambassador of France for use as a hall in honor of the wedding of the dauphin, and we went to see the noble decorations, having done the same when Mons. Canilliac staged his celebrations."[45] In a letter to the recently appointed foreign minister, Louis Philogène Brûlart, Marquis de Puysieulx (1702–1770), written immediately after the pope's visit on 12 July, La Rochefoucauld apologized that he had been unable to discuss diplomatic business with Benedict XIV "because I spoke to him in the large hall that I have had prepared for the cantata that will be performed this evening for the first time. As the ornaments and illuminations of this hall are quite good, His Holiness was curious to see them."[46] This uniform insistence on describing the redecorated theater as a hall may have been motivated by a desire to avoid an important legal restriction: in eighteenth-century Rome, women were prohibited from acting on the theater stage, and for all public performances in the city's opera houses, the female roles were sung by male sopranos. To an invitation-only event held in a hall, however, these regulations did not apply.

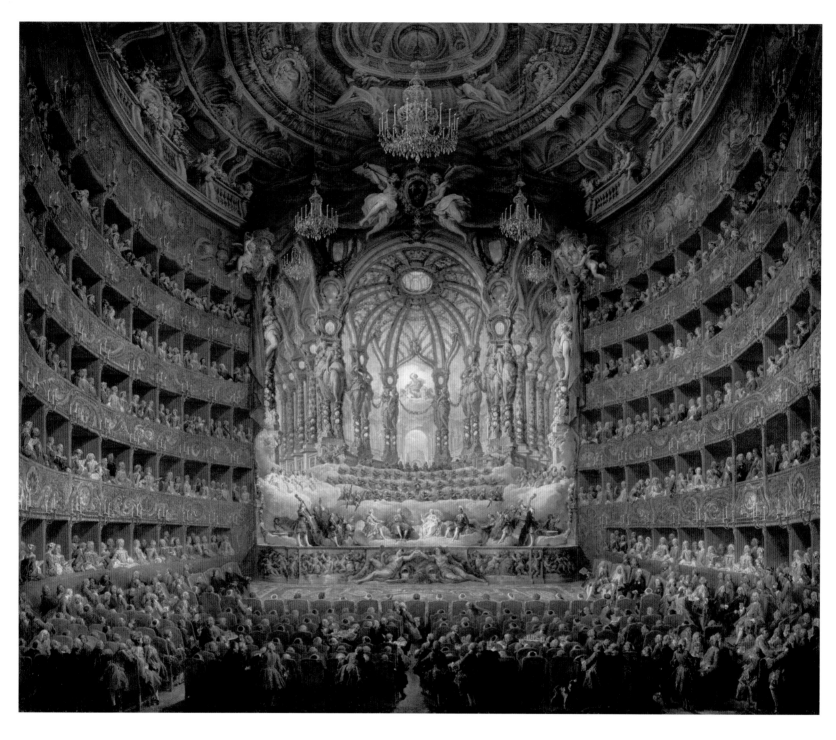

FIG. 112
Giovanni Paolo Panini (Italian, 1691–1765).
The Musical Performance in the Teatro Argentina
in Honor of the Marriage of the Dauphin, 1747.
Oil on canvas, 205 × 246 cm (80 11/16 × 96 7/8 in.).
Paris, Musée du Louvre, inv. 414

The music for the cantata, which has been aptly described as "a sung conversation piece,"[47] was composed by Niccolò Jommelli (1714–1774).[48] Each of the two parts consists of a succession of recitatives and arias and ends with an ensemble chorus. There was no stage action, and the four principal singers remained seated, as they are shown in the painting (fig. 113). This static arrangement may similarly have been devised to obey (in letter if not in spirit) the ban on women acting on stage, and Ghezzi noted on his caricature of the tenor Gregorio Babbi (1708–1768), who sang the role of Jupiter, that a female singer took the part of Minerva.[49]

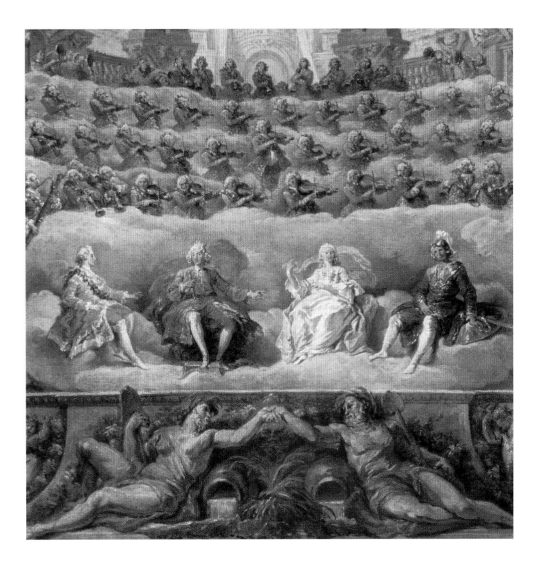

The libretto, supplied by the Bolognese poet Flaminio Scarselli (1705–1776), bears the title *Componimento dramatico per le felicissime nozze di Luigi Delfino di Francia con la Principessa Maria Giuseppa di Sassonia da cantarsi per ordine dell'Eminentissimo Signor Cardinale de la Rochefoucauld Ministro di Sua Maestà Cristianissima presso la Santa Sede.*[50] Set in the palace of Jupiter on Mount Olympus, the cantata's plot (such as it is) consists of a debate between Jupiter (tenor), Minerva (soprano), Mars (contralto), and Cupid (soprano). A dispute between Mars and Minerva regarding the respective merits of valor and wisdom in governance is resolved by Jupiter, who insists that they are not mutually exclusive and points to the youthful dauphin as the shining example of a future ruler who unites both virtues in himself. Cupid, who has been enlisted to select a worthy bride for Louis Ferdinand, reports that Juno has found the perfect match, Maria Josepha of Saxony, on the banks of the Elbe.

Printed copies of the libretto were handed out, and several members of the audience can be seen using them.[51] The booklet contains several engravings by Claude Olivier Gallimard (1719–1774) after Panini.[52] In an iconographic reminiscence of the *macchina* designed for the celebrations of the dauphin's first wedding, the title page shows Hymen and Cupid, respectively holding a torch and an arrow, on either side of

FIG. 113
Detail of fig. 112. Giovanni Paolo Panini, *The Musical Performance in the Teatro Argentina in Honor of the Marriage of the Dauphin,* 1747. Musée du Louvre

FIG. 114
Claude-Olivier Gallimard (French, 1719–
1774), after Giovanni Paolo Panini (Italian,
1691–1765). *Hymen and Cupid Presenting the
Double Coat of Arms of Louis Ferdinand of
France and Maria Josepha of Saxony*, in
Flaminio Scarselli, *Componimento dramatico
per le felicissime nozze di Luigi Delfino di Francia*,
Rome: de' Rossi, 1747, title page

FIG. 115
Claude-Olivier Gallimard (French, 1719–
1774), after Giovanni Paolo Panini (Italian,
1691–1765). *Cupid, Jupiter, Minerva, and Mars*,
in Flaminio Scarselli, *Componimento dramatico
per le felicissime nozze di Luigi Delfino di Francia*,
Rome: de' Rossi, 1747, p. 7

the newlywed couple's double coat of arms (fig. 114). The engraved headpiece to the first part displays the four conversing gods in the same configuration as the canvas (from left, Cupid, Jupiter, Minerva, and Mars), but Cupid and Jupiter are represented in the style of a history painting, with much bare skin, whereas the singers on the stage wear contemporary court attire (fig. 115). Minerva and Mars more closely resemble the figures in the painting.

By covering the orchestra pit, the stage has been extended toward the auditorium. The group of four singers occupies the center of this platform, flanked by two continuo groups each consisting of two double basses, a cello, and a harpsichord, the latter disguised behind white clouds (fig. 116). In effect, the standard configuration of an eighteenth-century opera orchestra with twin continuo groups has been lifted out of the pit and put on display at the front of the stage, as a comparison with Giovanni Michele Graneri's view of an opera performance in the Teatro Regio in Turin shows (fig. 117).[53] Panini has the rotund harpsichordist on the left raising his right hand to cue the orchestra, presumably to indicate that this is Jommelli himself directing his composition; according to Pietro Metastasio, he possessed "a spherical figure."[54] Ghezzi's caricature of him drawn soon after—or possibly during—the performance bears an inscription referring specifically to this cantata (fig. 118).[55]

Jommelli looks up toward the lead violinist, who stands at the front of a terraced tribune on which the instrumentalists are arrayed in four tiers. Off to the sides are two choirs, one of Graces on the left and one of *amoretti* (cupids) on the right. In total, approximately one hundred singers and musicians took part in the performance.[56] As the two drum players are poised for a downbeat and the trumpeters have also readied their instruments, it is tempting to identify Panini's depiction with a specific moment, the cantata's final chorus, for which a euphoric Mars has demanded in his preceding recitative: "May the royal chambers resound with the sound of drums and trumpets."[57]

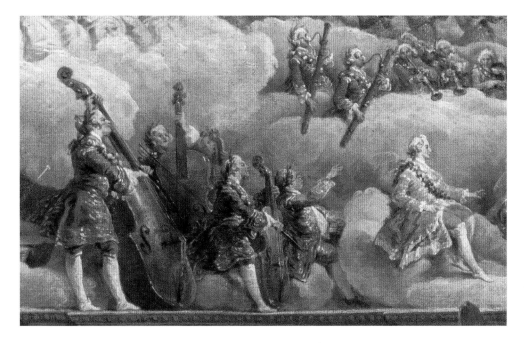

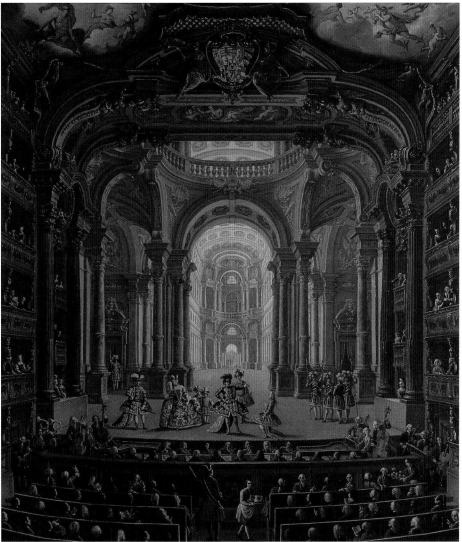

FIG. 116
Detail of fig. 112. Giovanni Paolo Panini, *The Musical Performance in the Teatro Argentina in Honor of the Marriage of the Dauphin*, 1747. Paris, Musée du Louvre

FIG. 117
Giovanni Michele Graneri (Italian, 1708–1762). *Interior of the Teatro Regio in Turin*, ca. 1753. Oil on canvas, 129 × 114 cm (50 13/16 × 44 7/8 in.). Turin, Museo Civico d'Arte Antica, Palazzo Madama, inv. 0534/D

FIG. 118
Pier Leone Ghezzi (Italian, 1674–1755). *Niccolò Jommelli*, ca. 1747, pen and brown ink on paper, 102 × 71 mm (4 × 2 13/16 in.). St. Petersburg, Hermitage, inv. 3289

The stage set is closed off with a receding perspective of arches painted on a semi-transparent backdrop lit from behind.[58] Aloft, Apollo (alluding to Louis XIV) emerges from an aureole of bright sunlight and rides into the theater to herald a glorious new era for the kingdom of France.

Three coats of arms decorate the proscenium arch: at upper left, that of the dauphin Louis Ferdinand; at upper right, that of Maria Josepha; and at center, the French royal arms. The last are held by two personifications of fame with trumpets; the others, by putti. As customary in the eighteenth century, the auditorium was fully lit during the performance, and one member of the audience, Michel Barthélemy Hazon (1722–1822), a pupil at the French Academy in Rome, complained that the one thousand candles distributed around the theater generated a stifling heat.[59]

The auditorium is thronged with hundreds of spectators. The front row of armchairs set up around a magnificent carpet is occupied exclusively by cardinals in their red skullcaps, while the black skullcaps of senior prelates fill most of the other seats in the stalls. In the boxes, the sumptuously dressed ladies (in a clear majority) and elegant gentlemen of the Roman nobility watch the performance, chat with each other, or read the libretto (fig. 119). Liveried footmen are visible in many of the boxes, and several attendants circulate in the stalls with trays of drinks.[60] Panini depicted himself with a glass in his hand, comfortably installed in front of two soldiers guarding the entrance to the auditorium at right (fig. 120). The serving of refreshments during a performance was common practice in eighteenth-century opera houses, as Graneri's painting also documents (see fig. 117).[61]

FIG. 119
Detail of fig. 112. Giovanni Paolo Panini, *The Musical Performance in the Teatro Argentina in Honor of the Marriage of the Dauphin*, 1747. Paris, Musée du Louvre

FIG. 120
Detail of fig. 112. Giovanni Paolo Panini, *The Musical Performance in the Teatro Argentina in Honor of the Marriage of the Dauphin*, 1747. Paris, Musée du Louvre

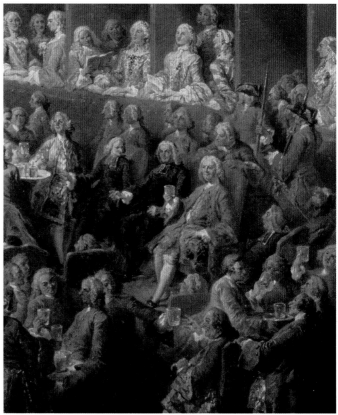

Portrait, Caricature, Identification

The approximately four hundred figures in the painting can be divided into three groups. The first and largest of these comprises spectators and musicians who are not intended as specific likenesses. Panini's studies for many of these figures, such as the double-bass player in the continuo group at left, are preserved in one of his sketchbooks (fig. 121).[62] The second group consists predominantly of Frenchmen living in or visiting Rome, many of them belonging to the staff of the French embassy. They are represented in recognizable portraits closely based on caricatures by Ghezzi.[63] Since the album containing many of these caricatures was owned by La Rochefoucauld, it seems likely that this unusual collaboration was encouraged by the patron asking for a number of his friends and staff to be included in the painting.[64] Caricature's exaggeration of physiognomic traits is in fact ideally suited to ensuring a recognizable likeness at the small scale of figures in a view painting.[65] Nearly all of Ghezzi's sheets show the faces in profile, and Panini skillfully integrated these heads into his composition. Among them is the French consul Joseph Digne (1684–1760), standing immediately underneath the boxes at the picture's far right edge and wearing the black riband of the Order of Saint Michael (figs. 122, 123). Next to him, the abbé de Canilliac appears in a likeness Panini reused from the depiction of the Piazza Farnese celebrations he had worked on two years earlier (see fig. 111).

The final group, constituted of the highest-ranking audience members, reveals yet another of Panini's working methods. Among the evening's illustrious guests were, according to the *Diario ordinario*, "His Majesty the King of Great Britain, with the Cardinal Duke of York, his son; twenty-one other cardinals; the grand constable [of Naples], the Venetian ambassador, the ambassador of Bologna, many representatives

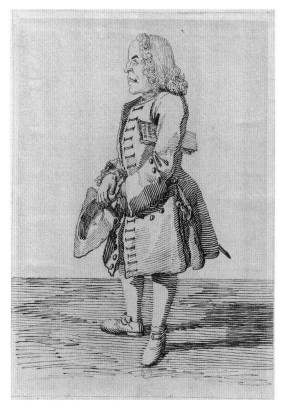

FIG. 121
Giovanni Paolo Panini (Italian, 1691–1765). *Study of a Double-Bass Player*, ca. 1747, black chalk on paper, 194 × 132 mm (7⅝ × 5³⁄₁₆ in.). London, British Museum, inv. 1858,0626.655 (197.b.5), fol. 60

FIG. 122
Detail of fig. 112. Giovanni Paolo Panini, *The Musical Performance in the Teatro Argentina in Honor of the Marriage of the Dauphin*, 1747. Paris, Musée du Louvre

FIG. 123
Pier Leone Ghezzi (Italian, 1674–1755). *Joseph Digne*, Paris, Bibliothèque Nationale de France, Département des Estampes, Réserve BE-12 (A), pet.-fol., fol. 23

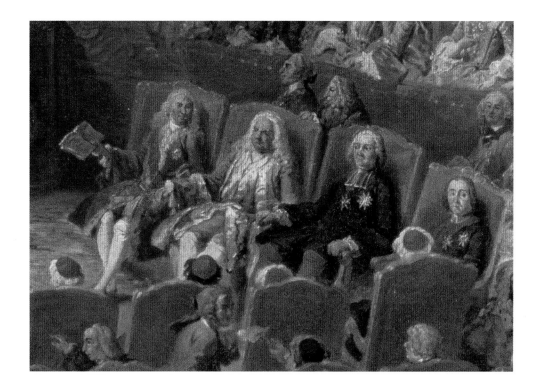

FIG. 124
Detail of fig. 112. Giovanni Paolo Panini,
*The Musical Performance in the Teatro Argentina
in Honor of the Marriage of the Dauphin*, 1747.
Paris, Musée du Louvre

of foreign princes, and numerous prelates, princes of noble blood, and knights."[66] James
Francis Edward Stuart, styled James III, the Jacobite claimant to the English and Scot-
tish thrones living in exile in Rome, was in the eyes of the Holy See the legitimate king
and therefore the highest-ranking person in Rome after the pope. A drawing showing
a man in a *justaucorps* with ecclesiastical bands at the neck has been erroneously identi-
fied as either James III or Henry Benedict Stuart, Cardinal York (1725–1807), his son.[67]
This form of dress, most commonly worn by French clerics and magistrates, excludes
both James III, who would always have been portrayed wearing the Order of the Gar-
ter, and his son, who would have been shown with the Garter prior to July 1747 and in
the robes of a cardinal thereafter.[68] The drawing most likely represents one of the abbés
attached to the French embassy.[69]

The fact that none of these men's likenesses appear in Panini's sketchbook or Ghez-
zi's caricatures has given rise to the suggestion that they must be based on pencil or oil
sketches the artist made from life.[70] Yet it is highly implausible that no such head or fig-
ure study for the prominent dignitaries, whose portraits warranted particular care, would
have survived. Moreover, Panini is unlikely to have had timely access to this group of
men at the pinnacle of Rome's social and ecclesiastical hierarchy. Given that they often
reacted with impatience to the need for sittings even when commissioning their own
official portraits from specialists, it seems far-fetched that he would have been granted
sittings with each of them for a composition in which they only appeared as small fig-
ures. It is therefore more likely that the painter relied on existing portraits or engrav-
ings after them. Cardinal La Rochefoucauld appears in the short section of the front row
on the right, in the third seat from the stage (fig. 124). He wears the red skullcap and
stockings proper to his ecclesiastical rank as well as the blue riband, badge, and star of
the Order of the Holy Spirit, which he had been awarded in 1742.[71] His likeness closely

Fridericus Hjeronymus de Roye Rupifucaldus,
Archiepiscopus Bituricensis, Gallus, S.R.E.
Presbyter Cardinalis creatus à SS.D.N.BENEDICTO XIV.
in Consistorio secreto die 10 Aprilis 1747.

Eques Jo:F. de Troy pinx Claud.Gallimard sculp.

Romae ex Chalcographia R.C.A. apud Pedem Marmoreum

Trojanus de Aquaviva de Aragonia, Neapolitanus Archiepis=
copus Larissæus Sacri Palatij Apostolici Præfectus, S.R.E.
Presbyter Cardinalis creatus à SSmo.D.N.CLEMENTE XII.
in Consistorio secreto die prima Octobris 1732.
Obijt die 21.Martij 1747.

Antonius David pinxit Hieronymus Rossi sculp.

follows an engraving by Gallimard (who had also provided the engravings after Panini for the printed libretto) after Jean-François de Troy (fig. 125).[72] For the figure seated to the right of La Rochefoucauld, an identification as Cardinal York has repeatedly been proposed,[73] but he is in fact the Spanish ambassador Cardinal Troiano Acquaviva, wearing the red riband, badge, and star of the Neapolitan Order of Saint Januarius, of which he had been one of the first recipients upon its foundation by King Charles VII of Naples (later Charles III of Spain) in 1738.[74] Acquaviva's likeness is based on an engraving by Girolamo Rossi after Antonio David, which shows him without the order (fig. 126).[75]

Closest to the stage sits another early recipient of the Order of Saint Januarius, the Grand Constable of Naples, Don Fabrizio Colonna (1700–1755), wearing its red riband and holding a copy of the libretto in his right hand.[76] Since the place of honor at the host's right would appropriately belong to the senior representative of the bride's nation, the man seated between Colonna and La Rochefoucauld is most likely to be Count Carlo Francesco Tapparello di Lagnasco (d. 1779), the long-serving minister plenipotentiary of the king of Poland and elector of Saxony to the Holy See. When the Polish-Saxon court had first announced the engagement of Maria Josepha to the dauphin in December 1746, it had been Lagnasco who had come to see La Rochefoucauld to inform him of the marital alliance between their nations.[77]

FIG. 125
Claude-Olivier Gallimard (French, 1719–1774), after Jean-François de Troy (French, 1679–1752). *Cardinal Frédéric-Jérôme de La Rochefoucauld*, ca. 1747, engraving. Vienna, Bildarchiv und Grafiksammlung, Porträtsammlung, inv. PORT_00089042_01

FIG. 126
Girolamo Rossi (Italian, 1682–1762), after Antonio David (Italian, 1698–1750). *Cardinal Troiano Acquaviva d'Aragona*, ca. 1735–37, engraving. Vienna, Österreichische Nationalbibliothek, Bildarchiv und Grafiksammlung, inv. PORT_00087688_01

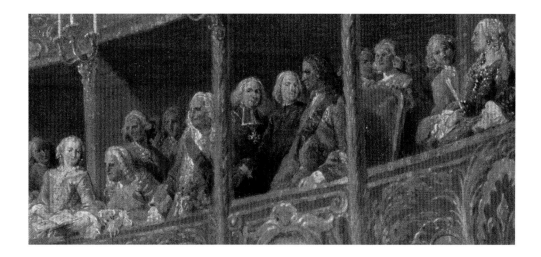

For the highest-ranking member of the audience, three boxes on the second tier were combined into one.[78] In its central section, framed by thin palm frond columns holding gilded torchères, stands James III, also known as the Old Pretender (fig. 127). He wears the star of the Order of the Garter on his coat and the blue riband from the left shoulder to the right hip. Running underneath it, from the right shoulder to the left hip, he wears a second sash. Its green color implies that this is intended to be the riband of the Order of the Thistle, which would correctly be worn in the opposite direction. In 1716, emphasizing his claim to be recognized as the rightful sovereign of both England and Scotland and therefore the head of both chivalric orders, James III had issued new guidelines permitting the simultaneous wearing of the Garter and the Thistle, previously considered incompatible. Nearly every portrait of him painted from 1717 onward shows him wearing the insignia of both orders.[79] However, the arrangement seen in his portraits as well as those of his sons differs from Panini's depiction: the Garter sash was combined with the badge of the Thistle suspended from a ribbon worn around the neck (fig. 128). Although this explanation must remain speculative, it is conceivable that Panini was asked to respect James III's desire to be consistently portrayed with both orders but that the small scale of the figures made it impossible to legibly depict the badge of the Order of the Thistle worn on the chest, leaving him with no choice but to invent a new style of wearing the green sash to make the order recognizable.

In an attempt at consistency, the man in a long powdered wig standing at the front of the Stuart box, over to the left, is also shown wearing the green sash of the Order of the Thistle in the wrong direction. Previously identified as Daniel O'Brien, 1st Earl of Lismore (1683–1759),[80] who was never awarded the order, he is most likely James Murray, 1st Earl of Dunbar (ca. 1690–1770), created a knight of the Thistle in 1725. As the Stuart court's secretary of state from 1727 until October 1747, Murray would have been an appropriate person to attend the French wedding celebration.[81]

While James III and Murray are both watching the stage, the two clerics in black cassocks and short powdered wigs standing between them are both looking directly at the viewer. The man next to the Old Pretender wears a red skullcap identifying him as a cardinal. His likeness matches, in reverse, the full-length portrait of Cardinal York by

FIG. 127
Detail of fig. 112. Giovanni Paolo Panini, *The Musical Performance in the Teatro Argentina in Honor of the Marriage of the Dauphin*, 1747. Paris, Musée du Louvre

Louis-Gabriel Blanchet (1705–1772) from 1748[82] as well as the pastel by Maurice-Quentin de La Tour (1704–1788) from 1746–47, showing him in ceremonial armor before he became a cardinal (see fig. 128).[83] Panini's direct source was probably the engraved portrait by Pier Antonio Pazzi (1706–after 1768) after Giovanni Domenico Campiglia (1692–1775) (fig. 129). Numerous other portraits of Cardinal York almost invariably show him wearing a short powdered wig.[84]

Taken a little over a month before the celebrations, the Duke of York's decision to pursue an ecclesiastical vocation had resulted in a flurry of political activity, with La Rochefoucauld, a staunch and trusted supporter of the Stuarts, finding himself in the eye of a diplomatic storm. On 7 June, while he was staying at his country villa in Frascati, La Rochefoucauld had received a sudden late-night visit from Henry Benedict, who had just arrived from Rome because he wanted to tell the French cardinal immediately about his momentous decision to take holy orders. La Rochefoucauld sprang into action. The next morning, he helped James III draft a letter to break the news to Louis XV before traveling to Rome to discuss the matter with Silvio Valenti Gonzaga (1690–1756), the cardinal secretary of state. A meeting with the pope—who had immediately offered to create the Stuart prince a cardinal when he had been informed only two days before La Rochefoucauld—followed a day later. For the next few weeks, the frenetic diplomatic maneuvers, conducted in the greatest secrecy, continued apace. La Rochefoucauld dispatched official reports to Versailles and conveyed the responses from Louis XV to the pope and James III. On 30 June 1747, Henry Benedict received the clerical tonsure, and on 3 July—nine days before the celebrations in Teatro Argentina—Benedict XIV held a special consistory and created the young Stuart prince a cardinal-deacon.[85]

Vexing questions of protocol arose immediately.[86] On 21 June, La Rochefoucauld predicted to Puysieulx that the lack of a precedent for the son of a monarch residing in Rome as a cardinal would create a multitude of ceremonial complications.[87] The newly minted Cardinal York had agreed to waive any rights of precedence when the College of

FIG. 128
Maurice-Quentin de La Tour (French, 1704–1788). *Prince Henry Benedict Stuart,* 1746–47, pastel on paper, 61 × 51 cm (24 × 20 1/16 in.). Edinburgh, Scottish National Portrait Gallery, inv. PG 2954

FIG. 129
Pier Antonio Pazzi (Italian, 1706–after 1768), after Giovanni Domenico Campiglia (Italian, 1692–1768). *Henry Benedict Stuart. Cardinal York,* 1747–48, engraving, 223 × 182 mm (8 3/4 × 7 3/16 in.). Royal Collection Trust, inv. RCIN 603664

FIG. 130
Pier Antonio Pazzi (Italian, 1706–after 1768), after Giovanni Domenico Campiglia (Italian, 1692–1775). *Cardinal Domenico Amedeo Orsini d'Aragona,* ca. 1744–45, engraving. Vienna, Österreichische Nationalbibliothek, Bildarchiv und Grafiksammlung, inv. PORT_00088921_01

Cardinals met or celebrated liturgies as a body, "but on all other occasions, he is going to avoid being with the Sacred College, for example during the cantata I am preparing to have performed next week at the celebrations I have been asked to stage on the occasion of the wedding of the dauphin."[88] The seating order in the stalls reminded at least one guest in the theater of a consistory of the College of Cardinals,[89] except that Cardinal York was not seated with his ecclesiastical peers. A few days after the performance, La Rochefoucauld told Puysieulx that "the Knight of Saint George [i.e., James III] attended it and the new cardinal, his son, was in his father's box"—where Panini depicted him.[90]

The cleric to the left of Cardinal York has previously been identified as the abbé de Canilliac, said to be wearing the red riband of the Order of Saint Louis.[91] Canilliac, however, never received this order, which required distinguished military service. The red riband and badge belong once again to the Order of Saint Januarius, and the ecclesiastical bands at the neck were worn by Neapolitan as well as French clergy. The man is almost certainly Cardinal Domenico Amedeo Orsini d'Aragona, Duke of Gravina (1719–1789), who received the order in 1740.[92] His likeness is derived from an engraving by Pazzi after Campiglia showing him with the order (fig. 130).[93]

The performances of the cantata in the transformed Teatro Argentina were widely acknowledged to have been a phenomenal success. The *Diario ordinario* emphasized the key role of Cardinal La Rochefoucauld as the driving intellectual and organizational force, stating that the event "succeeded in its words, music, selection of voices and instruments, in all of its parts due to the magnificent concept of the cardinal who had given the orders for it, particularly for the creation of the beautiful decoration of the theater by Giuseppe Panini."[94] When he returned to his diocese at the end of his embassy, La Rochefoucauld installed the painting recording the greatest triumph of his years in Rome in the dining room of the archiepiscopal palace in Bourges, where it is recorded in his estate inventory of 1757.[95]

The cardinal did not, however, avail himself of the other two principal methods of commemorating ephemeral events that some of his predecessors had used, namely engravings and printed reports. While the preparations were underway in April, La Rochefoucauld received a piece of advice from his first cousin and confidant Jean Frédéric Phélypeaux, comte de Maurepas (1701–1781), well connected at the court of Versailles: "Just send us a description that is a bit grandiloquent. Celebrations are never as beautiful as they are on paper, which is what one has to believe the next morning."[96] Four days after the last performance, Joseph Digne, the French consul, still expected that the ambassador would promptly have a report printed and an engraving made,[97] and a few days later, Maurepas warned La Rochefoucauld that not publishing a printed description of the celebrations would be akin to never having staged them at all.[98] When nothing of the kind had arrived in Paris by early September, Maurepas reproached the cardinal: "I do not approve at all of your not having sent a description and the design of your celebrations, which would have been in the center of attention here for a fortnight, but you have done so well that they are hardly talked about at all. Sending them would have paid off greatly in terms of your reputation and almost in hard cash."[99]

An Ancient Arena in Piazza Navona

Maurepas was not the only one of La Rochefoucauld's correspondents whose well-intentioned advice went unheeded. On 6 June 1747, the French ambassador in Madrid, Louis Guy de Guérapin de Vauréal (1687–1760), wrote to him with suggestions for staging the celebrations. The seasoned diplomat specifically recommended to the cardinal, who was in his first ambassadorial post, that he use the Roman celebrations for the birth of dauphin Louis Ferdinand, organized by Cardinal Melchior de Polignac (1661–1741) in 1729, as his model.[100] Polignac had deployed the whole range of options to commemorate the spectacular event he staged: he commissioned a painting from Panini in two versions, sent a printed report to Paris, and later had the painting engraved. In each case, he ensured that a special emphasis was placed on his role as the impresario of the celebrations and the author of its allegorical program—with lasting success: in his Italian travel journal published in 1769, the Parisian astronomer Joseph Jérôme Lefrançois de Lalande (1732–1807) ended his description of the Piazza Navona by recalling the "famous celebration" organized by Polignac—who is mentioned by name—forty years earlier and specifically referred to Panini's painting, confidently assuming that his readers would be familiar with it from an engraving or even in the original.[101]

As Panini's paintings for Canilliac and La Rochefoucauld had done, the view of the celebrations held in Piazza Navona in 1729 recorded a spectacular homage whose ultimate addressee, Louis XV, was absent (fig. 131).[102] This created a situation in which the celebration as documented on canvas and paper was more important to its organizer than the celebration as experienced in situ, a paradox perfectly encapsulated in Maurepas's later statement that "celebrations are never as beautiful as they are on paper."[103] Polignac, however went even further. Not content with sending a report, he commissioned two nearly identical versions of Panini's painting—one for himself, the other as a present to the king (fig. 132).[104] This strategic gift was the equivalent of placing of a large, colorful, and highly conspicuous advertisement that would be permanently on view at Versailles, extolling his munificence and originality in glorifying his sovereign's royal house. An inventory of the royal paintings collection of 1731 emphasizes the cardinal's role in the composition, showing that the visual message was understood exactly as intended: "A celebration staged by Cardinal de Polignac in Rome on the occasion of the birth of the dauphin, ornamented with several edifices erected for the glory of France, where the cardinal is seen giving orders."[105]

Panini had carefully designed his composition to communicate this: instead of depicting the spectacle itself, the artist shows its preparations, enabling him to portray Polignac as an active organizer rather than a passive spectator. Identifiable by the blue ribbon and badge of the Order of the Holy Spirit as well as the red stockings worn with the cassock, the cardinal appears prominently in the central foreground (fig. 133). Furthermore, the magnitude of the creative and financial effort that had been expended could be demonstrated far more effectively by showing the preparations, not the actual festivities. While it has been suggested that Panini's goal was to express the participation of all social classes and the sense of community generated by a celebration,[106] such an interpretation privileges the intentions of the artist over those of the patron and is an implausible scenario for a highly politicized image commissioned specifically for the king of France.

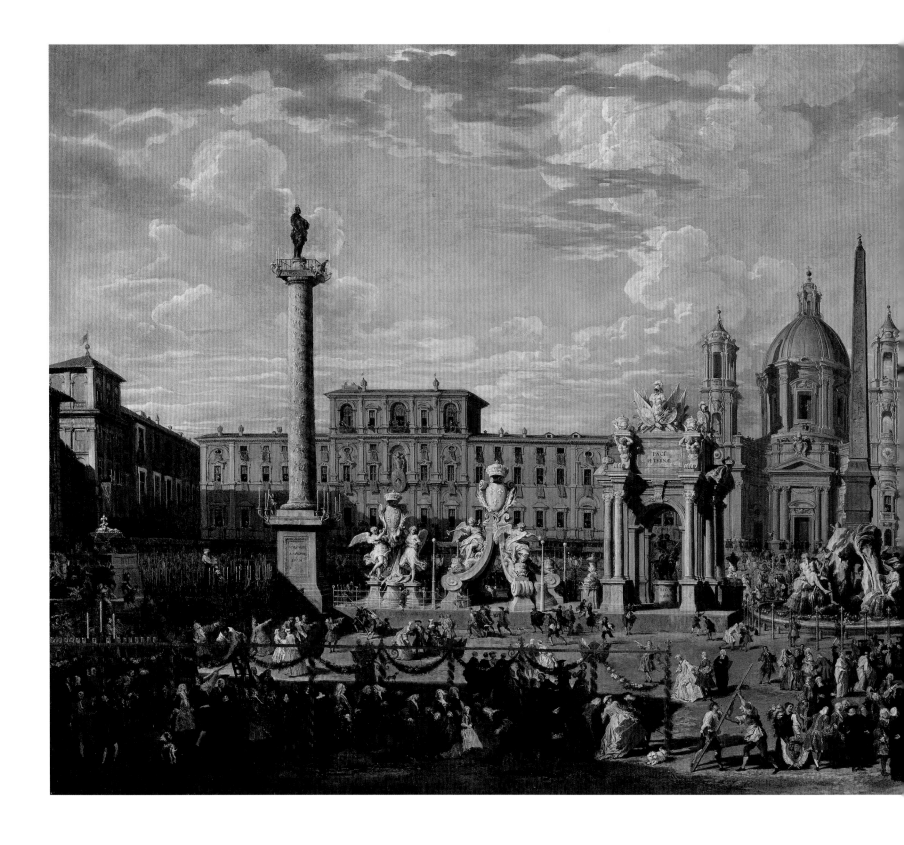

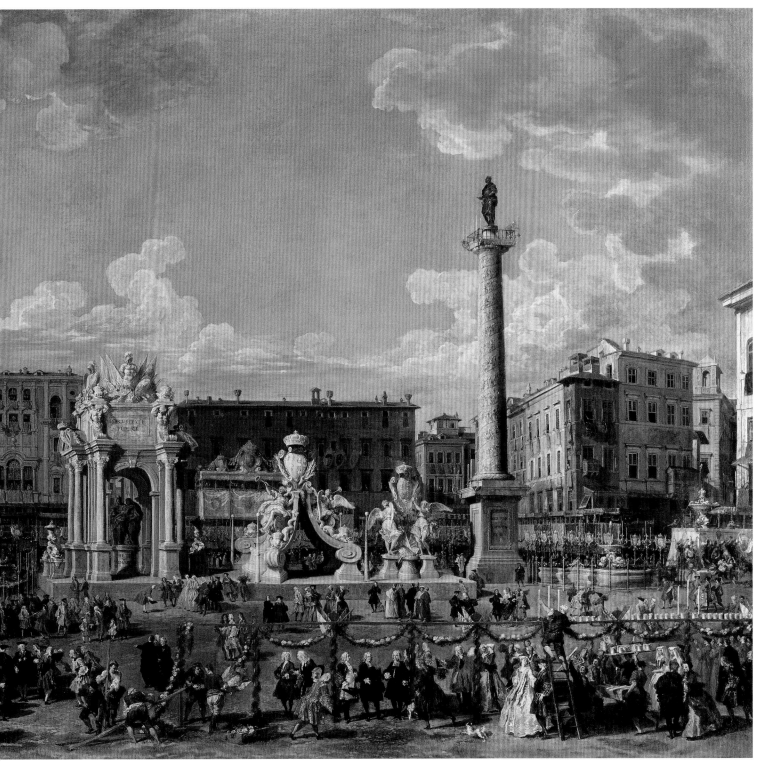

FIG. 131
Giovanni Paolo Panini (Italian, 1691–1765).
The Preparations to Celebrate the Birth of the
Dauphin of France in Piazza Navona, 1731.
Oil on canvas, 109 × 246 cm (42 15/16 × 96 7/8 in.).
Dublin, National Gallery of Ireland,
inv. NGI.95

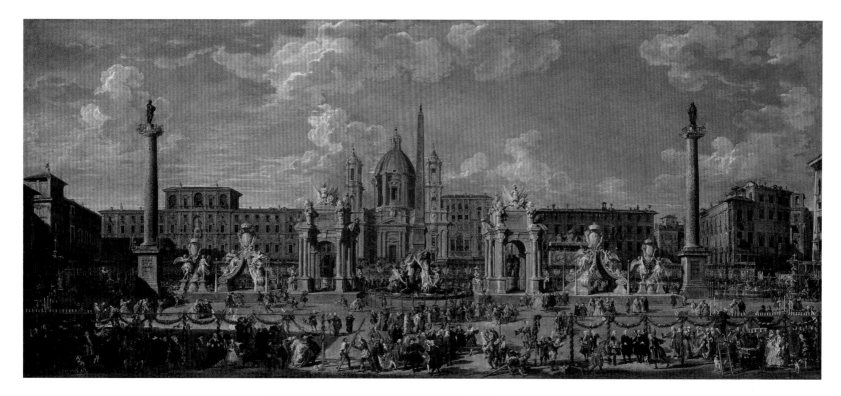

FIG. 132
Giovanni Paolo Panini (Italian, 1691–1765).
The Preparations to Celebrate the Birth of the
Dauphin of France in Piazza Navona, 1729.
Oil on canvas, 107 × 248 cm (42⅛ × 97⅝ in.).
Paris, Musée du Louvre, inv. 415

FIG. 133
Detail of fig. 131. Giovanni Paolo Panini,
The Preparations to Celebrate the Birth of the
Dauphin of France in Piazza Navona, 1729.
Dublin, National Gallery of Ireland

The event on 30 November 1729 was the capstone of an extensive program of celebrations staged in honor of Louis Ferdinand's birth on 4 September.[107] Like the celebrations for his wedding held in Piazza Farnese sixteen years later, it would culminate in a nighttime display of fireworks launched from the ephemeral structures. In the painting, an army of carpenters, set builders, painters, florists, fireworks technicians, and other workers are putting the finishing touches on the metamorphosis of one of Rome's most beautiful public spaces into an open-air ballroom, all supervised by Polignac. Throughout the day, eminent spectators promenaded the square to satisfy their curiosity,[108] among them James III with his sons Charles Edward (known as Bonnie Prince Charlie) and Henry Benedict (see fig. 133). The Old Pretender, who had lived at Saint-Germain-en-Laye near Paris under the protection of the French crown until 1713, was a close friend of Polignac's.[109] All three Stuarts wear the blue sash of the Order of the Garter from left shoulder to right hip. Between the two princes stands their governor, James Murray, in the green sash of the Order of the Thistle; he was to reappear in the Stuart box at the Teatro Argentina in Panini's painting of the celebrations for the dauphin's second marriage (see fig. 127).[110]

The three-dimensional stage set, designed by Pier Leone Ghezzi, aligned along the central axis of the oblong Piazza Navona, was intended to evoke the square's appearance at the time of the Roman emperor Domitian (r. AD 81–96).[111] Its function in antiquity was even cited as the reason for the choice of the Piazza Navona as the venue for the celebrations.[112] Polignac asked for the ancient sporting arena that had existed on the same site in the late first century AD to be imaginatively re-created; even the Fountain of the Four Rivers was subsumed into the sumptuous allegorical program.[113] Bernini's fountain, embellished with torches and dolphins (the French *dauphin* designated both the animal and the heir to the throne), was flanked by twin rectangular temples fronted by triumphal arches. An imitation bronze sculpture group representing Peace and Justice (in an embrace alluding to Psalm 84:11) stood in the left temple, while the one on the right contained a companion group representing Valor and Faith.

The patron's intention of linking the classical past to the present is equally evident in the inscription on the pedestal of the sculpture group in the right-hand temple (fig. 134), "Hae tibi erunt artes," a quotation from the counsel given to Aeneas by his deceased father, Anchises, during Aeneas's visit to the Underworld, to be completed by the viewer: "Hae tibi erunt artes; pacisque imponere morem, parcere subiectis, et debellare superbos" (Your great art shall be to keep the world in lasting peace, to spare the humbled and vanquish the proud).[114] A contemporary account citing this inscription did not consider it necessary to provide an explanation, stating merely that any erudite reader would easily be able to apply it to the dauphin.[115]

Farther to the left and right, respectively, stood the coats of arms of the royal parents, Louis XV and Maria Leszczyńska, accompanied by trumpeting personifications of Fame placed on volutes. After two more imitation stone sculptures surmounted by the arms of the dauphin, the ensemble culminated in a pair of columns modeled on those of Trajan and Marcus Aurelius, crowned with colossal imitation bronze statues of Saint Louis of Toulouse at left and Louis XIV at right. The most popular feature, however, were the two fountains dispensing white and red wine at the ends of the square.

FIG. 134
Detail of fig. 131. Giovanni Paolo Panini,
*The Preparations to Celebrate the Birth of the
Dauphin of France in Piazza Navona*, 1729.
Dublin, National Gallery of Ireland

The palaces along the west side of the piazza, with Borromini's imposing church of Sant'Agnese in Agone in the center, formed the backdrop.

Creating such magnificence did not come cheap, but Polignac was willing to pay. The foreign ministry had sent him 12,000 livres, the same amount La Rochefoucauld would receive in 1747.[116] Since this was only a fraction of what he needed to realize his grandiose plans, Polignac decided to raise the necessary funds by having a forest his family owned in France cut down to sell the wood.[117] "You can believe me that this sum [the 12,000 livres] will not suffice but it does not matter; for such a great cause, I shall spare nothing," he nonchalantly responded to Germain Louis Chauvelin (1685–1762), the foreign minister.[118] Nicolas Vleughels (1668–1737), director of the French Academy in Rome, noted with astonishment that the cardinal's outlay was on a scale never seen before in Rome.[119] The unprecedented extravagance was rewarded with a triumphant success. On the day after the event, an elated Vleughels wrote to Paris that "a more beautiful celebration and a more beautiful assembly will never be seen."[120] While the Frenchman was not the most impartial of observers, even the Venetian ambassador in Rome acknowledged in his report to the Senate that the French had staged a "much appreciated and applauded spectacle."[121]

A Commemorative Campaign

As soon as the Piazza Navona had turned from a Roman arena back into a market square, Polignac turned his attention to creating a textual and pictorial commemoration of the event in order to ensure that his investment in fleeting entertainments would leave a lasting impression. His first step was a letter to Chauvelin on 1 December, announcing that the success "has surpassed my hopes even more than my desires; I will send you a detailed description as soon as possible."[122] Chauvelin replied that the celebrations were being praised from all quarters; he had heard that they surpassed anything previously seen in Rome.[123] Eight days after the event had taken place, the cardinal sent him two reports, in Italian and French, the latter "written in haste" by his secretary, the abbé Daniel Le Blond, "so that it will not be preempted by others."[124] By the end of the year, two printed descriptions had appeared in Rome, one of which was quickly translated into French and published in Paris in early 1730.[125]

Two prints—neither of them related to Panini's painting—executed in Rome by Gaetano Piccini and Salvatore Colonnelli Sciarra perhaps betray the haste with which they had been produced.[126] While their lettering duly credited Polignac as the organizer, the quality of these sheets disappointed him, as Vleughels observed: "He is not satisfied with them, with good reason; he has been poorly served. It is true, I have to say, that there are no engravers here who are as capable as those in Paris."[127] The lack of an adequate engraving still rankled long after the cardinal had returned to France in 1732. In order to be able to send a reproduction of Panini's composition to those unable to see either of the two originals hanging at Versailles and in his Parisian residence,[128] or give one as a memento to those who did see them, he had his version of the

FIG. 135
Charles-Nicolas Cochin II (French, 1715–1790), after Jacques Dumont (French, 1701–1781). *Préparatifs du grand feu d'artifice que S.E.M. le Cardinal de Polignac fit tirer à Rome dans la place Navonne le 30 Novembre 1729 pour la Naissance de Monseigneur le Dauphin*, 1735, etching, 392 × 881 mm (15 7/16 × 34 11/16 in.). Paris, Bibliothèque Nationale de France, Département des Estampes, Réserve EE-15 (B)-FT 5

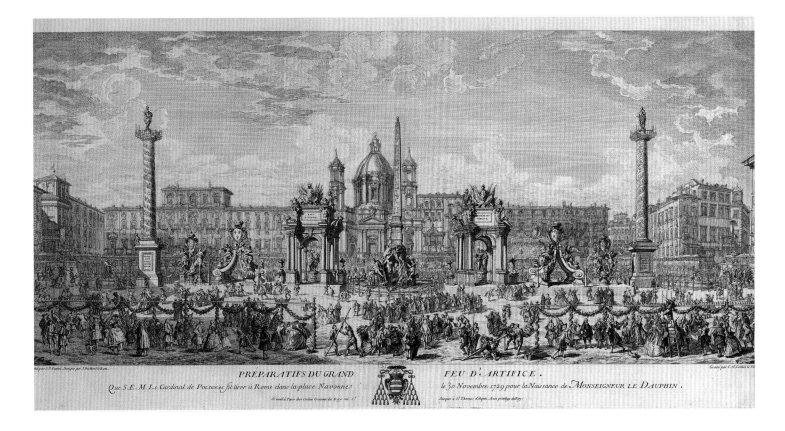

PRÉPARATIFS DU GRAND FEU D'ARTIFICE.
Que S.E.M. Le Cardinal de Polignac fit tirer à Rome dans la place Navonne le 30 Novembre 1729 pour la Naissance de Monseigneur le Dauphin.

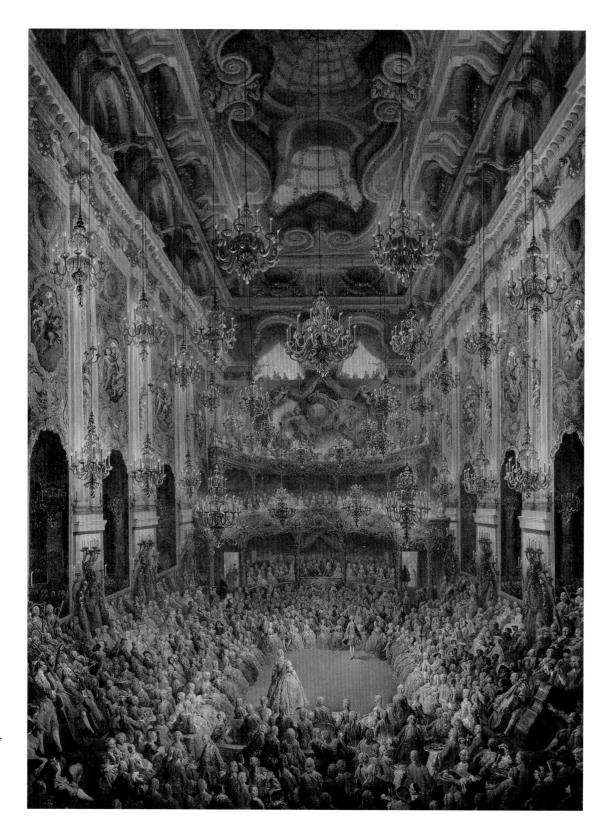

FIG. 136
Giovanni Paolo Panini (Italian, 1691–1765).
A Ball Given by the Duc de Nivernais to Mark the Birth of the Dauphin, 1751. Oil on canvas, 168 × 132 cm (66⅛ × 51¹⁵⁄₁₆ in.). National Trust, Waddesdon Manor, The Rothschild Collection, inv. 80.2007.2

FIG. 137
Giovanni Paolo Panini (Italian, 1691–1765). *A Concert Given by the Duc de Nivernais to Mark the Birth of the Dauphin*, 1751. Oil on canvas, 168 × 132 cm (66⅛ × 51¹⁵⁄₁₆ in.). National Trust, Waddesdon Manor, The Rothschild Collection, inv. 80.2007.1

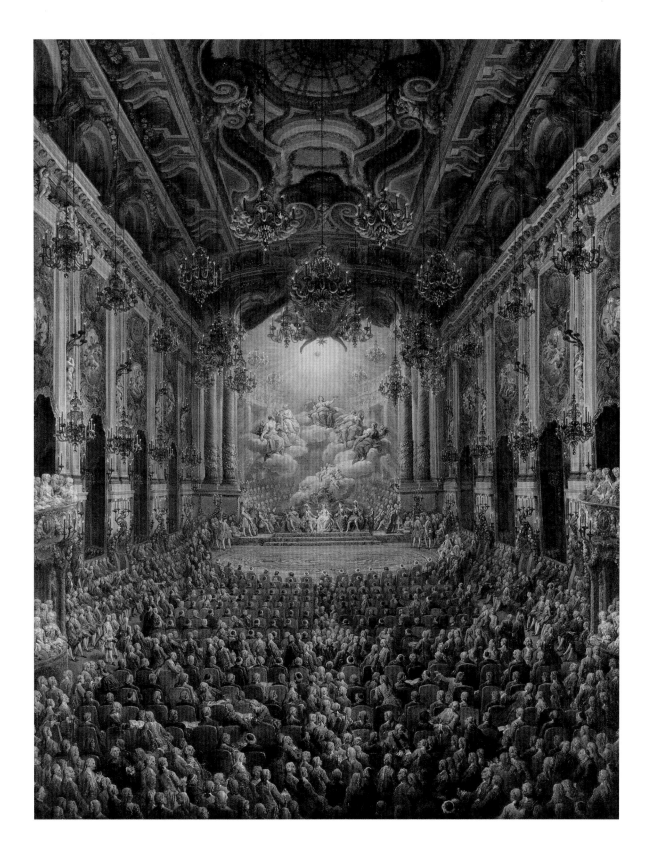

painting engraved by Charles-Nicolas Cochin II (1715–1790) in 1735 (fig. 135).[129] The lettering underneath the image once more recalled his role as the impresario of the event that had marked the pinnacle of his diplomatic career: "Preparations for the great fireworks that His Eminence the Cardinal de Polignac had launched in Rome in the Piazza Navona on 30 November 1729 for the birth of the dauphin."

Documenting the career-defining moments of French representatives in Rome was equally career defining for Panini and helped him gain an honor rarely accorded to a foreign artist, the membership of the Académie Royale de Peinture et de Sculpture in Paris. When the *Mercure de France* reported his acceptance into the Academy in August 1732, it referred its readers to the picture of Polignac's festivities in the Piazza Navona that hung at Versailles as an example of the painter's exceptional skill.[130] Cochin's engraving of the composition further enhanced Panini's reputation in France, and for two decades, the painter enjoyed a monopoly on recording the celebrations staged in Rome for the seminal events in the dauphin's life. The commissions from Canilliac and La Rochefoucauld for the celebrations of Louis Ferdinand's first and second weddings in 1745 and 1747 were followed by a pair of canvases showing the ball and the concert staged by the French ambassador Louis Jules Mancini-Mazarini, duc de Nivernais (1716–1798), in honor of the birth of the dauphin's first son, Louis Joseph Xavier, duc de Bourgogne (1751–1761), in Palazzo Farnese in November 1751 (figs. 136, 137).[131] Once again, the temporary transformation of the empty shell of a large, double-height room that had remained unfurnished since the building's construction into a glittering Rococo ballroom was entrusted to Giuseppe Panini (1718–1805), the painter's son. In the center of the ball scene, Nivernais opens the first dance with the Venetian ambassador's wife.

The Panini family duo working hand in hand offered a crucial advantage: the reality of the celebration could be designed from the beginning with its depiction in mind. Since Louis XV, the actual addressee, would only ever see their painted representation, it was ultimately more important for the ephemeral decorations to convey the intended message convincingly in two dimensions on canvas than in three dimensions made of papier-mâché and stucco. The artists who received such quasi-architectural commissions even before father and son Panini became the preferred option thought like painters because they were painters. In 1729, Ghezzi had designed the allegorical structures for the Piazza Navona, while the very first view painting of this type produced by Panini shows a *macchina* invented by Sebastiano Conca (1680–1764) (fig. 138).[132] His narrative tableau for the celebrations of the birth of the Infante Luis Antonio Jaime (1727–1785), son of Philip V of Spain (r. 1700–1746), held in front of the Spanish embassy in Piazza di Spagna on 23 September 1727,[133] likens the prince to a Greek hero: underneath the Temple of Glory for which her son is destined, Thetis consigns Achilles to the centaur Chiron for his education (fig. 139).[134]

While the grandest of his reportorial views were created for a French clientele, Panini's patrons also included numerous other foreigners, such as the Spanish ambassador Cardinal Cornelio Bentivoglio (1668–1732), who commissioned the view of the *macchina* erected in front of his embassy in 1727, and Clemens August (1700–1761), elector-archbishop of Cologne. The German prince appears to have been particularly taken

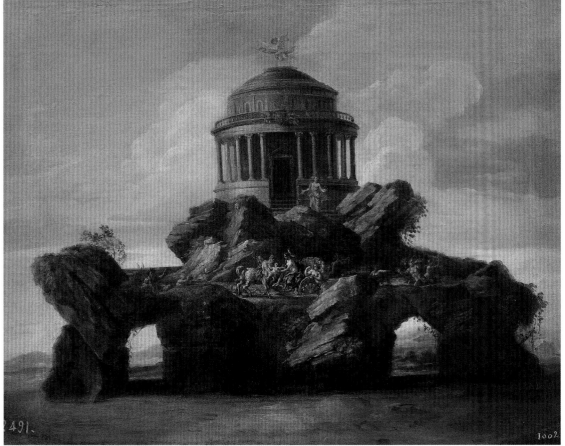

FIG. 138
Giovanni Paolo Panini (Italian, 1691–1765).
The Fireworks Machine in Piazza di Spagna
for the Celebration of the Birth of the Infante of
Spain, 1727. Oil on canvas, 46 × 100 cm
(18⅛ × 39⅜ in.). London, English Heritage,
Wellington Museum, Apsley House, inv. WM
1641-1948

FIG. 139
Sebastiano Conca (Italian, 1680–1764).
The Education of Achilles, 1727. Oil on canvas,
59 × 74 cm (23¼ × 29⅛ in.). Madrid, Museo del
Prado, inv. P02869

FIG. 140
Giovanni Paolo Panini (Italian, 1691–1765).
The Flooding of the Piazza Navona, 1756.
Oil on canvas, 96 × 136 cm (37¹³⁄₁₆ × 53⁹⁄₁₆ in.).
Hannover, Niedersächsisches Landes-
museum, inv. 284

with a recurring event he witnessed during his visit to Rome in summer 1755, a transfor-
mation of the Piazza Navona that was created not by the city's most skilled artisans but
by its plentiful water supply and that celebrated nothing but the population's enjoyment
of a cool lake in the oppressive heat of the Roman summer (fig. 140).[135] Panini's view
depicts the so-called lake of Piazza Navona: on the four Sundays of August the drains
of the three fountains were blocked. Within two hours, the water spilling out of their
basins flooded the square to a depth of about half a meter, which still allowed carriages
to drive around the square (fig. 141).[136] The pendant painting Clemens August acquired
from Panini echoed the artist's French commissions and showed the interior of Saint
Peter's from the same viewpoint as the canvases for Polignac, Canilliac, and Choiseul.[137]

 As a means of underscoring his authority as an eyewitness to the contemporary
events he painted, Panini frequently included himself in his compositions (see fig. 120).
His triple role as reporter, participant, and frequent co-designer of the celebrations

he depicted placed him at the nexus of the visual legacy making that a succession of French and Spanish ambassadors in Rome came to see as the primary purpose of the celebrations they staged in honor of their royal families. The two key political statements that these events and their paintings intended to make were the appropriation of the grandeur of ancient Rome and the claim to a role as defenders of Christendom for their crowns. As the ultimate addressees of these homages were unable to attend them, the representation of an event grew to be more important than its reality. The designer of each event's decoration would work closely with the artist producing its record, and it is likely that many a *macchina* was crafted with an eye to conveying its message in two dimensions as well as in three. Last but not least, Panini's reportorial paintings of Rome's most dazzling occasions left the viewer in no doubt that the intellectual author of each symbolic program was none other than the ambassador-impresario himself.

FIG. 141
Detail of fig. 140. Giovanni Paolo Panini, *The Flooding of the Piazza Navona*, 1756. Hannover, Niedersächsisches Landesmuseum

CHAPTER 5
THE EYE OF THE ITINERANT ARTIST
꒰·꒱

In the early decades of the eighteenth century, the most significant commissions for reportorial view paintings were almost invariably related to events taking place in Venice and Rome. Although ambassadorial entries and celebrations of royal births and marriages were held in most European capitals, the customary form of recording them was in engravings rather than paintings. The reasons for this disparity between events in the two Italian cities and Paris, Madrid, London, or Vienna were rooted in supply rather than demand. When foreign ambassadors and princes discovered that Carlevarijs, Canaletto, and Panini were able to produce impressive, authentic, large-scale images that could re-create an ephemeral event for an audience back at home, this realization traveled back to their native countries together with the paintings.

Ever since Charles Montagu, 4th Earl of Manchester, returned from Venice in 1708 with Luca Carlevarijs's grandiose rendition of Montagu's official entry (see fig. 46), the effectiveness of painted documents of great celebrations was understood and appreciated in London. If the efforts of English view painters of the period could not even remotely approach the verisimilitude of Carlevarijs's productions, Montagu was ideally placed to suggest a solution: deploy some of England's enormous financial resources to lure the best artists from the Continent to London. His relatively brief ambassadorship in Venice had been crucial in applying this strategy to another art form dominated by Italian practitioners, namely opera.[1] Italian painters were drawn to London to serve free-spending British patrons, although many of those arriving in the early eighteenth century were initially hired to produce theatrical scenery rather than history paintings or landscapes.[2]

Given the close links between theatrical design and view painting evidenced, above all, by the beginnings of Canaletto's career, it is not surprising that when an Italian view painter of the first rank finally did cross the Channel, he was lured by the money and prestige of the world of opera: in 1744, two years after he had painted some of his greatest reportorial view paintings (see fig. 25), Antonio Joli was appointed resident stage designer at the King's Theatre in the Haymarket. Nonetheless, his most important commission during his five years in England was decorating the country house of the King's Theatre's impresario, Johann Jakob Heidegger (1666–1749), at Richmond.[3]

At the same time, the desire to document the milestones of urban life was growing apace with the development of London as a whole. In the greatest public building project since Sir Christopher Wren (1632–1723) had erected some fifty new churches in the City of London to replace the eighty-six lost in the Great Fire of 1666, a second bridge across the Thames at Westminster was begun in 1739 in order to relieve the bottleneck of the narrow and congested Old London Bridge, which still had houses on it until 1758.[4] While it does not show a specific event in the strictest sense, the view of an early construction phase of Westminster Bridge by Samuel Scott was intended as a record of

FIG. 142
Samuel Scott (British, ca. 1702–1772).
The Building of Westminster Bridge, ca. 1742.
Oil on canvas, 69 × 119 cm (27 3/16 × 46 7/8 in.).
New Haven, Yale Center for British Art,
Paul Mellon Collection, inv. B1974.3.33

FIG. 143
Canaletto (Italian, 1697–1768). *The City Seen
through an Arch of Westminster Bridge*, 1746–47.
Oil on canvas, 60 × 98 cm (23 5/8 × 38 9/16 in.).
Collection of the Duke of Northumberland

the transitory state of a project that was a source of considerable civic pride (fig. 142).[5]
Perfectly competent as it was, Scott's canvas would not, however, have dissuaded any-
one from the opinion that it was high time to finally import the Handel of view paint-
ers, Canaletto. His work had been in demand by British patrons for well over a decade,
but in addition to his aversion to travel, he may simply not have seen the need to move
as long as his clients flocked to Venice on the Grand Tour and eagerly competed for
the privilege of buying his paintings. In the first half of the 1740s, however, northern
Italy turned into one of the major theaters of the War of the Austrian Succession. The
hostilities not only delayed the French ambassador La Rochefoucauld in taking up his
post in Rome (see chapter 4) but also kept the British at home, with George Vertue
(1684–1756) noting in October 1746 that "of late few persons travel to Italy from hence
during the wars."[6]

Vertue also mentioned that Canaletto was encouraged to move to London by Jacopo Amigoni (ca. 1685–1752), who had returned to Venice in 1739.[7] The prospect of lucrative commissions to commemorate Westminster Bridge may have been why Canaletto arrived in May 1746, shortly before its completion.[8] Billed by its architect as "a considerable Means towards the Increase of Trade, Manufactures, and useful Arts; a very great Ornament to the Capital of the British Empire; [and] an Honor to the Commissioners in particular,"[9] the monumental bridge was seen as a marvel of modern engineering and financial prowess. Its sober but elegant neo-Palladian design evoked Britain's aspiration to emulate the patrician virtue, stability, and rationality of the Serene Republic.[10] Several of the bridge's commissioners already owned Venetian views by Canaletto. The artist's mastery of water views coalesced with steady demand to make Westminster Bridge his most frequent English subject. These views further illustrate the quality gap that elevated a handful of Italian specialists above all other European view painters. Among Canaletto's earliest pictures painted in London is the striking composition—without precedent in his work—of an urban panorama seen through an arch of the bridge, still with its timber centering (fig. 143).[11]

Westminster Bridge: Anticipation and Completion

The bridge is also the protagonist in Canaletto's first English reportorial painting, which records a procession on the Thames on the occasion of Lord Mayor's Day on 29 October 1746 (fig. 144).[12] On his way to being sworn in before the Barons of the Exchequer and presented to the king, the new lord mayor, William Benn (d. 1755), sailed upriver from the City to Westminster "with the usual pomp."[13] As the term of office was only twelve months, this ceremony took place in the same manner every year on 29 October: "The lord mayor, aldermen, recorder, and sheriffs, go on board the city barge, attended by several corporations of the citizens, in their formalities, and magnificent barges, pompously adorned with a great number and variety of flags and pendants; and thence proceeding to Westminster, form an august and majestic appearance upon the Thames."[14] The city barge with the mayor, depicted in the central foreground with a blue cabin roof, is escorted by a flotilla of other vessels representing the City of London livery companies.[15] Shown on the open water, from left to right, are the barges of the skinners, goldsmiths, fishmongers, mercers, and drapers; under the arches are those of the clothworkers, vintners, and merchant tailors.[16] Although the final stone of the bridge had been laid a few days before Lord Mayor's Day, it was still lacking much of its balustrade. As Panini had done with Santa Maria Maggiore in 1742 (see fig. 211)[17] and as Bellotto would do with the Hofkirche in Dresden in 1748,[18] Canaletto completed the structure based on what was projected at the time. Ultimately, only twelve of the half-domed stone alcoves intended to protect pedestrians from sudden downpours were built, four each in the middle and at either end of the bridge, rather than over every pier, as Canaletto anticipated. He also included the planned statues of the river gods Thames and Isis over the central arch, which remained unexecuted. Richard Wilson similarly depicted one of the river god figures in a view of the bridge's early state of construction in 1744, suggesting that some patrons wanted the sculptures shown—perhaps as part of a campaign to ensure their realization—and made drawings or even a model available to the painters (fig. 145).[19]

FIG. 144
Canaletto (Italian, 1697–1768). *Westminster Bridge with the Lord Mayor's Procession on the Thames*, 1746–47. Oil on canvas, 96 × 128 cm (37¹³⁄₁₆ × 50³⁄₈ in.). New Haven, Yale Center for British Art, Paul Mellon Collection, inv. B1976.7.94

Canaletto's view showing the bridge under construction, executed probably in late 1746 for one of the project's most active commissioners, Sir Hugh Smithson, 4th Baronet, later 1st Duke of Northumberland (1712–1786), indicates that other patrons asked for the bridge to be shown in its state at a particular moment, with the shelters at the end and in the middle of the bridge already in place but the parapet and balustrades still unfinished (fig. 146).[20] In this as in several other Westminster Bridge paintings, the chronology of Canaletto's views in order of execution is not always corroborated by the state of construction shown.[21] The bridge was first opened on 25 October 1746, but after one of the piers was found to be subsiding in September of the following year,[22] two of the arches had to be dismantled and rebuilt before it could be reopened on 17 November 1750.[23] In the majority of his paintings and drawings of the bridge, Canaletto assumed

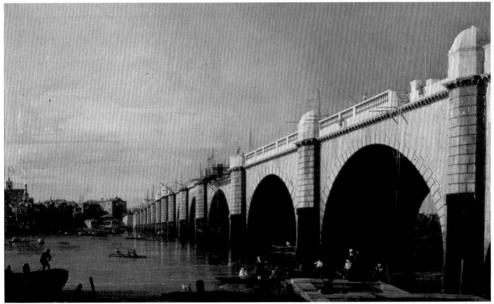

that the full complement of shelters as well as the pair of statues would eventually be installed.[24] This expectation is also evident in a description of the bridge in the *Universal Magazine* in December 1750 and (with identical text) in *Gephyralogia*, a treatise on the history of bridge building published the same month. Its anonymous author commended the presence of night watchmen on the bridge as "the recesses over each pier, which are built in the form of alcoves, and designed as places of shelter in bad weather, or of retirement in case of an accidental danger or difficulty in the passage, might have otherwise served for places of ambush to robbers and cut-throats."[25] The engraved view illustrating the description shows the shelters over every pier but no sculptures (fig. 147).

The largest and probably also the earliest of Canaletto's views of the bridge was acquired by a foreign visitor, Ferdinand Philip, 6th Prince Lobkowicz (1724–1784), who

FIG. 145
Richard Wilson (British, 1713/14–1782). *Westminster Bridge under Construction, from the West*, 1744. Oil on canvas, 73 × 146 cm (28¾ × 57½ in.). London, Tate, Purchased with assistance from the National Heritage Memorial Fund 1983, inv. T03665

FIG. 146
Canaletto (Italian, 1697–1768). *Westminster Bridge under Construction, from the Southeast*, ca. 1746. Oil on canvas, 59 × 97 cm (23¼ × 38³⁄₁₆ in.). Collection of the Duke of Northumberland

A Perspective View of the New Bridge at Westminster, Opened the 18.th Nov.r 1750.

FIG. 147
A Perspective View of the New Bridge at Westminster, Opened the 18.th Nov.r 1750, from *Universal Magazine*, December 1750, 168 × 293 mm (6⅝ × 11 9/16 in.). London, British Museum, inv. Y,4.33

FIG. 148
Canaletto (Italian, 1697–1768). *The Thames and Westminster Bridge from Lambeth*, ca. 1746. Oil on canvas, 118 × 238 cm (46 7/16 × 93 11/16 in.). Prague, Lobkowicz Collections

FIG. 149
Antonio Joli (Italian, 1700–1777). *The Thames and Westminster Bridge from Lambeth*, ca. 1747–48. Oil on canvas, 151 × 278 cm (59 7/16 × 109 7/16 in.). Private collection

arrived in London in 1745 (fig. 148).[26] The sweeping panorama of the Thames is framed on the left by the four towers of Saint John's, Smith Square, and the mass of Westminster Abbey. On the right, Lambeth Palace occupies the foreground, with the dome of Saint Paul's Cathedral discernible on the horizon. Whether the young prince commissioned the painting from Canaletto or saw it on a visit to his studio in the second half of 1746 cannot be determined with certainty. The bridge is shown in a state suggesting that the painting was at least begun before the initial opening in October 1746; the balustrade is incomplete, and several of the arches on the right are shown with their wooden centerings still in place. Two views of Westminster Bridge by Joli closely follow Canaletto's composition. In the larger version, datable to circa 1747–48, he showed the finished bridge but still anticipated shelters over every pier (fig. 149);[27] in the smaller version, probably executed circa 1748–49, he corrected the shelters to reflect their ultimate arrangement.[28]

On the river, a single ceremonial barge has moved into view from the left, preceded farther downriver by a smaller vessel of the same type. Two more ceremonial barges head in the opposite direction, one of them cropped to the carved tailpiece and part of the cabin, at the extreme left of the composition. While it is tempting to see their presence as indicating a specific occasion, these vessels—many of which were barges owned by the City's livery companies—were more frequently present on the Thames than, for example, the ambassadorial parade gondolas on the canals of Venice (see chapter 2).[29] The fact that Joli faithfully copied the river activity from Canaletto while making multiple changes to the bridge is further evidence that this composition was not understood as a record of a specific occasion.

The opposite is true of the pendant that Lobkowicz commissioned from Canaletto at some point before leaving London in summer 1748; it has few equals as an evocation of Georgian London at its most splendidly festive and numbers among the greatest

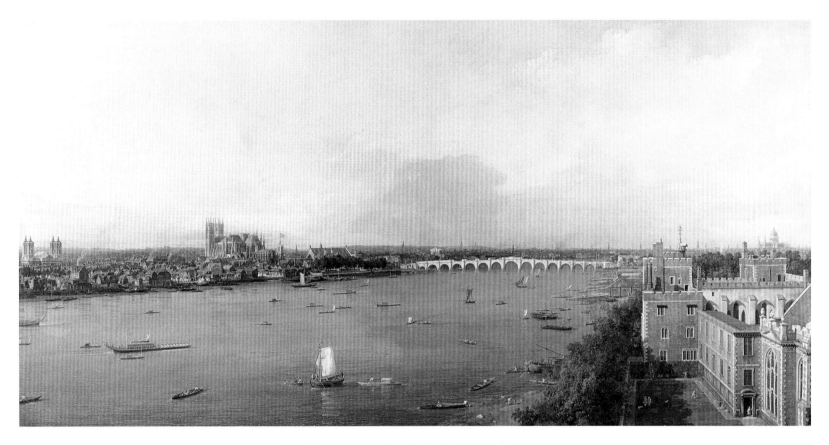

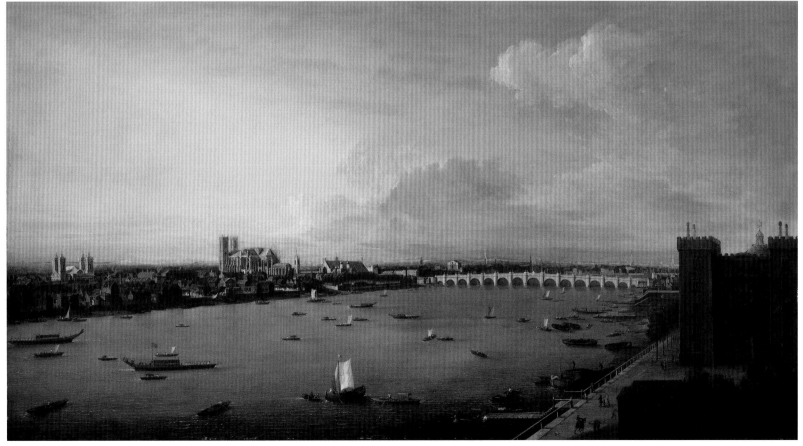

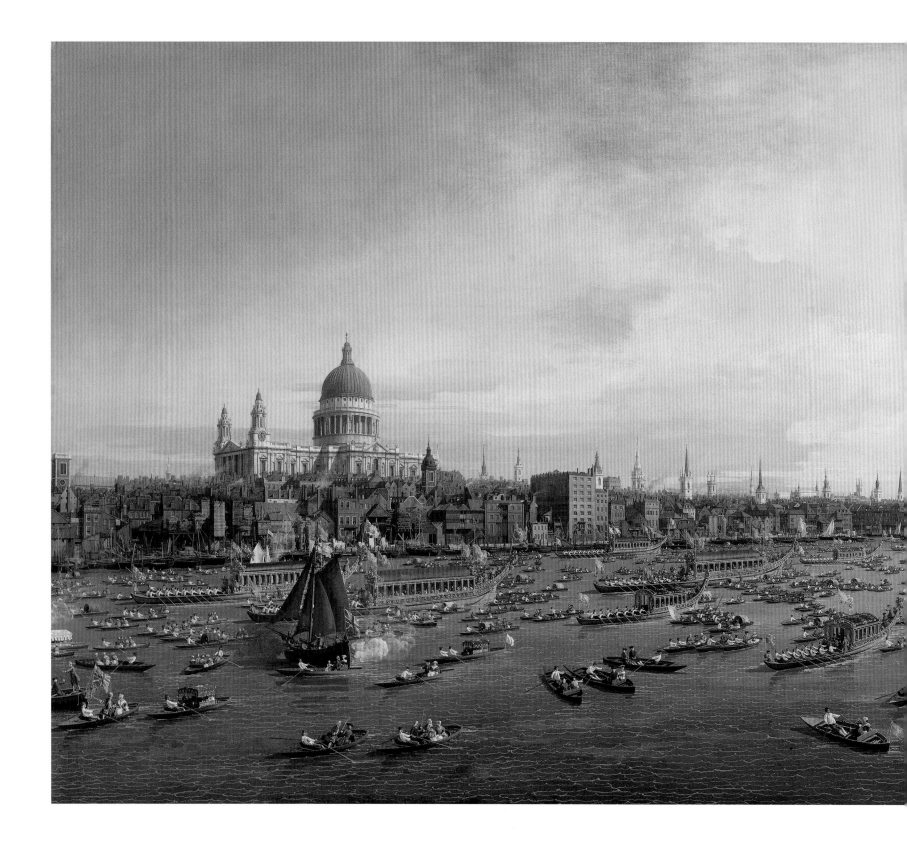

FIG. 150
Canaletto (Italian, 1697–1768). *The Thames with the Lord Mayor's Procession*, ca. 1748. Oil on canvas, 119 × 238 cm (46⅞ × 93¹¹⁄₁₆ in.). Prague, Lobkowicz Collections, inv. LR5516

accomplishments of his entire career (fig. 150).[30] The juxtaposition of a highly reportorial painting with a topographical view, of a transient with a permanent scene, is unusual but not unique.[31] In this case, it is perhaps best understood through the eyes of the patron: to Lobkowicz, a temporary visitor, it was not only the ceremony that was worth recording but the urban environment as a whole that took on an unrepeatable character and needed to be captured for display at home.

In unfurling the spectacular waterborne pageant, Canaletto created a visual next of kin to Handel's *Water Music*, composed in 1717 for an occasion not dissimilar to the one depicted and animated by the same spirit of naval exuberance as the painting.[32] The smoke of salutes fired from several sloops lingers in the air, colorful standards and pennants flutter in the wind, and the gilded barges of the livery companies proceeding upstream are surrounded by shoals of smaller boats carrying hundreds of spectators. Out of the disorderly clutter of rooftops on the north bank rises the monumental bulk of Saint Paul's Cathedral, followed by a parade of Wren's church spires that lead the eye toward the tall column of the Monument, which commemorated the fire that had necessitated their construction. In the far distance, two corner towers of the Tower of London, framing an English flag, jut out above the houses on Old London Bridge.

The two Lord Mayor's Day processions that occurred during Lobkowicz's stay in London—for Benn on 29 October 1746 and for Sir Robert Ladbroke (1713–1773) twelve months later—are the obvious candidates for the occasion depicted.[33] However, the scene's unalloyed exuberance raises two other possibilities: either Canaletto took a great deal of artistic license and created a spectacle far more dazzling than an actual Lord Mayor's Day, or he depicted a singular celebration held for a different reason. The latter alternative may also explain the existence of a Canaletto drawing at Stourhead, where it was catalogued in 1822 by Sir Richard Colt Hoare, 2nd Baronet (1758–1838), as "a spirited drawing by Canaletti of the River Thames on a Lord Mayor's day" (fig. 151).[34] A chronological difficulty arises from the fact that the mayoralty of Hoare's grandfather Sir Richard Hoare (1709–1754) commenced (and therefore his procession took place) on 29 October 1745, seven months prior to Canaletto's arrival in London.[35] The sheet shows several ceremonial barges in front of Westminster Bridge, which is depicted with shelters over every pier and the statues of Thames and Isis.

FIG. 151
Canaletto (Italian, 1697–1768). *Westminster Bridge with the Lord Mayor's Procession*, ca. 1746. Oil on canvas, 350 × 740 mm (13¾ × 29⅛ in.). Stourhead, National Trust, inv. NT 730687

An extraordinary event that appears to fit the parameters was reported in the *Gentleman's Magazine* for 6 August 1746—while Canaletto and Lobkowicz were both in London and Hoare was mayor: "The lord mayor, aldermen, and a committee of the common council of London went in a grand procession, and presented his royal highness the Duke of Cumberland with the freedom of the city in a gold box, curiously engraved with the city arms, which his R. H. accepted in a very obliging manner."[36] Although there is no direct evidence in the contemporary sources to determine whether this "grand procession" traveled to Westminster by road or on the Thames, it would be a considerably stronger candidate for the event depicted in Canaletto's imposing canvas than a routine Lord Mayor's Day. The Duke of Cumberland was feted as the victor over the Jacobite forces at the Battle of Culloden (16 April 1746), and Hoare, as lord mayor, had raised considerable sums of money to support his troops.[37] Canaletto produced at least two cabinet-sized versions of the composition first developed in the Stourhead drawing that show the arrival of the barges at Westminster Bridge, one version of which could originally have been intended for Hoare (fig. 152).[38] The procession held on 25 May 1750 for John Blachford, elected lord mayor for an abbreviated term after his predecessor's death in office, has been proposed as the event depicted in the two paintings on the basis of the identification of the arms of the Goldsmiths' Company, to which Blachford belonged, on one of the barges.[39] However, both Hoare and

FIG. 152
Canaletto (Italian, 1697–1768). *Westminster Bridge with the Lord Mayor's Procession*, ca. 1746–47. Oil on canvas, 46 × 76 cm (18⅛ × 29¹⁵⁄₁₆ in.). Private collection

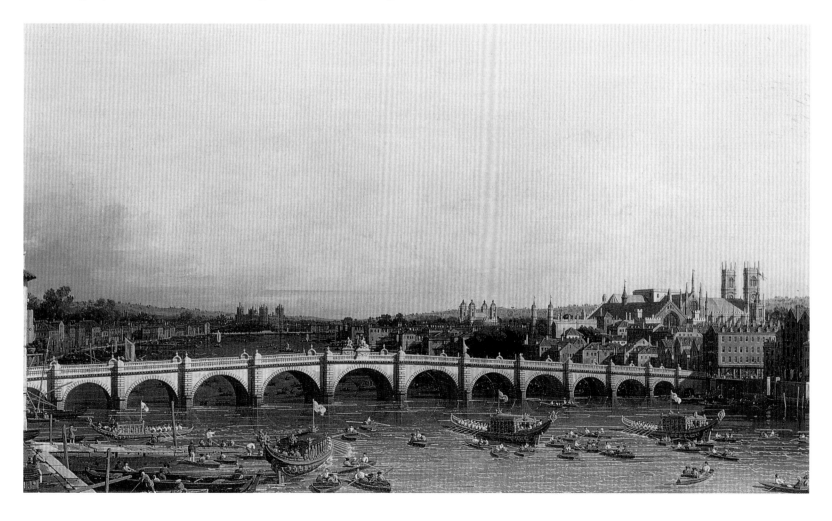

his successor, Benn, were also members of the Goldsmiths' Company, and the brief account of Blachford's procession in the *Gentleman's Magazine* states that the city barge was accompanied by only one other vessel.[40] Moreover, the composition and its pendant, *The Thames from Somerset House Terrace toward the City*,[41] were known to Joli by 1749 at the latest, when he painted a pair of canvases appropriating Canaletto's compositions but showing the Lord Mayor's Day procession of Blachford's predecessor, Sir Samuel Pennant (1709–1750), on 30 October 1749.[42] The event is identifiable by the arms of the Ironmongers' Company, who supplied only a single lord mayor during Joli's years in London.[43] Canaletto's paintings are therefore likely to predate Joli's departure for Madrid in the winter of 1749–50. This would exclude the Lord Mayor's Day procession of May 1750 as the subject of a canvas by Canaletto that Joli could have had access to before leaving London.[44]

Chronicling Courtly Entertainments

Just like his move to London in 1744, Joli's decision to leave for Spain at the end of 1749 was owed to the world of opera. His employment at the King's Theatre had come to an end a year earlier, and when the death of the stage designer for the royal theaters in Madrid, Giacomo Pavia (1699–1749), created an opening at the Spanish court, the singer Farinelli (Carlo Broschi, 1705–1782) recommended Joli.[45] His considerable talents as a view painter allowed Joli to become the chronicler of the festivals Farinelli organized for King Ferdinand VI (r. 1746–59) and Queen Maria Barbara of Braganza (1711–1758). The singer no longer appeared on the opera stage, performing exclusively for (and occasionally with) the highly musical royal couple. The court's preferred venue for leisure and diversion was the country palace of Aranjuez, fifty kilometers south of Madrid.[46] There, on the banks of the Tagus River, Farinelli initiated the construction of a pleasure fleet of five boats, presented to the king on the feast of Saint Ferdinand, his name day, on 30 May 1752.[47] It is tempting to speculate that Joli, who had gained relevant experience when designing some of the ceremonial barges for the regatta in honor of Friedrich Christian of Saxony in Venice in 1740 (see fig. 91), had a hand in the decoration of these vessels.[48]

In all probability, its first sailing occasioned Joli's view of the royal fleet at the hairpin bend in the Tagus (fig. 153).[49] In order to clarify the location to the viewer, the west facade of the palace appears at left, but the focus is on the royal longboat, the largest of the five vessels, in the foreground (fig. 154). Its cabin, combining carved and gilded rocaille ornamentation with luxurious fabrics, displays the same degree of opulent sophistication as the ambassadorial parade gondolas in Venice (see chapter 2); the sail was made of crimson damask.[50] These and many other details about the longboat and the four other vessels are recorded in an extraordinary document, a presentation manuscript compiled for and, in part, by Farinelli in 1758. The volume painstakingly describes the operas and all other festivities Farinelli organized for the court, including the royal boat trips on board the pleasure fleet at Aranjuez. Interspersed with the text is a set of watercolor illustrations for each of the vessels, matching their depictions in the painting, by Francesco Battaglioli, who had succeeded Joli as the stage designer for the royal theaters in 1754 (fig. 155).[51] The passenger list for 1754, the earliest available, records that the longboat was staffed by

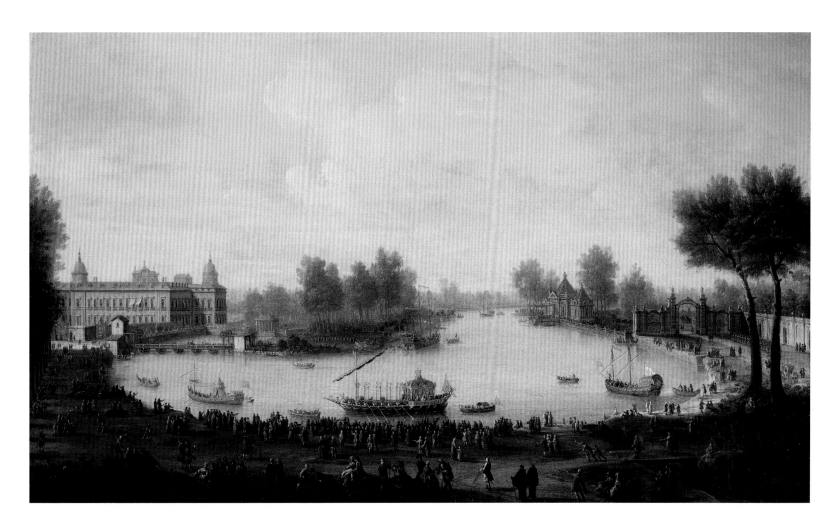

a crew of twenty-four sailors and carried the king, queen, Farinelli, and various senior court officials. On the prow, a band of two violins, two violas, two oboes, and two trumpets provided musical accompaniment during the voyage.[52] In Joli's view, the spectators on the riverbank may have assembled to greet their monarchs, but they could also have arrived in the expectation of a virtuoso performance: on the boat's balcony, Ferdinand VI appears at left, Maria Barbara in the center, and a figure likely to be Farinelli stands directly beside her on the right. The manuscript records that he usually sang two arias during the boat trips, often accompanied by the king or queen.[53]

In addition to waterborne entertainments, Farinelli's responsibilities as the impresario in charge of the court's festivals included the staging of operas, fireworks, and illuminations. The two most important occasions celebrated every year were the king's name day on 30 May and his birthday on 23 September. The feast of Saint Ferdinand fell during the court's annual residency at Aranjuez in late spring and early summer. In 1756 the singer commissioned a pair of view paintings documenting the elaborate illuminations he had arranged for this day (fig. 156).[54] At the center of the royal group advancing through the garden parterre, Maria Barbara of Braganza is seated on a three-wheeled chaise necessitated by her poor health (fig. 157). She is flanked on the left by Ferdinand VI and on the right by a wearer of the blue riband of the Order of the Holy Spirit, probably Fernando de Silva Alvarez de Toledo (1714–1776), a senior courtier and close

FIG. 153
Antonio Joli (Italian, 1700–1777). *King Ferdinand VI and Queen Maria Barbara of Braganza on the Royal Longboat at Aranjuez*, ca. 1752. Oil on canvas, 76 × 129 cm (29 15/16 × 50 13/16 in.). Private collection, courtesy Sotheby's

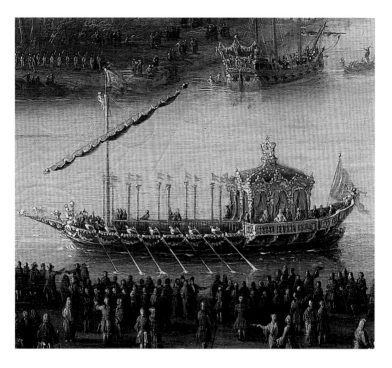

FIG. 154
Detail of fig. 153. Antonio Joli, *King Ferdinand VI and Queen Maria Barbara of Braganza on the Royal Longboat at Aranjuez*, ca. 1752. Private collection

FIG. 155
Francesco Battaglioli (Italian, ca. 1714– ca. 1796). *The Royal Longboat*, 1758, watercolor, from "Descripción del estado actual del Real Theatro del Buen Retiro," Madrid, Patrimonio Nacional, Real Biblioteca, II/1412, fol. 156r

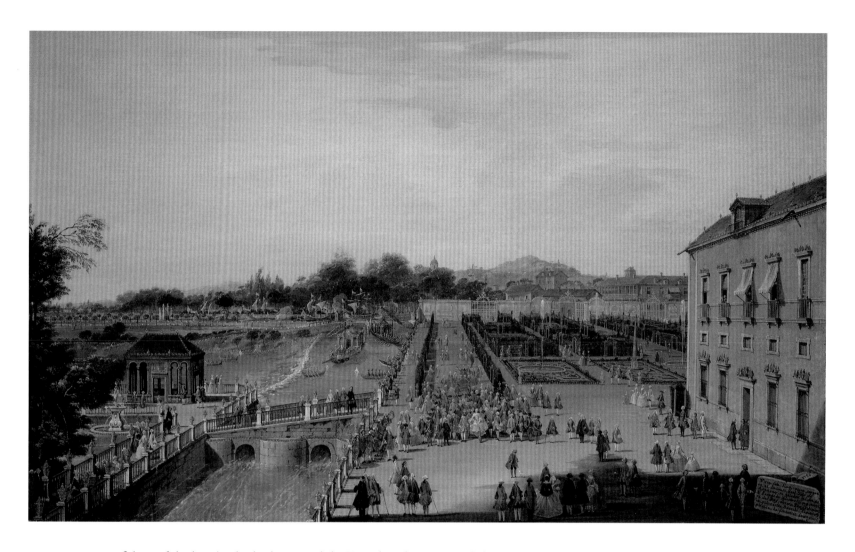

confidant of the king's who had received the French order in 1749 while serving as Spanish ambassador in Paris.[55] Behind him stands a cardinal clad in red robes and a pectoral cross. Due to the date of the painting, this can no longer be the Infante Luis Antonio Jaime, who had resigned his cardinalate and episcopal sees and returned to lay status in 1754. The figure probably represents Cardinal Alvaro de Mendoza (1671–1761), elevated to the Sacred College in 1747 at the request of Ferdinand VI.

Near the bridge at left stands a small group of musicians (with two trumpets, two bassoons, and two horns) in red coats.[56] In front of them appears Farinelli, the painting's patron, turning to directly face the viewer. He wears the same court livery of a blue coat with red cuffs over a red waistcoat in which Corrado Giaquinto (1703–1766) had portrayed him before a double portrait of the king and queen (fig. 158).[57] Battaglioli's pendant, which depicts the arrival of the guests at the gates of the palace, includes neither the singer, nor the royal couple, nor any other identifiable figures (fig. 159).[58] This is for two reasons: firstly, the two paintings were conceived and displayed as a pair, making a repetition of the protagonists redundant; secondly, showing Farinelli only in the presence of the monarch but not during the arrival of lower-ranking courtiers and guests underscored his elevated status and influence. The royal pleasure fleet he masterminded is included, although peripherally, in both views.

FIG. 156
Francesco Battaglioli (Italian, ca. 1714–ca. 1796). *King Ferdinand VI and Queen Maria Barbara of Braganza in the Gardens at Aranjuez on the Feast of Saint Ferdinand*, 1756. Oil on canvas, 68 × 112 cm (26¾ × 44⅛ in.). Madrid, Museo del Prado, inv. P04181

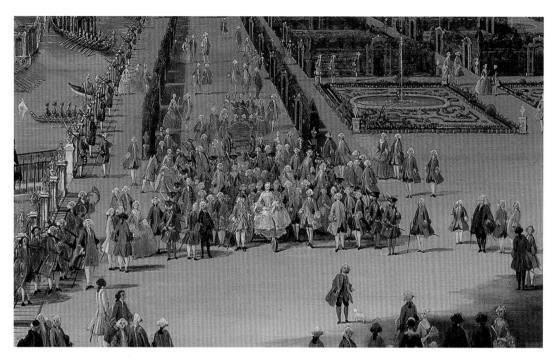

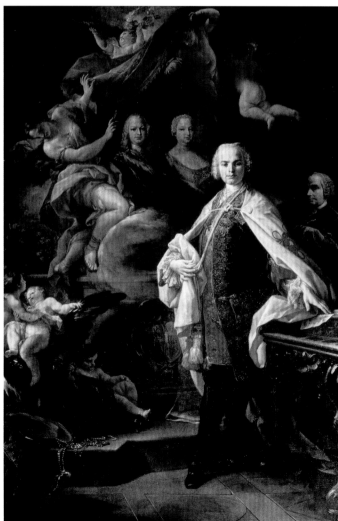

FIG. 157
Detail of fig. 156. Francesco Battaglioli, *King Ferdinand VI and Queen Maria Barbara of Braganza in the Gardens at Aranjuez on the Feast of Saint Ferdinand*, 1756. Madrid, Museo del Prado

FIG. 158
Corrado Giaquinto (Italian, 1703–1766). *Carlo Broschi, Called Farinelli*, ca. 1753. Oil on canvas, 276 × 186 cm (108¹¹⁄₁₆ × 73¼ in.). Bologna, Museo internazionale e biblioteca della musica, inv. B 10982 / B 39188

In many of its mechanisms and intended statements, the pair of paintings Farinelli commissioned from Battaglioli parallels Panini's view of the preparations for the celebrations in Piazza Navona commissioned by Cardinal de Polignac in 1729 (see figs. 131, 132).[59] As daytime scenes that record a point in time prior to the illuminations and fireworks after sunset, they allow the viewer to appreciate the enormous effort invested in the celebrations, with the lanterns and candles at Aranjuez outlining every architectural element, railing, and flower bed, stretching even along the banks of the Tagus. The patrons are clearly identifiable in the foreground—Polignac with his cardinal's robes and the Order of the Holy Spirit, and Farinelli in his court livery next to the musicians. Their status is heightened through their proximity to (implying familiarity with) crowned heads, even if the cardinal, in the absence of any other royalty in Rome, had to make do with an exiled Stuart king.

Battaglioli's compositions each include a stone slab placed prominently in the foreground, bearing identical inscriptions. In addition to providing a place for the artist's signature and the date, this visual device fulfills the same role as the lettering on the engraving of Polignac's painting (see fig. 135), which named the cardinal as the driving force behind the homage and identified its royal recipient. The inscriptions on the Aranjuez pair convey the equivalent message: "View of the illumination celebrating the

FIG. 159
Francesco Battaglioli (Italian, ca. 1714–ca. 1796). *Arrival of the Guests at Aranjuez on the Feast of Saint Ferdinand*, 1756. Oil on canvas, 68 × 112 cm (26¾ × 44⅛ in.). Madrid, Museo del Prado, inv. P04180

most glorious day of Saint Ferdinand, name of the king our lord, at the delightful royal residence of Aranjuez, arranged by Carlo Broschi Farinelli, painted by Francesco Battaglioli 1756."[60] This proclaims a joint authorship by Farinelli and Battaglioli, who share the responsibility and the credit for this reportorial view. The painter's role is to faithfully record his client's creation.

A Royal Abdication, Departure, and Entry

The flowering of Italian art in Spain was abruptly halted by the death of Ferdinand VI in 1759 and the accession of his half-brother Charles III (r. 1759–88), who quickly dismissed both Farinelli and Battaglioli. It is of some significance that the visual records of Charles's transfer from an Italian to an Iberian throne juxtapose the past and future approaches, that is, the hiring of the best itinerant specialists versus the fostering of local talent, in emblematic fashion.[61] The task of recording the ceremony of Charles's abdication as king of Naples in favor of his eight-year-old son Ferdinand (1751–1825) on 6 October 1759 fell to Joli, who had moved to the city in the interim (see fig. 10).[62] Later the same day, the monarch and his family departed for their new kingdom on board a Spanish fleet.

Since he was originally excluded from the Spanish throne, as the line of succession bypassed him in favor of the children from the first marriage of his father, Philip V, Charles's mother, Elisabeth Farnese (1692–1766), Philip V's second wife, had obtained the Duchy of Parma for him. With the capture of the Kingdom of Naples from the Austrians in 1734, Charles had already attained royal status, but when Ferdinand VI, the last of Philip V's sons by his first wife, died childless in 1759, Elisabeth saw her greatest ambitions for her eldest son fulfilled. To commemorate this triumphal culmination of her decades-long campaign, she commissioned a sweeping view of the bay of Naples showing the departure of the Spanish fleet against a backdrop of the smoking Vesuvius (fig. 160).[63] The painting concentrates on two messages: on the water, Spain's naval power, represented by the sixteen vessels sent to convey the king from Naples to Barcelona; on the shore, the reaction of the Neapolitan population of all social classes and all ages, "unable to hold back the tears" at the loss of a widely beloved king.[64]

Naples' loss was Spain's gain, but as in the case of foreign ambassadors in Rome or Venice (see chapter 2), the official entry of Charles III in Madrid was celebrated much later than his actual arrival. The ceremony took place on 13 July 1760 and was recorded in a printed chronicle and a series of five paintings.[65] With Battaglioli having returned to Italy, this was the first major commission for reportorial view paintings to be awarded to a local painter, Lorenzo de Quirós (1711–1789). He was among the first alumni of the Real Academia de Bellas Artes de San Fernando, founded by Ferdinand VI in 1752 with the purpose of training a cadre of Spanish artists who would be able to match the skill level of the foreign imports.[66] In comparison to the works Joli had produced in Madrid and Naples, Quirós's efforts may not have suggested that the new academy had already attained its goal. The most accomplished of his five views of the ceremonial entry shows the Calle Platerías (today a section of the Calle Mayor), named after the silversmiths whose workshops were located there (fig. 161).[67]

FIG. 160
Antonio Joli (Italian, 1700–1777). *The Departure of Charles III from Naples to Become King of Spain*, 1759. Oil on canvas, 128 × 205 cm (50⅜ × 80¹¹⁄₁₆ in.). Madrid, Museo del Prado, inv. P00232

FIG. 161
Lorenzo de Quirós (Spanish, 1711–1789). *Decoration of the Calle Platerías for the Entry of Charles III in Madrid*, ca. 1760. Oil on canvas, 111 × 167 cm (43¹¹⁄₁₆ × 65¾ in.). Madrid, Museo de Historia de Madrid (on deposit from Real Academia de Bellas Artes de San Fernando), inv. 0844

Among the city's wealthiest trades, the street's occupants had created one of the most spectacular displays along the route of the royal procession. Every available balcony had been hung with damask cloths or tapestries with subjects ranging from the Expulsion from Paradise to Hercules Slaying the Nemean Lion. The printed description noted that "in the street of the silversmiths, decorated by the craftsmen-silversmiths of Madrid, a matching order of composite pilasters runs along both sides of the street."[68] At either end, the decorative facade was bracketed by pairs of double columns surmounted by gilded vases and atlantids. These ephemeral structures, designed by the director of architecture at the recently established Academia de San Fernando, Ventura Rodríguez (1717–1785), used the same construction techniques as their equivalents in Italy: a wooden armature underneath painted canvas surfaces with stucco and papier-mâché decorations.[69] Their depiction, however, differs markedly from those created in Rome and Venice in the skill level that Quirós, trained as a history painter, was able to bring to the composition. The serried ranks of pilasters are given in sharp foreshortening, making them appear far less imposing than they must have looked in reality. Most significantly, the chosen perspective disguised the facades' most prominent features, narrowly visible between the columns: "In the center of each one, the Royal Coat of Arms, accompanied by two personifications of Fame, is placed above an inscription, Latin on one side and Castilian [Spanish] on the other."[70]

A comparison with the view of the decorations in Piazza Navona is revealing (see figs. 131, 132). An accomplished view painter, Panini decided to optically widen the long and narrow Piazza Navona in order to devise a viewpoint that allowed him to show the grandiose ephemeral architecture to best advantage and in its entirety, yet that was also close enough to make the inscriptions on the temples legible. Quirós, by contrast, was only able to mimic the topography as it presented itself to him.[71] While providing an accurate visual record, he failed to convey the essential statement, the homage to the monarch. Quirós is not known to have received any further commissions for view paintings after completing the series documenting the entry of Charles III.

The fact that Quirós's canvases lack a sense of occasion in keeping with the momentous nature of the event they depict is partly owed to the fact that the king does not appear in any of them; even Quirós's attempt to build a sense of anticipation in the Calle Platerías scene by showing the detachment of mounted soldiers that preceded the royal cortege falls flat because it creates a void in the center of the composition. In one respect, however, the Spanish artist continued a recent development seen in the work of his more accomplished contemporaries: the emphasis on a sympathetic and lively portrayal of all social classes. This trend echoed the heightened respect for the ordinary population and a concern for its welfare as a principal (though not disinterested) goal of political leadership that a new generation of European rulers—including Charles III, Pope Benedict XIV, and Doge Alvise IV Mocenigo—had in common.

The Population as Protagonist

A closely related effect of this shift in focus was the emergence of a second subcategory of reportorial view paintings. Rather than employing it as a picturesque or adulatory audience at events staged by and for the elite, these works turned the populace

into the protagonist. The distinction between the two subcategories can be summed up as one of date versus occasion: the first subcategory is exemplified by views of ambassadorial entries, celebrations organized to honor prominent visitors or royal births and marriages, and—as the most pronounced cases—the arrival of the courier at Schönbrunn after the battle of Kunersdorf (see fig. 8) and the abdication ceremony of Charles III in Naples, each of them recording a historical moment taking place on a specific date.

Views of the second subcategory represent a recurring occasion without necessarily intending to record a particular occurrence or date. Chief among the subjects of this type were the religious festivals that punctuated the annual rhythms of life. Typically, these works did not include depictions of recognizable individuals, but the absence of the patrons in the compositions did not imply their absence as purchasers. All of these aspects come together in a work that represents the pinnacle of view painting in eighteenth-century Spain, the rendition by Francisco de Goya (1746–1828) of the feast of Saint Isidore, Madrid's patron saint, on 15 May (fig. 162).[72] This annual celebration united all social classes and took place in the meadows sloping down from the hilltop church of Saint Isidore, from which the view is taken, to the river Manzanares. Commencing with a pilgrimage from the city and culminating in an alfresco repast, the event happily combined devotional and recreational elements. Goya captured the day's atmosphere in consummately observed details such as the woman pouring red wine into the glass of a gentleman stretched out on the grass at right (fig. 163). The small canvas is an oil sketch produced as the design of a tapestry for the apartment of the king's granddaughters in the El Pardo palace in Madrid. At its intended size, the view would have exceeded even the largest of Canaletto's and Panini's paintings, creating an immersive

FIG. 162
Francisco de Goya (Spanish, 1746–1828). *The Meadow of San Isidro*, 1788. Oil on canvas, 42 × 91 cm (16 9/16 × 35 13/16 in.). Madrid, Museo del Prado, inv. P00750

FIG. 163
Detail of fig. 162. Francisco de Goya, *The Meadow of San Isidro*, 1788. Madrid, Museo del Prado

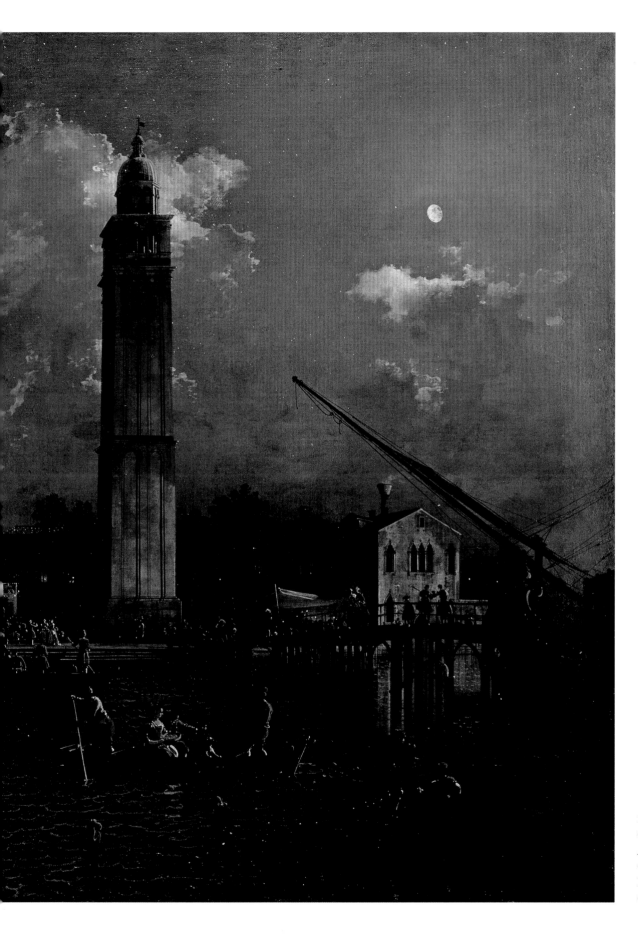

FIG. 164
Canaletto (Italian, 1697–1768). *The Night Festival of San Pietro di Castello*, ca. 1760. Oil on canvas, 119 × 187 cm (46⅞ × 73⅝ in.). Berlin, Streitsche Stiftung, on loan to Gemäldegalerie, inv. Streit.4

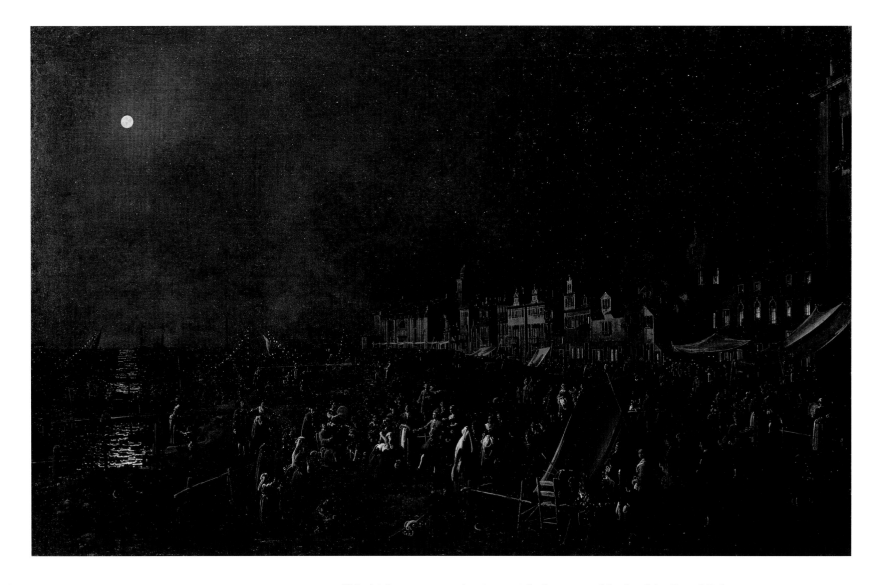

FIG. 165
Canaletto (Italian, 1697–1768). *The Night Festival of Santa Marta*, ca. 1760. Oil on canvas, 119 × 187 cm (46⅞ × 73⅝ in.). Berlin, Streitsche Stiftung, on loan to Gemäldegalerie, inv. Streit.6

panorama of Madrid seen across the river, with the square block of the Royal Palace on the left and the dome of the church of San Francisco el Grande in the center, but the death of Charles III in 1788 caused the project to be put on hold, and the tapestry was never executed.

Periodic yet far from mundane, recurring events offered view painters a rich seam of anecdotal material and picturesque customs. The closest Venetian equivalent of Goya's convivial feast day gathering is Canaletto's pair of moonlit scenes depicting the night festivals of Saint Peter and Saint Martha (figs. 164, 165).[73] A festive mood of eating, drinking, singing, and dancing by the shine of bonfires and lanterns pervades both. In the square in front of San Pietro in Castello, the city's cathedral church and seat of the patriarch (the bishop of Venice) until 1807, a bakery set up underneath a canvas awning at left offers fresh cakes, while a performance in the puppet theater between the church and the belfry draws an appreciative crowd. The festival took place on 28 June, the vigil (or eve) of the feast of Saints Peter and Paul, the patronal feast of the church. Correspondingly, the vigil of Saint Martha on 28 July was celebrated at the opposite, west end of the city on the waterfront near the church of Santa Marta.

Venice by Candlelight

Neither of the two night scenes, produced around 1760, can be securely dated to a specific year, yet they are expressly documentary in character. They were commissioned by Sigismund Streit (1687–1775), a wealthy German merchant who had settled in Venice in 1709. After his retirement in 1750, the bachelor decided to leave an endowment to the school in Berlin he had attended as a boy. Wishing to ensure that the pupils would benefit not only from his largesse but also from his experience abroad, he donated a group of Venetian paintings to the school in 1758 and 1763, coupled with the stipulation that the pupils be given an annual lecture on Venice.[74] The didactic goal of bringing the traditions of Venice, his chosen home, to life for students in Berlin also motivated the choice of the two night festivals, which are unique subjects in the artist's oeuvre. Canaletto observed the participants, ranging from humble fishermen to well-dressed patricians, with an almost anthropological eye, and Streit himself wrote detailed explanations identifying the occasions, customs, costumes, activities, musical instruments, and foodstuffs so that the images would be properly understood in Berlin.[75]

Due to the artistic challenges they presented, views of nocturnal events remained relatively rare. Although it was the most atmospheric religious ritual of the whole year, the Good Friday procession was painted by Guardi in Piazza San Marco only once in his entire career (fig. 166).[76] The patriarchate of Venice, while celebrating its liturgies in the Latin rite, had adopted certain elements of the Alexandrian rite in reverence to Saint Mark, first bishop of Alexandria, whose relics had been transferred to Venice in 828 and were venerated in the basilica named after him. The most spectacular of these Alexandrian rite ceremonies was a procession of the Blessed Sacrament taking place in the illuminated Piazza San Marco at 9 pm on Good Friday.[77] The French geographer and historian Antoine Augustin Bruzen de La Martinière (1662–1746) described the stunning effect of the profusion of candlelight:

> Nothing in the world is as beautiful as Venice during this night, lit by a million torches. The Piazza San Marco offers an enchanting spectacle at this moment. There are two large torches of white wax at each window of the Procuratie. This double row of torches, arranged with regularity, and those lit on the church portal create a very beautiful effect and illuminate all the processions of the confraternities and neighboring parishes that expressly pass through the square. During this time, the entire city seems to be ablaze: white wax is used so liberally that Venice is thought to burn as much of it in this one evening as the rest of Italy in an entire year.[78]

In the procession of the clergy of San Marco, the Blessed Sacrament was carried around the square in a *cataletto* (a symbolic coffin evoking Christ's entombment in the Holy Sepulchre) covered in black velvet. This does not, however, figure in Guardi's view, which appears to depict one of the subsequent confraternity processions. At right, the Sacrament is carried underneath a black canopy, preceded and followed by large and particularly bright lanterns. In the *Histoire générale des cérémonies, moeurs et coutumes*

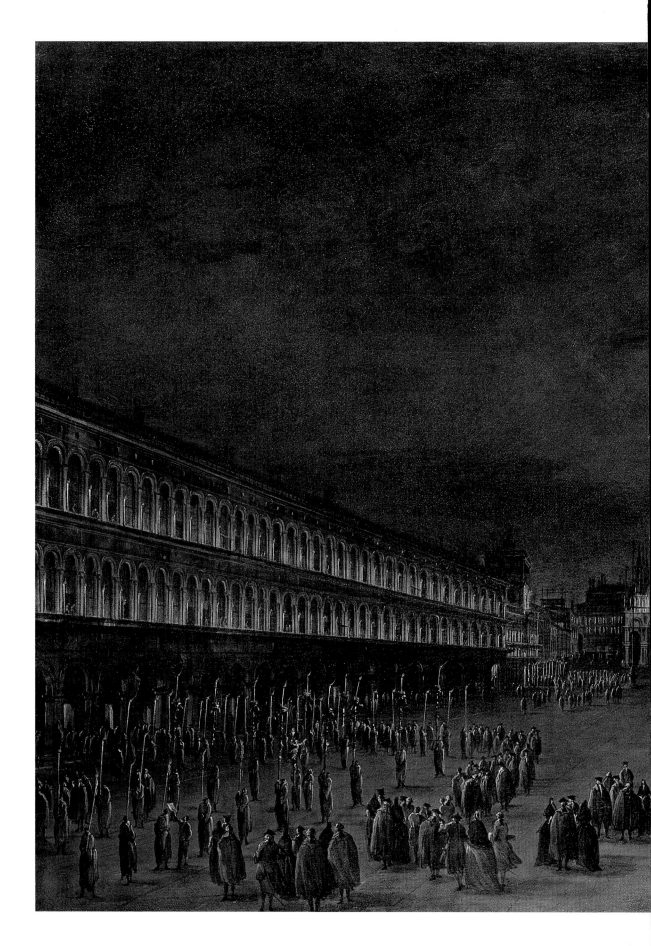

FIG. 166. Francesco Guardi (Italian, 1712–
1793). *The Nocturnal Good Friday Procession
in Piazza San Marco*, ca. 1755. Oil on canvas,
48 × 85 cm (14 15⁄16 × 33 7⁄16 in.). Oxford,
Ashmolean Museum, inv. WA 2937.1 / A386

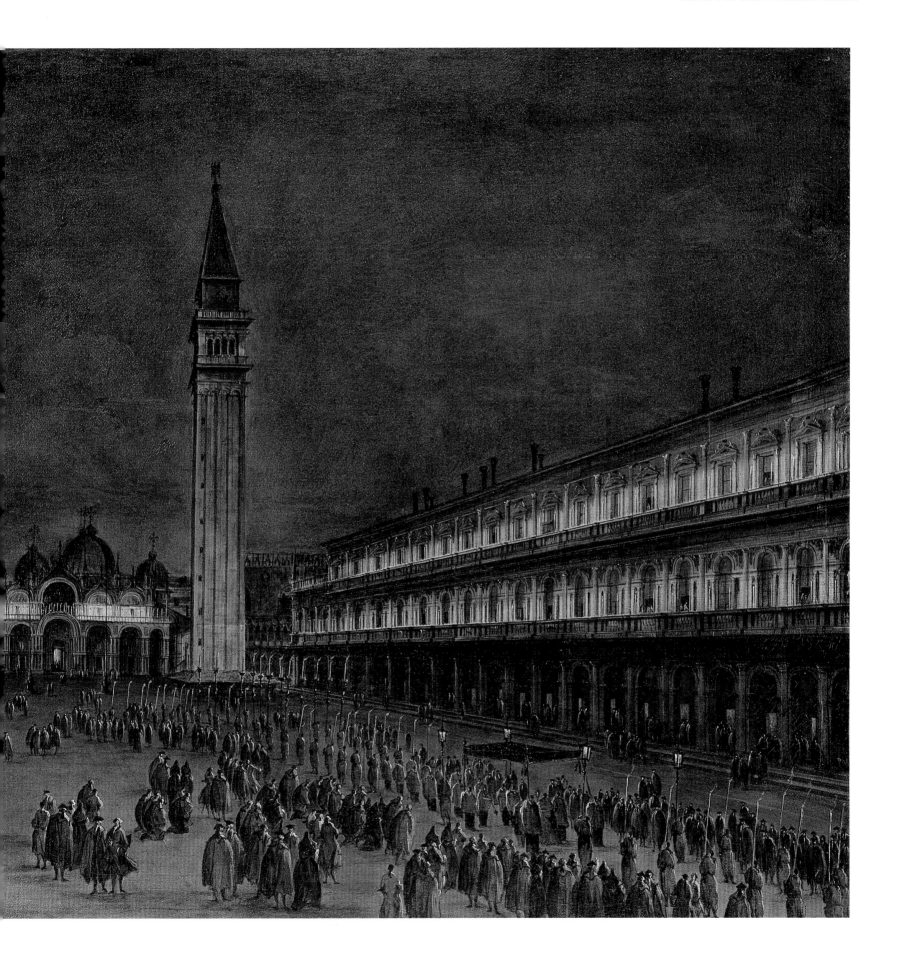

religieuses de tous les peuples du monde, a comprehensive study of the ceremonies of the world's religions published in 1741, the French historian Antoine Banier (1673–1741) provided a detailed explanation:

These are the order and the peculiarities observed in these processions: one sees three or four hundred people carrying large torches of white wax, six feet tall and weighing at least twelve to fifteen pounds each. They walk two and two, with a similar number of other persons who each hold a lantern and walk between two torches, so that one sees a torch alternating with a lantern.... The lanterns are quite large and attached to the end of a pole, with several candles inside them spreading a very bright light through the clear glass that they are made of.[79]

Almost as evocative in its use of the properties of light—in this case, dusk—is an early articulation of the recurring event view: the depiction of the festival of Santa Maria della Salute by Johan Richter (1665–1745), a pupil of Carlevarijs (fig. 167).[80] For the feast of the Presentation of the Virgin on 21 November, a boat bridge across the

FIG. 167
Johan Richter (Swedish, 1665–1745). *The Bridge for the Feast of Santa Maria della Salute*, before 1728. Oil on canvas, 121 × 151 cm (47⅝ × 59⁷⁄₁₆ in.). Hartford, Wadsworth Atheneum Museum of Art, The Ella Gallup Sumner and Mary Catlin Sumner Collection Fund, inv. 1939.268

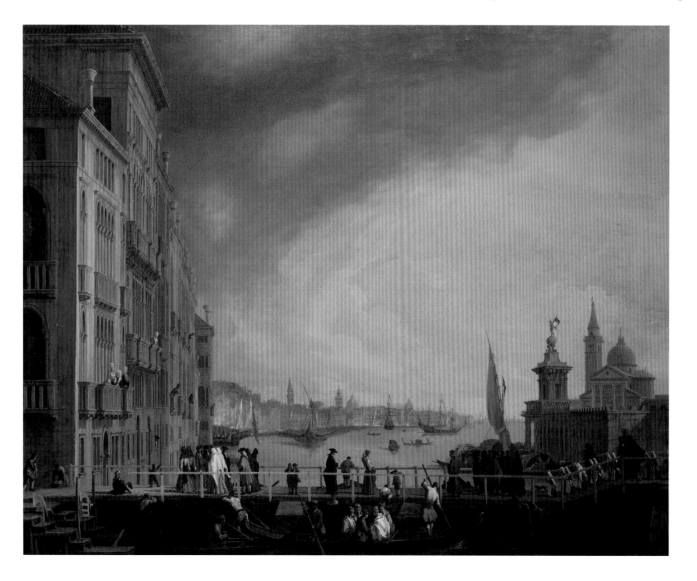

mouth of the Grand Canal was constructed for the pilgrimage to the church, built in thanksgiving for the city's liberation from the plague in 1630. Richter shows neither Santa Maria della Salute, out of the picture at right, nor the formal procession. After a Te Deum celebrated by the patriarch of Venice, the church remained open for the rest of the day, and the population came to pray for divine assistance in all health-related matters. The artist captured the rich and the poor, the old and the young, the pious and the curious on the bridge just before sunset, with a group of schoolgirls in red-and-white uniforms making the return trip after their visit.

Picturesque Piety

The degree to which Canaletto's, Guardi's, and Richter's compositions presume a close familiarity with the occasions they depict suggests that such works were mostly commissioned by local patrons rather than visitors—this is what necessitated Streit's extensive written description of his Canalettos for the benefit of viewers in Berlin. Nonetheless, picturesque renditions of religious festivals were equally attractive to patrons north of the Alps, and when Canaletto's nephew and pupil Bernardo Bellotto had the chance to depict these events, he did so with enthusiasm and empathy. His position as court painter in Dresden offered few opportunities of this nature since, with the exception of the elector who had hired him, practically all of Saxony was Protestant. When the Seven Years' War forced him to move to Vienna in 1759–60, Bellotto captured—with bemusement, one suspects—the colliding exigencies of profound piety and silk stockings (fig. 168).[81] On the feast of Corpus Christi, a procession emerges from the Schottenkirche, a Benedictine abbey church, into the Freyung. As the Blessed Sacrament, carried underneath a canopy, passes the bystanders, they express their veneration by kneeling—to varying degrees: the beggar in the foreground at left and the two monks in the center are unconcerned about their clothes and have both knees in the dirt of the unpaved square, whereas the gentleman in a gray coat by the church entrance is gingerly keeping his bent knee off the ground (fig. 169). Two other gentlemen behind the carriage are bowing rather than kneeling, tricornes in hand. The most awkward posture is that of the coachman, who is trying to bow while staying in his seat so as not to delay his presumably impatient employer inside the carriage.

Bellotto spent the final phase of his career as court painter in Warsaw, as devoutly Catholic as Vienna. As part of a series of views of the city's principal monuments, he recorded the procession of Our Lady of Grace as it passes Krasiński Palace (fig. 170).[82] In this procession, a statue of the Virgin holding broken arrows, alluding to her role as a merciful intercessor against divine wrath, is carried through the streets (fig. 171). The polychrome lindenwood sculpture, attributed to the workshop of Bartłomiej Michał Bernatowicz (ca. 1680–1730) and carved around 1720, wears a gilded crown studded with precious stones and a blue cloak over a gold-colored robe (fig. 172). The event, and by extension Bellotto's painting, brought together the city's faithful, from the nobility to the poor.

The observation of the different social classes and their interactions is equally astute in the work of Panini, both in his views of unrepeatable celebrations (see figs. 106, 131, 132) and of recurring events such as the lottery draw in Piazza di Montecitorio

FIG. 168
Bernardo Bellotto (Italian, 1721–1780).
*The Freyung in Vienna with the Corpus Christi
Procession at the Schottenkirche*, 1759–60.
Oil on canvas, 116 × 152 cm (45 11/16 × 59 13/16 in.).
Vienna, Kunsthistorisches Museum,
inv. GG 1652

FIG. 169
Detail of fig. 168. Bernardo Bellotto,
*The Freyung in Vienna with the Corpus Christi
Procession at the Schottenkirche*, 1759–60.
Vienna, Kunsthistorisches Museum

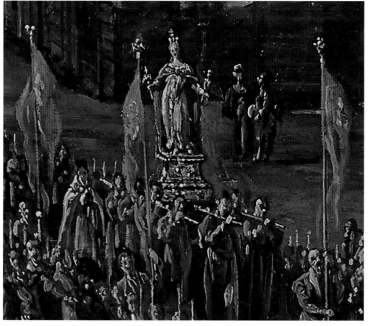

FIG. 170
Bernardo Bellotto (Italian, 1721–1780).
*The Procession of Our Lady of Grace in Front
of Krasiński Palace*, 1778. Oil on canvas,
116 × 164 cm (45¹¹⁄₁₆ × 64⁹⁄₁₆ in.). Warsaw,
Royal Castle, inv. ZKW 454

FIG. 171
Detail of fig. 170. Bernardo Bellotto, *The
Procession of Our Lady of Grace in Front of
Krasiński Palace*, 1778. Warsaw, Royal Castle

FIG. 172
Attributed to workshop of Bartłomiej
Michał Bernatowicz (Polish, ca. 1680–1730).
Our Lady of Grace, ca. 1720, lindenwood
with polychromy, Warsaw, Church of the
Gracious Mother of God

FIG. 173
Giovanni Paolo Panini (Italian, 1691–1765).
The Lottery Draw in Piazza di Montecitorio,
1743–44. Oil on canvas, 105 × 163 cm
(41⁵⁄₁₆ × 64³⁄₁₆ in.). London, National Gallery,
inv. NG6605

FIG. 174
Detail of fig. 173. Giovanni Paolo Panini,
The Lottery Draw in Piazza di Montecitorio,
1743–44. London, National Gallery

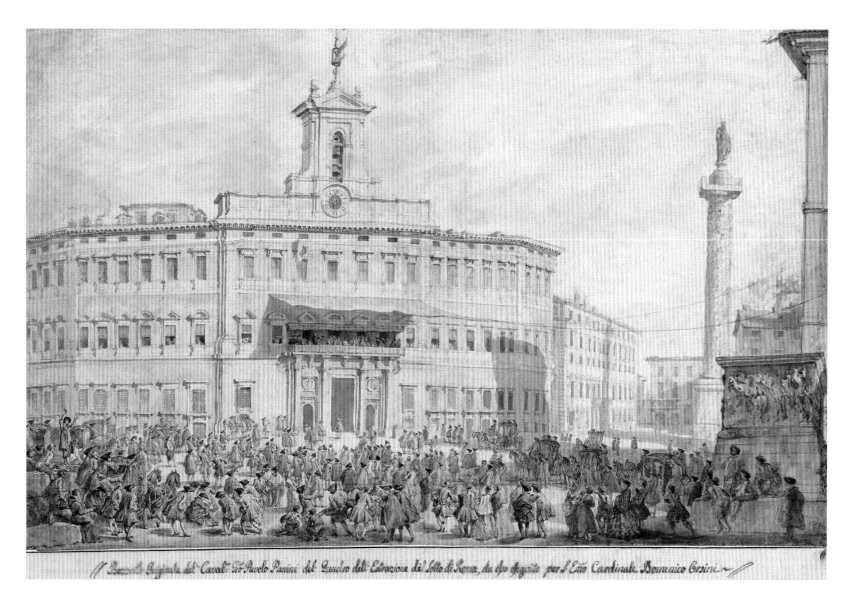

(fig. 173).[83] This is particularly apparent when comparing the painting to the large preparatory drawing Panini made for it (fig. 175).[84] In the study, virtually all of the figures are well-dressed gentlemen wearing black tricornes pointed toward the balcony where the numbers are drawn and will be announced to the crowd; in the painting, Panini captured the whole panoply of the Roman populace—hoop-skirted ladies courted by bewigged gentlemen, clerics, tradesmen, laborers, and mischievous children (fig. 174).[85]

Disaster and Destruction

In contrast to topographical views, which often employed farmers and laborers as charming staffage figures, reportorial views that downplay or even eliminate the presence of the nobility and the bourgeoisie in favor of the lower classes are rare—with one important exception: paintings of disastrous events, such as the fire in Paris captured by Panini's pupil Hubert Robert (fig. 176). The canvas, traditionally identified as depicting the fire at the Hôtel-Dieu in 1772,[86] evokes in fact the blaze at the opera house at the Palais-Royal on 8 June 1781.[87] Opened only eleven years earlier, the opera house was

FIG. 175
Giovanni Paolo Panini (Italian, 1691–1765). *The Lottery Draw in Piazza di Montecitorio*, 1743–44, pen and black ink, watercolor, over graphite, 340 × 545 mm (13⅜ × 21⁷⁄₁₆ in.). New York, Metropolitan Museum of Art, Rogers Fund, 1968, inv. 68.53

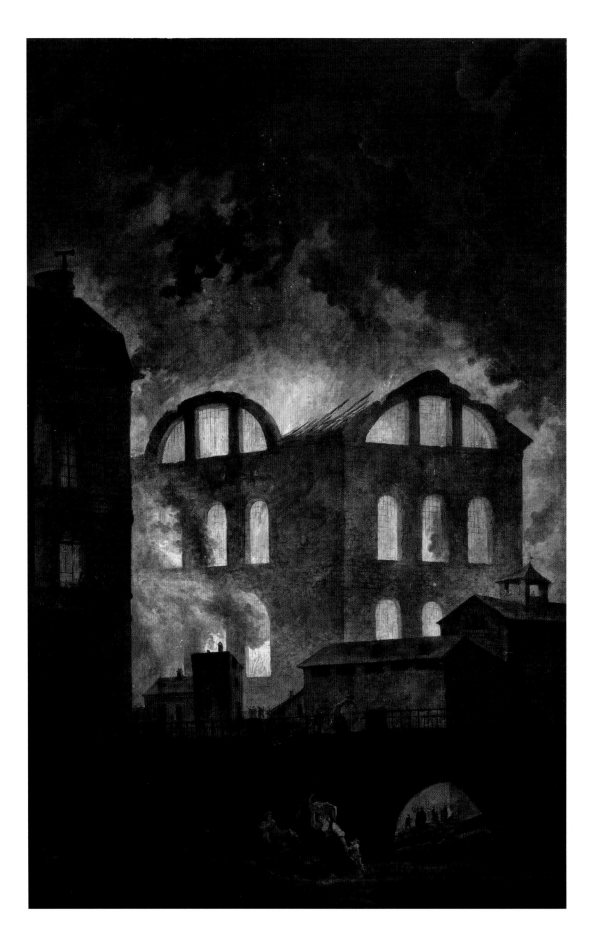

FIG. 176
Hubert Robert (French, 1733–1808). *The Fire
at the Opera House of the Palais-Royal*, ca. 1781.
Oil on canvas, 255 × 166 cm (100⅜ × 65⅜ in.).
Houston, Sarah Campbell Blaffer Founda-
tion, inv. BF.1989.6

completely gutted. The flames were reported to have reached a height of one hundred meters and consumed the entire interior of the theater as well as the rafters within an hour.[88] In the foreground, several mothers with young children are fleeing in terror. The purpose of these figures is twofold: they produce plausibility, since a witness on the scene of the fire would indeed have seen nearby residents escaping to safety; even more importantly, these vulnerable figures emotionally engage the viewer and make the experience of the painting more profound.

Robert's canvas of the morning after the fire is, in every respect, a foil to the horrific nocturnal scene (fig. 177).[89] In the gardens of the Palais-Royal, a crowd of fashionably dressed aristocratic spectators—probably including regular patrons of the opera—has assembled to gawk at the dark smoke rising above the structure, although the site of the burnt-out opera house is hidden from view by a wing of the palace. The frantic dash to safety has been replaced by a leisurely promenade, and the tragedy has become a source of pleasurable frisson. Once again, the figures invite involvement, since the viewer of the painting becomes one of them and experiences the same emotional reactions—awe at the fire's destructive power, relief at not being personally affected.

After the blaze at the opera house, the nocturnal spectacle of the flames shooting up into the sky was inevitably compared to a disaster scene that stimulated the proto-romantic imagination of the late eighteenth century like no other—the eruption of Vesuvius.[90] In *Les Nuits de Paris*, the novelist Nicolas-Edme Rétif de La Bretonne

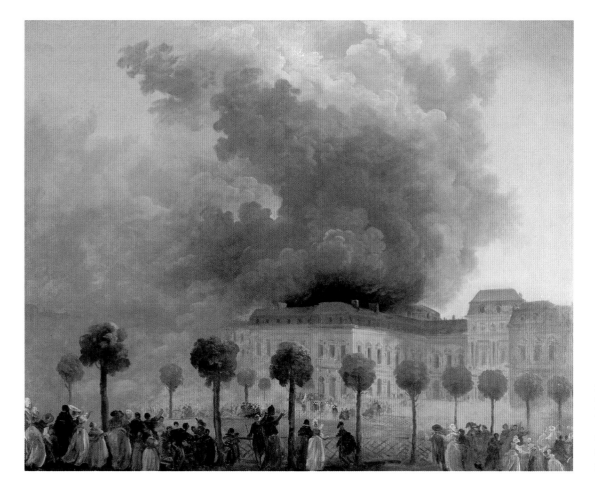

FIG. 177
Hubert Robert (French, 1733–1808).
The Morning after the Fire at the Opera House of the Palais-Royal, ca. 1781. Oil on canvas, 85 × 114 cm (33 7⁄16 × 44 7⁄8 in.). Paris, Musée Carnavalet, inv. P1081

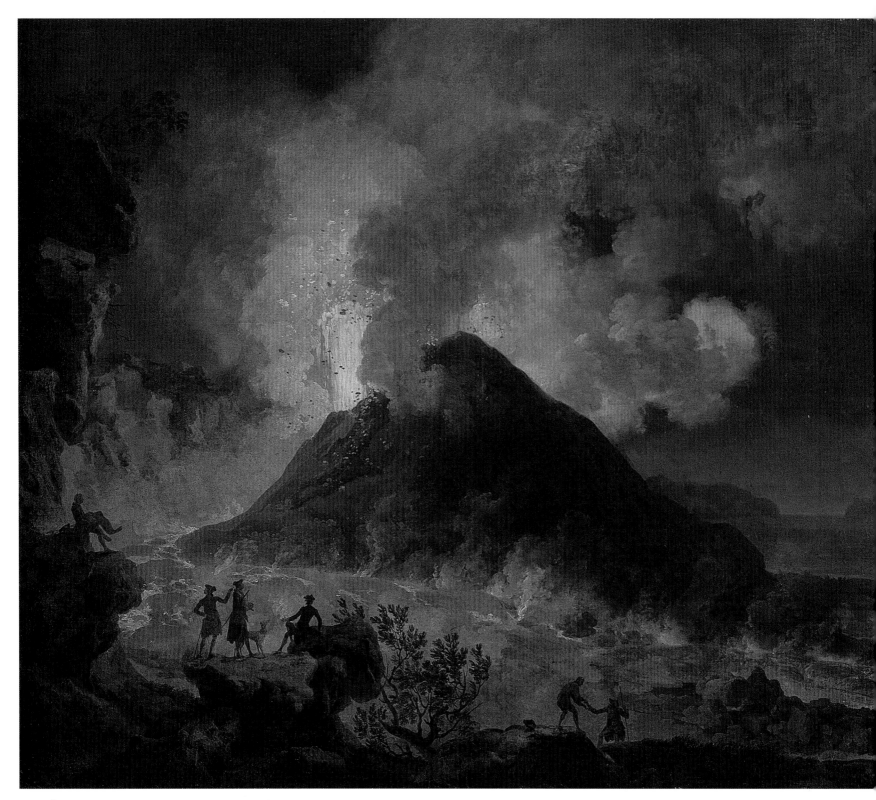

FIG. 178
Pierre Jacques Volaire (French, 1729–1799).
The Eruption of Vesuvius, 1771. Oil on canvas,
117 × 243 cm (46 1/16 × 95 11/16 in.). Chicago,
Art Institute of Chicago, Charles H. and
Mary F. S. Worcester Collection, inv. 1978.426

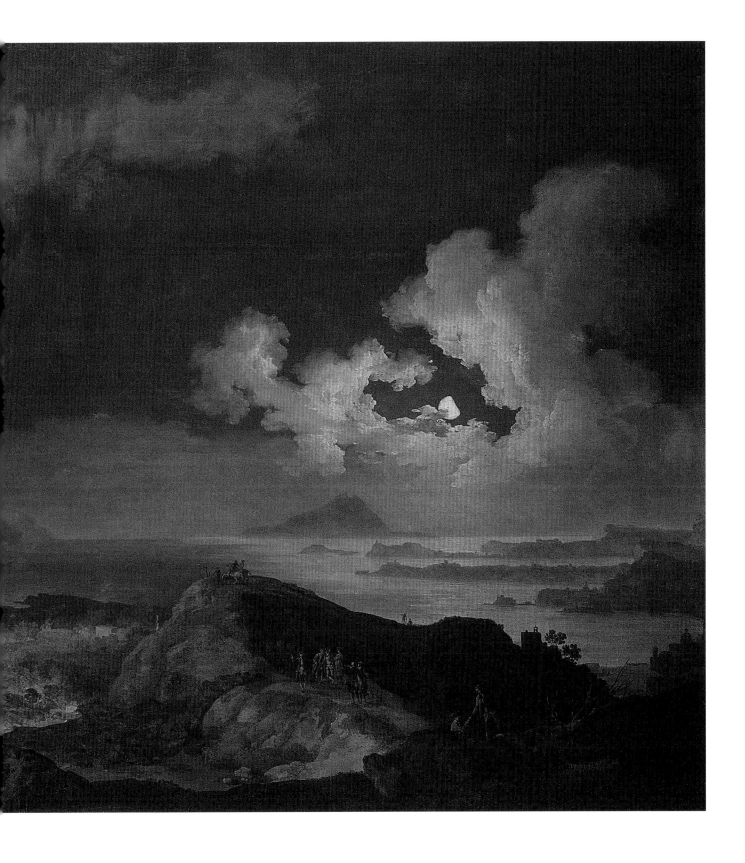

(1734–1806) recalled his reaction on the night of the Palais-Royal calamity: "I never saw a more perfect image of Vesuvius or Etna. . . . From up close, the spectacle of the fire was horrifying. What power nature has through this terrible element! How frightening a blazing volcano must be!"[91] The images that had conditioned the writer's response to the urban conflagration were the countless views of the eruption of Vesuvius produced by painters such as Joseph Wright of Derby (1734–1797), Jakob Philipp Hackert (1737–1807), and, in France, Pierre Jacques Volaire.[92] The latter made a career-defining specialty out of this subject.[93] To distinguish his work from the many imitators who painted the eruption without having seen it, the inscription on one of the largest and most important of Volaire's canvases asserts its authenticity by emphasizing his credentials as an eyewitness: "View of the eruption of Mount Vesuvius on 14 May 1771 painted on-site by the Chevalier Volaire" (fig. 178).[94] Illuminated by the glow of the lava, a group of gentlemen watches with a detached interest that does not even hint at the loss of life and property wrought by the volcano (fig. 179). This rendition of the explosion as a controlled experiment staged for the edification of a gracefully reclining audience contrasts sharply with another of Volaire's finest paintings of the eruption, in which the tourists have been replaced by the helter-skelter flight of the townspeople attempting to save their lives and belongings (fig. 180).[95]

The number of paintings that Robert and Volaire produced of the incidents in Paris and Naples speaks to the high demand for images of fiery destruction. While these depictions still employ the visual tools of reportage, their acquisition and reception was primarily motivated by a desire to stimulate the imagination. This dual purpose is equally obvious in Guardi's view of a fire at the oil depot near the Ponte di San Marcuola in Venice on 28 November 1789 (fig. 181).[96] An oil carpet on the water has ignited, creating the impression that the canal is ablaze. Guardi does not show the oil depot as the source of the fire, focusing instead on the reaction of a throng of onlookers on the other side of the canal. As one of their number, the viewer watches as the inhabitants of the neighboring houses are on the rooftops, desperately trying to stop the fire from spreading. When he executed the picture, Guardi would have been aware of the futility of these efforts, knowing that sixty houses were destroyed by the raging fire, yet he was prepared to subordinate topographical accuracy to a riveting visual account of the event's emotional impact in all its horror and helplessness.

Five years after Charles III had handed over the crown of Naples to his young son, a devastating famine swept the kingdom, claiming two hundred thousand lives, or 5 percent of its population.[97] In order to ease the starvation, the government of prime minister Bernardo Tanucci (1698–1783) set up wooden sheds in Largo di Castello to

FIG. 180
Pierre Jacques Volaire (French, 1729–1799). *The Eruption of Vesuvius from the Ponte della Maddalena*, 1777. Oil on canvas, 135 × 226 cm (53⅛ × 89 in.). Raleigh, North Carolina Museum of Art, Purchased with funds from the Alcy C. Kendrick Bequest and the State of North Carolina, by exchange, inv. 82.1

FIG. 181
Francesco Guardi (Italian, 1712–1793).
The Fire at San Marcuola, ca. 1789–90.
Oil on canvas, 43 × 62 cm (16¹⁵⁄₁₆ × 24⁷⁄₁₆ in.).
Munich, Alte Pinakothek, Unicredit
collection, inv. HuW12

sell the strictly rationed bread supplies at controlled prices, but crowds of peasants flooded into the city from the countryside and stormed them. Joli's depiction of this incident is among the most unusual images produced by a major eighteenth-century view painter (fig. 182).[98] The subject could not be further removed from the sumptuous celebrations in which the lower classes participated only as curious spectators, clambering over a balcony to catch a better look at a foreign dignitary (see figs. 23, 46, 52). Equally extraordinary is the painting's early provenance; it was commissioned by the Neapolitan government as a diplomatic gift to the Habsburg court in Vienna during the negotiations prior to the betrothal of Ferdinand IV, the young king of Naples, to Maria Carolina of Austria (1752–1814) in 1768. Since Tanucci would certainly not have sought to represent Naples as a city in crisis, the message he intended to convey was most likely one of resilience and the need for reform. In the painting, a troop of soldiers arrives to restore order, while the mass of the impregnable fortress dominates the center of the composition, providing a reassuring bulwark against social unrest.[99] Moreover, the prime minister regarded the famine as an opportunity to push for a transformation of

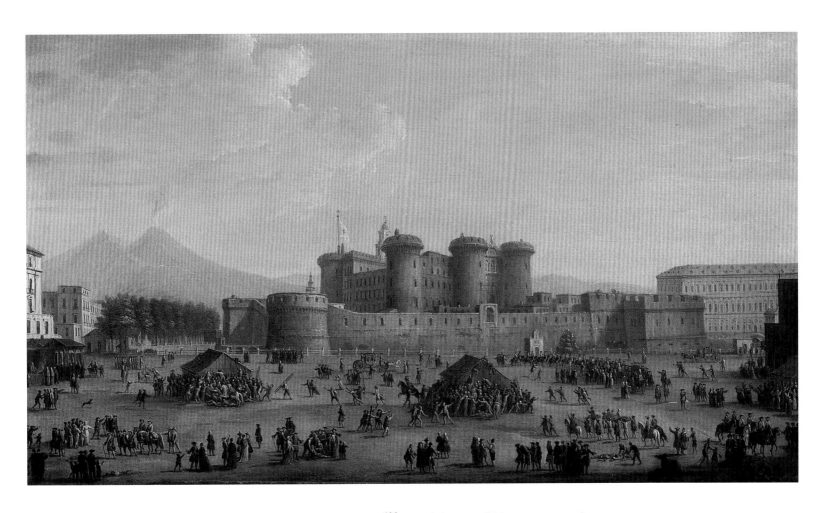

feudal land ownership and agricultural production,[100] a goal that would have resonated with the bride's reform-minded brother Joseph II, crowned Holy Roman Emperor in 1765, in Vienna.

Paintings of tragic incidents satisfied the curiosity of their viewership and offered an agreeable illusion of having witnessed them. Through these images, events became embedded in the popular imagination to the point where they could be invoked as a literary topos by writers such as Rétif de La Bretonne, notwithstanding the fact that neither he nor his readers had ever experienced a volcanic explosion. In Robert's renditions of the fire in Paris, as in Volaire's of the eruption of Vesuvius, Guardi's of the fire in Venice, and Joli's of the revolt in Naples, none of the figures are intended to be recognizable likenesses of actual people the painters might have encountered on-site. As is especially apparent in the comparisons of several paintings of the same event, they serve as proxies—not unlike the secondary figures in many history paintings—through which the viewer's reactions are funneled.

Both artists and patrons keenly understood the crucial role that reportorial view paintings played in determining the recollection of contemporary events, whether celebratory or catastrophic. As these works acquired a growing importance as potent instruments of political communication, it was not only the figures that were manipulated to shape the viewer's perception but also the core of the view painter's art: topographical representation.

FIG. 182
Antonio Joli (Italian, 1700–1777). *The Popular Revolt in Largo di Castello during the Famine*, 1764–68. Oil on canvas, 56 × 97 cm (22 1/16 × 38 3/16 in.). Vienna, Kunsthistorisches Museum, inv. GG 8626

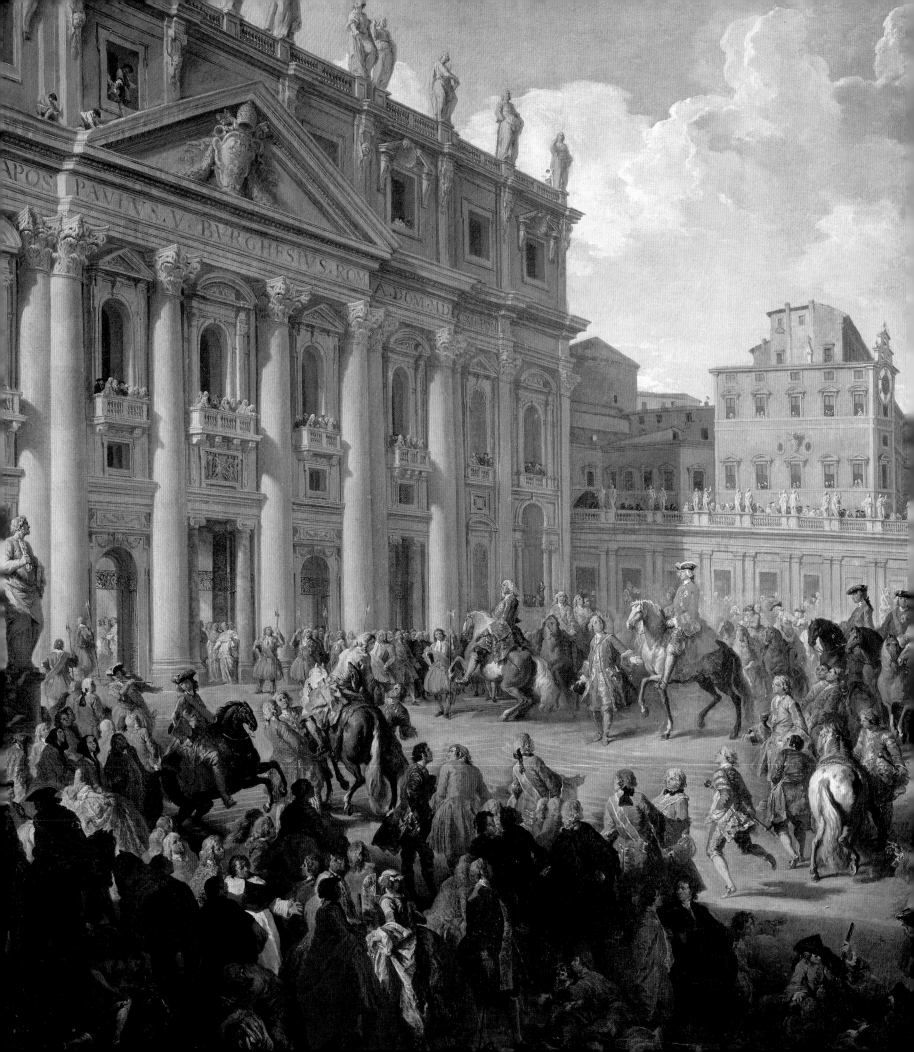

MEMORY AND MANIPULATION

Among the annual events that guided the rhythms of life as well as the flows of tourism in eighteenth-century Venice, none drew more visitors, generated more descriptions, and triggered more diplomatic squabbles about status and precedence than the Bucintoro festival, the ritual marriage of Venice and the sea celebrated on Ascension Day.[1] Its celebrity was fueled in no small part by its countless representations in various media, which were widely disseminated all over Europe. Even more than the paintings of ambassadorial receptions (see chapter 2), the depiction of an occasion that changed little from year to year meant that artists were able to rely upon well-known precedents (whether from their own work or that of others) but were also challenged to surpass them. An analysis of the paintings of the Bucintoro festival reveals how a composition was adapted to suit the wishes of different patrons.

Luca Carlevarijs's rendition of the Serene Republic's state barge as it is about to leave from the Molo provides a vivid sense of the day's energy and excitement (fig. 183).[2] The Bacino is bustling with vessels ranging from plain open barges to gilded ambassadorial gondolas. At left, smoke is rising from the cannon of a warship that has just fired a salute to mark the departure of the doge to the Lido, where the ceremony of the marriage with the sea will take place. The painting shows the Bucintoro that had been constructed in 1606 and remained in use until 1727.[3] An engraving of the state barge executed by Alessandro dalla Via (1669–1729) in circa 1690 and published several times by Vincenzo Coronelli illustrates how carefully Carlevarijs reproduced its shape and decoration (fig. 184).[4] In the foreground, two parade gondolas announce the participation of the Austrian ambassador Filippo Hercolani. On the first gondola's prow, behind an ornate prow-head topped by the imperial double-headed eagle, the gilded sculptures described in a report of Hercolani's official entry in 1708 are visible—an enthroned Juno, Hercules (in allusion to the ambassador's name) with his club, and the dragon Ladon, defeated by the ancient hero in the Garden of the Hesperides.[5]

In 1719 the Venetian government had decided to commission a new Bucintoro. Designed by the shipbuilder Michele Stefano Conti in collaboration with the sculptor Antonio Corradini, the vessel was thirty-five meters long and took almost a decade to complete. It appears in Canaletto's view of the Bacino on Ascension Day on 26 May 1729 (fig. 185).[6] The painting, usually dated to 1728–29, cannot predate the gilding of the new state barge. In 1728, the Bucintoro sailed for the first time but was still covered in the red bole primer for gilding.[7] A few days later, most of the gilders active in Venice began the work of applying gold leaf to the enormous hull, finishing just in time for the following year's Ascension Day.[8] Canaletto's painting must therefore date from 1729, a conclusion confirmed by the presence of the parade gondolas of the imperial ambassador Giuseppe Bolagnos, who had celebrated his official entry only ten days earlier.[9]

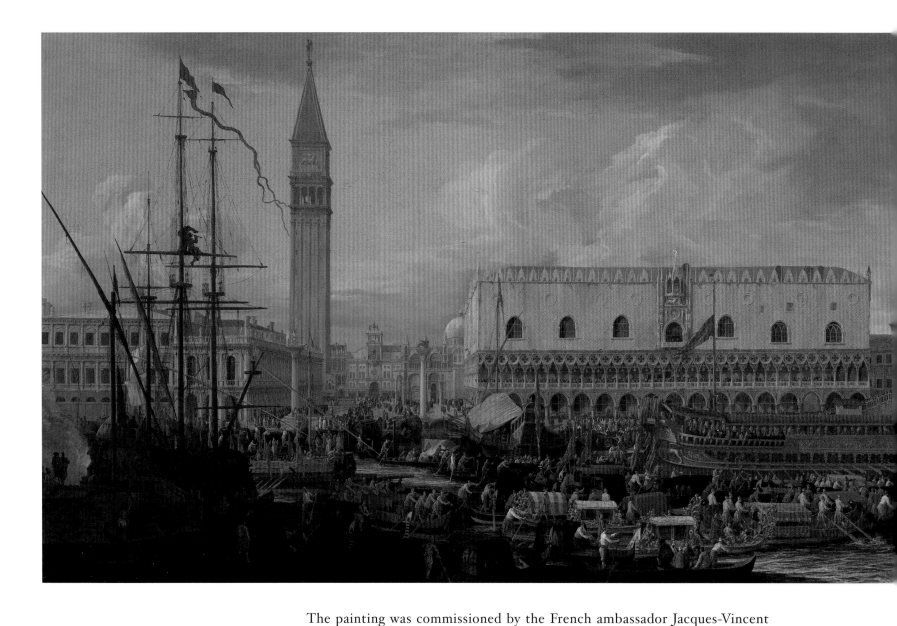

FIG. 183
Luca Carlevarijs (Italian, 1663–1730).
The Bucintoro Departing from the Molo, 1710.
Oil on canvas, 135 × 260 cm (53⅛ × 102⅜ in.).
Los Angeles, J. Paul Getty Museum,
inv. 85.PA.600

The painting was commissioned by the French ambassador Jacques-Vincent Languet de Gergy as a pendant to Canaletto's view of his official entry (see fig. 52).[10] Once again, Canaletto treated Carlevarijs's precedent as a model to be surpassed rather than followed. Instead of the frontal view of the Bucintoro and the Doge's Palace, he shifted the viewpoint to the left, creating a *scena per angolo* (scene viewed at an angle) effect reminiscent of the opera stage sets he had painted at the very beginning of his career. As in the pendant, he pulled back his viewpoint in order to create additional space for the parade gondolas. This was necessitated not only by Carlevarijs's excessively crowded composition but also by the unusual circumstance of the simultaneous participation of the French, papal, and imperial ambassadors. In a letter sent to Louis XV a week later, Gergy pointed out that this had occurred for the first time in two decades.[11] Canaletto thus increased the number of parade gondolas from two to seven, with the primary vessels of the three representatives occupying the center of the composition (fig. 186). Nearest to the viewer is Gergy's first gondola, previously seen in the painting of his official entry (see fig. 53), with the king's dual arms—the gold fleur-de-lis

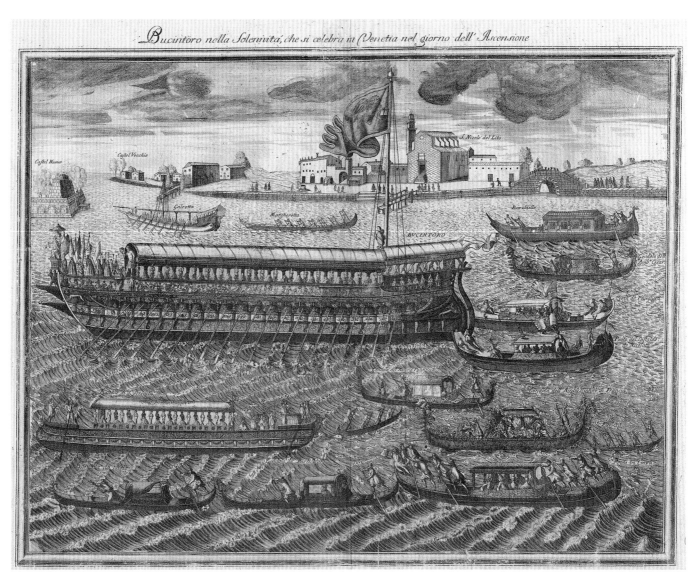

Bucintoro nella Solennità, che si celebra in Venetia nel giorno dell' Ascensione

of France in a blue shield and the gold chains of Navarre in a red shield—on the side of the cabin. Behind it emerges the first gondola of the papal nuncio, displaying the Holy See's tiara and crossed keys in its prow head. The ornament is visible thanks to the vessels' carefully staged staggered formation. In the position closest to the Molo is Bolagnos's gondola with its distinctive prow-head of four curving tongues, prominently displayed in the view of his entry (see fig. 31). Bolagnos's second and third gondolas, respectively with light blue draperies and a crimson velvet roof, are seen in front of the Bucintoro. Moving into the picture in the foreground on the right are Gergy's second and third gondolas. The latter's highly distinctive red lacquer hull had attracted great admiration at Gergy's entry.[12] Even more effectively than Carlevarijs, Canaletto immerses viewers in the scene by placing them on a boat in the midst of the teeming Bacino and turning them from spectators into participants in the day's exuberant proceedings.

When Bolagnos followed in Gergy's footsteps by also commissioning a painting of the Bucintoro festival as a pendant to the view of his ceremonial entry, Canaletto kept

FIG. 184
Alessandro dalla Via (Italian, act. 1688–1729), after Lodovico Lamberti (Italian, 1650–1712). *Bucintoro nella Solennità, che si celebra in Venetia nel giorno dell'Ascensione*, ca. 1690, etching, 462 × 610 mm (18³⁄₁₆ × 24 in.). Los Angeles, Getty Research Institute, inv. 2651-726

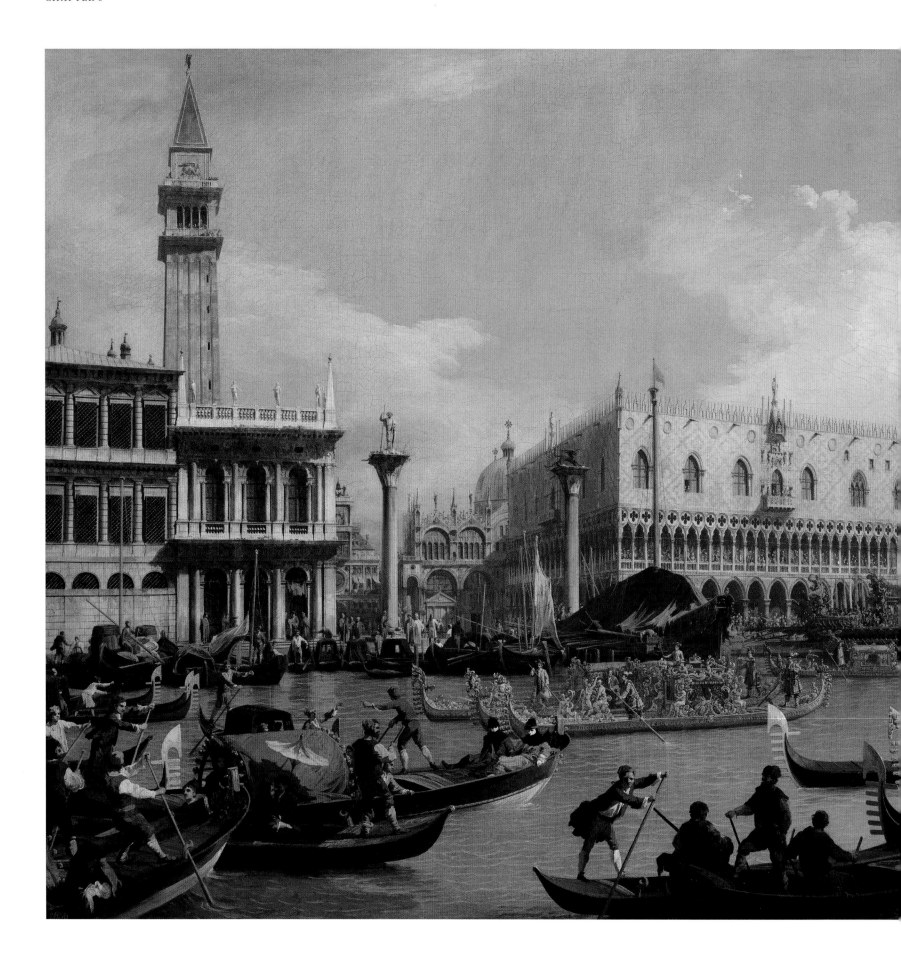

FIG. 185
Canaletto (Italian, 1697–1768). *The Return of the Bucintoro on Ascension Day*, 1729. Oil on canvas, 182 × 259 cm (71 5/8 × 101 15/16 in.). Moscow, Pushkin Museum, inv. Ж-2678

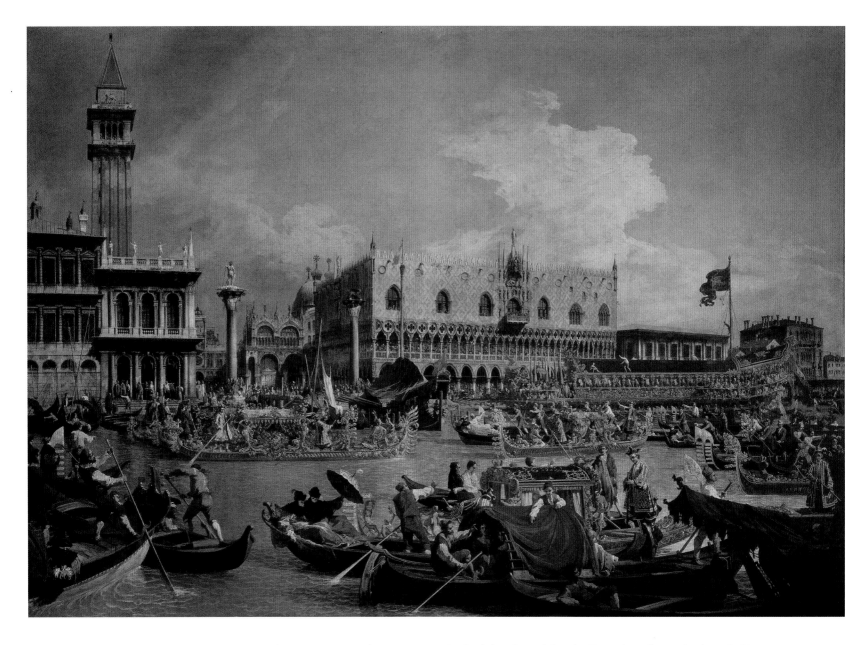

FIG. 186
Canaletto (Italian, 1697–1768). *The Return
of the Bucintoro on Ascension Day*, ca. 1730.
Oil on canvas, 182 × 259 cm (71⅝ × 101¹⁵⁄₁₆ in.).
Private collection

the viewpoint and composition he had developed for the French ambassador but deftly
rearranged the positions of the vessels (fig. 186).[13] The prominent foreground posi-
tions are now occupied by the imperial gondolas, while the famous red-lacquer hull is
barely noticeable at the right-hand edge.

The atmosphere of the canvases commissioned by Gergy and Bolagnos stands
in marked contrast to a view of the Bucintoro at the Molo that Canaletto produced
in about 1745, shortly before his departure for London or possibly even just after his
arrival there (fig. 187).[14] On the morning of Ascension Day, the doge and the senior
officials of the Venetian government left the Doge's Palace in a procession from
the Piazzetta to the Molo, where they boarded the Bucintoro. Canaletto chose the
moment when the doge emerges from between the temporary market stalls set up
for the Ascension Day fair and rounds the corner (fig. 188). In state processions, the
doge was usually flanked by the papal nuncio and the French ambassador.[15] In this

case, Martino Innico Caracciolo (1713–1754), the nuncio, walks on the doge's right, dressed in the purple mozzetta, white rochet, and purple cassock proper to his rank as an archbishop, with Pierre François, comte de Montaigu (1692–1764), the French ambassador, dressed in black with a powdered wig and a hat, on the doge's left.[16]

Canaletto had acquired a detailed knowledge of the protocol of ducal processions when painting a close-up view of the doge and his retinue as they emerge from the church dedicated to Saint Roch on 16 August, his feast day (fig. 189).[17] This annual event honored the saint's role as an intercessor for the city's deliverance from the plague of 1575–76. As in the Ascension Day view, the doge is accompanied by the papal nuncio in a black mozzetta on his right and the French ambassador on his left (fig. 190). The painting has traditionally been dated to circa 1735 on stylistic grounds. The French ambassador from 1733 until 1743 was Charles François de Froulay, while the papal nuncios were Carlo Gaetano Stampa until May 1735 and Giacomo Oddi (1679–1770) from August 1735. Since both nuncios held the rank of a titular archbishop, entitling them to a purple mozzetta, the painting might show the ceremony on 16 August 1735, when the papal embassy's second-in-command, Virgilio Giannotti (1671–1751), who would have worn a black mozzetta, as he was not yet a bishop, temporarily represented the Holy See.[18] The doge, shielded by his *ombrellino*, is preceded by the grand chancellor, wearing a scarlet toga, and two equerries carrying the gilt-wood faldstool upholstered in brocade as well as a cushion made of the same material. Behind him walks a nobleman with the ceremonial sword in a sheath, held aloft with both hands.[19] Many of the participants are holding nosegays, regarded as symbols of protection against the plague.

The grand chancellor, cushion, faldstool, *ombrellino*, and sword are all discernible even at the much smaller scale of the figures in the procession toward the Bucintoro (see fig. 188), yet in order to render this group and its highly realistic details visible, Canaletto had to resort to a departure from reality. In his many other paintings of the Bacino on Ascension Day, the *fusta*, the doge's single-masted state galley, is moored in its permanent location at the Molo, usually covered by an awning with red-and-yellow stripes (see figs. 185, 186).[20] It is consistently shown in the same position by Carlevarijs (see fig. 183), in an engraving by Antonio Visentini after Canaletto (fig. 191),[21] and in numerous views of the Molo on occasions other than Ascension Day (see figs. 23, 29, 33, 37, 46, 51, 52, 54). A comparison with Carlevarijs's composition, taken from a viewpoint only slightly to the left, makes clear that the *fusta* was moored directly in front of the left-hand corner of the Doge's Palace and would have hidden the procession. Even though Canaletto showed the same event, the impression he conveyed could not be more different. The older painter's claustrophobic melee and the spirited grandeur of Canaletto's own canvases for the two ambassadors (see figs. 185, 187) have given way to a vision of the Republic at its most serene: unruffled like the water of the Bacino, moving sedately like the red gondola gliding across the foreground, at ease like the passengers reclining in it, Venice celebrates its most important occasion of the year not for the gratification of wealthy foreigners but for itself, upholding its traditions with unflinching conviction in the face of a slide into economic and political insignificance.

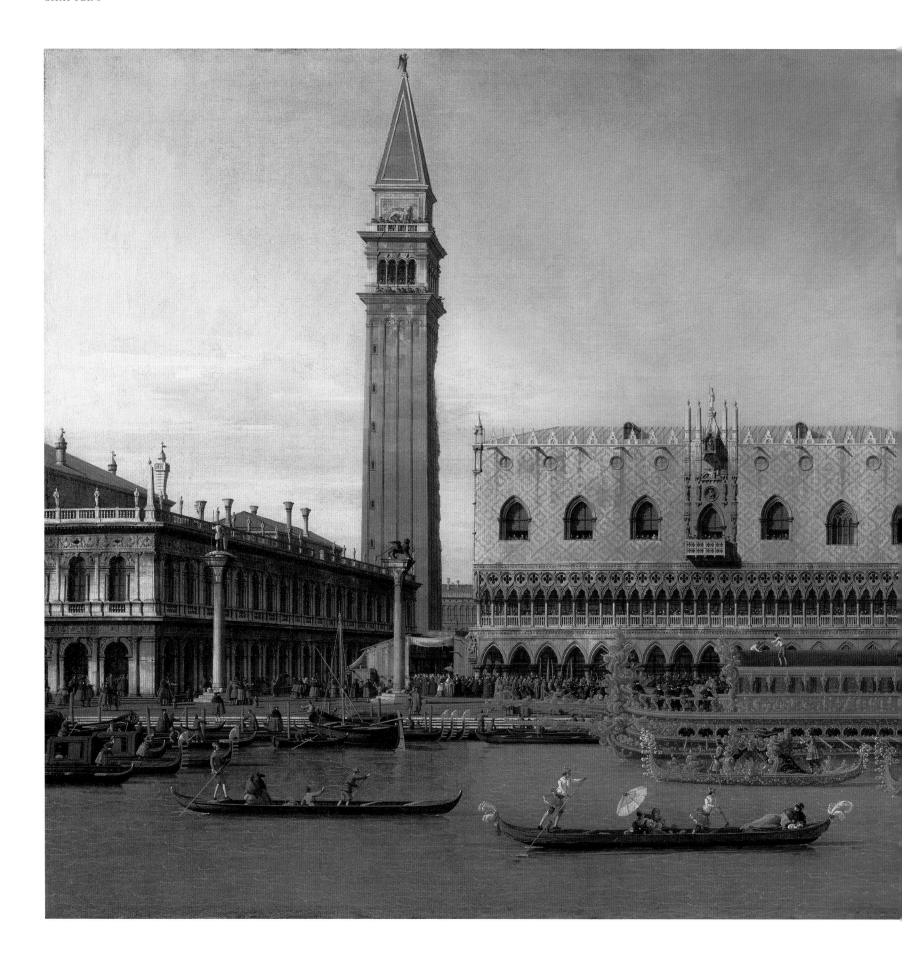

FIG. 187
Canaletto (Italian, 1697–1768). *The Bucintoro at the Molo on Ascension Day*, ca. 1745. Oil on canvas, 115 × 163 cm (45¼ × 64³⁄₁₆ in.). Philadelphia Museum of Art, The William L. Eakins Collection, inv. E1924-3-48

FIG. 188
Detail of fig. 187. Canaletto, *The Bucintoro at the Molo on Ascension Day*, ca. 1745. Philadelphia Museum of Art

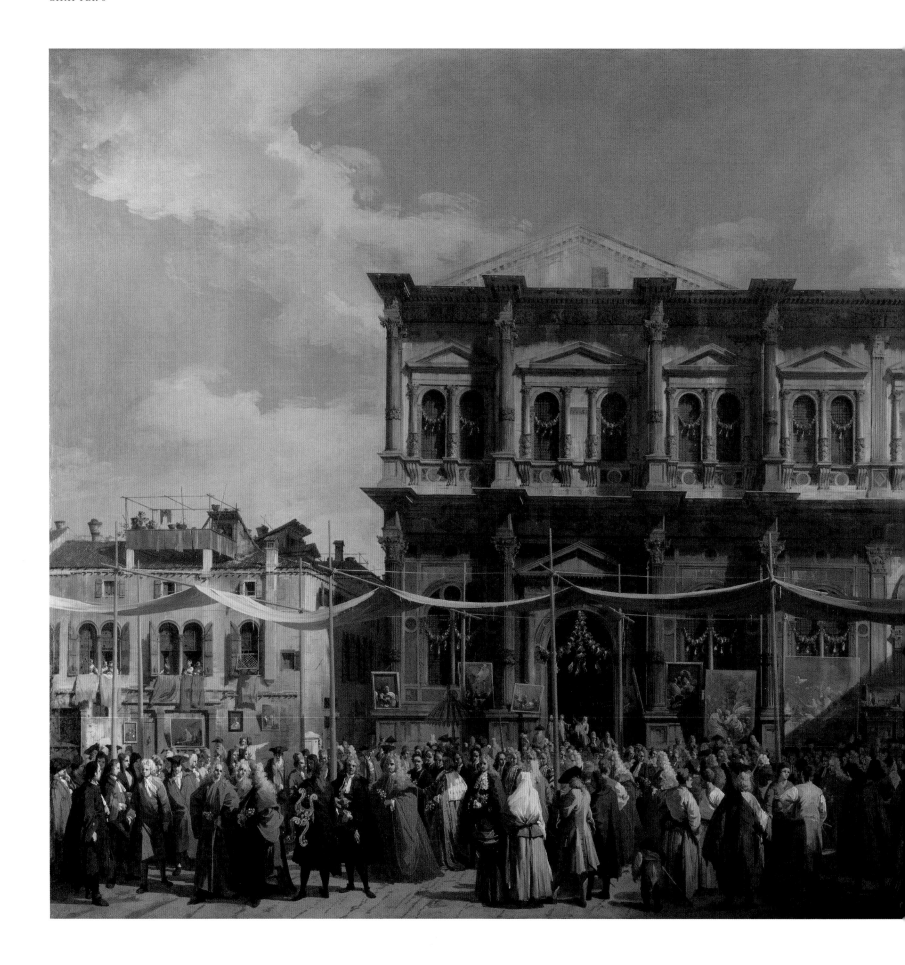

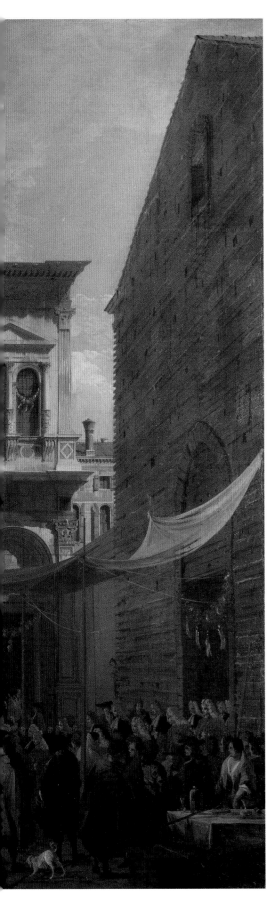

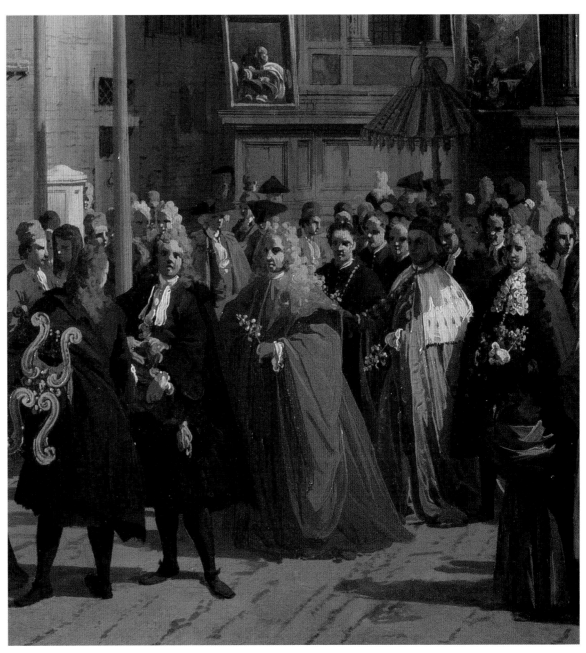

FIG. 189
Canaletto (Italian, 1697–1768). *The Procession on the Feast Day of Saint Roch*, ca. 1735. Oil on canvas, 148 × 199 cm (58¼ × 78⅜ in.). London, National Gallery, inv. NG937

FIG. 190
Detail of fig. 189. Canaletto, *The Procession on the Feast Day of Saint Roch*, ca. 1735. London, National Gallery

Bucentaurus et Nundinae Venetae in die Ascensionis.

XIV.

FIG. 191
Antonio Visentini (Italian, 1688–1782), after
Canaletto (Italian, 1697–1768). *The Return
of the Bucintoro on Ascension Day*, etching,
272 × 427 mm (10¹¹⁄₁₆ × 16¹³⁄₁₆ in.), in *Prospectus
Magni Canalis Venetiarum*, Venice: Pasquali,
1742, Los Angeles, Getty Research Institute,
pl. XIV

FIG. 192
Canaletto (Italian, 1697–1768). *The Campanile
under Repair*, 1745, pen and ink with gray
wash over ruled pencil and pinpointing,
425 × 292 mm (16¾ × 11½ in.). Windsor,
Royal Collection, inv. RCIN 907426

Emphasis, Elaboration, Illusion

The comparison between these two renditions of the Bucintoro festival underscores some of the recurring challenges presented by reportorial views. In a genre that prided itself on the ability to convey reality or at least a plausible version thereof, the painter had to navigate a course between its faithful reproduction, a stage-managed improvement upon it that was often more convincing than reality itself, and the patrons' desire to commemorate a specific perspective on reality.

The sense of calm and spaciousness in Canaletto's painting is also a reflection of the sharp decline in tourism caused by the War of the Austrian Succession. It had been the foreigners who had planned their itineraries to be in Venice for Ascension Day, hired every available vessel to witness the Bucintoro's journey, thronged the Bacino in the earlier Ascension Day pictures, and provided the lion's share of the view painter's business. The calmer Venice may have been more to Canaletto's liking, but at the same time, the absence of his clients documented in this view was the reason he had to leave.

Coupled with the tactical removal of the *fusta*, his gifts of observation captured the symbolism of the doge's stately procession with fidelity and specificity, as they did with another detail of the scene: on 23 April 1745, the campanile in Piazza San Marco had been struck by lightning, leaving it with a jagged edge (see fig. 185). Presumably because the erection of a scaffold had to wait until the stalls of the Ascension Day fair (which lasted until 10 June) had been dismantled, the repairs did not get underway until after the Bucintoro festival. The ingenious mechanism devised for the work—a suspended cradle allowing the masons to move up and down the outside of the tower by means of a windlass placed on the roof of the Loggetta—was recorded by Canaletto in a drawing he inscribed "On 23 April 1745, the day of Saint George the Knight, a thunderbolt struck the Campanile of San Marco" (fig. 192).[22] The artist knew that the repairs would soon be finished (the drawing almost certainly predates the completion of the painting) and that the inclusion of the damage on the campanile would therefore date his canvas to a specific year. This juxtaposition of express adherence to reality (the campanile) with a deliberate departure from it (the missing *fusta*) underscores how carefully considered Canaletto's choices in either direction were.[23]

If the drawing of the damaged Campanile represents the most reportorial end of the spectrum, the opposite end is marked by commissions that were, by their very nature, highly politically charged. Among the various ceremonies staged by the Serene Republic, one surpassed even the Bucintoro festival in significance and splendor, but its timing was unpredictable: the installation of a new doge.[24] Upon his election, the doge took his oath of office in Saint Mark's Basilica. He was then carried out into the piazza in a float known as a *pozzetto*.[25] The canonical depiction of this ritual is one of the twelve images of the series known as the Festivals of the Doge (*Solennità Dogali*), each of which was engraved by Giovanni Battista Brustolon on the basis of a highly finished drawing executed by Canaletto (figs. 193, 194; see also figs. 18, 19).[26] Based on the execution date of the drawing and the publication of the engraving, they almost certainly show the election of Doge Alvise IV Mocenigo in 1763.

In the foreground, the *arsenalotti* (dockyard workers) wield long staffs to clear a path for the new doge. The enthusiasm of the surging populace for a political leader

175

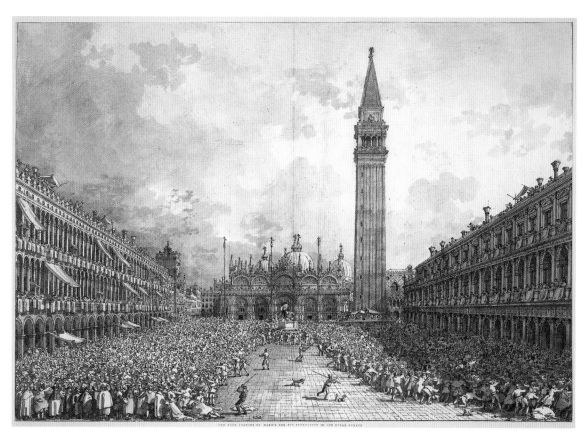

FIG. 193
Canaletto (Italian, 1697–1768). *Doge Alvise IV Mocenigo Carried into Piazza San Marco after His Election*, 1763–66. Pen and brown ink, with gray wash, heightened with white, over black and red chalk, 379 × 552 mm (14 15/16 × 21 3/4 in.). London, British Museum, inv. 1910,0212.18

FIG. 194
Giovanni Battista Brustolon (Italian, 1712–1796), after Canaletto (Italian, 1697–1768). *Doge Alvise IV Mocenigo Carried into Piazza San Marco after His Election*, ca. 1763–66. Engraving, 502 × 675 mm (19 3/4 × 26 9/16 in.). Los Angeles, Getty Research Institute, inv. 86-B1723

FIG. 195
Silver Ducato of Doge Alvise Mocenigo IV, 1763–78, silver, 22.58 gm, Diam.: 40 mm, (1 9/16 in.). New Haven, Yale University Art Gallery, Transfer from the Yale University Library, Numismatic Collection, 2001, Gift of Reverend William H. Owen, B.A. 1897, inv. 2001.87.32863

FIG. 196
Francesco Guardi (Italian, 1712–1793). *Doge Alvise IV Mocenigo Carried into Piazza San Marco after His Election*, ca. 1775. Oil on canvas, 67 × 100 cm (26 3/8 × 39 3/8 in.). Musée de Grenoble

FIG. 197
Detail of fig. 194. Giovanni Battista Brustolon, after Canaletto, *Doge Alvise IV Mocenigo Carried into Piazza San Marco after His Election*, ca. 1763–66. Los Angeles, Getty Research Institute

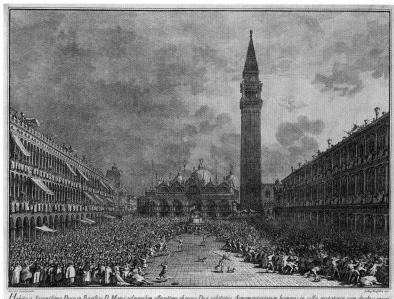

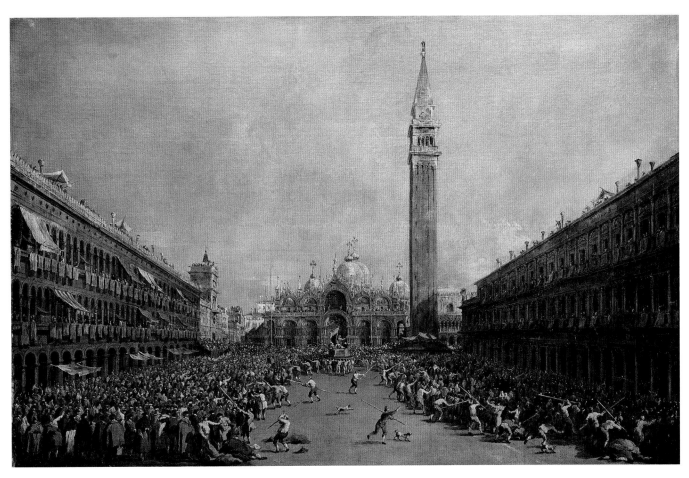

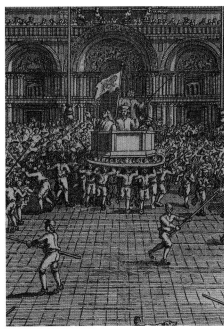

in whose election they had played no role was perhaps partly due to the fact that, as part of the ceremony, he threw silver and gold coins, freshly struck overnight, into the crowds (fig. 195).[27] Under the Republic's regulations, a new doge had to distribute at least 150 but no more than 500 ducats.[28] The French traveler Jérôme Richard (b. ca. 1720), who witnessed this spectacle after the election of the previous doge, Marco Foscarini (r. 1762–63), posited that the circuit around the square was made at a rapid pace in order to save the doge from having to distribute too much money;[29] a German visitor recorded in 1709 that the entire ceremony had taken less than eight minutes.[30]

Around 1775 Francesco Guardi received a commission, possibly from Alvise IV Mocenigo or a member of his family, to produce twelve oil paintings on the basis of the Brustolon prints (fig. 196).[31] The drawing, engraving, and painting of the doge's emergence into Piazza San Marco offer the quintessential characteristics of reportorial views: a vivid sense of occasion, a convincing rendition of the urban setting, and carefully observed details specific to the ceremony, such as the admiral of the Arsenale, who stood next to the doge in the *pozzetto*, holding a flag with the lion of Saint Mark (fig. 197). It serves, in equal measure, as a record of the celebrations after the election of a specific doge—in another canvas from the series, showing the carnival celebrations in the Piazzetta, the Mocenigo coat of arms appears on the *macchina* (see fig. 20)[32]—and as a manifestation of one of the rituals in which much of the Serene Republic's political identity was rooted.

Spectators within and beyond the Canvas

In Guardi's Festivals of the Doge, as in his views of the visit of Pius VI or Bellotto's of Schönbrunn Palace (see figs. 4, 8), the figures are almost subsumed by the architectural environment. In Canaletto's Ascension Day scenes, the ambassadors themselves are even invisible, represented only by their parade gondolas. This key characteristic of reportorial views—treating the protagonists as a pictorial element interacting with the urban setting rather than with each other (as they do in documentary works by portraitists and history painters)—is both a result of and a precondition for another of the type's core traits: the spectator inside the painting as a surrogate for the viewer in front of it.

This is especially evident in Marieschi's depiction of the exit of Doge Pietro Grimani, elected on 30 June 1741, from Saint Mark's into the square (fig. 198).[33] In comparison to Guardi's painting of several decades later, the float with the doge is pushed much further into the background, to the point of being barely visible (fig. 199). The *arsenalotti* are swarming out with their red staffs to drive back the Venetians jostling for the most promising spots, eager to snatch some of the coins that are about to rain down from the *pozzetto*. The emphasis has shifted away from the ceremonial aspect toward the role of the viewer. Although the foreground figures are much larger than any in Canaletto's and Guardi's versions of the scene, the overall number of spectators present in Piazza San Marco is much smaller. The possibility that this is merely a reflection of lower public interest in the election of 1741 compared to 1763 is excluded by

FIG. 198
Michele Marieschi (Italian, 1710–1744).
Doge Pietro Grimani Carried into Piazza San Marco after His Election, ca. 1741. Oil on canvas, 57 × 113 cm (22⁷⁄₁₆ × 44½ in.).
Paris, Galerie G. Sarti

the testimony of the Oxford professor Joseph Spence (1699–1768), who witnessed the event depicted by Marieschi during a visit to Venice in 1741: "The whole place (which is very large) was so full of people, that about six foot above the ground it looked all as if it were paved with heads. Several of the Arsenal-men, each with a red baton, kept the whole line clear where the triumphal chariot was to pass. The Doge had a sack of money open by him, and all the way, as he passed along, tossed out handfuls of crowns and half-crowns among the mob: which gave me much more diversion than the sight of his Serenity."[34]

The description of a square "paved with heads" when seen from above fits Guardi's painting much better than Marieschi's. The crucial difference lies in the artists' goals; each of them magnified the aspects that mattered most to the intended patrons. Guardi, who was working for the doge or someone closely linked to him, adopted the densely massed crowds captured by Canaletto's calligraphic pen. The implication is one of widespread enthusiasm for the doge—or at least his coins—among the city's population. To any Venetian, the occasion and its significance were instantly recognizable. Marieschi, by contrast, worked almost exclusively for foreign clients. Finding themselves in Venice for the election of a new doge in late June 1741 would have been a boon for all visitors, giving them the opportunity to witness a famous ceremony that few other travelers before or after them were able to experience. It was for this clientele that Marieschi designed his composition. The decision to relegate the doge, ostensibly the event's protagonist, to a speck of paint in the far distance and focus attention

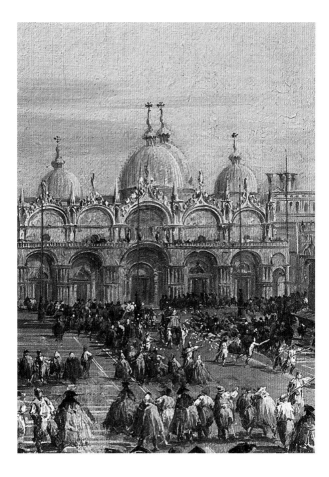

FIG. 199
Detail of fig. 198. Michele Marieschi,
*Doge Pietro Grimani Carried into Piazza
San Marco after His Election*, ca. 1741.
Paris, Galerie G. Sarti

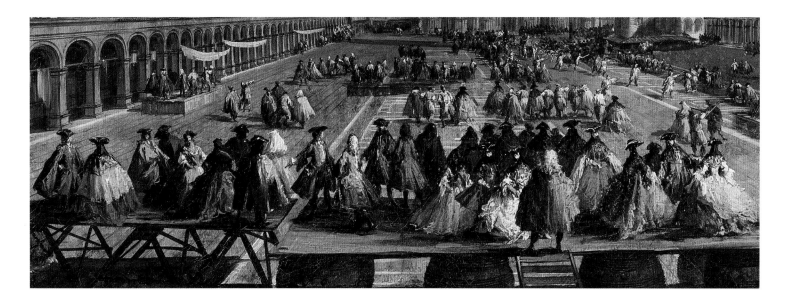

FIG. 200
Detail of fig. 198. Michele Marieschi,
*Doge Pietro Grimani Carried into Piazza
San Marco after His Election*, ca. 1741.
Paris, Galerie G. Sarti

FIG. 201
Rosalba Carriera (Italian, 1673–1757).
*Gustavus Hamilton, 2nd Viscount Boyne,
in Masquerade Costume*, 1730–33, pastel on
paper, laid down on canvas, 570 × 430 mm
(22⁷⁄₁₆ × 16¹⁵⁄₁₆ in.). New York, Metropolitan
Museum of Art, Purchase, George Delacorte
Fund Gift, in memory of George T. Delacorte
Jr., and Gwynne Andrews, Victor Wilbour
Memorial, and Marquand Funds, 2002,
inv. 2002.22

on the carnival costumes and the *arsenalotti* mirrors the perspective of foreign visitors
such as Spence, who devoted his attention to "the Arsenal-men" and "the mob" rather
than the doge.

As Spence indicates when he mentions being "six foot above the ground," the
makeshift viewing platforms constructed of planks of wood placed on trestles and
barrels were erected for the tourists, who most likely had to pay for the better view
(fig. 200). The Venetian nobility, officially barred from mixing with foreigners, watched
from the windows of the Procuratie Vecchie and the Procuratie Nuove. Most of the
foreground figures are in traditional Venetian masquerade dress, beloved particularly
by Englishmen on the Grand Tour and seen in many of their portraits by artists such as
Rosalba Carriera (fig. 201).[34] The costume consists of a black tricorne; a mask called the
volto or *larva*, made of white waxed cloth in a shape that permitted unimpeded breath-
ing, eating, and drinking; a black veil made of silk and lace known as the *bauta*; and a
cloak called the *taba[r]ro*. Even though there were several periods of the year in addi-
tion to carnival proper when masked costume was allowed, the most recent one, which
lasted from a fortnight before Ascension Day until the end of the Ascension Day fair on
10 June, had ended three weeks earlier. However, the Republic's dress and sumptuary
laws expressly permitted wearing masks during special occasions such as the crowning
of a new doge and visits of illustrious foreigners.[36]

As in many other reportorial views, especially some of Panini's masterpieces of
the type (see figs. 112, 173, 203), the spectators in the painting reflect and continue
the role of the viewer outside it. For views that went beyond the purely topographi-
cal, Marieschi often brought in a specialist to add the figures, which in this case have
been convincingly attributed to Gian Antonio Guardi (1699–1760), Francesco's older
brother. This collaboration had two direct effects on the composition: the quality and
size of the figures rises above those found in almost any other of Marieschi's works, but
because he would have had to pay the elder Guardi on a per-figure basis, their quantity
is much lower than in the view of the same event by Francesco Guardi, who painted his
own figures. Marieschi had built a successful career on the fact that his paintings were

substantially cheaper than Canaletto's, leaving him little profit to pay a figure painter for a large number of figures. With a few subtle emphases, the artist calibrated his composition to present the event through the eyes of a tourist, matching how Spence and other foreigners experienced and remembered it.[37]

Manipulating Architecture and Topography

The amplification or suppression of certain aspects of an event in order to convey a specific message of importance to the patron was the same technique that Canaletto had employed in his views of ambassadorial entries in front of the Doge's Palace.[38] This can be distinguished from a different form of manipulation that frequently occurred in topographical view painting: the deliberate alteration of specific buildings or of the urban geography.[39] In Venice, a quintessential example is the height of the Campanile, which Canaletto, Marieschi, Guardi, and other view painters almost invariably reduced to fit the proportions of the typical landscape format. Somewhat surprisingly, Marieschi undertook his most eye-catching distortion in a reportorial view likely to have been painted for Venetian clients, who would often have stood in the spot it blatantly misrepresents. For his depiction of the official entry of the new patriarch Francesco Antonio Correr (1676–1741) at the Rialto Bridge, Marieschi fused views of the Grand Canal taken in two different directions into a composition suggesting that the waterway makes a 180-degree turn and that its arms might meet, out of sight, in the center (fig. 202).[40]

Correr, who had entered the Capuchin order in 1730, was consecrated patriarch in the church of the Redentore on 30 January 1735 and made his entry on 7 February.[41] The ceremony was, in geographic terms, the reverse of the official entry of a new ambassador, who arrived at the Molo and, as the final step in the protocol, departed from the Rialto Bridge after a walk from San Marco through the Merceria.[42] The new patriarch was rowed to the Fondaco dei Tedeschi in a cortege of state barges, accompanied by the ambassadors in their parade gondolas.[43] He disembarked at the foot of the Rialto and processed via the Merceria to the Doge's Palace, where the head of state received him. On 9 February he took possession of his cathedral of San Pietro in Castello.[44]

It is difficult to understand Marieschi's motivations for creating such a jarringly inaccurate representation of what was, after Piazza San Marco, the city's most frequented and iconic site. The simultaneous view up and down the Grand Canal would have provided more space for *peote* and gondolas than a standard view of the bridge from either side, of which Marieschi produced numerous versions.[45] It might also have offered advantages when depicting the continuous action of an event that took place on the canal and passed underneath the bridge on the way to a destination beyond, such as a regatta.[46] Neither reason is applicable here. The waterborne procession in which each of the seventy-two parishes in Venice participated with a decorated *peota* to convey the patriarch to his cathedral took place two days after his arrival at the Rialto Bridge. The shipping Marieschi included—three opulent *peote* in the foreground, the three gilded parade gondolas of the imperial ambassador (decorated with the imperial double-headed eagle) at right, and a few incidental vessels—could have been accommodated in a topographically accurate view. By virtue of its specific subject and large size, the canvas was probably commissioned by the Correr family. The only known evidence of

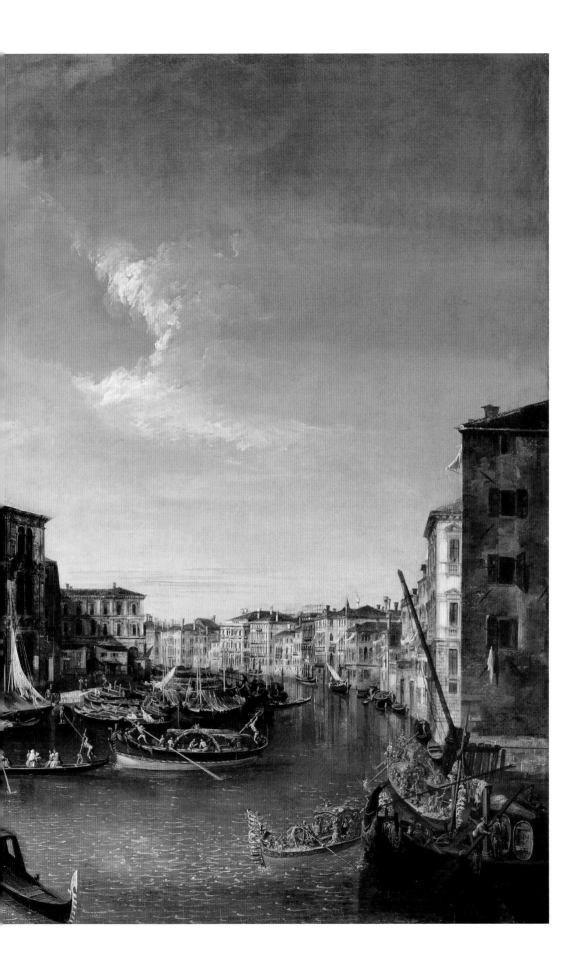

FIG. 202
Michele Marieschi (Italian, 1710–1744).
The Rialto Bridge with the Festive Entry of the Patriarch Antonio Correr, 1735. Oil on canvas, 157 × 253 cm (61¹³⁄₁₆ × 99⅝ in.). Osterley Park, National Trust, inv. NT 771297

its reception is the fact that two years after the event, a second version was acquired by Field Marshal Matthias von der Schulenburg (1661–1747),[47] an important local patron, which suggests that the liberties the artist took were acceptable (or perhaps even amusing) to a long-term resident of Venice.

An equally impossible viewpoint was chosen by Panini for his rendition of the consecration of Giuseppe Pozzobonelli (1696–1783) as archbishop of Milan (fig. 203).[48] The event took place on 21 July 1743 in the Roman church of San Carlo al Corso. Pope Benedict XIV, the principal consecrator, is seated at the high altar in the background. The ceremony has just finished and the new archbishop, wearing a golden mitre, processes toward the front of the nave, flanked by his two co-consecrators, the archbishops Antonio Maria Pallavicini and Carlo Alberto Guidoboni Cavalchini. San Carlo al Corso was the Milanese national church in Rome and dedicated to Saint Charles Borromeo, who had himself held the see of Milan. The building therefore played an important role, and in order to show the interior in its entirety including all the bays of the nave, Panini chose a fictive viewpoint that would be located outside the church facade.

FIG. 203
Giovanni Paolo Panini (Italian, 1691–1765). *The Consecration of Giuseppe Pozzobonelli as Archbishop in San Carlo al Corso*, 1743–44. Oil on canvas, 198 × 297 cm (77¹⁵⁄₁₆ × 116¹⁵⁄₁₆ in.). Como, Museo Civico Storico Giuseppe Garibaldi, inv. P451

FIG. 204
Francesco Guardi (Italian, 1712–1793).
The Balloon Flight of Count Zambeccari, 1784.
Oil on canvas, 66 × 51 cm (26 × 20¹⁄₁₆ in.).
Berlin, Gemäldegalerie, inv. 501 F

In Guardi's depiction of the first hot air balloon flight in Venice on 15 April 1784, the artist selected a vantage point that allowed him to employ the portico of the Dogana as a framing device with strong contrasts of light and shade (fig. 204).[49] This necessitated moving the location of the launch platform that had been constructed on the open water away from its real position—a price he was happy to pay in order to create an effective composition.

A final corollary of patrons' wishes triggering departures from reality is the calculated architectural alteration of specific buildings. During the War of the Austrian Succession, a few months after his victory over the Austrian forces at Velletri on 12 August 1744, Charles of Bourbon (later Charles III of Spain), the new king of Naples and son of King Philip V of Spain and Elisabeth Farnese,[50] traveled to Rome for an audience with Pope Benedict XIV on 3 November 1744.[51] To record the occasion, Charles commissioned a pair of paintings from Panini, the first of which shows the king's arrival at the Caffeaus (coffee house), a pavilion in the gardens of the Quirinal Palace (fig. 205).[52]

FIG. 205
Giovanni Paolo Panini (Italian, 1691–1765). *King Charles III Visiting Pope Benedict XIV at the Coffee House of the Palazzo del Quirinale*, 1746. Oil on canvas, 124 × 174 cm (48 13/16 × 68½ in.). Naples, Museo di Capodimonte, inv. 205

Designed by Ferdinando Fuga (1699–1782) and completed only a year before the king's visit, the structure had been built to satisfy Benedict XIV's express desire for an informal, low-key environment in which to receive guests, away from the pressures of courtly pomp and protocol.[53] The pope was extremely pleased with the result and reported with great satisfaction to a friend in Bologna that on the same day, he had been able to welcome the king of Naples in the morning and the duke of Modena in the afternoon in his new "loggia."[54]

The real structure is much simpler than Panini's view suggests (fig. 206). In his fictitious gallery of views of modern Rome painted for Choiseul in 1757, the Caffeaus appears in its true form (fig. 207), but the king and his advisers evidently felt that since his first meeting with the pontiff ought not to have taken place in such modest surroundings, some visual revisionism was in order. Panini obliged by doubling the pilasters between the windows as well as the number of busts on the roof balustrade and extending the side wings from one to two window axes. He also added a large papal coat of arms presented by two putti to the center of the facade. The restrained garden pavilion thus metamorphosed into a small palace. The fact that the architectural amplification had been devised at an early stage of the commission—quite possibly at the behest of one of Charles's courtiers—is demonstrated by the existence of an unpublished *bozzetto* that already shows the doubled pilasters (fig. 208). This ravishing oil sketch surpasses even the finished painting in its perceptive portrayal of the king as he is greeted by Cardinal Troiano Acquaviva, the Spanish ambassador, who wears the red riband and badge of the Neapolitan Order of Saint Januarius (see fig. 124).

The artist was even more unabashed in his manipulation of Rome's most famous architectural ensemble, Saint Peter's Square, in the pendant (fig. 209).[55] In order to make the figure of the king on horseback look more imposing, Panini shrunk the

FIG. 206
Ferdinando Fuga (Italian, 1699–1782). Caffeaus, 1741–43, Rome, Palazzo del Quirinale gardens, photo: Segretariato Generale della Presidenza della Repubblica

FIG. 207
Giovanni Paolo Panini (Italian, 1691–1765). *Modern Rome* (detail), 1757. Oil on canvas, 170 × 245 cm (66¹⁵⁄₁₆ × 96⁷⁄₁₆ in.). Boston, Museum of Fine Arts, inv. 1975.805

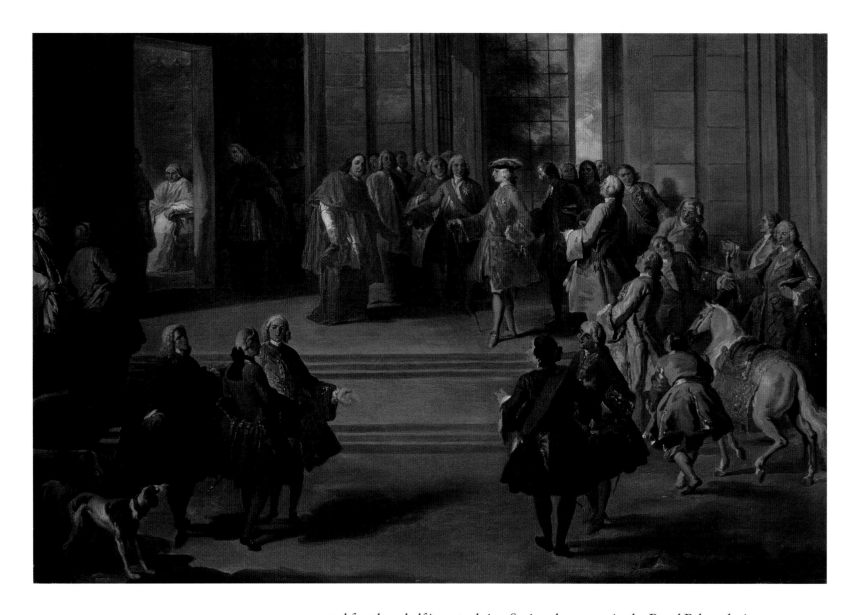

FIG. 208
Giovanni Paolo Panini (Italian, 1691–1765).
*King Charles III Visiting Pope Benedict XIV
at the Coffee House of the Palazzo del Quirinale,*
ca. 1744–45. Oil on canvas, 53 × 79 cm (20⅞ ×
31¹/₁₆ in.). Private collection

FIG. 209
Giovanni Paolo Panini (Italian, 1691–1765).
King Charles III Visiting St. Peter's, 1745. Oil on
canvas, 121 × 171 cm (47⅝ × 67⁵/₁₆ in.). Naples,
Museo di Capodimonte, inv. 204

monumental facade to half its actual size. Seeing the canvas in the Royal Palace during
a trip to Naples in 1750–51, the French draftsman Charles Nicolas Cochin criticized
that "the figures are absurdly large and make this enormous church look like a small
chapel." He did not particularly like either of the two paintings, but his harsh criti-
cism of the composition was limited to the view of Saint Peter's.[56] Compared to the
perfectly judged renditions of the site that Panini was to create for Choiseul and Canil-
liac a decade later, the colossal Spaniard diminishes everything around him (including
the head of his mount) and is thereby diminished himself, whereas the Frenchmen are
aggrandized by their surroundings (see fig. 60).

Cochin's criticism, later echoed by Luigi Lanzi,[57] concerned not so much a lack of
realism as a lack of plausibility. The obvious falsification of Rome's most famous square
violated the latter principle, whereas the architectural enhancements to the Caffeaus
may be the artist's fabrications but look perfectly convincing—all the more since the
building was tucked away inside the pope's private gardens, was known only to a hand-
ful of select guests, and did not appear in a forfeit of engravings like Saint Peter's.

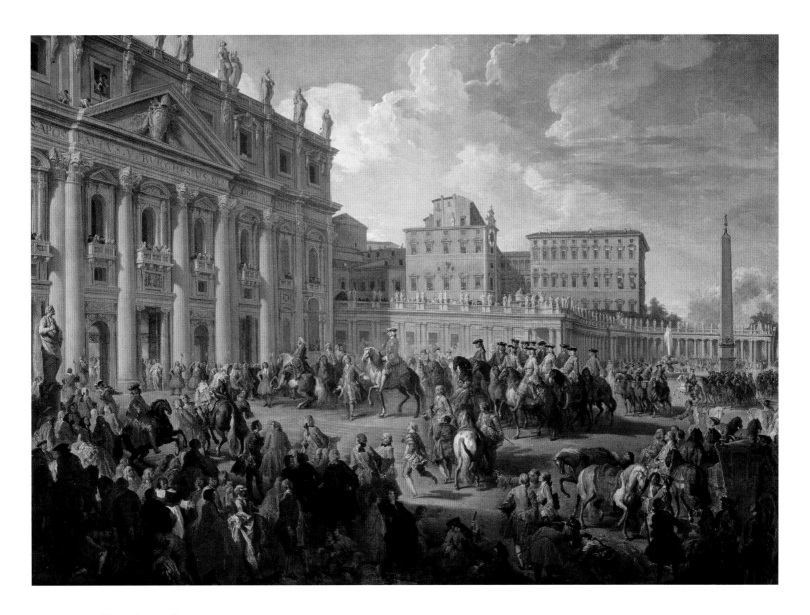

Eyewitness Cues

Among the paintings that Benedict XIV had commissioned to decorate the Caffeaus was a view of his arrival at Santa Maria Maggiore to inspect the new facade, another major work by Panini (fig. 210).[58] The canvas was delivered in 1742, one year before construction on the church was actually completed. Having been given access to Fuga's architectural plans, Panini painted the facade not as it was but as it would be, creating an image that the future would transform into a faithful rendition of reality.

The view of the pope's visit to Santa Maria Maggiore encapsulates both the paradigms and the visual cues of reportorial view painting that have been established in this study. The painting adopts the eyewitness principle as its compositional strategy and lets the viewer experience the occasion along with spectators modeling various states of attention and participation. The painting's protagonist and patron is subordinated to the architectural setting. His likeness and dress are identifiable but based on an existing prototype rather than studies from life.[59] The built environment (permanent in this case, ephemeral in others) appears as a partner he interacts with and a reflection of his achievements.

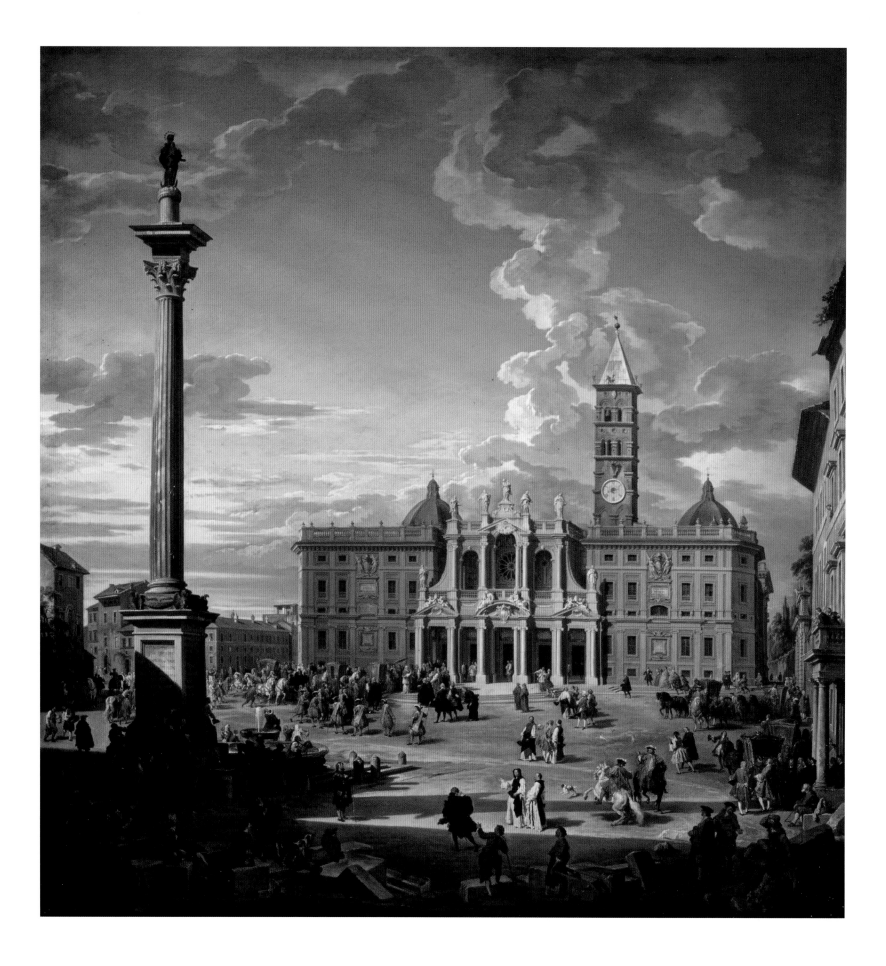

As the eighteenth century drew to a close, the reportorial view of the type examined in this book lost its raison d'être along with most of its patrons and protagonists to the social changes triggered by the French Revolution. In July 1789 Robert captured the destruction of the Bastille (fig. 211).[60] His painting was intended as a picturesque ruin scene. The artist had neither a specific commission for the work nor any inkling of the enormous symbolic importance the event would acquire from subsequent developments. An eyewitness account by design, this view was turned into an icon only by history itself.

Drawing on the convincing rendition of topography that lies at the heart of the view painter's art, reportorial views purposefully create a plausible rather than a mimetic vision of reality by leveraging, magnifying, manipulating, and occasionally even predicting events and buildings. Ceremonial traditions as well as civic and religious monuments are appropriated in order to place the protagonist in a continuum of history stretching from antiquity to the present. By determining how the event will be perceived and remembered in the future, the image becomes the creator of a visual legacy and transforms the present into history.

FIG. 210
Giovanni Paolo Panini (Italian, 1691–1765). *Pope Benedict XIV Arriving at Santa Maria Maggiore*, 1742. Oil on canvas, 265 × 253 cm (104⅝ × 99⅝ in.). Rome, Palazzo del Quirinale, Caffeaus, inv. 323

FIG. 211
Hubert Robert (French, 1733–1808). *The Bastille in the First Days of Demolition*, 1789. Oil on canvas, 77 × 114 cm (30⅝ × 44⅞ in.). Paris, Musée Carnavalet, inv. P1476

NOTES

CHAPTER 1

1 See Morassi 1973, vol. 1, pp. 358–61, cat. nos. 262–76.

2 See the agreement between Edwards and Guardi, 21 May 1782: Guardi agreed "di prender le vedute dei siti sopralluogo, e di dipendere dalla direzione del sud.to Sig. Edwards in quanto riguarda la disposizione e collocazione delle figurine rappresentanti le funzioni medesime." Transcribed in Simonson 1904, p. 82.

3 Gombrich 1982, p. 253.

4 Burke 2001, p. 185.

5 The German term *Festvedute* (festival view) encompasses most of these works, but reportorial views also include paintings of disastrous events, for example. Although developed for a subgenre of history painting, the definition of the *geschichtliches Ereignisbild* (historical event painting) in Hager 1939, pp. 1–2, as "Darstellungen, in denen eine historische Begebenheit, die noch als gegenwärtig im Bewußtsein lebt, in berichtender Schilderung abgebildet wird" could be profitably applied to reportorial view paintings as well.

6 See Pedrocco 2003, p. 15: "Cioè, in pratica, il vedutismo settecentesco nasce come rappresentazione di un evento che si compie in un sito della città e ha principalmente un valore memorativo dell'evento stesso: non a caso, si tratta costantemente di opere commissionate dai protagonisti dell'evento stesso, interessati a possederne un ricordo visivo."

7 Madrid, Museo del Prado. See Pavanello and Craievich 2008, p. 242, cat. no. 1; Benzi 2002, p. 190, cat. no. 60. Vanvitelli's *View of the Abbey of San Paolo at Albano* of 1710 (Florence, Palazzo Pitti, Galleria Palatina) has been described as "his only depiction of a specific event" (Bowron and Rishel 2000, p. 458), but the contemporary sources do not permit the identification of an occasion matching the depicted papal visit (Benzi 2002, p. 172).

8 See, for example, the account of the presentation of Panini's view of the celebrations in the Piazza Navona (see fig. 132) to Louis XV at Versailles in Faucher 1777, vol. 2, p. 419: "Les personnes qui avoient été à Rome en furent d'autant plus charmées, qu'elles y reconnurent les principaux spectateurs peints au naturel."

9 Rome, Archivio di Stato, 30 Notai Capitolini, ufficio 2, vol. 571, fol. 1, nos. 160, 162: "Un quadro in misura da otto e sei per traverso rappresentante il di dentro della chiesa di S. Pietro con moltissime figure dipinto dal Sig.re Cavaliere Pannini con cornice a tre ordini d'intaglio dorata ad oro buono"; "Altro di misura da otto e sei parimente per traverso rappresentante la Piazza di S. Pietro con carrozze e figure, cornicetta stretta dorata ad oro buono." Transcribed in Michel 2016, p. 131.

10 See Wildenstein 1961, p. 64, no. 20: "deux tableaux de Jean-Paul Pannini, représentant l'intérieur et l'extérieur de Saint Pierre de Rome dans leur bordure de bois dorée."

11 Henning et al. 2011, p. 119, cat. no. 16; see Marx 2005, vol. 1, pp. 66; Kozakiewicz 1972, vol. 2, pp. 147–48, 238–41, cat. nos. 181, 297.

12 Inscribed at lower right: "XVI. Augusti. Anno M.D.C.C.LIX Prusso caeso ad Francofurtum ab exercitu Russo-Austriaco." See Kozakiewicz 1972, vol. 2, pp. 220–23, cat. nos. 280–81.

13 See Urrea Fernández 2012, pp. 62–64; Toledano 2006, p. 346, cat. no. N.XVII.1; Morales Vallejo and Ruiz Gómez 2001, p. 101; Manzelli 1999, p. 37.

14 See Arisi 1993, p. 110, cat. no. 18; Kiene 1992, p. 118, cat. no. 18; Arisi 1986, p. 443, cat. no. 428; Michel and Rosenberg 1987, pp. 85–90, 211–13, cat. no. 42.

15 Voss 1924, p. 629.

16 See Zugni-Tauro 1971, p. 94.

17 See Bowron and Rishel 2000, p. 454, cat. no. 302; Ingersoll-Smouse 1926, vol. 1, pp. 48–49, cat. no. 167.

18 See Morassi 1973, vol. 1, p. 358, cat. no. 262.

19 See Tamassia Mazzarotto 1980, pp. 324–28; Morassi 1973, vol. 1, p. 360, cat. no. 268.

20 For the construction of the benediction loggia, see *Storia del viaggio* 1782, p. 63; CC, registro VI, fols. 33v–34r. Transcribed in Gaier 2003, p. 127; see also p. 137 n. 53. For the structure's political significance, see Gaier 2003, pp. 134, 138–39. For contemporary accounts of the papal visit, see Gozzi 1782 and Coggiola Pittoni 1915.

21 Lalande 1769, vol. 4, p. 21: "M. le cardinal de Polignac, à la naissance de M. le Dauphin en 1729, donna sur la place Navone une fête célébre, qui a été peinte par Jean Paul [i.e., Giovanni Paolo Panini], peintre qui étoit alors fort considéré dans Rome."

22 See Pavanello and Craievich 2008, p. 294, cat. no. 90; Morassi 1973, vol. 1, p. 356, cat. no. 251.

CHAPTER 2

1 See Monmerqué 1843–65.

2 See Succi 2015, pp. 116–21, cat. no. 2; Pavanello and Craievich 2008, pp. 246–47, cat. no. 10; Reale and Succi 1994, pp. 200–206, cat. no. 36.

3 Fenlon 2007, pp. 108–9.

4 Pomponne was first identified and his arrival date established by Mariuz 1994, p. 50, and Succi 1994, p. 64.

5 "La République aiant si peu de part et d'influence dans les principales affaires de l'Europe que la résidence d'un ambassadeur du roy auprès d'elle semble estre plustost pour entretenir l'ancienne union

entre la couronne et ceste République que pour y traiter aucune affaire considérable." Transcribed in Duparc 1958, p. 159.

6 Montesquieu 2012, p. 122: "rien de si inutile qu'un ambassadeur de France à Venise comme un marchand dans un lazaret."

7 De Brosses 1991, vol. 1, p. 286, letter XV, 20 August 1739: "Le métier d'ambassadeur est assez triste icy."

8 Bernis 1878, vol. 1, p. 422: "Je suis très-aise de n'avoir pas des occupations plus importantes. L'Europe n'est heureuse que quand les ambassadeurs n'ont rien à faire."

9 The detailed instructions he received from the French foreign ministry before his departure from Paris, dated 28 January 1705, are transcribed in Duparc 1958, pp. 129–49.

10 For a modern summary of the standard ceremony, see Richert 1987, p. 10. For a detailed contemporary description, see Cole 1733, pp. 12–14.

11 See Grevembroch 1981, vol. 1, no. 42.

12 See CPV, vol. 147, fols. 49r–64v, "Relation de l'entrée publique de M.r l'abbé de Pomponne Amb.r du Roy à Venise," 15 May 1706, at fol. 55v. Transcribed in Tipton 2010, Quellenanhang, Pomponne.

13 See CPV, vol. 147, fols. 49r–64v, "Relation de l'entrée publique de M.r l'abbé de Pomponne Amb.r du Roy à Venise," 15 May 1706, at fol. 62r. Transcribed in Tipton 2010, Quellenanhang, Pomponne.

14 See CPV, vol. 147, fols. 49r–64v, "Relation de l'entrée publique de M.r l'abbé de Pomponne Amb.r du Roy à Venise," 15 May 1706, at fol. 55v: "Les valets de pieds de M.r l'amb.r au nombre de douze … leur livrée est d'un drap fin couleur d'or chamarrée en plain d'une large galon de soie de sa … livrée redoublée et de deux autres galons d'argent avec des vestes de damas cramoisy et des cocardes blanches. … Quatre valets de chambre avec un habit uniforme de drap d'écarlate avec de grands aegremens d'argent en plain." Transcribed in Tipton 2010, Quellenanhang, Pomponne.

15 This procedure is mentioned in the description of the official entry of a later French ambassador; see CPV, vol. 180, fols. 367r–369v, "Déscription de l'Entrée de M. le C.te de Gergy, Amb.r du Roy à la Rep.e de Venise," 4–5 November 1726, at fol. 369r: "Pendant que M.r l'amb.r étoit en chemin pour se rendre au Palais du Doge, tous ses domestiques prirent les devants pour se trouver rangés en double haye à sa descente de gondole et le précéder jusqu'en haut à l'appartement du Doge." Transcribed in Tipton 2010, Quellenanhang, Gergy.

16 See CPV, vol. 147, fols. 49r–64v, "Relation de l'entrée publique de M.r l'abbé de Pomponne Amb.r du Roy à Venise," 15 May 1706, at fol. 50r: "[Pisani] s'estant fait raporter en detail le cérémonial que M.r l'amb.r se proposoit de garder il dit au consul que M.r l'amb.r n'estant qu'abbé, il devoit porter le rochet couvert du mantelet selon l'usage des abbés Italiens." Transcribed in Tipton 2010, Quellenanhang, Pomponne.

17 See Perrin and Vasco Rocca 1999, p. 319.

18 Inside his diocese, the territory of his ecclesiastical jurisdiction, a bishop would wear the mozzetta instead, which left much of the rochet visible, but he would wear the mantelletta when greeting a visiting cardinal, who outranked him; see *Caeremoniale* 1680, pp. 2, 9, 16 (section I:1, I:3, I:4). The French ambassador to the Holy See and archbishop of Bourges, La Rochefoucauld (see chapter 4), wore the mantelletta over the rochet when he was received by Pope Benedict XIV in 1745; see Brimont 1913, p. 57.

19 Nani 1702, vol. 2, pp. 118–19.

20 See CPV, vol. 147, fols. 49r–64v, "Relation de l'entrée publique de M.r l'abbé de Pomponne Amb.r du Roy à Venise," 15 May 1706, at fols. 50r–v: "Le sujet de cette contestation estoit qu'à Rome et dans le reste d'Italie le rochet de[couvert] est la marque d'une jurisdiction libre, au lieu que le mantelet est une signe que le prelat n'a point de jurisdiction, où qu'elle est suspendue, et pour ainsy dire, eclypsée. … Le Nonce du Pape à Venise y porte le crochet decouvert dans la ville et lors qu'il va au Collège jusqu'au pieds des deux statues de géants qui sont sur l'escalier par lequel on monte a la Salle parcequ'il exerce une jurisdiction dans la ville, mais il prend le mantelet aux pieds de ses statues pour marquer qu'il n'exerce point de iurisdiction à l'egard de la Seigneurie et du corps de la République. Les Venitiens regardent encore cet habit comme la marque d'une vénération particulière qu'un ministre ecclesiastique rend au Prince." Transcribed in Tipton 2010, Quellenanhang, Pomponne.

21 See Pavanello and Craievich 2008, p. 278, cat. no. 59; Toledano 2006, pp. 204–6, cat. no. V.X; De Grazia and Garberson 1996, pp. 334–40.

22 See CC, registro IV, fol. 110. Cited in Succi 1994, p. 84.

23 For his official entry, Giovanni Francesco Stoppani (1695–1774), papal nuncio in Venice from 1739 to 1743, was accompanied by twenty-one bishops from dioceses on Venetian territory; see the list enclosed with his letter, Vatican City, Archivio Segreto Vaticano, Segreteria di Stato, Venezia, Segnatura 194, fol. 256r–260v, Giovanni Francesco Stoppani to Silvio Valenti Gonzaga, 22 April 1741, at fol. 260r. Tipton 2010, n. 258, mistakes the patriarch-elect of Aquileia (a different diocese) for the patriarch of Venice.

24 For Pomponne's biography, see Balteau 1933ff, vol. 3, cols. 889–90.

25 Pomponne had been ordained a priest in 1698, but the designation *abbé* was also frequently used for those who had only received minor orders. This was a common practice for later-born, non-inheriting sons of the nobility who thereby obtained a respectable position in life and the right to wear ecclesiastical dress (prized because it was far more economical than the luxurious male fashions otherwise de rigeur for a nobleman).

26 In an anonymously published pamphlet defending the Jansenists' French translation of the New Testament against criticisms Feuillade had voiced in a petition to Louis XIV, Arnauld had attacked Feuillade for neglecting his pastoral duties as a diocesan bishop by serving in the secular role of ambassador to Venice and Spain; see Arnauld 1668, p. 8 n. 16; republished under the author's name in Arnauld 1776, pp. 6–7 n. 16. Pomponne's family's close association with Jansenism had also adversely affected the career of his father, Simon Arnauld de Pomponne (1618–1699), one of the most gifted

diplomats of his generation who had served as Louis XIV's secretary of state for foreign affairs before suffering a precipitous fall from grace in 1679; see Niderst 1998.

27 At the time of his embassy to Venice, Estrades was commendatory abbot of Saint-Pierre in Moissac (since 1672). He later added the abbey of Saint-Melaine in Rennes.

28 See CPV, vol. 147, fols. 49r–64v, "Relation de l'entrée publique de M.r l'abbé de Pomponne Amb.r du Roy à Venise," 15 May 1706, at fols. 50v–51r. Transcribed in Tipton 2010, Quellenanhang, Pomponne.

29 See CC, registro IV, fols. 1v–2v: "La mattina poi del 10 fu da Sua Eccellenza [Pisani] levato l'Ambasciatore dalla sua casa alla Madona dell'Orto, essendosi Sua Eccellenza col seguito de' Senatori fermato prima in chiesa alla Madona dell'Orto sin a tanto fecce prenderli aviso del suo arrivo, ove havuta la notizia l'Ambasciatore si fece vedere nell'incontro al secondo ramo di scala del suo Palazzo, vestito con sottana e Mozetta nera e Rochetto scoperto e Beretta ecclesiastica, per accoglier Sua Eccellenza ove si condussero nella camera di udienza. Doppo breve spazio si levarono e Sua Eccellenza tolto alla drita l'Ambasciator, che lasciò la Beretta, e prese il Capello, si portarono alla Barca di Sua Eccellenza Cavalier Pisani, ove unitamente col seguito d'altre Barche si incaminarono alla Piazzetta. Capitati al primo patto della Scala de Giganti, pigliò l'Ambasciatore la Mantelletta, e coprì il Rochetto. Alla porta dell'anticolegio lasciò l'Ambasciator il capello e comparso alla presenza di Sua Signoria suplì come sopra si è detto e nel partire lasciò la Beretta, e Mantelletta nel sito medesimo che anteriormente li prese: fu restituito da Sua Eccellenza col seguito stessa alla sua Casa, con le solite maniere della sera precedente." Transcribed in Mariuz 1994, pp. 51–52 n. 7 (with incorrect year 1707). See also Tipton 2010, Quellenanhang, Pomponne, for a transcription with some omissions and the incorrect year 1726.

30 See CPV, vol. 147, fols. 49r–64v, "Relation de l'entrée publique de M.r l'abbé de Pomponne Amb.r du Roy à Venise," 15 May 1706, at fol. 61v: "en habit de cérémonie avec la muzzette, le rochet decouvert et le chapeau"; fol. 62v: "M.r l'amb.r s'arrête au pied des statues des géans pour y prendre le mantelet." Transcribed in Tipton 2010, Quellenanhang, Pomponne. The erroneous interpretation of Pomponne's dress in Succi 2015, p. 120, is due to a misconception of the mozzetta and the mantelletta as the same vestment and a misunderstanding of their symbolic significance.

31 Venice, Museo Correr, ms. Gradenigo-Dolfin 49, vol. 2, fol. 102; inscribed: "Enrico Carlo Arnauld di Pomponna Consigliere, ed Elemosiniere del Re Cristianissimo venne suo Ambasciadore a Venezia del 1705 a 5 di Giugno.... Seguì con questo Abito il di lui Ingresso a 10 di Maggio dell'anno seguente." See Grevembroch 1981, vol. 2, no. 102. The likeness of Pomponne is based on an engraving by Isabella Piccini; see Mariuz 1994, p. 51 n. 6, fig. 3.

32 See CPV, vol. 147, fols. 40r–48v, Pomponne to Louis XIV, 15 May 1706, at fol. 41r: "Je me suis efforcé de la rendre la plus éclatante qu'il m'a esté possible." Transcribed in Tipton 2010, Quellenanhang, Pomponne.

33 See Penzo 1999, p. 234; Orlandini 1903, pp. 17–20.

34 See CPV, vol. 147, fols. 49r–64v, "Relation de l'entrée publique de M.r l'abbé de Pomponne Amb.r du Roy à Venise," 15 May 1706, at fol. 55v: "Les Venitiens assûrent qu'ils n'avoient pas encore vu une entrée sí pompeuse icy, sí magnifique"; fol. 62v: "c'est le bruit general de toutte la ville qu'il n'y en a jamais en de sì grand à l'occasion d'aucune entrée d'amb.r." Transcribed in Tipton 2010, Quellenanhang, Pomponne.

35 Temanza 1963, p. 65: "Riportò molto applauso per le figure et intagli fatti sulle Gondole del Abbate di Pompona Ambasciatore a Venezia pel Re di Francia."

36 See CPV, vol. 147, fols. 49r–64v, "Relation de l'entrée publique de M.r l'abbé de Pomponne Amb.r du Roy à Venise," 15 May 1706, at fol. 61v: "On a fait et repandu plusieurs sonets et d'autres poesis Italiennes et Latines a la louage du Roy, outres celles qui expliquent le dessein des gondoles." Transcribed in Tipton 2010, Quellenanhang, Pomponne.

37 See CPV, vol. 147, fols. 49r–64v, "Relation de l'entrée publique de M.r l'abbé de Pomponne Amb.r du Roy à Venise," 15 May 1706, at fol. 56r–58r: "M.r l'amb.r a voulu représenter dans les deux premièrs qui sont d'une grandeur extraordinaire, la gloire de la France sous l'heureux règne de S. M. tant sur la terre, que sur la mer. Sur la proue de la première gondole est une Renomée qui tient dans son bras gauche un bouclier ou est l'armee de France et de la main droitte une trompette. Elle est suivie de deux autres figures plus grandes que le naturel, l'une tenant un baston de comandement fleurdelisé, revêtue d'habit yaune et assise sur des trophées d'armes represente la France. L'Histoire à ses pieds écrit dans un grand livre les evènemens du règne glorieux de S. M., un petit genie soutient ce livre, d'autres genies portent autour des branches de lauriers, comme les marquet de la Victoire. Le felze est soutenu par quatres grandes consoles ornées de beaucoup de sculpture, de feuillages, de guirlandes. Quatre grandes figures au pied des montans du felze représentent la Religion, la Piété, la Magnimité, la Liberalité du Roy." Transcribed in Tipton 2010, Quellenanhang, Pomponne.

38 The chains of Navarre are misinterpreted as the monogram of Louis XIV in Succi 2015, pp. 77, 78, 116.

39 See Jougla de Morenas 1975, vol. 1, p. 238; Rolland and Rolland 1967, vol. 1, pl. LXIX.

40 See CPV, vol. 147, fols. 49r–64v, "Relation de l'entrée publique de M.r l'abbé de Pomponne Amb.r du Roy à Venise," 15 May 1706, at fol. 58r–59r: "La seconde gondole représente la Gloire du Roy sur la mer par les victoires que les flottes de Sa Majesté y ont remportées, et particulièrement par l'union des deux mers pour procurer la facilité, et l'abondance du commerce. Deux grandes figures de Neptune et de Thetis qui se tiennent par la main expriment cette union. Elles sont assises sur un chariot magnifique, fait en forme de coquille, tirée par deux dauphins, qui sont guidées par une figure demi homme et demi poisson. D'autre grands Tritons sont au pié des montants du felze, les deux premiers avec des trombes marines,

et les deux autres portant des guirlandes.... Il y à sur les deux cotés deux grands soleils qui font le corps de la devise du roy, sur le portique de devant les armes de France, et sur le derrière les chiffres de S. M. avec les couronnes de France.... La troisième Gondole est aussi garnie de figures et d'autres ornemens, et son felze couvert d'un velour bleu galoné d'or tant en dehors qu'en dedans avec des coussins et un strate de mesme; les portières, les pentes, les banquettes, et les rideaux sont d'un damas de la mesme couleur. Le tout avec des crépines et des franges d'or." Transcribed in Tipton 2010, Quellenanhang, Pomponne.

41 See Grevembroch 1981, vol. 2, no. 102.

42 See MC, ET/CXIII, 319, codicil to Pomponne's will, 13 August 1729, bequeathing "deux tableaux, l'un représentant l'entrée de l'abbé à Venise en qualité d'ambassadeur de France, l'autre, sa première audience" to his brother. Transcribed in Rambaud 1964, p. 565. See also Tipton 2010, Quellenanhang, Pomponne. The paintings are listed in the inventory of Pomponne's estate of 6 July 1756, MC, ET/CXIII, 389: "un grand tableau peint sur toille representant M. l'abbé de Pomponne à Venise un autre repr[esentan]t le Senat de Venise"; transcribed in Pavanello and Craievich 2008, p. 246.

43 See CC, registro III, fol. 220. Cited in Succi 2015, p. 114.

44 This was in spite of being informed in his instructions from the French foreign ministry, dated 15 October 1723, that the king expected him to make his official entry as soon as possible after his arrival: "L'intention de S. M. est qu'il fasse son entrée publique le plus tost qu'il lui sera possible, afin d'estre plus promptement en estat de traiter lui mesme de toutes les affaires et d'exécuter les ordres que S. M. lui envoyera." Transcribed in Duparc 1958, p. 162.

45 See SVB, Kasten 18, Giovanni Battista Colloredo to Philipp Ludwig von Sinzendorf, 26 July 1720; Vienna, Österreichische Nationalbibliothek, Cod. Ser. n. 18215, fols. 85–86, Giovanni Battista Colloredo to Girolamo Colloredo, 9 October 1723. Transcribed in Tipton 2010, Quellenanhang, Colloredo.

46 See CC, registro IV, fol. 52r. Cited in Bettagno and Kowalczyk 2001, p. 130; Succi 2015, p. 148.

47 Three consecutive French ambassadors, Pierre François, comte de Montaigu (in office 1743–49), Théodore Chevignard de Chavigny (in office 1750–51), and Cardinal de Bernis (in office 1752–55), did not celebrate an official entry.

48 Bernis 1878, vol. 1, p. 425: "Mon intérêt n'est pas d'être fort pressé de faire une dépense aussi considérable qui me sera toujours fort onéreuse, quel que soit le secours que le Roi me donne. C'est à vous, Monsieur, à juger si les affaires et les circonstances l'exigent. Il faut bien du temps pour s'y préparer." A previous French ambassador, Charles François de Froulay (in office 1733–43; entry in 1738), informed the foreign ministry that the preparation of his official entry would require at least four months. See Laigue 1913, p. 100.

49 See SVB, Kasten 15, Hercolani to Joseph I, 20 February 1708: "In fine, padrone aug.mo e V. M. comanda, che io lasci tutto il negozio, e mi contenti dell'honore del carattere, et in questo caso io m'humiliarò à di Lei sovrani comandi, benche con molto dolore d'havere à spendere cinquanta mille fiorini della mia borsa, solo per passeggiar Venezia nelle gondole dorate." Transcribed in Tipton 2010, Quellenanhang, Hercolani. The entry of the imperial ambassador Prié in 1753 was reported by the Cardinal de Bernis to have cost 80,000 florins; see CPV, vol. 214, fol. 309v. Transcribed in Tipton 2010, Quellenanhang, Bernis.

50 See SVB, Kasten 18, Giovanni Battista Colloredo to Philipp Ludwig von Sinzendorf, 26 July 1720: "Per le Gondole: Fior.ni 28.863 = 19; Per le Livree: Fior.ni 11.933 = 15; Per li rinfreschi, illuminationi: Fior.ni 8.808 = 3; Fiorini: 49.604 = 37." Transcribed in Tipton 2010, Quellenanhang, Colloredo. For a description of Hercolani's entry, see Frati 1908, pp. 38–40.

51 See SVB, Kasten 16, Filippo Hercolani to Charles VI, 2 July 1712. Transcribed in Tipton 2010, Quellenanhang, Hercolani. See also Tipton 2010, n. 247, giving the annual rent as 1,114 silver ducats or approximately 1,650 florins. The palace is also known under its later name Palazzo Papadopoli.

52 Cited in Tipton 2010, n. 245.

53 See SVB, Kasten 33, Philipp Joseph von Orsini-Rosenberg to Wenzel Anton von Kaunitz, 29 December 1754. Transcribed in Tipton 2010, Quellenanhang, Orsini-Rosenberg. See also Tipton 2010, n. 282, misidentifying the imperial ambassador and author of the letter as Franz Xaver Wolf von Orsini-Rosenberg (1723–1796), who served as imperial envoy in Copenhagen between 1750 and 1757.

54 See CPV, vol. 183, fol. 143v, Jacques Vincent Languet de Gergy to Louis XV, 21 May 1729: "Le comte de Bolagnos, ambassadeur de l'Empereur a cette Republique, fit son entrée dimanche dernier et le lundy suivant il fut conduit au Collège ou il haranguat suivant la coustume le Doge e la Republique; quelques belles q[ue] soient les gondolles de cet ambassadeur, dont il avoit acheptè les corps et les sculptures dorées du feu cav. Colloredo, son prédécesseur, j'ose assurer Votre Majesté qu'elles rapprochent pas ni de la magnificence, ni du goust des miennes." Transcribed in Tipton 2010, Quellenanhang, Gergy.

55 See SVB, Kasten 19, fols. 138r–145r, Giuseppe Bolagnos to Charles VI, 21 May 1729, at fol. 139r. Transcribed in Tipton 2010, Quellenanhang, Bolagnos.

56 See Succi 2015, p. 85, figs. 66–68; Romanelli and Pedrocco 1980, p. 11, cat. no. 10. The first and third gondolas were designed by Paolo Orio; the second, by Antonio Gai.

57 For a detailed comparison of Colloredo's and Bolagnos's gondolas, see Succi 2015, p. 93.

58 SVB, Kasten 19, fols. 138r–145r, Giuseppe Bolagnos to Charles VI, 21 May 1729, at fol. 140r: "oltre l'artificiosa benintesa disposizione delle statue, e figure, e la vaghezza delli ornamenti vi erano li ferri di tutte le tre gondole à poppa, e prova, lavorati all'ultima perfezione, come non si sono veduti eguali in Venezia, dorati in diverse foglie, che li facevano comparire più belli, e li rendevano d'universale ammirazione." Transcribed in Tipton 2010, Quellenanhang, Bolagnos.

59 See Scarpa 2008, p. 257, cat. no. 22; Montecuccoli degli Erri and Pedrocco 1999, p. 238, cat. no. 18. The signed painting has been dated to circa 1735 on stylistic grounds. However, there was no official entry of an imperial ambassador that took place during Marieschi's brief career as a view painter in Venice between 1735 and his early death in 1744. Bolagnos's successor, Luigi Prince Pio di Savoia (d. 1755), celebrated his entry in December 1732 and remained in office until 1743; the next ambassador, Giovanni Antonio Turinetti, Marquis of Prié, arrived in 1747 and waited until April 1753 to stage his entry. Two further views by Marieschi, both showing the church of San Stae, also include the parade gondolas; see Montecuccoli degli Erri and Pedrocco 1999, pp. 239–40, cat. nos. 19–20.

60 See Romanelli and Pedrocco 1980, pp. 9–10, cat. no. 2.

61 "Sur la proie sont 2 figures qui s'embrassent et qui représentent la Justice et la Paix… elles ont leur génies auprès d'elles pour les conferrer entre le venin de la discorde representée sous la figure d'un dragon qui sert d'armement et de fer a la Gondole. Un 3me génie, qui est celuij de la France, tenant un boucluj sur lequel est un soleil, chasse cet animal de division."

62 "Les fers de celuij de devant qui est le dragon que celuij de derrière qui est un feuillage sont l'effort d'une main savante dans le maniement de ce metail, et tout ce que l'art en peut faire."

63 See CPV, vol. 137, fols. 184r–194v, "Relation de l'Entrée de M.r de Charmont," 12 May 1703, at fol. 187r: "La première estoient enrichie de plusieurs figures parmy lesquelles on remarquoit sur la prove l'union de l'Espagne avec la France, représentée par deux femmes vestues d'habits Royaux, un Enfant représentant le nouveau siècle, accompagné de plusieurs autres presentoit a ces deux puissances unis une branche d'olivier, au milieu de ces enfans etoit une Renommée qui tenoit dans son bras gauche un boucluj où estoient les armes de France et de la main droite une trompette." Transcribed in Tipton 2010, Quellenanhang, Charmont.

64 See note 37.

65 See SVB, Kasten 33, Philipp Joseph von Orsini-Rosenberg to Wenzel Anton von Kaunitz, 8 October 1754. Transcribed in Tipton 2010, Quellenanhang, Orsini-Rosenberg.

66 See Ritzler 1952, p. 156.

67 The sheet is inscribed: "Questa fastosa Barca, che qui esponiamo, è una delle tre, che Monsig.e Stampa fece vedere l'anno 1721 a 15 di Luglio, giorno del di Lui solenne Ingresso in Venezia, con rispettabile figura di Nunzio Pontificio appresso la Repubblica." Transcribed in Grevembroch 1981, vol. 4, no. 124.

68 On the artistic practices of appropriation and emulation in eighteenth-century Venice, see also Franzini 2012.

69 See Succi 2015, pp. 114–16, cat. no. 1; Scarpa 2008, p. 249, cat. no. 1. On the importance of this painting in Carlevarijs's artistic development, see Barcham 2002, pp. 58–59, 62.

70 See Mijnlieff 1997, p. 192; Faucheux 1969, p. 51, cat. no. 11.

71 See Succi 2015, cat. nos. 2, 3, 16, 5, 10, 9. The figure also appears in other paintings by Carlevarijs that do not show specific events.

72 London, Victoria and Albert Museum; London, British Museum; Venice, Museo Correr. See Ald. Rizzi 1967, pp. 97–99, 101–2. For the oil study of the gentleman in blue, see Ald. Rizzi 1967, p. 97, no. 40.

73 For a parallel development, the paintings of ambassadorial entries in Constantinople by Jean-Baptiste Vanmour, see Bull 2003, pp. 29–31.

74 Da Canal 1809, p. xxix: "[Carlevarijs was] impiegato perciò e da' nostri negl'incontri di pubblici ingressi e di solenni regate, e dagli ambasciatori e principi stranieri sino all'ultimo della vita."

75 Charles Montagu to Charles Spencer, 3rd Earl of Sunderland, 16 September 1707. Transcribed in W. Montagu 1864, vol. 2, p. 247.

76 See Tipton 2010, n. 123.

77 See CC, registro IV, fol. 8: Manchester "era vestito con habito ricco di colore." Cited in Succi 2015, p. 124.

78 See Succi 2015, pp. 121–25, cat. no. 3.

79 Charles Montagu to Charles Spencer, 3rd Earl of Sunderland, 2 March 1708. Transcribed in W. Montagu 1864, vol. 2, p. 298.

80 See Dean and Knapp 1987, pp. 146, 181.

81 See Succi 2015, pp. 148–49, cat. no. 15; Pavanello and Craievich 2008, p. 250, cat. no. 16.

82 See Marx 2005, vol. 1, p. 72; vol. 2, p. 149, cat. no. 282; Constable and Links 1989, vol. 2, p. 288, cat. no. 208.

83 See Bettagno and Kowalczyk 2001, pp. 126–27, 130, cat. no. 57; Constable and Links 1989, vol. 2, pp. 255–56, cat. no. 144.

84 See CC, registro IV, fol. 53. Cited in Bettagno 1997, p. 357.

85 See Succi 2015, pp. 150–55, cat. no. 16; Pavanello and Craievich 2008, pp. 250–52, cat. no. 17. On the basis of the many similarities with the Pomponne painting, Mariuz 2004, p. 86, has suggested that this canvas was a modello or smaller version of the Pomponne painting that had remained in the artist's possession and that Carlevarijs overpainted the figure of Pomponne twenty years later with the new ambassador at the latter's request.

86 See Pavanello and Craievich 2008, pp. 260–61, cat. no. 32; Bettagno 1997, pp. 357–59, cat. no. 39; Constable and Links 1989, vol. 2, pp. 369–70, cat. no. 356.

87 Cited in Hogwood 2005, p. 50.

88 Reynolds 1975, p. 101.

89 See MC, ET/CXI, 178, 9 December 1734: "deux grands tableaux peints sur toile l'un représentant l'entrée de Son Excellence le Comte de Gergy à venise et l'autre la feste du Bucentaure dans leurs bordures de bois doré"; "un tableau peint sur toile représentant l'Entrée de Son Excellence monsieur le Comte de Gergy à venise en petit." Transcribed in Véron-Denise and Droguet 1998, p. 101.

90 See Constable and Links 1989, vol. 2, p. 369, cat. no. 355. For the date of Bolagnos's official entry, see CC, registro IV, fol. 59. Cited in Tipton 2010, Quellenanhang, Bolagnos.

91 See SVB, Kasten 19, fols. 138r–145r, Giuseppe Bolagnos to Charles VI, 21 May 1729, at fols. 139r–140r; 142r–v. Transcribed in Tipton 2010, Quellenanhang, Bolagnos.

92 See SVB, Kasten 19, fols. 138r–145r, Giuseppe Bolagnos to Charles VI, 21 May 1729, at fol. 138v: Corner was "vestito in abito di gala con

toga rossa, e la stola d'oro." Transcribed in Tipton 2010, Quellenanhang, Bolagnos.

93 Cole 1733, p. 13.

94 Cole 1733, pp. 13–14.

95 Cole 1733, p. 14.

96 See SVB, Kasten 19, fols. 138r–145r, Giuseppe Bolagnos to Charles VI, 21 May 1729, at fols. 144v–145r: "Questa mattina … per andare à ricevere la risposta alle credenziali di V. M. C., ed alla orazione da me fatta in Collegio, mi sono portate nel medesimo coll'istessa formalità, e pubblica comparsa di gondole, e famiglia in gala … e datami l'una, e l'altra risposta, … ritornai colla stessa formalità e seguito, andando à piedi per la piazza di San Marco addirittura per la Merceria fino al Fondaco de' Tedeschi, ove mi imbarcai con tutto il corteggio mio al mio palazzo." Transcribed in Tipton 2010, Quellenanhang, Bolagnos.

97 See Vatican City, Archivio Segreto Vaticano, Segreteria di Stato, Venezia, vol. 172, fols. 172r–173v, Carlo Gaetano Stampa to Nicolò Maria Lercari, 28 May 1729, at fol. 172r–v: "Il divisato S. conte Bolagno ambasc.re cesareo si portò sabato mattina della scorsa settimana nuovam.e in collegio col suo nobil treno di gondole à oro, e famiglia nobile e bassa in gala, à prendere la risposta della sua avvisata esposiz.e, e credenziali dopo di che si trasferì à piedi per la via della Merceria corteggiato dai suoi domestici, e seguito da varij soggetti di sfera, con essersi imbarcato al fondaco de' Tedeschi sopra d.e gondole con tutta l'accennata comitiva." Transcribed in Tipton 2010, Quellenanhang, Stampa.

98 See Carr 2015, p. 46, cat. no. 7; Links 1998, pp. 23–24, cat. no. 228*; Constable and Links 1989, vol. 1, pp. lvii–lviii.

99 Mary Wortley Montagu to Edward Wortley Montagu, 29 March 1740. Transcribed in M. Montagu 1965–67, vol. 2, p. 180.

100 See CPV, vol. 147, fols. 49r–64v, "Relation de l'entrée publique de M.r l'abbé de Pomponne Amb.r du Roy à Venise," 15 May 1706, at fol. 64v: "Le Secrétaire reconduisit M.r l'amb.r jusqu'à la porte de la grande salle qui tient d'un costé au Collège et de l'autre à la Chapelle, après quoy M.r l'amb.r se mit en marche, et au lieu d'aller remonter dans des gondoles à la place de S. Marc, il traversa à pied toute la Mercerie, la livrée marchant à l'ordinaire devant luy, ensuite les valets de chambre, les pages, leur gouverneurs, les gentilshommes et ceux de son cortège. M.r l'amb.r alloit le dernier accompagné de son Secretaire. Il alla en cet ordre jusqu'au bas du pont du Réalte où il monta dans ses gondoles." Transcribed in Tipton 2010, Quellenanhang, Pomponne.

101 See Hausmann 1950, pp. 168–69; Laigue 1913, p. 97.

102 See Ford and Ingamells 1997, p. 508.

103 See Horace Mann to Horace Walpole, 18 May 1745: "Lord Holdernesse has laid down his public character, but still stays at Venice." Transcribed in Walpole 1937–83, vol. 19, p. 41.

104 See Tipton 2010, nn. 285–86.

105 See Laigue 1913, pp. 86, 136.

106 See Tipton 2010, n. 286; Laigue 1913, pp. 107–8. A report on the preparations in Venice, Archivio di Stato, Inquisitori di Stato, vol. 915, Ambasciatori Esteri, 25 February 1737 [more veneto, i.e., 1738], describes neither the gondolas' sculptural decoration nor the oarsmen's gala liveries. Transcribed in Tipton 2010, Quellenanhang, Froullay.

107 Beddington 2006, pp. 12, 162, has tentatively identified the painting with a canvas listed in the catalogue of the Carpenter Garnier sale (Christie's, London, 13 July 1895) as "The Rialto," with dimensions similar to the present painting and sold by the descendants of George Garnier (1703–1763) of Rookesbury. If this identification is correct, the canvas may have been acquired during Garnier's visit to Venice in 1745 (see Ford and Ingamells 1997, p. 391), although he was known mainly as a collector of porcelain and his only recorded purchase in Italy was a papal indulgence permitting the consumption of meat during Lent (see Garnier 1900, pp. 23–24). If the painting was originally commissioned by Froulay, it may have been unfinished at the time of the ambassador's departure in 1743, could have remained with Canaletto due to Froulay's death in 1744, and may have been sold to Garnier in 1745 as a generic view of the Rialto Bridge rather than the depiction of a specific event.

108 Cole 1733, p. 13.

109 See SVB, Kasten 21, Pio di Savoia to Charles VI, 6 December 1732, Anlage A: "La prima delle sudd.e gondole dorate era magnifica di statue, che rappresentavano sopra la prova l'Europa con scettri e corone, ed il Valore, che tiene oppressa l'Asia, quattro figure, che sostenevano il felze, cioè la Giustitia, il Consiglio, la Guerra, ed il Premio; sopra la poppa v'era altra figura che rappresentava la Grazia con puttini fra le nuvole: Due scudi laterali ne' quali erano rappresentate le corone dell'Imperio, Ungheria, e Boemia. Il cielo di fuori e di dentro era coperto d'un drappo d'oro con soprariccio à mosaico, e questo foderato, e con le bandinelle d'un damaschetto cremisi con dissegno di fiori d'oro. La seconda gondola aveva tre figure a Prova, cioè la Pace, la Concordia, e la Temperanza, e sopra la poppa lo Splendore del nome: Era coperta d'un drappo d'oro con fiori grandi di seta alla persiana foderato, e con bandinelle di un damaschetto turchino con disegno di fiori d'oro. La terza gondola aveva sopra la prova figura, che rappresentava Pallade con diversi puttini, che adornavano felze, prova, e poppa, portando tutti instromenti guerrieri. Questa era coperta di un veluto verde tutto gallonato riccamente d'oro à cifra foderato, e con bandinelle d'un camelotto color di rosa col bordo per tutto di un gallone d'oro." Transcribed in Tipton 2010, Quellenanhang, Pio di Savoia.

110 See Arisi 1986, p. 466, cat. no. 472.

111 See Bock 2010, pp. 412–13; Arisi 1986, pp. 450–51, cat. no. 445; Bock 1985, pp. 390–92; Bock 1980, pp. 208–16.

112 See Charles Natoire to Abel François Poisson de Vandières, Marquis de Marigny, 6 November 1754. Transcribed in Montaiglon 1887–1912, vol. 11, p. 56, no. 5058.

113 See Chracas 1716–1836, no. 6042, 3 April 1756, pp. 4–10; no. 6045, 10 April 1756, pp. 4–12.

114 See De Martini 2012, pp. 103–6, cat. no. 30; Kragelund 2010, pp. 210–11; Toledano 2006, p. 176, cat. no. R.X.1; Manzelli 1999, pp. 27, 96, cat. no. R. 37.

115 Venice, Archivio di Stato, Senato, Dispacci Ambasciatori, Inghilterra, vol. 81, nos. 19–20, 15 April 1707: "quando giunto l'equipaggio faremo istanza per l'ingresso, et udienza"; 29 April 1707: "Non può acquietarsi la giusta passione degl'animi di noi Erizzo, e Pisani, nel veder fatalm.e fermati di là dal mare li nostri equipaggi." Transcribed in Tipton 2010, Quellenanhang, Pisani.

116 Venice, Archivio di Stato, Senato, Dispacci Ambasciatori, Inghilterra, vol. 81, nos. 21–22, 13 and 27 May 1707. Transcribed in Tipton 2010, Quellenanhang, Pisani.

117 Venice, Museo Correr, ms. Cicogna, no. 1186, fols. 210v–214r, "Relatione dell'Ingresso in Londra fatta dalli N. N. H. H.," at fol. 211v: "Esiggette l'applausi e può dirsi anche li stupori di Londra, a benchè non sia sì facile a donare ammirazione alla magnificenza de' stranieri, la ricca, nobile e strepitosa carrozza di Sue Ecc.e Erizzo e Pisani." Transcribed in Tipton 2010, Quellenanhang, Pisani.

118 Vienna, Österreichisches Staatsarchiv, Haus-, Hof- und Staatsarchiv, Staatenabteilungen, England, Berichte, Kasten 41, no. 39, Gallas to Joseph I, 31 May 1707: "Gestern haben die zwey Venetianischen Extraordinari Bottschaffter Erizzo und Pisani ihren ordentlichen Einzug gehalten, welcher Equipage sehr brächtig warr." Transcribed in Tipton 2010, n. 50.

119 See Succi 2015, pp. 140–42, cat. no. 9; Tipton 2010, §§ 19–30; Kultzen and Reuss 1991, pp. 44–45.

120 See Moroni 1840–61, vol. 82, p. 29.

121 See CPR, vol. 820, 4 April 1756: "La berline, appellée l'avant-garde, précédait le carrosse du corps; elle était attelée de six magnifiques chevaux et portait un grand carreau de velours bleu céleste galonné d'argent et garni de houppes de même." Transcribed in Boutry 1895, p. 123.

122 See Chracas 1716–1836, no. 6045, 10 April 1756, pp. 5–6: "S'incaminò prima d'ogn'altro il solito ombrello con fiocchi d'oro, indi la muta detta di Vanguardia, entro la quale era solamente il cuscino grande di velluto turchino riccamente gallonato d'argento."

123 Chracas 1716–1836, no. 6042, 3 April 1756, p. 6: "con la Croce dell'Ordine dello Spirito Santo, detto del Cordone Blò, con cui venne ultimamente decorato da Sua Maestà Cristianissima."

124 See Boutry 1895, p. xvi.

125 While it is theoretically possible that Choiseul could have asked Panini to include the order in anticipation of its bestowal, the ceremony depicted by Panini took place only once, in 1756. The proposal made in Blanning 2007, pp. 355–56, that the painting relates to Choiseul's final audience with the pope prior to his departure from Rome in 1757 can be rejected for the same reason.

126 Choiseul to Rouillé, 12 February 1755: "Je ne vous parle pas des décorations que mes prédécesseurs ont obtenues [...]. C'est à vos bontés pour moi à examiner si, pour le service du Roi, il n'est pas nécessaire de décorer celui qui le représente." Transcribed in Boutry 1895, p. 30.

127 Benedict XIV to Tencin, 19 February 1755. Transcribed in Morelli 1955–84, vol. 3, p. 215.

128 Marquise de Pompadour to Choiseul, 7 June 1755: "Les assurances d'amitié que vous me donnez me font grand plaisir; elles m'en feront encore davantage quand je me serai acquittée envers vous, en vous procurant le Saint-Esprit." Transcribed in Piépape 1917, p. 20.

129 Louis XV to Benedict XIV, 1 January 1756: "J'aurais cependant différé encore à lui accorder la décoration de mon ordre du Saint-Esprit, cette faveur étant la récompense que je destine à des services continués depuis longtemps, mais ayant appris que Votre Sainteté désirait de voir le comte de Stainville revêtu de cette distinction, je me suis volontiers déterminé à faire pour lui une exception à mon usage ordinaire." Transcribed in Boutry 1895, p. 77 n. 1.

130 See Chracas 1716–1836, no. 6045, 10 April 1756, pp. 4–12; CPR, vol. 820, 4 April 1756, transcribed in Boutry 1895, pp. 122–26.

131 Chracas 1716–1836, no. 6045, 10 April 1756, pp. 10–11: "Conforme poi l'Eccellenza Sua dovea in seguito visitar la Basilica Vaticana, ed indi dar principio alle publiche visite di questo sagro Collegio, ne fece nuovo invito a tutti i disopranominati per la publica Udienza, acciò volessero nuovamente favorirlo del corteggio per il Lunedì seguente il dopo pranzo, nel qual giorno essendo questi tutto adunato nel Palazzo del Sig. Ambasciatore, ... s'incaminò dipoi, collo stesso nobile treno, e consimile corteggio con cui era andato alla prima Udienza di Nostro Signore, alla suddetta Basilica di S. Pietro, dove, dopo avere orato, lasciò nel partire copiosa elemosina a poveri."

132 See Kiene 1992, pp. 138–39, cat. no. 37; Arisi 1986, p. 331, cat. no. 200.

133 See Bowron and Rishel 2000, pp. 428–29, cat. no. 277; Arisi 1986, p. 466, cat. no. 473.

134 The early provenance for the pair can be revised as follows: Étienne François, comte de Choiseul-Stainville; his sale, Paris, 18 December 1786 (Lugt 4111), lot 2; sale of Louis Antoine Auguste, duc de Rohan-Chabot, Paris, 10 December 1787 (Lugt 4230), lot 101 bis ("Ils ont fait partie de la Collection de M. le Duc de Choiseul," with annotation in copy in New York, Metropolitan Museum of Art, Watson Library, 119.5 F772 1777-1788 v.4: "ces 2 Tablx. ont été vendus séparément à la seconde vente du duc de Choiseul le 18. X.bre 1786 / L'intérieur de St. Pierre 5600 [livres] / L'entrée du duc de Choiseul 3400 [livres] / et les 2. ensemble chez Mr. Bergeret 8200 [livres]"; for the Bergeret pair, see note 146); seen in Paris in January 1787 by the future King Louis Philippe I, Paris, Bibliothèque de l'Arsenal, Ms-15265, "Journal de Mme de Genlis," 1776–1798, fol. 72: "des tableaux de Panini: l'un représentant l'intérieur de St Pierre de Rome, l'autre l'entrée d'ambassadeur de M. de Choiseul à Rome" (transcribed in Guichard 2008, p. 174); sale of Jean-Baptiste Pierre Lebrun, Paris, 21 July 1795 (Lugt 5350), lot 33 ("Deux tableaux, dont l'un représente la vue intérieure, et l'autre la vue extérieure de S. Pierre de Rome, avec l'entrée du Duc de Choiseuil, ambassadeur de France, pour qui ils furent faits, et qui proviennent de sa vente, faite en 1786, sous le No. 2, où ils furent vendus 13500 livres"); sale of Jean-Baptiste Pierre Lebrun, Paris, 26 December 1797 (Lugt 5682), lot 12; sale, Paris, 16 February 1798 (Lugt 5708), lot 5 ("Ces deux magnifiques tableaux ont été faits par J.-Paul pour le ci-devant duc

de Choiseuil, & proviennent de sa vente, où ils furent vendus 12 à 13 mille liv."), to [Hubert] Robert; estate inventory of his wife, Anne Gabrielle Soos, 18 August 1821, no. 275 (transcribed in Gabillot 1895, p. 253); her sale, Paris, 16 November 1821 (Lugt 10127), lot 55.

135 See De Grazia and Garberson 1996, pp. 193–98.

136 See De Grazia and Garberson 1996, p. 197.

137 For Canilliac, see Michel 2016, esp. pp. 111–25.

138 See p. 94.

139 See Colleville and Saint-Christo 1925, p. 37; *Almanach* 1756, p. 109; *Mercure de France*, July 1753, pp. 203–4.

140 See Chracas 1716–1836, no. 5790, 24 August 1754, pp. 18–19. For the statues, see Rocchi Coopmans de Yoldi 1996, pp. 411–20.

141 See Arisi 1986, pp. 476–77, cat. no. 499.

142 See Chracas 1716–1836, no. 6045, 10 April 1756, p. 7: "[Choiseul] ascese nella sua prima muta nobile, e con esso unitamente presero luogo nella medesima li Monsignori Arcivescovi Tria, Gritti, e Giordani, Monsig. Vescovo Giampè, e Monsig. di Canilliach Uditore di Rota Francese." Canilliac was the only one of these to have been awarded the cordon bleu.

143 Rome, Archivio di Stato, 30 Notai Capitolini, ufficio 2, vol. 571, fol. 1, nos. 160, 162: "Un quadro in misura da otto e sei per traverso rappresentante il di dentro della chiesa di S. Pietro con moltissime figure dipinto dal Sig.re Cavaliere Pannini con cornice a tre ordini d'intaglio dorata ad oro buono"; "Altro di misura da otto e sei parimente per traverso rappresentante la Piazza di S. Pietro con carrozze e figure, cornicetta stretta dorata ad oro buono." Transcribed in Michel 2016, p. 131. The estimated size of 6 Roman palmi high by 8 palmi wide converts to 134 × 179 cm, compared to the paintings' actual sizes of 155 × 197 cm (Washington) and 152 × 195 cm (Berlin), which is within the margin of error for inventories of this period. The size of 9 × 12 palmi or 201 × 268 cm given for Canilliac's versions of *Ancient Rome* and *Modern Rome* (both Paris, Musée du Louvre), listed as no. 163, similarly underestimates the paintings' actual measurements of 231 × 303 cm.

144 See p. [chapter 4, at Panini Piazza Farnese].

145 See Arisi 1986, pp. 476–77, cat. nos. 499, 500.

146 The early provenance for the Washington and Berlin paintings proposed in Bock 2010, p. 412; Millon 1999, p. 426; De Grazia and Garberson 1996, pp. 194, 197 nn. 2–5; and Bock 1980, pp. 213–14, can be revised as follows: Claude François Rogier de Beaufort-Montboissier, abbé de Canilliac, until 1761; acquired in Rome in 1773–74 by Pierre-Jacques-Onésime Bergeret de Grancourt; listed in his estate inventory of 1785 (see Wildenstein 1961, p. 64, no. 20: "deux tableaux de Jean-Paul Pannini, représentant l'intérieur et l'extérieur de Saint Pierre de Rome dans leur bordure de bois dorée"); his sale, Paris, 24 April 1786 (Lugt 4027), lot 2; sale of François-Antoine Robit l'aîné, Paris, 6 December 1800 (Lugt 6161), lot 33 ("Ils viennent de la collection de Bergeret, No. 2 du catalogue"), sale canceled; sale of François-Antoine Robit l'aîné, Paris, 11–18 May 1801 (Lugt 6259), lots 83–84 ("Ils proviennent de la collection de M. Bergeret, qui les a

rapportés de Rome"), to Jacques Gamba; his sale, Paris, 17 December 1811 (Lugt 8091), lots 9–10 ("Ils proviennent de la Collection de feu M. Bergeret qui les a rapportés de Rome"), to Guillaume-Jean Constantin.

147 See Mijnlieff 1997, pp. 195–96. By contrast, Mariuz 2004, p. 78, emphasizes that the paintings were commissioned by the ambassadors themselves.

148 In November 1725, Canaletto was reported to be "engaged by the French ambassador." See Alessandro Marchesini to Stefano Conti, 10 November 1725: "impegnato con l'ambasciadore di Francia." Transcribed in Succi and Delneri 1993, p. 343. Although the painting to which this refers has not been conclusively identified, Haskell 1956, p. 298 n. 14, has suggested that Canaletto may have received the commission for the painting showing the entry of the French ambassador Gergy prior to the event itself.

CHAPTER 3

1 Mary Wortley Montagu to Edward Wortley Montagu, 16 March 1740. Transcribed in M. Montagu 1965–67, vol. 2, pp. 178–79.

2 Albrizzi 1740, pp. 342–43: "La Regata per ultimo è uno dei più lieti divertimenti che soglia dare il Pubblico ai Principi Forestieri."

3 Renier Michiel 1829, vol. 4, p. 117: "lo spettacolo il più interessante ed il più imponente per Venezia."

4 For the history of the annual regatta, see Tamassia Mazzarotto 1980, pp. 51–56.

5 See Limojon de Saint-Didier 1680, pp. 479–80: "Cette Course se fait depuis l'endroit que j'ay dit jusques au bout du grand Canal, où pour allonger davantage la carriere, l'on plante au milieu de l'eau un grand pieu, autour duquel les vogueurs sont obligez de tourner, & de revenir tout d'une haleine jusques au Palais, où l'on distribuë les prix aux premiers qui sautent dans un batteau paré, & destiné pour ce sujet."

6 See Succi 2015, p. 132; Clayton 2005, p. 76, cat. no. 13; Levey 1991, pp. 34–35, cat. no. 396; Constable and Links 1989, vol. 2, pp. 364–66, cat. no. 347.

7 See Constable and Links 1989, vol. 2, p. 664.

8 See Constable and Links 1989, vol. 2, pp. 366–68, cat. nos. 348–51.

9 See Kowalczyk 2012, pp. 156–57, cat. no. 38; Constable and Links 1989, vol. 2, pp. 366–67, cat. no. 349.

10 See Albrizzi 1771, p. 477; Mutinelli 1831, p. 137. According to other sources, the sequence was red, blue, green, and yellow, the order in which the flags appear in Carlevarijs's painting of the 1709 regatta (fig. 78).

11 See Constable and Links 1989, vol. 2, pp. 289–91, cat. nos. 210–16.

12 See Pavanello and Craievich 2008, p. 324, cat. no. 48.

13 See Succi 2015, pp. 125–32, cat. no. 4; Pavanello and Craievich 2008, pp. 247–48, cat. no. 11.

14 See CC, registro IV, fols. 10–11: "Il giorno 4 marzo antecedente alla sua partenza da questa Città, gli Eccellentissimi Cavalieri sudetti li fecero godere una nobilissima Regata, che seguì con tutta magnificenza di 26 Pedote guarnite riccamente, e moltissime Bissone

ed altro genere di Barche che rese amirato tutto il Popolo. Doppo esser stato il Re nella Bissona riccamente guarnita, che lo levò l'Eccellentissimo Cavalier Delfino dalla propria casa col seguito delle 26 Pedote…che lo volssero nel mezo et accompagnato per il Canal Grande con molta pompa e maestà." Transcribed in Reale 1994, p. 107.

15 See Succi 2015, pp. 132–36, cat. no. 6.

16 See Mutinelli 1831, p. 138.

17 *Magnificenza veneta* 1709, p. 15: "Era tutta addobata di veluto Cremese, Trinato di Frangia d'oro, che Calandosi in aqua portava i Tesori della Terra nel Mare."

18 See *Magnificenza veneta* 1709, p. 15.

19 See *Magnificenza veneta* 1709, pp. 10–11.

20 Rossi previously worked in Venice as the stage designer for the opera *Taican Rè della Cina* by Francesco Gasparini and is credited in the libretto (Venice: Rossetti, 1707, p. 11). The opera was first performed at the Teatro San Cassiano on 4 January 1707; see Selfridge-Field 2007, pp. 273–74.

21 Venice, Museo Correr, ms. Gradenigo-Dolfin 49, vol. 4, fol. 131. See Grevembroch 1981, vol. 4, no. 131: "[la] valorosa Figliuola di Giove, che risplendeva sù l'alta Puppa."

22 The royal coat of arms on the front of the *macchina*, visible in the painting, is not shown in the engraving.

23 See *Magnificenza veneta* 1709, pp. 7–8.

24 *Magnificenza veneta* 1709, p. 7: "Il Stema Reale di Sua Maestà Danese."

25 Alternatively, the anonymous chronicler writing the printed account of the regatta may have been unfamiliar with the coats of arms of a faraway Northern kingdom, and his mistake then misled the engraver, who did not necessarily see the actual barge.

26 See Succi 2015, pp. 145–47, cat. no. 11.

27 See Succi 2015, pp. 147–48, cat. no. 13; Pavanello and Craievich 2008, pp. 245–46, cat. no. 9.

28 On the Mauro family of stage designers, see Casellato 2009.

29 "La China condotta in trionfo dall'Asia"; see Romanelli and Pedrocco 1980, p. 20, cat. no. 69.

30 Albrizzi 1740, p. 343, pl. 70.

31 For an overview of Friedrich Christian's tour of Italy from May 1738 to September 1740, see Fastenrath Vinattieri 2003, esp. §§ 23–26 on his stay in Venice.

32 See note 1.

33 Goethe 1932–33, vol. 1, p. 63, letter XIII, 1 March 1740: "Se mai ho avuto la pazzia di poter dividermi in due corpi, egli fu in questa occorrenza, per mandare l'uno verso Roma e restar coll'altro a Venezia, acciocchè godessi ancora d'una si famosa cerimonia."

34 See Montecuccoli degli Erri and Pedrocco 1999, p. 377, cat. no. 149; Succi 1989, pp. 159–60.

35 See Bassi 1976, pp. 396–99.

36 Dresden, Sächsisches Hauptstaatsarchiv, Loc. 769/1, vol. 4, "Ihrer Hoheit…Reise von Rom nach Venedig und Dero Sejour allda betr.

Ao 1739–40," 6 May 1740: "[Friedrich Christian] se placea sur une loge de son Palais, d'ou l'on dominoit a plein sur tout le Canal jusqu'au Pont de Rialte vers la gauche, et jusqu'à l'Eglise de la charité vers la droite, ce qui formoit le plus beau point de veüe de toute la Ville." The author is deeply indebted to Maureen Cassidy-Geiger for the transcriptions from Wackerbarth's dispatches, Friedrich Christian's diary, and related archival documents.

37 See Tassini 1891, p. 37 n. 2.

38 See Luigi Ballarini to Daniele Dolfin, 25 January 1782. Transcribed in Ballarini 1870, pp. 22–23.

39 Mary Wortley Montagu to Lady Pomfret, 17 May 1740. Transcribed in M. Montagu 1965–67, vol. 2, pp. 187–88.

40 Mary Wortley Montagu to Edward Wortley Montagu, 1 June 1740. Transcribed in M. Montagu 1965–67, vol. 2, p. 190.

41 Mary Wortley Montagu to Edward Wortley Montagu, 1 June 1740. Transcribed in M. Montagu 1965–67, vol. 2, p. 191.

42 Dresden, Sächsisches Hauptstaatsarchiv, 10076, Rechnungen der Hof- und Staatsbehörden, 7/55, Einnahme und Ausgabe über Seiner Königlichen Hoheit des Kurprinzen zu Sachsen Schatullengelder, vol. 1 [unfoliated], 23 May 1740: "Gratification dem Antonio Jolli Mahler von Theatro Grimani à S. Gio: Crihostomo vor überreichte Zeichnungen deren 5. Peotten." Transcribed in Cassidy-Geiger 2014, pp. 60–61. For the watercolors, see Urrea Fernández 2012, pp. 33–36; Manzelli 1999, pp. 135–36, cat. nos. D.3–6.

43 See Manzelli 1999, p. 17.

44 Pietro Gradenigo's account of the regatta held for the visit of Duke Carl Eugen of Württemberg in 1767 describes a highly similar *peota*, raising the possibility that the barge from 1740 was stored and reused; Venice, Biblioteca del Museo Correr, ms. Gradenigo 67, "Notatori," vol. 18, fol. 71v, 4 June 1767: "La sempre rispettabile Procuratessa Elisabetta Cornaro Foscarini à proprie spese fece vedere una Peota, sotto il titolo degl' Orti dell'Esperidi, di cui le piante germogliavano Pomi d'oro; mà impossessatosene un fiero, e mostruoso Dragone, fù cura di Ercole, allo scrivere delle Favole, di uccidere il furioso animale." Transcribed in Gradenigo 1942, p. 155.

45 *Adria festosa* 1740, pp. 80–81: "gli Orti Esperidi con la Pianta de' Pomi d'oro, al di cui ingresso stava in difesa sulla Puppa il vigile Drago, con Alcide, o sia Ercole in atto con la Clava d'ucciderlo: sulla prora stavano le tre Sorelle Esperidi Egle, Creusa, ed Esperdusa in gesto d'adorare il simolacro della Dea Venere eretto sopra d'un Piedestallo; e tutta la Peota formata sì vivamente a Giardino, che parevano i fiori prodotti più della natura, che dall'Arte."

46 Dresden, Sächsisches Hauptstaatsarchiv, 10026, Geheimes Kabinett, Loc. 355/3–5, "Journal du voyage de Son Altesse Royale Monseigneur le Prince Royal de Pologne etc. Electoral de Saxe etc. ecrit de sa propre main," vol. 2: "Depuis Son depart de Rome, jusqu' à Son arrivée à Vienne. 14 Octobre 1739–23 Juin 1740," 1–15 May 1740: "La Peote du deuxieme deputes Alvise Mocenigo Casa Vecchia qui represente les jardins des Esperides avec Hercule sur la pouppe qui

tuë le dragon et sur la prouie sur les trois sœurs Esperides qui adore Venus."

47 Dresden, Sächsisches Hauptstaatsarchiv, 10026, Geheimes Kabinett, Loc. 355/3–5, "Journal du voyage de Son Altesse Royale Monseigneur le Prince Royal de Pologne etc. Electoral de Saxe etc. ecrit de sa propre main," vol. 2: "Depuis Son depart de Rome, jusqu' à Son arrivée à Vienne. 14 Octobre 1739–23 Juin 1740," 1–15 May 1740: "La Peotte de M.r Polo Dona figurant une Chasse. Diane y paroissoit à la pouppe accompagnée de ses Nimphes, et on voyoit à la Proüe Endimion l'attendant avec l'attirail de Chasse; le Gibier, et la meute garnissoient les bords du Bâtiment."

48 Mary Wortley Montagu to Edward Wortley Montagu, 1 June 1740. Transcribed in M. Montagu 1965–67, vol. 2, p. 191.

49 *Adria festosa* 1740, p. 82: "la Pace in Trionfo, portando nella destra un verde ramo d'Uliva, con la Discordia atterrata, e incatenati lo Sdegno, e le risse, premendo col piede Aste, Bandiere, e militari strumenti."

50 *Adria festosa* 1740, pp. 81–82: "Adorna di magnifica Maestà si fè vedere l'altra [peota] di S. E. Angelo Maria Labia, che rappresentava la Sassonia coronata dalla Polonia, e corteggiata dalla Virtù, con simbole, e geroglifici di virtù Reali, varj Scettri, Corone, e trionfi; vestiti quelli, che la guidavano alla Polacca con ricche divise. Opera mirabile del mentovato Signor Antonio Joli."

51 *Adria festosa* 1740, p. 83: "la Peota di S. E. Giacomo Soranzo di Rio Marin, che dimostrava sulla Puppa la Moscovia, e la Polonia insieme collegate a favore del Re Augusto sulla Prora assiso sotto Regio Baldachino formato di varie piume trà militari stromenti, de' quali era sparsa la Peota tutta con varj fogliami messi a oro, con i due fiumi principali dei due Regni, la Vistula, e 'l Volga. . . . Opera, e direzione del celebre Signor Gio: Battista Tiepolo."

52 See Romanelli 1983, p. 44, cat. no. 17; Stock 1980, p. 60, cat. no. 80; Morassi 1958, p. 19, cat. no. 32. The drawing was first tentatively connected with the regatta of 1740 in Pavanello 1981, p. 134 n. 8; Succi 1994, p. 79.

53 See Pedrocco 2002, pp. 80–81, 244–45, cat. no. 142; Levey 1986, pp. 91–98, fig. 94.

54 See Romanelli and Pedrocco 1980, p. 20, cat. no. 69.

55 Mary Wortley Montagu to Edward Wortley Montagu, 1 June 1740. Transcribed in M. Montagu 1965–67, vol. 2, p. 191.

56 Dresden, Sächsisches Hauptstaatsarchiv, 10026, Geheimes Kabinett, Loc. 355/3–5, "Journal du voyage de Son Altesse Royale Monseigneur le Prince Royal de Pologne etc. Electoral de Saxe etc. ecrit de sa propre main," vol. 2: "Depuis Son depart de Rome, jusqu' à Son arrivée à Vienne. 14 Octobre 1739–23 Juin 1740," 1–15 May 1740: "La Peote del Sigr. Giacomo Sur Soranzo in Rio Manin representa . . . le triomphe de la Pologne sur les Tartares avec la Pologne represente sur la pouppe avec les deux fleuves Elbe, et Vistule et le à la prouë le Dieu Mars sous un lorier qui embrasse un Polonois."

57 Dresden, Sächsisches Hauptstaatsarchiv, Loc. 769/1, vol. 4: "Ihrer Hoheit . . . Reise von Rom nach Venedig und Dero Sejour allda betr.

Ao. 1739–40," 6 May 1740: "La Peotte de Mr. Giacomo Soranzo. Elle representoit le Triomphe de la Pologne, et on n'avoit rien epargné pour la rendre magnifique, on y avoit employé une quantité de plumes blanches, et l'aigle blanc de Pologne, qui se voyoit à la pouppe en étoit artistement formé. Les rameurs en étoient habillez à la Polonoise, et il y avoit dessus une bande de musiciens dans le goût des Turcs."

58 For the history of the bull chase, see Johnson 2011, pp. 30–34; Friedrichs 2006, pp. 177–80; Tamassia Mazzarotto 1980, pp. 1–5.

59 See Renier Michiel 1829, vol. 4, pp. 105–6.

60 See Rosenberg 1782, pp. 66–68.

61 For the engravings of the bull chases for Duke Carl Eugen of Württemberg in 1767 and Grand Duke Paul of Russia in 1782, see Friedrichs 2006, pp. 173, 180, figs. 128, 142.

62 Goethe 1932–33, vol. 1, p. 20, letter III, 17 February 1740.

63 See Spadotto 2011, p. 242, cat. no. 82; Beddington 2010, pp. 102, 184, cat. no. 33.

64 Goethe 1932–33, vol. 1, p. 20, letter III, 17 February 1740: "Dentro lo steccato ove si faceva la caccia entrarono tante mila uomini d'ogni sorta, che certo fu miracolo quasi che non vi perderono molti o vita o membra, giacchè appena si vedevano i tori, ed in fatti uomini e cani venivano portati via a morte feriti."

65 See *Storia dell'anno MDCCXL* (Amsterdam: Pitteri, 1740), cited in Battagia 1844, p. 36: "Oltre ai divertimenti che i suddetti quattro cavalieri, facevano godere giornalmente a quel principe, gli diedero nel giorno 16 febbrajo il godimento di una reale caccia di tori nella gran piazza di s. Marco. Preparato quivi un magnifico steccato si radunò un immenso numero di spettatori, buona parte venuti a posta dalle città circonvicine. Quarantotto giovani de' più esperti nell' arte di tirar il toro, mascherati all' europea, asiatica, africana, e americana per tre ore continue fecero la suddetta caccia, in cui vennero adoperati più di 50 bravi cani." See also the description in *Adria festosa* 1740, p. 26.

66 See Goethe 1932–33, vol. 1, p. 19, letter III, 17 February 1740: "Il Principe Elettorale si trovò a canto della Procuratia vecchia, sotto la di cui finestra fu posto un altro bel coro di sonatori squisitissimi con i loro trombetti e tamburini."

67 Dresden, Sächsisches Hauptstaatsarchiv, 10026, Geheimes Kabinett, Loc. 355/3–5, "Journal du voyage de Son Altesse Royale Monseigneur le Prince Royal de Pologne etc. Electoral de Saxe etc. ecrit de sa propre main," vol. 2: "Depuis Son depart de Rome, jusqu' à Son arrivée à Vienne. 14 Octobre 1739–23 Juin 1740," 16–29 February 1740: "On chassa 120 Taureaux dont chacun etoit conduit par deux hommes. On lacha 20 taureaux par fois. Plusieurs de ces hommes etoit habille à l'Heroique representant l'Europe plusieurs en Turcs ou Persans representant les Asiatiques; Plusieurs en Mores representant les Africains, et plusieurs en autres habit barbares representant l'Amerique. Un homme fut aussi pour faire le vol, mais la corde lui ayant eté relaché ne put point le continuer."

68 *Adria festosa* 1740, p. 27: "dalla sommità dell'altissimo Campanile scese il volo, presentando a S. R. A. un mazzetto di fiori." It is also

possible that this text was printed before the event was held, as festival publicaions sometimes were.

69 See Gillio 2006, pp. 263–68.

70 See Selfridge-Field 2007, pp. 645–46: *Il coro delle muse*, Pietà, 21 March 1740; *La concordia del Tempo colla Fama*, Incurabili, 28 March 1740; *Le muse in gara*, Mendicanti, 4 April 1740. For an overview of these and other musical performances Friedrich Christian attended during his stay in Venice, see Witkowska 1996, pp. 290–95.

71 See Friedrichs 2006, pp. 137–38; Arnold and Arnold 1985, pp. 124–25. The piece is not listed in Selfridge-Field 2007. The printed libretto is *Telemaco nell' isola Ogigia. Cantata per musica* (Venice: Albrizzi, 1782).

72 See Friedrichs 2006, pp. 127–83. See also Pask 1992 on the commedia dell'arte performance on 21 January 1782.

73 See Friedrichs 2006, pp. 146–61.

74 Berlin, Kupferstichkabinett, inv. KdZ 9294; see Friedrichs 2006, p. 160, fig. 117; Rosenberg 1782, p. 53.

75 See Friedrichs 2006, pp. 136–38; Kultzen and Reuss 1991, pp. 66–67.

76 Nonni 1782, p. 6, mentions that "in due ampie Orchestre trovavasi unito dai quattro Conservatorj della Città il numero considerabile di 80 Figlie, tutte vestite in uniforme, che chi col canto, e chi col suono di varj Strumenti formarono un gradevole trattenimento per circa un'ora, e mezza," presumably referring to the musicians on the first and second tiers as separate orchestras.

77 Rosenberg 1782, p. 35: "L'envie d'approcher des Comtes du Nord, de les voir face à face, & peut-être aussi d'en être remarqué, avoit encouragé les plus timides. Malgré la chaleur, qui regnoit dans la Salle du Concert, les Comtes du Nord persisterent jusqu'à la fin de la Cantate, & même après se tinrent quelque tems dans la Salle, pour contenter l'avidité affectueuse des Spectateurs, dont les yeux ne pouvoient se rassasier de l'aspect de ces Personnages."

78 See Sottili 2010; Gabbrielli 2004, pp. 253–54.

CHAPTER 4

1 Grosley 1764, vol. 2, pp. 401–2: "On appelle à Rome, du nom de fonction, toutes les cérémonies civiles & religieuses qu'accompagnent la pompe & l'éclat: elles suppléent aux spectacles dont le Peuple Romain étoit autrefois si affamé."

2 For the history of the Chinea, see Moore 1998, pp. 183–84.

3 See Gori Sassoli 1994, pp. 81–82, cat. no. 1.

4 For an example from 1759, see Moore 1998, p. 187.

5 See Kieven 2007, pp. 278, 282–83.

6 See Moore 1995, p. 588.

7 See Gori Sassoli 1994, pp. 81–169, cat. nos. 1–122.

8 See Buranelli 2010, pp. 338–39, cat. no. 47; Gori Sassoli 1994, p. 113, cat. no. 39.

9 "Prospettiva della p.a Macchina, con cui si rappresenta la fondazione del Regno di Napoli, e Sicilia fatta dal conte Rogiero Normanno, il quale doppo di aver conquistate quelle Provincie, distratte prima in varij Pn.pi Naturali, e la mag.r parte negl'Imperatori di Costantinop. prese poi il Titolo di Rè datogli dal Sommo Pontefice Rom.o."

10 For Joli, see De Martini 2012, pp. 35–38, cat. no. 6b; Toledano 2006, pp. 96–97, cat. nos. C.VI.1–2. For Panini, see Sestieri 2015, vol. 3, p. 76, cat. nos. 136, 136.1; Arisi 1986, pp. 326, 361, cat. nos. 191, 258.

11 For the reuse of the armature in 1745, see Moore 1998, pp. 219–23.

12 See Buranelli 2010, p. 338, cat. no. 46; Gori Sassoli 1994, pp. 185–86, cat. no. 138. Inscribed: "Dessein du feu d'artifice representant l'union de l'amour, et de l'Hymenèe dans le Temple de Minerve, faisant allusion au Mariage de Monseigneur le Dauphin avec l'Infante d'Espagne Marie Therese, ordonnè a Rome dans la Place Farnese, par M. de Canilliac Ministre du Roy auprès du Pape Benoit XIV. dans le Mois de May 1745. / Macchina artificiale rappresentante l'unione d'amore ed Imeneo, nel Tempio di Minerva allusiva alle nozze del Real Delfino, e Maria Teresa Infanta di Spagna, fatta erigere in Roma nella piazza Farnese da Monsignor di Canilliac, Ministro della Maestà del Rè Christianissimo presso la Santità di N.o Sig.re Benedetto XIV. nel Mese di Maggio 1745."

13 See Naples, Archivio di Stato, Affari esteri, Roma, vol. 1065, 18 May 1745: "Benche il tempo si mantenesse costantemente, mà interpollatam.te piovoso, volle Sua Santità eseguire la partenza per Castel Gandolfo…. Hanno poi continuate le belle giornate, onde molti altri sono partiti per le reciproche Villeggiature, e atteso questo spopolamento di Roma non meno che l'incostanza della stagione Mons.re di Canillach hà anche pensato di differire le allegrezze per il Matrimonio del Delfino fin dopo il ritorno della Santità Sua." Transcribed in Moore 1998, p. 221 n. 135. For further reasons for the delay, see Brimont 1913, p. 51.

14 See CPR, vol. 797, 16 June 1745. Cited in Boiteux 1989, p. 336.

15 The architect Giuseppe Doria paid 90 scudi to Giovanni Paolo Panini's son Giuseppe Panini (1718–1805), the architect working for Canilliac, who in turn handed the money over to the master mason (heavy wood construction being carried out by masons rather than carpenters) and the blacksmith who had built the thirty-eight-meter *macchina* celebrating the French royal wedding. The contractors had to be reimbursed because recovering and keeping the *macchina*'s wood and hardware for reuse in future projects would normally have been part of their compensation. See Subiaco, Monumento Nazionale di S. Scolastica, Biblioteca Statale, Archivio Colonna, Libro mastro, 1745, I.A. 332, no. 494: "Io Sotto Scritto faccio fede come Mastro Ludovico: Capo Mastro Muratore principale Padrone del Lavoro di Muratore, e Castello della Macchina fatta fare dall'Eccell:mo Monsignore di Canilliac Ministro di Francia in occasione del Matrimonio del Real Delfino, in Piazza Farnese, avendo Sua Eccellenza Monsignor di Canilliac ceduto al Sig:re Contestabile Colonna il sudetto Castello per le sue Macchine di fuoco in occasione della Chinea, il Sud:o Capo Mastro, e restato d'accordo con il Sig:re Giuseppe Doria Architetto per nolo, di d.o Castello scudi novanta Mta de quali, me sotto scritto presente promise di rilassare à Mastro Simone Moretti Ferraro per nolo de Ferramenti di detto Castello Scudi dieci mta in fede il Sud:o Sig:re Giuseppe Doria potrà liberamente ritenerli, e pagarli al sudetto Moretti queso di p:mo

16 See Subiaco, Monumento Nazionale di S. Scolastica, Biblioteca Statale, Archivio Colonna, I.B. 46, fol. 1196. Transcribed in Moore 1998, p. 223 n. 139.

17 Chracas 1716–1836, no. 4356, 26 June 1745, pp. 6–7: "E siccome il principale festeggiamento era destinato farsi in Piazza Farnese, ove il prenominato Monsig. de Canilliach avea fatto erigere una nobilissima Machina di fuoco d'artificio di altezza 170 palmi Romani Geometrici, lavorata di tele ottimamente dipinte, con vaghissimi ornati di Statue, e Geroglifici, di particolare bellezza, e struttura, rappresentante L'unione di Amore, e d'Imeneo nel Tempio di Minerva, la cui invenzione è stata del Sign. Giuseppe Pannini Romano."

18 Harrison 1991, p. 73.

19 See note 12.

20 Ovid 1977, p. 233.

21 See Buranelli 2010, pp. 337–38, cat. no. 45; Harrison 1991, p. 73, cat. no. 54; Arisi 1986, p. 405, cat. no. 348.

22 Vatican City, Biblioteca Apostolica Vaticana, ms. Ott.lat. 3119, fol. 91r: "Giovan' Pauolo Pannini Pittore di Prospettive Parmigiano, che fece fare il Foco nella Piazza Farnese, ordinatogli da Mon.r di Cavigniach con lo sproposito di metter una Guglia sopra il tempio d'Himeneo, come si potrà veder meglio nella stampa, fatto da' me Cav. Ghezzi il di 28 Giugno 1745." Transcribed in Dorati da Empoli 2008, p. 325. See also Rostirolla 2001, p. 407, cat. no. 279.

23 This is also suggested by a comment from the director of the French Academy in Rome, Jean François de Troy, who—had he intended to—would certainly have explained to his correspondent in Paris that he was referring to the barely known son; see De Troy to Orry, 28 April 1745: "M. de Canillac se prépare à donner de grandes fêtes pour le mariage de Mgr le Dauphin.... Notre ministre [i.e., Canilliac] aura sans doute ses raisons pour avoir préféré le s.r Pannini, peintre de perspective en petit, aux peintres et aux architectes de cette Académie." Transcribed in Montaiglon 1887–1912, vol. 10, pp. 82–83, no. 4516. Officially, the design was credited to the son; see Chracas 1716–1836, no. 4356, 26 June 1745, p. 7: "la cui invenzione è stata del Sign. Giuseppe Pannini Romano."

24 See Naples, Archivio di Stato, Affari esteri, Roma, vol. 1065, 22 June 1745: "Corrisposero alla generale aspettativa le Feste quì fattesi per l'altro per il Matrimonio del Delfino... la ben intesa, ed eseguita Machina di fuoco all'ultimo gusto dipinta fece risaltare la commune curiosità à segno, che spinse l'Animo anche del Papa ad'esserne spettatore, onde... prendendo motivo d'uscire per la Visita dell'Esposizione del Venerabile, venne poi à questo Real Palazzo gustando della vista della Machina dal Balcone; Ivi con la stampa alla mano confrontò molte cose sù la Machina istessa, e compiacendosene per quasi mezz'ora, alle strida del numerosis.o Popolo ritrovatosi in Piazza non potè trattenersi di benedirlo per più volte." Transcribed in Moore 1995, p. 587 n. 20. See also Chracas 1716–1836, no. 4356, 26 June 1745, p. 9: "Quindi corrispondendo la Ringhiera

dirimpetto a cui si godeva la vista della descritta Machina si degnò anche il Santo Padre osservarla per poco tempo, ricevutane pria dal medesimo Monsign. de Canilliach la stampa in seta guarnita di merletto d'oro." See also Nantes, Centre des Archives diplomatiques de Nantes, Rome Saint-Siège, vol. 87, fols. 77–80, Canilliac to Argenson, 23 June 1745, at fols. 79–80: "Le Pape s'y transporta, l'après diner, pour voir les préparatifs de cette fête.... Sa Sainteté parcourut tout l'appartement et s'y arrêta une heure entière pour examiner la décoration. Elle se fit voir ensuite à un balcon qui étoit en face du feu d'artifice, et d'où elle donna la bénédiction à un peuple innombrable qui s'étoit rassemblé dans la place." Transcribed in Brimont 1913, p. 61.

25 Harrison 1991, p. 73.

26 Chracas 1716–1836, no. 4356, 26 June 1745, p. 7: "Furono in quella prima sera anche illuminate... tutta la Piazza all'intorno da quantità di torce sopra copiosi Doppieri dipinti a chiaroscuro, e disposti con tutta simetria, e buon' ordine tra varj festoni di verdura, il che ne rendeva anche più vaga la comparsa."

27 For the materials and construction techniques of the *macchine*, see Moore 1998, pp. 212–52.

28 Of the twelve judges comprising the tribunal of the Rota, three were nominated by the pope, two by Spain, and one each by the Holy Roman Empire, France, Venice, Milan, Bologna, Ferrara, and Florence.

29 See CPR, vol. 789, Jean Jacques Amelot de Chaillou to Canilliac, 4 September 1742: "Il me semble que, comme vous êtes déjà auditeur de rote, vous pourriez être regardé comme suffisamment autorisé à parler au nom du Roi." Transcribed in Hanoteau 1913, p. 199 n. 2.

30 Morelli 1955–84, vol. 1, p. 26, Benedict XIV to Tencin, 27 October 1742: "ci servirà di lume per i casi futuri, e fino che viveremo non accettaremo per ministro verun uditore di Rota, il che anche servirà alla giustizia."

31 Morelli 1955–84, vol. 1, p. 250, Benedict XIV to Tencin, 18 May 1745: "Mons. di Canilliac più non c'inquieta per questo capo, avendolo pregato a non parlarcene più, imperocchè la sua aria flebile accompagnata da motivi che sono sempre i medesimi, non ostante l'averli dileguati, farebbe alterare quel S. Pietro di bronzo che nella basilica di S. Pietro sta sedendo a mano destra sotto il baldacchino."

32 See Hanoteau 1913, pp. 200–201, 203 n. 2.

33 See De Brosses 1991, vol. 2, p. 969, letter L, undated; Lavalle 1981, p. 255; Brimont 1913, p. 23.

34 See Brimont 1913, pp. 54–56; Hanoteau 1913, pp. 202–5.

35 See Michel 2016, p. 116; Boiteux 2010, p. 241; Brimont 1913, p. 62. La Rochefoucauld's first audience with Benedict XIV took place on 22 June 1745; see Brimont 1913, p. 57.

36 See pp. 58–59.

37 Rome, Archivio di Stato, 30 Notai Capitolini, ufficio 2, vol. 571, fol. 1, no. 161: "Altro [quadro] di palmi nove, e mezzo e sei avantagiato parimente per traverso rappresentante La Festa di Francia fatta in Piazza Farnese con figure dipinto dal sudetto Cavaliere Giovanni

38 See chapter 2, note 146.

39 See Cola 2012, pp. 202, 217, no. 27: "Un Quadro grande di misura 6. 11 per traverso rappresentante la Piazza Farnese con macchina del Fuoco non terminato con piccola cornice dorata a vernice, originale del Cav. Gio. Paolo Panini baiocchi 80."

40 See Jean Frédéric Phélypeaux, comte de Maurepas, to La Rochefoucauld, 10 April 1747, 22 May 1747. Transcribed in Girardot 1871, pp. 333, 338.

41 For the Teatro Argentina as the setting for the celebrations, see Rinaldi 1978, esp. vol. 1, pp. 56–62.

42 See Chracas 1716–1836, no. 4677, 15 July 1747, p. 20: "la invenzione della vaga disposizione del Teatro del Sig. Giuseppe Pannini Romano."

43 See Lo Bianco and Negro 2005, p. 246, cat. no. 144; Arisi 1993, pp. 100–102, cat. no. 14; Kiene 1992, pp. 33–46, 102–3, cat. no. 4; Kiene 1990; Arisi 1986, p. 416, cat. no. 371 bis.

44 See Chracas 1716–1836, no. 4677, 15 July 1747, pp. 16–17: "con aver fatto l'Em.za Sua tutto abbellire di vaghissime pitture, e superbi ricchi apparati, che può dirsi nuovamente rifatto con la più grandiosa nobilissima idea il Teatro dietro al suo Palazzo, detto di Torre Argentina, ridotto in Sala, con una nuova Scena trasparente veramente maestosissima, & ogn'altro corrispondente ornamento per una festa Regia, e suntuosa."

45 Benedict XIV to Tencin, 12 July 1747: "Questa sera, e nelle due seguenti, si farà la solenne cantata nel teatro d'Argentina accomodato ad uso di sala in onore del matrimonio del Delfino da questo card. ministro di Francia, e Noi siamo stati a vedere il nobile apparato, avendo fatto lo stesso quando mons. di Canilliac fece le sue feste." Transcribed in Morelli 1955–84, vol. 1, p. 436.

46 La Rochefoucauld to Puysieulx, 12 July 1747: "Je ne pus pas m'étendre à ce sujet davantage avec le Pape parce que je lui parlai dans la grande salle que j'ay fait préparer pour la cantate qui s'exécutera ce soir pour la première fois. Comme les ornemens et illuminations de cette sale sont assez bien, Sa Sainteté a esté curieuse de les voir." Transcribed in Brimont 1913, p. 296.

47 Savage 1998, p. 633.

48 A manuscript copy of the score is in Turin, Biblioteca dell'Accademia Filarmonica, 9 VII 38. See Berti 2011, pp. 107–11.

49 St. Petersburg, Hermitage, inv. 3299, inscribed: "S.r Babbi tenore naturale, et à una bellissima voce … il quale cantò alla Cantata che fece fare il cardinale Rosefocon nel teatro Argentina, … e ci cantò Lisi, Babbi e la figlia di Pelaia cantarina, e Gioseppino della Longara." See Rostirolla 2009, pp. 238, 244, 264, fig. 10. Michel Barthélemy Hazon also observed the presence of female performers: "Tous les musiciens et musiciennes représentaient l'assemblée des Dieux." Transcribed in Launay 1940, p. 183.

50 Scarselli 1747.

51 See Chracas 1716–1836, no. 4677, 15 July 1747, p. 21: "furono dispensati in gran copia, e nobilmente stampati gl'esemplari della Cantata sudetta."

52 Ghezzi's caricature of Gallimard (St. Petersburg, Hermitage, inv. 3496) is inscribed: "Intagliatore in rame bolino e acquaforte di nation Francese e si porta assai bene 1747 di luglio a l'intagliato in acqua forte tutti i rametti della cantata fatto in Argentina ed il S.r Card.le Rosefocon gli si donò, e si chiama il presente intagliatore C. Gallimard." Transcribed in Sørensen 2002, p. 469 n. 15.

53 For the typical arrangement with the harpsichords placed at far left and far right and an eighteenth-century opera orchestra seating plan, see Butler 2009, p. 144, fig. 4.

54 Metastasio to Farinelli, 12 November 1749. Transcribed in Metastasio 1951–54, vol. 3, p. 444.

55 Inscribed: "Signor Jumella compositor di musica napolitano, che à fatto la cantata al S.r Ambasciator di Francia nel Teatro Argentina nel mese di luglio 1747." See Rostirolla 2009, p. 237.

56 According to Hazon's account, "M. l'Ambassadeur avait fait venir de toute l'Italie les plus fameux musiciens; ils étaient au nombre de cent, tant voix qu'instruments de toutes sortes." Transcribed in Launay 1940, p. 182. For a listing of the ninety-six performers visible in the painting, see Berti 2011, p. 113.

57 Scarselli 1747, p. 28: "Di timpani, e di trombe ne le regali stanze il suon rimbombe."

58 The stage set was described in the *Diario ordinario* as "una nuova Scena trasparente veramente maestosissima." See Chracas 1716–1836, no. 4677, 15 July 1747, p. 16.

59 "L'illumination de cette salle était à proportion de la richesse des ornements, mais trop grande pour la chaleur qu'il faisait." Transcribed in Launay 1940, p. 183. The *Diario ordinario* noted "la grandiosa illuminazione di Cera distribuita in buon ordine sopra varj Cornucopj, e Lampadari, ascendenti al numero di circa 1000. lumi, che decorava tutta la detta gran Sala." See Chracas 1716–1836, no. 4677, 15 July 1747, p. 17.

60 Hazon noted: "Il y avait aux deux premiers rangs de loges où était toute la noblesse, deux hommes à chaque loge pour servir et un à celles qui étaient plus élevées." Transcribed in Launay 1940, p. 183.

61 Lo Bianco and Negro 2005, p. 246; Arisi 1993, p. 100; and Arisi 1986, p. 155, have suggested that the painting shows the intermission, but the singers would not have remained on stage, and the refreshments offered at that moment were considerably more elaborate than just beverages, as Hazon observed: "La Cantate était partagée en deux parties; c'est entre ces deux parties que l'on donna les rafraîchissements qui furent servis tous les trois jours avec une profusion étonnante. Ils consistaient en biscuits glacés, fruits gelés de toutes façons." Transcribed in Launay 1940, p. 183. Joseph Digne, the French consul in Rome, similarly noted in his description of the celebrations, Paris, Archives Nationales, Affaires étrangères, B1, 965, fols. 242r–243r: "Lorsque la première partie de la cantate fust finie,

Paolo Panini con cornice liscia dorata." Transcribed in Michel 2016, p. 131. The estimated size of 6 Roman palmi high by 9½ palmi wide converts to 134 × 212 cm. The sizes given for other paintings in the inventory similarly underestimate the paintings' actual measurements; see chapter 1, note 9.

on servit au parterre de toutes les loges un grand rafraîchissement de toutes sortes d'eaux et fruits, glaces, biscuits, gaufres." Transcribed in Pietrangeli 1961, p. 218, cat. no. 515 (with erroneous date of 9 July for 19 July 1747).

62 London, British Museum, inv. 1858,0626.655 (197.b.5). See Kiene 1992, pp. 38–45, figs. 6–21, 23–26; Arisi 1961, pp. 190, 263–70.

63 See Sørensen 2002, pp. 470–73.

64 Paris, Bibliothèque Nationale de France, Département des Estampes, Réserve BE-12 (A), pet.-fol. See Bouchot 1901. A sheet showing the cantata's composer Jommelli and its librettist Scarselli together must date from the time of the wedding celebrations (fol. 42).

65 Sørensen 2002, pp. 472–73, figs. 10, 11, has proposed the identification of a figure in the painting as Antoine-René de Voyer d'Argenson, Marquis de Paulmy (1722–1787), son of the French foreign minister. He had briefly visited Rome in March and April 1746. While the facial likeness is plausible without being compelling, Ghezzi's caricature shows him as being exceptionally short, whereas the man in the painting is taller than the footmen surrounding him. Argenson's important family connections notwithstanding, there is no reason to believe that La Rochefoucauld would have asked for someone who had paid a brief visit to Rome more than a year before the event to be included in the painting.

66 See Chracas 1716–1836, no. 4677, 15 July 1747, pp. 20–21: "V'intervennero la Maestà del Rè della Gran Brittannia, con il Cardinale Duca di Yorck suo figlio; ed inoltre 21 Em.i Porporati; il Sig. Contestabile, il Sig. Ambasciatore Veneto, il Sig. Ambasciatore di Bologna, molti Ministri de Principi Esteri, e numerosa Prelatura, e Nobiltà di Principi, e Cavalieri."

67 See Kiene 1992, p. 44, fig. 27, where the drawing is described as James III in the caption but as Cardinal York in the text.

68 In Panini's view of the celebrations in Piazza Navona in 1729, the young Prince Henry Benedict, his brother, Charles Edward, and their father, James III, all wear the Order of the Garter; see figure 133.

69 As a comparison for the dress of a French abbé in Rome, see Ghezzi's caricatures of the abbé Emeric Brulon: Vatican City, Biblioteca Apostolica Vaticana, ms. Ott.lat. 3118, fol. 102r; Paris, Bibliothèque Nationale de France, Département des Estampes, Réserve BE-12 (A), pet.-fol., fol. 49. See Dorati da Empoli 2008, p. 295; Sørensen 2002, p. 472, fig. 9. For the canonical example of the abbé Jean-Jacques Huber by Maurice-Quentin de La Tour from 1742, showing him in a very similar *justaucorps* with deep cuffs, see Debrie and Salmon 2000, pp. 78–79, figs. 26, 27.

70 Sørensen 2002, p. 467.

71 See Colleville and Saint-Christo 1925, p. 33; Panhard 1868, p. 51.

72 See De Crescenzo and Diotallevi 2008, p. 104, cat. no. 394.

73 See Berti 2011, p. 101; Sørensen 2002, p. 469; Arisi 1993, p. 100; Kiene 1990, p. 25; Arisi 1986, p. 155.

74 See Villareal de Alava 1964, p. 513; Nicolini 1960, p. 199. For an engraving by Georg Caspar Prenner of Acquaviva wearing the order, see Vienna, Österreichische Nationalbibliothek, Bildarchiv und Grafiksammlung, inv. PORT_00087691_01.

75 The lettering refers to Acquaviva as the (titular) archbishop of Larissa in Thessalia and prefect of the Apostolic Palace, positions he held from 1730 and 1729, respectively.

76 See Villareal de Alava 1964, p. 518.

77 See La Rochefoucauld to Argenson, 4 December 1746: "Les nouvelles sont arrivées icy de la publication faite à Varsovie du mariage de M.gr le dauphin avec la princesse de Saxe: M. le comte de Lagnano, ministre du roy de Pologne, électeur de Saxe, est venu m'en faire part et s'en conjouir avec moi." Transcribed in Girardot 1871, p. 296.

78 See Chracas 1716–1836, no. 4677, 15 July 1747, p. 21: "state servite le Sig. Principesse, e Dame, ed anche molti Cavalieri col comodo de Palchetti, tra quali però fu distinto quello per la Maestà Sua."

79 See Corp 1997, p. 324.

80 See Berti 2011, p. 101; Sørensen 2002, p. 468. For O'Brien, see Massue de Ruvigny 1904, pp. 74–76.

81 For Murray, see Ford and Ingamells 1997, pp. 690–91; Massue de Ruvigny 1904, pp. 44, 194, 215. For a portrait of the young Murray by Francesco Trevisani (1719, private collection), see Corp 2011, p. 162, fig. 17.

82 Private collection; see Kerslake 1977, vol. 1, p. 327, vol. 2, pl. 938.

83 Edinburgh, Scottish National Portrait Gallery. The pastel was exhibited at the Paris Salon of 1747; see Grosvenor 2008, pp. 30–32, fig. 3. It was sent to Rome in late 1747 or early 1748; see Corp 2009, p. 53.

84 In addition to the examples cited above, see, for example, the portrait by Domenico Corvi (Hartford, Wadsworth Atheneum); see Cadogan 1991, pp. 118–20. The only exception appears to be a canvas attributed to the studio of Blanchet (private collection), in which the cardinal's brown wig is not powdered; see Grosvenor 2008, p. 28, fig. 2.

85 See Fothergill 1958, pp. 63–64; Brimont 1913, pp. 285–94.

86 See Fothergill 1958, p. 65; Shield 1908, p. 119.

87 La Rochefoucauld to Puysieulx, 21 June 1747: "On prévoit beaucoup de difficultés de cérémonial, parce qu'on n'a point d'exemples, à ce qu'on prétend, qu'aucun fils de Roy, cardinal, ayt résidé à Rome." Transcribed in Brimont 1913, p. 294.

88 La Rochefoucauld to Puysieulx, 5 July 1747: "Il compte ne demander aucune distinction pour venir aux chapelles et aux congrégations. Mais il évitera de se trouver dans les autres occasions avec le Sacré Collège, comme par exemple à la cantate que je me dispose à faire exécuter la semaine prochaine pour la feste qui m'a esté ordonnée au sujet du mariage de M. le Dauphin." Transcribed in Brimont 1913, p. 295.

89 "Le Sacré Collège était rangé en cercle sur des fauteuils dans le parterre, dans le même ordre que lorsqu'il tient consistoire." Transcribed in Launay 1940, p. 183.

90 La Rochefoucauld to Puysieulx, 16 July 1747: "Le Chevalier de Saint-Georges y assista et le nouveau cardinal, son fils, étant dans la loge de son père." Transcribed in Brimont 1913, p. 297.

91 See Berti 2011, p. 101; Sørensen 2002, p. 468.

92 See Colombo 2013, p. 720; Villareal de Alava 1964, p. 536.

93 See De Crescenzo and Diotallevi 2008, p. 104, cat. no. 389.

94 Chracas 1716–1836, no. 4677, 15 July 1747, p. 20: "riuscì per le parole, musica, sceltezza di voci, & istrumenti, in tutte le sue parti secondo la grandiosa idea del Porporato, che ne avea dato l'ordine, particolarmente per la invenzione della vaga disposizione del Teatro del Sig. Gioseppe Pannini Romano."

95 Bourges, Archives Départementales du Cher, G13, no. 15. Cited in Sørensen 2002, p. 467 n. 5; Brimont 1913, p. 298. Berti 2011, pp. 95, 100, 114, has erroneously claimed that the painting was sent to the dauphin as a wedding gift.

96 Maurepas to La Rochefoucauld, 10 April 1747: "Envoyez-nous seulement une description un peu pompeuse. Les fêtes ne sont jamais si belles que sur le papier qu'on est toujours obligé d'en croire le lendemain." Transcribed in Girardot 1871, p. 334.

97 Paris, Archives Nationales, Affaires étrangères, B1, 965, fols. 242r–243r, 19 July 1747: "Comme on doit en imprimer la relation, et qu'on travaille a graver une Estampe, je n'en dirai pas d'avantage a Votre Excellence." Transcribed in Moore 1995, p. 587 n. 15.

98 Maurepas to La Rochefoucauld, 23 July 1747: "Il vaudroit autant n'en avoir pas donné que de ne pas la faire imprimer." Transcribed in Girardot 1871, p. 362. For the family relationship between them, see Brimont 1913, p. 8 n. 1.

99 Maurepas to La Rochefoucauld, 4 September 1747: "Je ne vous approuve point du tout de n'avoir pas donné la description et le dessin de votre fête, vous aurez si bien fait qu'on n'en parlera point icy, où l'on s'en seroit entretenu quinze jours, et où cela vaut réputation et presque de l'argent comptant." Transcribed in Girardot 1871, pp. 373–74.

100 See Guérapin de Vauréal to La Rochefoucauld, 6 June 1747: "Vous pouviez, par exemple, sçavoir comment on a traité le cardinal de Polignac, qui donna une belle feste pour la naissance de M. le dauphin." Transcribed in Girardot 1871, p. 348.

101 Lalande 1769, vol. 4, p. 21: "M. le cardinal de Polignac, à la naissance de M. le Dauphin en 1729, donna sur la place Navone une fête célébre, qui a été peinte par Jean Paul [i.e., Giovanni Paolo Panini], peintre qui étoit alors fort considéré dans Rome."

102 See Bowron and Rishel 2000, pp. 417–18, cat. no. 264; Arisi 1986, p. 336, cat. no. 211; Wynne 1986, pp. 81–82, cat. no. 95.

103 Maurepas to La Rochefoucauld, 10 April 1747: "Les fêtes ne sont jamais si belles que sur le papier qu'on est toujours obligé d'en croire le lendemain." Transcribed in Girardot 1871, p. 334.

104 See Kiene 1992, pp. 47–59, 106–7, cat. no. 6; Arisi 1986, p. 330, cat. no. 199.

105 Paris, Archives Nationales, O¹ 1965, Jacques Bailly, "Memoire des tableaux du Roy origineau qui ce sont faits depuis le mois d'avril 1725 jusque a ce jour 1731, qu'il faut ajouter à l'inventaire général et particuliers des tableaux de la Couronne et au changements qui ce sont faits par ordre de Mgr le duc d'Antin": "Une feste que M. le Cardinal de Polignac a donné a Rome a l'occasion de la naissance de Mgr. le dauphin, ornée de plusieurs édifices élevés à la gloire de la France, où M. le cardinal paroit donner les ordres." Transcribed in Kiene 1991, p. 225 n. 12.

106 See Kiene 1991, pp. 247–48.

107 See Boiteux 2014, pp. 705–7.

108 See Faucher 1777, vol. 2, p. 414: "on voyoit à pied les Cardinaux, Prélats, Princes, Princesses & autres dames & Seigneurs se promenant & admirant de tous côtés la beauté aussi-bien que la magnificence de cette place dont on n'avoit jamais rien vu de pareil en ce genre"; Valesio 1977–79, vol. 5, p. 147: "il re d'Inghilterra e molti cardinali vi passeggiavano a piedi e similmente molte dame"; Chracas 1716–1836, no. 1924, 3 December 1729, p. 17: "si vide tutta la Piazza…con grandissimo concorso di Nobiltà, e Popolo, per vedere così grandioso preparamento"; Nicolas Vleughels to Antin, 1 December 1729: "Dès le matin, la place fut pleine de dames et de toutes sortes de personnes; elle étoit déjà toute ornée." Transcribed in Montaiglon 1887–1912, vol. 8, p. 74, no. 3283.

109 See Corp 2011, p. 246.

110 See Corp 2011, pp. 161–62; Ford and Ingamells 1997, p. 690.

111 The anonymous author of the report published as "Réjouissances faites à Rome, par le Cardinal de Polignac" in *Mercure de France*, December 1729, pp. 3125–43, at p. 3126, describes the "grand feu d'artifice dans la Place Navone, en achevant de lui rendre par de nouveaux ornemens, l'ancienne majesté des Cirques de Rome." Another report published in Rome referred to the Piazza Navona in its title as having been "restored to its ancient form"; see *Circo Agonale* 1729. For Ghezzi's design sketches for the decorations, see Kiene 1992, pp. 110–11, cat. nos. 9–10; Jacob 1975, pp. 152–53, cat. nos. 775–76.

112 *Distinta relazione* 1729, p. 10: "Fù dunque prescielta dall' E.S. [de Polignac] la Piazza Navona per l'esecuzione de' suoi grandiosi progetti a riflesso non solo della vicinanza del suo Palazzo, ma colla principale considerazione, che era molto ben presente alla sua gran mente, esser quest'amplo sito reliquia di quel Circo Agonale, ove l'antichità più augusta aveva riservati i spettacoli più insigni."

113 The following discussion of the allegorical program is based on *Distinta relazione* 1729, pp. 11–12; *Circo Agonale* 1729, pp. 7–9; *Mercure de France,* December 1729, pp. 3133–34.

114 Aeneid 6:852–53.

115 See *Distinta relazione* 1729, p. 11: "l'allusione, e presage delle quali sarà assai facile d'aplicare al Real Delfino dall'intendimento d'ogni erudito Lettore."

116 See CPR, vol. 706, fol. 80v, Germain Louis Chauvelin to Polignac, 6 September 1729. Transcribed in Gaviglia 2005, pp. 34–35, no. 3.

117 See Paul 1922, p. 387.

118 See CPR, vol. 710, fols. 334r–336v, Polignac to Chauvelin, 24 September 1729: "croyez bien que cette somme [i.e., the 12,000 livres] ne suffira pas mais qu'importe; je n'épargne rien pour un si grand Sujet." Transcribed in Gaviglia 2005, p. 35, no. 4.

119 Vleughels to Antin, 9 November 1729: "M. le Cardinal de Polignac fait ici une dépense que personne n'a jamais faite." Transcribed in Montaiglon 1887–1912, vol. 8, p. 65, no. 3278.

120 Vleughels to Antin, 1 December 1729: "jamais on ne verra une plus belle fête et une plus belle assemblée." Transcribed in Montaiglon 1887–1912, vol. 8, p. 75, no. 3283.

121 Venice, Archivio di Stato, Senato, Dispacci, Roma, filza 250, no. 172, fols. 514–17, Barbon Morosini to Senate, 3 December 1729: "le macchine de fuochi artificiali erette nella piazza Navona, ornata con magnificenza e tutta illuminata che si abbrugiorno, diedero qui spettacoli molto grati e applauditi." Transcribed in Gaviglia 2005, p. 23.

122 See CPR, vol. 707, fol. 108, Polignac to Chauvelin, 1 December 1729: "J'ai terminé toutes mes fêtes avec un succès dont je n'oserais vous parler. Il a surpassé mes expérances plus que mes désirs, je vous en enverrai au plus tôt une relation détaillée." Transcribed in Gaviglia 2005, p. 35, no. 8.

123 See CPR, vol. 707, fol. 112, Chauvelin to Polignac, 20 December 1729: "J'ai grande impatience de voir la relation de la magnifique fête que vous avez donnée. Il en revient de toutes les parts de grands éloges, je m'y attendais bien, mais on dit que cela passe tout ce que l'on avait vu jusques à présent à Rome." Transcribed in Gaviglia 2005, p. 35, no. 9.

124 See CPR, vol. 710, fol. 445r, Polignac to Chauvelin, 8 December 1729: "Je prends la liberté de vous envoyer une relation italienne de ma fête que le C. Carminati a composée et une française de l'a. le Blond qui l'a écrite à la hâte pour ne se point laisser prévenir par d'autres." Transcribed in Gaviglia 2005, p. 36, no. 10.

125 *Circo Agonale* 1729; *Distinta relazione* 1729; *Relation des fêtes* 1730.

126 See Gori Sassoli 1994, pp. 181–83, cat. nos. 134–35.

127 Vleughels to Antin, 9 March 1730: "Il n'en est pas content, et il a raison; il a été mal servi. Il est vrai, car il faut tout dire, qu'il n'y a pas ici des graveurs capables comme à Paris." Transcribed in Montaiglon 1887–1912, vol. 8, p. 94, no. 3306.

128 Polignac's version of the painting (see fig. 131) is listed in his estate inventory of 4 December 1741. See Rambaud 1964, p. 600.

129 Inscribed: "Préparatifs du grand feu d'artifice que S.E.M. le Cardinal de Polignac fit tirer à Rome dans la place Navonne le 30 Novembre 1729 pour la Naissance de Monseigneur le Dauphin." See Gori Sassoli 1994, p. 183, cat. no. 136; Kiene 1992, p. 114, cat. no. 13.

130 See *Mercure de France*, August 1732, p. 1813: "M. Jean-Paul Panini, de Plaisance, fort habile Peintre, établi à Rome, a desiré depuis peu d'être de l'Académie Royale de Peinture et de Sculpture. C'est lui qui a fait le beau Tableau qu'on a vû à Versailles, représentant la Fête que le Cardinal de Polignac a donnée à Rome pour la Naissance de Monseigneur le Dauphin."

131 See Carey 2008, pp. 52–55; Arisi 2005.

132 See Arisi 1986, p. 324, cat. no. 189.

133 See Simancas, Archivo General de Simancas, Estado, leg. 4.847, "Relación de la función del día 23 de septiembre en ocasión del nacimiento del infante Don Luis por…maestro de ceremonias y archivista de S.M.": "un castillo de fuego artificial que representaba, como se ve por su disegnio impreso, la fábula de Tetis diosa de la Mar que entregaba Aquiles a Chirón para instruirle y encaminarle al templo de la Gloria, aludiendo a las que nuestra nación espera deber al valor y virtud de este nuevo príncipe." Transcribed in Urrea Fernández 2006, p. 40. See also Valesio 1977–79, vol. 4, pp. 858–59; Chracas 1716–1836, no. 1582, 27 September 1727, pp. 7–8.

134 See Falomir Faus 2014, p. 256. The painting has been extended on all four sides; its original bottom edge was at the foot of the rocks. For the engraving of the *macchina* by Filippo Vasconi, see Gori Sassoli 1994, pp. 177–78, cat. no. 130.

135 See Arisi 1986, p. 462, cat. no. 466.

136 See Boiteux 2014, p. 718; Lalande 1769, vol. 4, p. 20.

137 See Arisi 1986, p. 454, cat. no. 450.

CHAPTER 5

1 See, for example, Burrows 2012, pp. 82–87, for the singer Nicolini.

2 As previously mentioned, when Montagu returned from Venice in 1708, he brought Marco Ricci and Giovanni Antonio Pellegrini with him. Among their first commissions in London were the stage sets for the operas *Pirro e Demetrio* by Alessandro Scarlatti (1660–1725) and *Camilla* by Giovanni Bononcini (1670–1747), both in 1709, followed a year later by Ricci's sets for *Idaspe fedele* by Francesco Mancini (1672–1737). In Pellegrini's footsteps, some of Venice's more prominent history painters, such as Marco's uncle Sebastiano Ricci (1659–1734), Antonio Bellucci (1654–1726), and Jacopo Amigoni (ca. 1685–1752), each spent a number of years in England. See Allen 2006, pp. 30–31; Allen 1993, pp. 31–33.

3 See Toledano 2006, pp. 274–76, cat. nos. V.V.VII.a–n; Manzelli 1999, pp. 63–64.

4 See Walker 1979.

5 See Kingzett 1982, p. 57.

6 Vertue 1934, p. 132.

7 Vertue 1934, p. 132.

8 See Beddington 2006, p. 9. For possible parallels with Canaletto's early commissions in Venice, see Eglin 1999, pp. 105, 113–14.

9 Labelye 1751, p. 26.

10 See Redford 1996, pp. 76–78; Hallett 1993, p. 47; Haskell 1980, p. 278. For a divergent view, see Eglin 1999, pp. 114–15.

11 See Russell 2006, p. 42 (suggesting a date of summer 1746); Beddington 2006, pp. 103–6, cat. no. 24 (suggesting a date of spring 1747); Constable and Links 1989, vol. 2, pp. 406–7, cat. no. 412.

12 See Kowalczyk 2015, pp. 134–35, cat. no. 26; Doran 2012, p. 89, cat. no. 48; Beddington 2006, pp. 101–2, cat. no. 23; Baetjer and Links 1989, pp. 224–26, cat. no. 63; Constable and Links 1989, vol. 2, p. 423, cat. no. 435.

13 *Gentleman's Magazine*, October 1746, p. 557. In the engraving *The Industrious Prentice Lord Mayor of London* (Industry and Idleness series, pl. 12), William Hogarth (1697–1764) satirized a different part of the ceremony, the new lord mayor's return journey from Westminster by coach.

14 Entick 1766, vol. 3, pp. 305–6.

15 For the livery companies' barges, see Archer 2012, pp. 83–84.

16 Their standards are not all identifiable, but the barges are named in the key to Richard Parr's engraving after the painting, published in March 1747 (London, British Museum, Mm,15.119).

17 See p. 187.

18 See Bowron 2001, p. 154, cat. no. 42; Kozakiewicz 1972, vol. 2, pp. 121–22, cat. no. 151.

19 See Solkin 1982, pp. 146–47, cat. no. 5.

20 See Beddington 2006, pp. 103–6, cat. no. 25; Constable and Links 1989, vol. 2, p. 422, cat. no. 434.

21 Beddington 2006, p. 21.

22 *Gentleman's Magazine*, September 1747, pp. 434–35.

23 Entick 1766, vol. 3, p. 38; *Gentleman's Magazine*, November 1750, p. 523. The bridge was opened shortly before midnight.

24 Two drawings of circa 1750 in the Royal Collection (inv. RCIN 907558, RCIN 907557) show the final arrangement of twelve shelters in combination with the unexecuted statues. See Beddington 2006, p. 114, cat. no. 30; Liversidge and Farrington 1993, pp. 77–78, cat. nos. 16–17; Constable and Links 1989, vol. 2, pp. 578–80, cat. nos. 749–50.

25 *Universal Magazine*, December 1750, p. 278; *Gephyralogia* 1751, p. 116. The latter bears the date 1751 on the title page but was in fact published in December 1750. See *Gentleman's Magazine*, December 1750, p. 575; *Universal Magazine*, December 1750, p. 286.

26 See Martineau and Robison 1994, pp. 239, 434, cat. no. 133; Constable and Links 1989, vol. 2, pp. 416–17, cat. no. 426.

27 See Toledano 2006, p. 227, cat. no. L.III.1; Manzelli 1999, pp. 108–9, cat. no. L.12; sold Sotheby's New York, 28 January 2016, lot 56.

28 See Toledano 2006, p. 228, cat. no. L.III.2; Manzelli 1999, p. 108, cat. no. L.11; Liversidge and Farrington 1993, p. 103, cat. no. 42.

29 See Palmer 1997, pp. 3–5, 18.

30 See Doran 2012, p. 92, cat. no. 52; Constable and Links 1989, vol. 2, p. 416, cat. no. 425.

31 See pp. 5–8, 116, 118.

32 During the royal water party on 17 July 1717, a livery company barge carried the fifty musicians playing Handel's compositions. See Burrows and Hume 1991, p. 333.

33 See *Gentleman's Magazine*, October 1746, p. 557, October 1747, p. 495.

34 See Beddington 2006, p. 112; Constable and Links 1989, vol. 2, p. 579, cat. no. 749 (b).

35 See *Gentleman's Magazine*, October 1745, p. 557. O'Connell 2003, p. 129, gives an erroneous date of 1746–47 for Hoare's term of office.

36 *Gentleman's Magazine*, August 1746, p. 437.

37 *Gentleman's Magazine*, June 1746, p. 325.

38 See Liversidge and Farrington 1993, p. 72, cat. no. 13; Constable and Links 1989, vol. 2, p. 424, cat. no. 436 (a). For the second version, painted for William Barnard, Bishop of Derry (1696/97–1768), see Beddington 2006, p. 110, cat. no. 27; Links 1998, pp. 40–41, cat. no. 436; Constable and Links 1989, vol. 2, p. 424, cat. no. 436.

39 See Liversidge and Farrington 1993, p. 72; Constable and Links 1989, vol. 1, p. lxii; Walker 1979, p. 241.

40 *Gentleman's Magazine*, May 1750, p. 234.

41 See Liversidge and Farrington 1993, p. 72, cat. no. 13; Constable and Links 1989, vol. 2, p. 418, cat. no. 428 (a).

42 See *Gentleman's Magazine*, October 1749, p. 475. The delay of one day may have been owed to the fact that 29 October fell on a Sunday. For the paintings, see Toledano 2006, pp. 214–15, cat. nos. L. I. 3, L. II. 3.

43 See Toledano 2006, p. 214, cat. no. L.I.3.

44 The alternative but much less plausible scenarios are that Canaletto based his numerous paintings and drawings of Westminster Bridge from the north on a composition first developed by Joli, or that Joli based his views on a lost Canaletto.

45 The stage sets for *Demofoonte* by Baldassare Galuppi (1706–1785) in January 1750, *L'asilo d'amore* by Francisco Courcelle (1705–1778) on 8 April 1750, and *Armida placata* by Giovanni Battista Mele (1693/94 or 1701–after 1752) on 12 April 1750, all performed at the Buen Retiro in Madrid, were Joli's first endeavors in his new role. See Kleinertz 2003, vol. 1, pp. 22–23, 45, 132; Cotarelo y Mori 1917, pp. 142, 144, 149. The claim in Toledano 2006, p. 30, that Joli was responsible for the sets for *El Artajerjes* in January 1749 and a revival of *Il vello d'oro conquistato* on 23 September 1749 is erroneous; their printed libretti state that the sets for both were designed by Pavia. See Kleinertz 2003, vol. 1, pp. 23–24, 124; Cotarelo y Mori 1917, pp. 139–40.

46 See Tovar Martín 2002, pp. 155–62; Bottineau 1986, pp. 257–68.

47 *Gaceta de Madrid*, no. 23, 6 June 1752, pp. 185–87. See also Torrione 1998, pp. 282–83.

48 See De Martini 2012, p. 15.

49 See Toledano 2006, p. 258, cat. no. S.IX.2; Manzelli 1999, pp. 114–15, cat. no. S.16.

50 See Broschi 1992, p. 242.

51 See Madrid, Patrimonio Nacional, Real Biblioteca, II/1412, fol. 156r, "Descripción del estado actual del Real Theatro del Buen Retiro, de las funciones hechas en él desde el año de 1747 hasta el presente, de sus individuos, sueldos y encargos, según se expresa en este primer libro. En el segundo se manifiestan las diversiones, que annualmente tienen los Reyes Nrs. Sers. en el Real sitio de Aranjuez / dispuesto por Don Carlos Broschi Farinelo, criado familiar de Ss. Ms. Año de 1758." For the facsimile edition, see Broschi 1992. For the attribution of the watercolors to Battaglioli, based on a note in the manuscript describing their author as the current painter at the royal theater, see Bonet Correa 1992, p. xix; Urrea Fernández 1977, pp. 91–93.

52 Broschi 1992, p. 245.

53 De Martini and Morillas Alcázar 2001, pp. 50; Broschi 1992, pp. 364, 382, 390, 396.

54 See Urrea Fernández 2012, pp. 24–26, 50–54; Bonet Correa and Blasco Esquivias 2002, pp. 44–46, 395, cat. no. 70. For a description of the festivities, see *Gaceta de Madrid*, no. 22, 1 June 1756, p. 176.

55 See Colleville and Saint-Christo 1925, p. 43; Panhard 1868, p. 91.

56 See Broschi 1992, p. 87.

57 See Pérez Sánchez 2006, p. 154, cat. no. 28.

58 See Urrea Fernández 2012, pp. 24–26, 50–54; Bonet Correa and Blasco Esquivias 2002, p. 395, cat. no. 69.

59 See p. 107.

60 "Vista de la iluminación côque en el Delicioso Real Sitio de Arangez se celebra el día de S. Fernando Gloriosísimo nombre del rey ntro. señor, dispuesto por D. Carlo Broschi Farinelli pintada da Francesco Battaglioli 1756."

61 While Charles III promoted the training of local artists to replace foreigners, he also brought Giovanni Battista Tiepolo and Anton Raphael Mengs (1728–1779) to Madrid as court painters.

62 See Toledano 2006, p. 346, cat. no. N.XVII.1; Morales Vallejo and Ruiz Gómez 2001, pp. 101–3.

63 See Toledano 2006, pp. 334–36, cat. no. N.XV.1; Manzelli 1999, p. 71, cat. no. N.I. For the pendant with the departure viewed from the sea, see Toledano 2006, p. 343, cat. no. N.XVI.1; Manzelli 1999, p. 73, cat. no. N.II. For the commission, see Aterido 2004, vol. 2, p. 417.

64 Becattini 1790, vol. 1, pp. 277–78: "Tutto il popolo di Napoli, grandi, piccoli, uomini, donne, fanciulli, giovani, e vecchi, di ogni età, di ogni sesso, e di ogni condizione stavano sulla riva per osservare ocularmente la partenza dell'amabilissimo loro Signore, e pochi erano quelli, che poteano contenere le lagrime."

65 *Relación de los arcos* 1760. For the paintings, see Pérez Sánchez 1992, pp. 106–15, cat. nos. 32–36.

66 For a summary of the history of the academy and its forerunners, see Bonet Correa 2012, pp. 10–15.

67 See Pérez Sánchez 1992, p. 110, cat. no. 34.

68 *Relación de los arcos* 1760, p. 12: "En la calle de la Platería, adornada por los Artífices-Plateros de Madrid, corre sobre un pedestal un orden de pilastras compositas por ambos lados de la calle, en todo igual."

69 See p. 87.

70 *Relación de los arcos* 1760, p. 12: "En el medio de cada uno està colocado el Escudo de las Armas Reales, acompañado de dos Famas, y de èl pende una Inscripcion Latina de un lado, y Castellana del otro."

71 In one of the other paintings in the series, *The Triumphal Arch of Santa María in Calle Mayor*, the ephemeral architecture presented no compositional challenges, and Quirós depicted it frontally with a legible inscription. See Pérez Sánchez 1992, p. 114, cat. no. 36.

72 See Mena Marqués and Maurer 2014, pp. 132–34; Pérez Sánchez 1992, pp. 146–47, cat. no. 51.

73 See Constable and Links 1989, vol. 2, pp. 371–73, cat. nos. 359–60.

74 See Hartje 2002, pp. 27–32; Zimmermann 1954, p. 197.

75 Transcribed in Zimmermann 1954, pp. 215–24.

76 See Craievich and Pedrocco 2012, pp. 127–28, cat. no. 31; Pavanello and Craievich 2008, pp. 283–84, cat. no. 74; Morassi 1973, vol. 1, p. 374, cat. no. 337.

77 Deseine 1699, p. 202: "Quoy qu'on chante l'Office divin à l'Eglise Saint Marc en Latin, neanmoins il y a bien des ceremonies où l'on affecte de suivre le rit Alexandrin, à cause de Saint Marc qui en étoit Evêque, dont le corps repose en cette Eglise. Une des plus remarquables est la procession du Saint Sacrement, que le Clergé de Saint Marc fait tous les ans le Vendredi Saint à neuf heures du soir, au tour de la place qui est toute illuminée de gros flambeaux de cire blanche dont il y en a deux rangs aux fenetres des Procuraties, & sur la facade de l'Eglise de Saint Marc. Tous ceux qui assistent à cette procession, ont aussi un flambeau à la main, & l'on use plus de cire à Venise cette nuit-là qu'en toute l'Italie en un an de tems. On y porte le precieux corps de Nôtre Seigneur dans une espece de sepulcre couvert d'un poile de velours noir, comme si on le vouloit porter en terre, il est precedé d'un grand nombre de penitens couverts de sacs, avec un bonnet pointu long de deux pieds, qui se donnent la discipline jusqu'au sang sur les épaules nües, leur sac étant fendu exprès, & tout ouvert en cet endroit."

78 Bruzen de La Martinière 1726–39, vol. 9, p. 105: "Rien au monde n'est plus beau que Venise pendant cette nuit, qui est éclairée d'un million de Flambeaux. La Place de St. Marc est pour lors un charmant Spectacle. Il y a deux grands Flambeaux de cire blanche, à chaque fenêtre des Procuraties. Ce double rang de Flambeaux disposez avec ordre, & ceux qu'on allume sur le Portail de l'Eglise, font un très-bel effet & éclairent toutes les Processions des Confrairies & des Paroisses voisines qui passent exprès dans cette Place. Pendant ce tems-là toute la Ville est comme en feu: on épargne si peu la cire blanche, qu'on croit que ce soir-là il s'en brûle autant à Venise que pendant un an entier dans tout le reste de l'Italie."

79 Banier 1741, vol. 2, p. 241: "Voici l'Ordre & les singularités, qui s'observent à ces Processions. On y voit trois ou quatre cens hommes chargés de gros flambeaux de cire blanche de six pieds de haut, pesant chacun au moins douze à quinze livres. Ils vont deux à deux, avec un pareil nombre d'autres personnes, tenant chacun une lanterne, & marchant entre deux flambeaux; ensorte qu'on voit alternativement un flambeau & une lanterne. Les uns & les autres sont vêtus de serge blanche ou noire, selon les différentes Confréries, avec un grand capuchon pointu de deux pieds de haut, qui leur pend derriére la tête. Les lanternes sont fort grandes, & attachées au bout d'un bâton. On met dedans plusieurs bougies, qui répandent une très-grande clarté au travers du verre blanc dont elles sont construites." Deseine, Bruzen de La Martinière, and Banier all rely on the account in Limojon de Saint-Didier 1680, pp. 46–48. Banier is the only one to acknowledge this source. Limojon does not mention the lanterns.

80 See Beddington 2010, pp. 68, 180, cat. no. 6. For the attribution to Richter, see also Reale and Succi 1994, p. 127.

81 See Succi 2011, pp. 172–73; Seipel 2005, pp. 114–17; Alb. Rizzi 1995, pp. 108–9; Kozakiewicz 1972, vol. 2, pp. 202–7, cat. no. 262.

82 See Loire 2004, pp. 86–89, cat. no. 12; Kozakiewicz 1972, vol. 2, pp. 350–53, cat. no. 413.

83 See Johns 2015, pp. 155–56; Arisi 1986, p. 404, cat. no. 346.

84 See Lo Bianco and Negro 2005, pp. 248–49, cat. no. 145; Bowron and Rishel 2000, pp. 538–39, cat. no. 383.

85 See Draper 1969, p. 29.

86 For depictions of the fire at the Hôtel-Dieu, see Aubert 1910.

87 For other depictions of the fire at the opera house, see Grasselli and Jackall 2016, p. 243, cat. no. 80; Dubin 2010, pp. 61–70, figs. 23–26, 34; Farge 1908.

88 *Mercure de France*, 12 June 1781, pp. 134–36.

89 See Bruson and Leribault 1999, p. 364.

90 See Seydl 2012.

91 Rétif de La Bretonne 1788–94, vol. 6, pp. 2498–99: "Je n'ai jamais vu de plûs parfaite image du Vésuve ou de l'Etna. . . . Le spectacle de feu était horrible de près: Quelle puissance a la nature, par ce terrible élément! Comme un Volcan enflamé doit être épouvantable!"

92 See Weicherding 2001, pp. 479–83.

93 See Beck Saiello 2010, pp. 130–45.

94 Inscribed at lower left: "Vue de l'Eruption / du mont Vesuve du 14 / may 1771 peinte Sur le / lieu par le Che Volaire." See Beck Saiello 2010, pp. 222–23, cat. no. P. 49; Wise and Warner 1996, pp. 156–59.

95 See Beck Saiello 2010, pp. 236–37, cat. no. P. 82; Bowron 1991.

96 See Morassi 1973, vol. 1, pp. 206, 369–70, cat. no. 313.

97 See Venturi 1973.

98 See Toledano 2006, p. 360, cat. no. N.XXV.1; Manzelli 1999, pp. 80–81, cat. no. N.40.

99 To a Neapolitan observer, the scene would also have evoked the spectacle of the *cuccagna*, the sacking of a temporary edifice constructed from cheese, sausages, ham, bacon, poultry, bread, and other foodstuffs by the city's beggars. See Reed 2015, pp. 87–99; Feldman 2007, pp. 196–203.

100 See Imbruglia 2000, p. 78.

CHAPTER 6

1 See Urban Padoan 1998, pp. 89–95; Tamassia Mazzarotto 1980, pp. 180–85.

2 See Succi 2015, pp. 132–36, cat. no. 5.

3 See Urban Padoan 1988, pp. 68–74.

4 See Pavanello and Craievich 2008, p. 323, cat. no. 45.

5 Venice, Biblioteca Nazionale Marciana, Mss. it., cl. VI, Gazzetta, Mercuri o Avvisi, 484 (12128), 29 September 1708, fol. 163r–v: "Il treno poi delle quattro gondole ad oro fu nobilissimo, e nella prima vedevasi scolpito al di dietro Pallade con Marte alla dritta, e davanti sulla dritta Giove, et alla sinistra Mercurio, e sul principio della prova Giunone iun trono con scettro, e pavone, et ai suoi piedi colla clave d'Ercole, e l'aquila che leva l'occhio al dragone." Transcribed in Tipton 2010, Quellenanhang, Hercolani.

6 See Pavanello and Craievich 2008, pp. 261–62, cat. no. 33; Bettagno 1997, pp. 359–60, cat. no. 40; Constable and Links 1989, vol. 2, p. 359, cat. no. 338.

7 See Venice, Biblioteca del Museo Correr, ms. Gradenigo 200, Pietro Gradenigo, "Commemoriali," vol. 8, fol. 79. Cited in Urban Padoan 1988, p. 82.

8 See Urban Padoan 1988, pp. 79–94. For an engraving of the finished Bucintoro, dated 1729, see Pavanello and Craievich 2008, p. 326, cat. no. 52.

9 See also Succi 2015, p. 92.

10 See p. 42.

11 See CPV, vol. 183, fol. 156v, Gergy to Louis XV, 4 June 1729. Transcribed in Tipton 2010, Quellenanhang, Gergy.

12 See CPV, vol. 180, fols. 367r–369v, "Déscription de l'Entrée de M. le C.te de Gergy, Amb.r du Roy à la Rep.e de Venise," 4–5 November 1726, at fol. 367v: "Le corps de la 3.me étoit entièrement doré, mais le fond de la prove et de la pouppe étoint d'un vernis couleur de feu réhaussé partout de grands ramajeux et feuillages d'or sculpturé, toutte la garniture de cette gondolle étoit de velour cramoisy que la 1.re, touttes les franges et galons soye cramoisy de même tincture. Cette gondolle, quoique moins riche, fut d'autant plus applaudie que l'on n'en avoit fa[it?] jusqu'à present de ce goust." Transcribed in Tipton 2010, Quellenanhang, Gergy.

13 See Constable and Links 1989, vol. 2, pp. 358–59, cat. no. 336.

14 See Beddington 2006, pp. 28 n. 45, 161–62, cat. no. 54; Constable and Links 1989, vol. 2, p. 363, cat. no. 344. The depiction of the Bucintoro (including the figures on its roof and the flag), the red pleasure craft in the foreground with its lounging passengers, and the gilded parade gondola with gondoliers in red liveries were painstakingly copied by Joli in a view painted in London in circa 1747–48 for Philip Dormer Stanhope, 4th Earl of Chesterfield (1694–1773). For Joli's painting, see Christie's London, 3 July 2012, lot 33; Urrea Fernández 2012, pp. 39–40; Toledano 2006, p. 195, cat. no. V.II; Russell 1988, p. 628.

15 Jonard 1978, p. 261.

16 For Montaigu, see Duparc 1958, p. 193. The event depicted by Canaletto would have been witnessed by the ambassador's private secretary, the young Jean-Jacques Rousseau (1712–1778). For the quarrel between Montaigu and Rousseau, see Mostefai 2016, pp. 92–96; Montaigu 1904.

17 See Carr 2013; Kowalczyk 2005, pp. 124–26, cat. no. 27; Constable and Links 1989, vol. 2, pp. 354–55, cat. no. 331.

18 Oddi arrived in Venice on 2 August 1735 but did not immediately assume his functions; the report sent to Rome on 6 August 1735 was still signed by Giannotti. See Hausmann 1950, p. 267. The figure cannot be the *guardiano grande* of the Scuola di San Rocco, as this position was occupied by a layman, and the figure wears clerical dress. A date of 1735 would also support the identification of the doge as Alvise Pisani, elected on 17 January 1735, made in Levey 1971, p. 24. Tipton 2010, §§ 75–77, n. 180, fig. 26, has proposed that the painting shows the ceremony on 16 August 1729 and that the figure on the doge's left is the imperial ambassador Bolagnos, on the basis of a portrait of Bolagnos (Milan, Ospedale Maggiore) attributed to Giovan Angelo Borroni (1684–1772). However, the identification must remain tentative, as the figure's likeness and costume are insufficiently specific. On stylistic grounds, a date of 1729 would be difficult to accept.

19 The cushion, faldstool, *ombrellino*, and sword were four of the seven *trionfi* carried in the doge's processions. See Muir 1981, pp. 204–6.

20 See Constable and Links 1989, vol. 2, pp. 355–62, cat. nos. 332–42.

21 See Succi 2013, vol. 1, pp. 198–99, cat. no. 16.

22 Inscribed at upper left: "A di 23 aprile 1745 giorno di S. Giogio Cavalier / diede la saeta nel Canpanil di S. Marco." See Clayton 2005, p. 192, cat. no. 64; Parker 1990, p. 40, cat. no. 55; Constable and Links 1989, vol. 2, p. 493, cat. no. 552.

23 While it is tempting to consider the possibility that the *fusta* may have been temporarily moved to a different location in May 1745, the contemporary sources do not offer any evidence of this.

24 See Urban Padoan 1998, pp. 194–97; Tamassia Mazzarotto 1980, pp. 206–23.

25 The term is a diminutive of *pozzo*, because the shape of the float was akin to a small well.

26 See Succi 2013, vol. 2, p. 884, cat. no. 25; Friedrichs 2006, pp. 56–58.

27 Knezevich 1986, p. 99; Schuhmann 1962–63, p. 144.

28 Jonard 1978, pp. 73–74.

29 Richard 1766, vol. 2, pp. 190–91: "Après quoi il sort par la porte principale, & monte dans une machine ronde appellée il pozzo, le puits, avec un de ses parens sénateur, & son ballottin.... Cette machine, posée sur un brancard, est portée par les ouvriers de l'arsenal autour de la place saint Marc. Pendant cette espece d'ostension solemnelle, le doge jette de l'argent au peuple. C'est toujours de la monnoie nouvelle frappée à son nom, & qui se fabrique tout de suite après l'élection. Le tour de la place se fait très-vîte, sans doute pour épargner l'argent de sa sérénité, qui dépenseroit davantage, si on la montroit plus long-temps au peuple. A la fin de la course, quand il approche de la Piazzetta, il jette quelques sequins d'or."

30 Schuhmann 1962–63, p. 143.

31 See Craievich and Pedrocco 2012, pp. 216–17, cat. no. 76; Friedrichs 2006, pp. 65–70; Morassi 1973, vol. 1, p. 354, cat. no. 244. For the entire series, see Morassi 1973, vol. 1, pp. 354–57, cat. nos. 243–54.

32 See Craievich and Pedrocco 2012, p. 217, cat. no. 77; Friedrichs 2006, pp. 93–100; Morassi 1973, vol. 1, p. 355, cat. no. 249.

33 See Montecuccoli degli Erri and Pedrocco 1999, pp. 388–89, cat. no. 160; Succi 1989, p. 149.

34 Spence 1975, p. 395.

35 See Sani 2007, p. 275, cat. no. 302.

36 Reato 1988, pp. 11–12.

37 The painting entered the collection of the English philosopher James Harris (1709–1780), who is not known to ever have visited Venice. It is recorded in the manuscript list of his collection as "St. Mark's place on a public day." See Montecuccoli degli Erri and Pedrocco 1999, pp. 388–89. The painting has traditionally been said to have been acquired out of the contents of Marieschi's studio after the artist's death. However, it is recorded as having been imported into England by the merchant William Hayter (d. 1750) on Harris's behalf in March 1743, ten months before Marieschi's death on 18 January 1744.

38 See pp. 44–46.

39 For Canaletto, Corboz 1985, vol. 1, pp. 13–140, remains the fundamental study on this subject.

40 See Pavanello and Craievich 2008, p. 164, 272–73, cat. no. 48; Montecuccoli degli Erri and Pedrocco 1999, pp. 234–37, cat. no. 17; Succi 1994, pp. 74–78.

41 See Povolo 1998; *Niova e destinta Relazione* 1735, p. 4. Certain aspects of the depiction remain to be clarified, especially whether Correr himself is represented. The figure identified as the patriarch in Pavanello and Craievich 2008, p. 273 (entry by Filippo Pedrocco), and Montecuccoli degli Erri and Pedrocco 1999, p. 236, where described as standing on the barge with the baldachin, giving a blessing to the bystanders, and wearing the long beard of a Capuchin friar, does not exist in the painting. None of the three men seated under the baldachin wear clerical dress. As Correr had already been consecrated, he would have been depicted in episcopal vestments.

42 See pp. 46–50.

43 See CC, registro IV, fol. 86. Cited in Succi 1994, p. 77.

44 For this ceremony, see Tamassia Mazzarotto 1980, pp. 279–82.

45 See Montecuccoli degli Erri and Pedrocco 1999, pp. 243, 245–46, 255, 295, 312, 342–43, 378–81, 384, 411–13, cat. nos. 22, 26–27, 35, 75, 90, 116–17, 150–53, 156, 183.

46 For the route of the regatta, see pp. 61–62.

47 See Succi 1989, p. 91.

48 See Arisi 1993, p. 160, cat. no. 41; Arisi 1986, p. 400, cat. no. 338.

49 See Bock 2010, p. 410; Morassi 1973, vol. 1, p. 369, cat. no. 310.

50 See p. 138.

51 See Chracas 1744; Chracas 1716–1836, no. 4257, 7 November 1744, p. 11.

52 See Johns 2015, pp. 225–31; Bowron and Rishel 2000, pp. 423–24, cat. no. 272; Arisi 1993, p. 164, cat. no. 43; Arisi 1986, p. 414, cat. no. 368.

53 See Johns 2015, pp. 204, 210–11; Stoschek 1999, pp. 148–57.

54 Benedict XIV to Paolo Magnani, Rome, 7 November 1744: "Faccia, come facciamo Noi, che avendo fatto in questo giardino di Monte Cavallo, ridotto ora veramente a dovere, una bella loggia coperta con due camere, una in un lato, e l'altra nell'altro con un camerino per i bisogni del corpo, ce lo godiamo e d'estate e d'inverno, calando più volte ad esso anche a sentire i ministri. In esso ricevemmo il re di Napoli la mattina, il dopo pranzo il duca di Modena, il mercordì il conte generale Gages, con cui parlammo di lei, assicurandola, che fa la dovuta stima della sua persona, e poi tutta la generalità, ed officialità spagnuola." Transcribed in Prodi and Fattori 2011, p. 326, no. 91.

55 See Bowron and Rishel 2000, pp. 423–24, cat. no. 271; Arisi 1993, p. 162, cat. no. 42; Arisi 1986, p. 414, cat. no. 367.

56 Cochin 1991, p. 144, 1758 ed., p. 132: "Il y a deux tableaux de Panini, qui ne sont pas beaux, surtout celui qui représente l'église de Saint Pierre de Rome, dont les figures sont ridiculement trop grandes, & font paroître cette vaste église comme une petite chapelle."

57 Lanzi 1809, vol. 2, p. 276.

58 See Arisi 1993, p. 158, cat. no. 40; Arisi 1986, p. 392, cat. no. 322.

59 Panini used the official portrait of Benedict XIV by Pierre Subleyras or the engraving after it. See Michel and Rosenberg 1987, pp. 248–53, cat. no. 69, fig. 19.

60 See Grasselli and Jackall 2016, pp. 248–49, cat. no. 88.

LIST OF WORKS IN THE EXHIBITION

✂·✄

Works are arranged in alphabetical order by artist, then in chronological order.

The date of the event and the original patron commissioning the work are provided where known.

All works exhibited in Los Angeles, Minneapolis, and Cleveland unless otherwise noted.

FRANCESCO BATTAGLIOLI (Italian, 1714–ca. 1796)

1

King Ferdinand VI and Queen Maria Barbara of Braganza
in the Gardens at Aranjuez on the Feast of Saint Ferdinand
1756
Oil on canvas, 68 × 112 cm (26¾ × 44⅛ in.)
Madrid, Museo del Prado, inv. P04181
References: Urrea Fernández 2012, pp. 24–26, 50–54; Bonet Correa and Blasco Esquivias 2002, pp. 44–46, 395, cat. no. 70.
Date of event: 30 May 1756
Commissioned by: Carlo Broschi, called Farinelli (1705–1782)
Fig. 156

BERNARDO BELLOTTO (Italian, 1721–1780)

2

The Demolition of the Ruins of the Kreuzkirche
1765
Oil on canvas, 80 × 110 cm (31½ × 43⁵⁄₁₆ in.)
Dresden, Gemäldegalerie Alte Meister, inv. 638
References: Henning et al. 2011, p. 119, cat. no. 16; Marx 2005, vol. 1, p. 66; vol. 2, p. 113, cat. no. 121; Kozakiewicz 1972, vol. 2, pp. 238–41, cat. no. 297.
Date of event: early July 1765
Fig. 6

3

The Procession of Our Lady of Grace in Front of Krasiński Palace
1778
Oil on canvas, 116 × 164 cm (45¹¹⁄₁₆ × 64⁹⁄₁₆ in.)
Warsaw, Royal Castle, inv. ZKW 454
References: Loire 2004, pp. 86–89, cat. no. 12; Kozakiewicz 1972, vol. 2, p. 350–53, cat. no. 413.
Commissioned by: King Stanislaw II August of Poland (r. 1764–1795)
Fig. 170

GIOVANNI BATTISTA BRUSTOLON (Italian, 1712–1796), after Canaletto (Italian, 1697–1768)

4

The Giovedì Grasso Festival in the Piazzetta
1763–66
Etching and engraving on laid paper, 460 × 610 mm (18⅛ × 24 in.)
Los Angeles, Getty Research Institute, inv. 86-B1723
References: Succi 2013, vol. 2, p. 887, cat. no. 30; Pavanello and Craievich 2008, p. 329, cat. no. 65.
Fig. 19
Los Angeles only

CANALETTO (Italian, 1697–1768)

5

The Procession on the Feast Day of Saint Roch
Ca. 1735
Oil on canvas, 148 × 199 cm (58¼ × 78⅜ in.)
London, National Gallery, inv. NG937
References: Carr 2013; Kowalczyk 2005, pp. 124–26, cat. no. 27; Constable and Links 1989, vol. 2, pp. 354–55, cat. no. 331.
Date of event: 16 August 1735[?]
Fig. 189

6

Regatta on the Grand Canal
Ca. 1735–40
Oil on canvas, 150 × 218 cm (59¹⁄₁₆ × 85¹³⁄₁₆ in.)
Barnard Castle, Bowes Museum, inv. 1982.32.2
References: Kowalczyk 2012, pp. 156–57, cat. no. 38; Constable and Links 1989, vol. 2, pp. 366–67, cat. no. 349.
Fig. 75
Cleveland only

7

The Grand Canal in Venice from Palazzo Flangini to Campo San Marcuola
Ca. 1738
Oil on canvas, 47 × 78 cm (18½ × 30⅝ in.)
Los Angeles, J. Paul Getty Museum, inv. 2013.22
References: Kowalczyk 2008, pp. 94–96, cat. no. 22; Constable and Links 1989, vol. 2, pp. 316–17, cat. no. 257(d).
Not illustrated
Los Angeles only

8

The Grand Canal in Venice from Palazzo Flangini to Campo San Marcuola
Ca. 1740
Oil on canvas, 61 × 92 cm (24⅛ × 36⅜ in.)
Minneapolis Institute of Art, Bequest of Miss Tessie Jones
in memory of Herschel V. Jones, inv. 68.41.11
References: Constable and Links 1989, vol. 2, p. 316, cat. no. 257(a).
Not illustrated
Minneapolis and Cleveland only

9

The Bucintoro at the Molo on Ascension Day
Ca. 1745
Oil on canvas, 115 × 163 cm (45¼ × 64³⁄₁₆ in.)
Philadelphia Museum of Art, The William L. Eakins Collection,
inv. E1924-3-48
References: Beddington 2006, pp. 28 n. 45, 161–62, cat. no. 54;
Constable and Links 1989, vol. 2, p. 363, cat. no. 344.
Date of event: 27 May 1745
Commissioned by: Possibly George Garnier (1703–1763)
Fig. 187

10

The Giovedì Grasso Festival in the Piazzetta
1763–66
Pen and brown ink with gray wash over graphite and red chalk height-
ened with white gouache, on laid paper, 386 × 555 mm (15³⁄₁₆ × 21⅞ in.)
Washington, D.C., National Gallery of Art, Wolfgang Ratjen Collection,
Paul Wellon Fund, inv. 2007.111.55
References: Chapman and Lachenmann 2011, pp. 132–33, cat. no. 57;
Constable and Links 1989, vol. 2, pp. 530–31, cat. no. 636.
Fig. 18
Los Angeles only

LUCA CARLEVARIJS (Italian, 1663–1730)

11

The Reception of the French Ambassador Henri Charles Arnauld,
Abbé de Pomponne, at the Doge's Palace
Ca. 1706–8
Oil on canvas, 130 × 260 cm (51³⁄₁₆ × 102⅜ in.)
Amsterdam, Rijksmuseum, inv. SK-C-1612
References: Succi 2015, pp. 116–21, cat. no. 2; Pavanello and
Craievich 2008, pp. 246–47, cat. no. 10; Reale and Succi 1994,
pp. 200–6, cat. no. 36.
Date of event: 10 May 1706
Commissioned by: Henri Charles Arnauld, abbé de Pomponne
(1669–1756)
Fig. 23
Los Angeles only

12

The Bucintoro Departing from the Molo
1710
Oil on canvas, 135 × 260 cm (53⅛ × 102⅜ in.)
Los Angeles, J. Paul Getty Museum, inv. 86.PA.600
References: Succi 2015, pp. 132–36, cat. no. 5; Beddington 2010, pp. 60,
180, cat. no. 3.
Date of event: Probably 29 May 1710
Fig. 42

13

The Regatta on the Grand Canal in Honor of King Frederick IV of Denmark
1711
Oil on canvas, 135 × 260 cm (53⅛ × 102⅜ in.)
Los Angeles, J. Paul Getty Museum, inv. 86.PA.599
References: Succi 2015, pp. 132–36, cat. no. 6; Beddington 2010, pp. 60,
180, cat. no. 4.
Date of event: 4 March 1709
Fig. 79

FRANCESCO GUARDI (Italian, 1712–1793)

14

The Nocturnal Good Friday Procession in Piazza San Marco
Ca. 1755
Oil on canvas, 48 × 85 cm (14¹⁵⁄₁₆ × 33⁷⁄₁₆ in.)
Oxford, Ashmolean Museum, inv. WA 2937.1 / A386
References: Craievich and Pedrocco 2012, pp. 127–28, cat. no. 31;
Pavanello and Craievich 2008, pp. 283–84, cat. no. 74; Morassi 1973,
vol. 1, p. 374, cat. no. 337.
Fig. 166

15

The Giovedì Grasso Festival in the Piazzetta
Ca. 1775
Oil on canvas, 67 × 100 cm (26⅜ × 39⅜ in.)
Paris, Musée du Louvre, inv. 321
References: Craievich and Pedrocco 2012, p. 217, cat. no. 77; Friedrichs
2006, pp. 93–94; Morassi 1973, vol. 1, pp. 355–56, cat. no. 249.
Commissioned by: Possibly Doge Alvise IV Mocenigo (r. 1763–1778)
Fig. 20
Los Angeles and Minneapolis only

16

Doge Alvise IV Mocenigo in the Corpus Christi Procession in Piazza San Marco
Ca. 1775
Oil on canvas, 67 × 98 cm (26⅜ × 38⁹⁄₁₆ in.)
Paris, Musée du Louvre, inv. 322
References: Pavanello and Craievich 2008, p. 294, cat. no. 90; Friedrichs
2006, pp. 104–6; Morassi 1973, vol. 1, p. 356, cat. no. 251.
Commissioned by: Possibly Doge Alvise IV Mocenigo (r. 1763–1778)
Fig. 22
Los Angeles and Minneapolis only

17

The Meeting of Pope Pius VI and Doge Paolo Renier at San Giorgio in Alga

1782

Oil on canvas, 51 × 67 cm (20 1/16 × 26 3/8 in.)

Private collection

References: Morassi 1973, vol. 1, p. 359, cat. no. 262.

Date of event: 15 May 1782

Commissioned by: Pietro Edwards (1744–1821) on behalf of the government of the Republic of Venice

Fig. 1

18

Pontifical Ceremony in Ss. Giovanni e Paolo

1782

Oil on canvas, 51 × 69 cm (20 3/16 × 27 1/16 in.)

Cleveland Museum of Art, Gift of the Hanna Fund, 1949.187

References: Morassi 1973, vol. 1, p. 359, cat. no. 264.

Date of event: 19 May 1782

Commissioned by: Pietro Edwards (1744–1821) on behalf of the government of the Republic of Venice

Fig. 2

Minneapolis and Cleveland only

19

Pope Pius VI Descending the Throne to Take Leave of the Doge in the Hall of Ss. Giovanni e Paolo

1782

Oil on canvas, 51 × 69 cm (20 3/16 × 27 1/16 in.)

Cleveland Museum of Art, Gift of the Hanna Fund, 1949.187

References: Morassi 1973, vol. 1, p. 359, cat. no. 266.

Date of event: 19 May 1782

Commissioned by: Pietro Edwards (1744–1821) on behalf of the government of the Republic of Venice

Fig. 3

Minneapolis and Cleveland only

20

The Balloon Flight of Count Zambeccari

1784

Oil on canvas, 66 × 51 cm (26 × 20 1/16 in.)

Berlin, Gemäldegalerie, inv. 501 F

References: Bock 2010, p. 410; Morassi 1973, vol. 1, p. 369, cat. no. 310.

Date of event: 15 April 1784

Fig. 204

Los Angeles and Minneapolis only

21

The Fire at San Marcuola

Ca. 1789–90

Oil on canvas, 43 × 62 cm (16 15/16 × 24 7/16 in.)

Munich, Alte Pinakothek, Unicredit collection, inv. HuW 12

References: Morassi 1973, vol. 1, pp. 206, 369–70, cat. no. 313.

Date of event: 28 November 1789

Fig. 181

ANTONIO JOLI (Italian, 1700–1777)

22

Peota with the Hunt of Diana and Endymion

1740

Ink and wash, 468 × 720 mm (18 7/6 × 28 3/8 in.)

Dresden, Kupferstich-Kabinett, inv. C-1979-8

References: Middione 1995, p. 40.

Date of event: 4 May 1740

Commissioned by: Crown Prince Friedrich Christian of Saxony (1722–1764)

Fig. 92

Los Angeles only

23

The Courtyard of the Doge's Palace with the Papal Nuncio Giovanni Francesco Stoppani and Senators in Procession

Ca. 1742

Oil on canvas, 161 × 222 cm (63 3/8 × 87 3/8 in.)

Washington, D.C, National Gallery of Art, Gift of Mrs. Barbara Hutton, inv. 1945.15.1

References: Pavanello and Craievich 2008, p. 278, cat. no. 59; Toledano 2006, pp. 204–6, cat. no. V.X; De Grazia and Garberson 1996, pp. 334–40.

Date of event: 17 April 1741

Commissioned by: Probably Giovanni Francesco Stoppani (1695–1774)

Fig. 25

24

King Ferdinand VI and Queen Maria Barbara of Braganza on the Royal Longboat at Aranjuez

Ca. 1752

Oil on canvas, 76 × 129 cm (29 15/16 × 50 13/16 in.)

Private collection, Courtesy Sotheby's

References: Toledano 2006, p. 258, cat. no. S.IX.2; Manzelli 1999, pp. 114–15, cat. no. S.16.

Fig. 153

25

The Abdication of Charles III as King of Naples in Favor of His Son Ferdinand
Ca. 1759
Oil on canvas, 77 × 126 cm (30 5/16 × 49 5/8 in.)
Madrid, Museo del Prado, inv. P07696
References: Urrea Fernández 2012, pp. 62–64; Toledano 2006, p. 346,
cat. no. N.XVII.1; Morales Vallejo and Ruiz Gómez 2001, p. 101;
Manzelli 1999, p. 37.
Date of event: 6 October 1759
Fig. 10

26

The Departure of Charles III from Naples to Become King of Spain
1759
Oil on canvas, 128 × 205 cm (50 3/8 × 80 11/16 in.)
Madrid, Museo del Prado, inv. P00232
References: Toledano 2006, pp. 334–36, cat. no. N.XV.1; Manzelli 1999,
p. 71, cat. no. N.1.
Date of event: 6 October 1759
Commissioned by: Elisabeth Farnese, Dowager Queen of Spain
(1692–1776)
Fig. 160

27

The Popular Revolt in Largo di Castello During the Famine
1764–68
Oil on canvas, 56 × 97 cm (22 1/6 × 38 3/16 in.)
Vienna, Kunsthistorisches Museum, inv. GG 8626
References: Toledano 2006, p. 360, cat. no. N.XXV.1; Manzelli 1999,
pp. 80–81, cat. no. N.40.
Date of event: Carnival 1764
Commissioned by: Government of the Kingdom of Naples
Fig. 182

MICHELE MARIESCHI (Italian, 1710–1744)

28

The Rialto Bridge with the Festive Entry of the Patriarch Antonio Correr
1735
Oil on canvas, 157 × 253 cm (61 13/16 × 99 5/8 in.)
Osterley Park, National Trust, inv. NT 771297
References: Pavanello and Craievich 2008, p. 164, 272–73, cat. no. 48;
Montecuccoli degli Erri and Pedrocco 1999, pp. 234–37, cat. no. 17;
Succi 1994, pp. 74–78
Date of event: 7 February 1735
Commissioned by: Probably a member of the Correr family
Fig. 202

29

The Regatta in Honor of Prince Friedrich Christian of Saxony
Ca. 1740
Oil on canvas, 56 × 85 cm (22 1/16 × 33 7/16 in.)
Private collection
References: Montecuccoli degli Erri and Pedrocco 1999, p. 377,
cat. no. 149; Succi 1989, pp. 159–60.
Date of event: 4 May 1740
Fig. 90

30

Doge Pietro Grimani Carried into Piazza San Marco after his Election
Ca. 1741
Oil on canvas, 57 × 113 cm (22 7/16 × 44 1/2 in.)
Paris, Galerie G. Sarti
References: Montecuccoli degli Erri and Pedrocco 1999, pp. 388–89,
cat. no. 160; Succi 1989, p. 149.
Date of event: 30 June 1741
Commissioned by: Possibly William Hayter (d. 1750) on behalf of
James Harris (1709–1780)
Fig. 198

GIOVANNI PAOLO PANINI (Italian, 1691–1765)

31

The Preparations to Celebrate the Birth of the Dauphin of France in Piazza Navona
1731
Oil on canvas, 109 × 246 cm (42 15/16 × 96 7/8 in.)
Dublin, National Gallery of Ireland, inv. NGI.95
References: Bowron and Rishel 2000, pp. 417–18, cat. no. 264; Arisi 1986,
p. 336, cat. no. 211; Wynne 1986, pp. 81–82, cat. no. 95.
Date of event: 30 November 1729
Commissioned by: Cardinal Melchior de Polignac (1661–1741)
Fig. 131
Cleveland only

32

The Lottery Draw in Piazza di Montecitorio
1743–44
Oil on canvas, 105 × 163 cm (41 5/16 × 64 3/16 in.)
London, National Gallery, inv. NG6605
References: Johns 2015, pp. 155–56; Arisi 1986, p. 404, cat. no. 346.
Commissioned by: Probably Cardinal Domenico Amedeo Orsini
d'Aragona (1719–1789)
Fig. 173
Los Angeles only

33

The Consecration of Giuseppe Pozzobonelli as Archbishop in San Carlo al Corso
1743–44
Oil on canvas, 198 × 297 cm (77¹⁵⁄₁₆ × 116¹⁵⁄₁₆ in.)
Como, Museo Civico Storico Giuseppe Garibaldi, inv. P451
References: Arisi 1993, p. 160, cat. no. 41; Arisi 1986, p. 400, cat. no. 338.
Date of event: 21 July 1743
Commissioned by: Cardinal Giuseppe Pozzobonelli (1696–1783)
Fig. 203

34

King Charles III Visiting Pope Benedict XIV at the Coffee House of the Palazzo del Quirinale
Ca. 1744–45
Oil on canvas, 53 × 79 cm (20⅞ × 31⅛ in.)
Private collection
References: Unpublished
Date of event: 3 November 1744
Fig. 208

35

The Decoration of the Piazza Farnese for the Celebration of the Marriage of the Dauphin
1745
Oil on canvas, 166 × 238 cm (65⁶⁄₁₆ × 93¹¹⁄₁₆ in.)
Norfolk, VA, Chrysler Museum, Gift of Walter P. Chrysler Jr.,
inv. 71.523
References: Buranelli 2010, pp. 337–38, cat. no. 45; Harrison 1991, p. 73,
cat. no. 54; Arisi 1986, p. 405, cat. no. 348.
Date of event: 19 June 1745
Commissioned by: Claude François Rogier de Beaufort-Montboissier,
abbé de Canilliac (1699–1761)
Fig. 106

36

King Charles III Visiting Pope Benedict XIV at the Coffee House of the Palazzo del Quirinale
1746
Oil on canvas, 124 × 174 cm (48¹³⁄₁₆ × 68½ in.)
Naples, Museo di Capodimonte, inv. 205
References: Johns 2015, pp. 225–31; Bowron and Rishel 2000, p. 423–24,
cat. no. 272; Arisi 1993, p. 164, cat. no. 43; Arisi 1986, p. 414, cat. no. 368.
Date of event: 3 November 1744
Commissioned by: Charles of Bourbon, later Charles III of Spain
(r. 1734–1759 as king of Naples, 1759–1788 as king of Spain)
Fig. 205

37

The Musical Performance in the Teatro Argentina in Honor of the Marriage of the Dauphin
1747
Oil on canvas, 205 × 246 cm (80¹¹⁄₁₆ × 96⅞ in.)
Paris, Musée du Louvre, inv. 414
References: Lo Bianco and Negro 2005, p. 246, cat. no. 144;
Arisi 1993, pp. 100–2, cat. no. 14; Kiene 1992, pp. 33–46, 102–3,
cat. no. 4; Kiene 1990; Arisi 1986, p. 416, cat. no. 371 bis.
Date of event: 12 July 1747
Commissioned by: Cardinal Frédéric Jérôme de La Rochefoucauld
(1701–1757)
Fig. 112
Los Angeles and Minneapolis only

38

A Ball Given by the Duc de Nivernais to Mark the Birth of the Dauphin
1751
Oil on canvas, 168 × 132 cm (66⅛ × 51¹⁵⁄₁₆ in.)
National Trust, Waddesdon Manor, Rothschild Collection,
inv. 80.2007.2
References: Carey 2008, pp. 52–55; Arisi 2005.
Date of event: 24 November 1751
Commissioned by: Louis Jules Mancini-Mazarini, duc de Nivernais
(1716–1798)
Fig. 136

39

The Flooding of the Piazza Navona
1756
Oil on canvas, 96 × 136 cm (37¹³⁄₁₆ × 53⁹⁄₁₆ in.)
Hannover, Niedersächsisches Landesmuseum, inv. 284
References: Arisi 1986, p. 462, cat. no. 466.
Date of event: August 1755
Commissioned by: Clemens August, Elector-Archbishop of Cologne
(1700–1761)
Fig. 140
Los Angeles and Minneapolis only

40

Interior of St. Peter's with the Visit of the Duc de Choiseul
1756–57
Oil on canvas, 164 × 236 cm (64⁹⁄₁₀ × 92¹⁵⁄₁₆ in.)
Boston, Athenaeum, purchase, 1834, inv. UR12
References: Bowron and Rishel 2000, pp. 428–29, cat. no. 277; Arisi 1986,
p. 466, cat. no. 473.
Date of event: 5 April 1756
Commissioned by: Étienne François, comte de Choiseul-Stainville
(1719–1785)
Fig. 67

LORENZO DE QUIRÓS (Spanish, 1717–1789)

41

Decoration of the Calle Platerías for the Entry of Charles III in Madrid

Ca. 1760

Oil on canvas, 111 × 167 cm (43¹¹⁄₁₆ × 65¾ in.)

Madrid, Museo de Historia de Madrid (on deposit from

Real Academia de Bellas Artes de San Fernando), inv. 0844

References: Pérez Sánchez 1992, p. 110, cat. no. 34.

Date of event: 13 July 1760

Fig. 161

JOHAN RICHTER (Swedish, 1665–1745)

42

The Bridge for the Feast of Santa Maria della Salute

Before 1728

Oil on canvas, 121 × 151 cm (47⅝ × 59⁷⁄₁₆ in.)

Hartford, Wadsworth Atheneum Museum of Art, The Ella Gallup

Sumner and Mary Catlin Sumner Collection Fund, inv. 1939.268

References: Beddington 2010, pp. 68, 180, cat. no. 6;

Reale and Succi 1994, p. 127.

Fig. 167

HUBERT ROBERT (French, 1733–1808)

43

The Fire at the Opera House of the Palais-Royal

Ca. 1781

Oil on canvas, 255 × 166 cm (100⅜ × 65⅜ in.)

Houston, Sarah Campbell Blaffer Foundation, inv. BF.1989.6

Date of event: 8 June 1781

Fig. 176

44

The Morning after the Fire at the Opera House of the Palais-Royal

Ca. 1781

Oil on canvas, 85 × 114 cm (33⁷⁄₁₆ × 44⅞ in.)

Paris, Musée Carnavalet, inv. P1081

References: Bruson and Leribault 1999, p. 364.

Date of event: 9 June 1781

Fig. 177

Los Angeles only

GIOVANNI BATTISTA TIEPOLO (Italian, 1696–1770)

45

Ceremonial Barge for the Regatta in Honor of Prince Friedrich
Christian of Saxony

1740

Pencil and wash, 469 × 789 mm (18⁷⁄₁₆ × 31⅛₆ in.)

Private collection

References: Succi 1994, p. 79; Romanelli 1983, p. 44, cat. no. 17;

Pavanello 1981, p. 134 n. 8; Stock 1980, p. 60, cat. no. 80; Morassi 1958,

p. 19, cat. no. 32.

Date of event: 4 May 1740

Commissioned by: Probably Giacomo Soranzo (1686–1761)

Fig. 93

Los Angeles and Minneapolis only

LUDOVICO UGHI (Italian, active 1729)

46

Iconographia rappresentatione della inclita citta di Venezia consacrata al Reggio
Serenissimo Dominio Veneto

1729

13 etchings on paper, between 20 × 46 cm (7⅞ × 18⅛ in.) and 65.5 × 45 cm

(25¹³⁄₁₆ × 17¾ in.) each

Los Angeles, Getty Research Institute, inv. 93-M1

Not illustrated

Los Angeles only

CLAUDE JOSEPH VERNET (French, 1714–1789)

47

The Visit of Elisabeth Farnese, Queen of Spain, to Villa Farnese at Caprarola

1746

Oil on canvas, 133 × 309 cm (52⅜ × 121⅝ in.)

Philadelphia Museum of Art, Purchased with the Edith H. Bell Fund,

inv. 1977-79-1

References: Bowron and Rishel 2000, p. 454, cat. no. 302; Ingersoll-

Smouse 1926, vol. 1, pp. 48–49, cat. no. 167.

Date of event: Possibly June 1745

Commissioned by: Cardinal Troiano Acquaviva d'Aragona (1694–1747) for

Elisabeth Farnese, Queen of Spain (1692–1776)

Fig. 16

Cleveland only

PIERRE JACQUES VOLAIRE (French, 1729–1799)

48

The Eruption of Vesuvius

1771

Oil on canvas, 117 × 243 cm (46⅛₆ × 95¹¹⁄₁₆ in.)

Chicago, Art Institute of Chicago, Charles H. and Mary F. S. Worcester

Collection, inv. 1978.426

References: Beck Saiello 2010, pp. 222–23, cat. no. P. 49; Wise and Warner

1996, pp. 156–59.

Date of event: 14 May 1771

Fig. 178

GIUSEPPE ZOCCHI (Italian, 1711/17–1767)

49

The Palio Race in the Campo in Honor of Grand Duke Francis of Tuscany and Archduchess Maria Theresa of Austria

1740

Oil on canvas, 82 × 132 cm (32¼ × 52 in.)

Siena, Banca Monte dei Paschi di Siena, Museo San Donato, inv. 381466

References: Sottili 2010; Gabbrielli 2004, pp. 253–54.

Date of event: 2 April 1739

Commissioned by: Orazio Sansedoni (1680–1751)

Fig. 101

BIBLIOGRAPHY

ABBREVIATED ARCHIVES

CC

Venice, Archivio di Stato, Collegio, Cerimoniali

CPR

Paris, Archives du Ministère des Affaires étrangères, Correspondance Politique, Rome

CPV

Paris, Archives du Ministère des Affaires étrangères, Correspondance Politique, Venise

MC

Paris, Archives Nationales, Minutier Central

SVB

Vienna, Österreichisches Staatsarchiv, Haus-, Hof- und Staatsarchiv, Staatenabteilungen, Venedig, Berichte

PUBLICATIONS

ADRIA FESTOSA 1740

L'Adria festosa. Notizie Storiche dell'Arrivo, e Passaggio della Regina delle due Sicilie per lo Stato della Sereniss. Repubblica di Venezia nel suo Viaggio al Real Sposo in Napoli l'Anno 1738 e del soggiorno di Sua Altezza Reale ed Electorale Federico Cristiano…ove si spiegano tutte le Funzioni Pubbliche, e Private fatte a divertimento di S. A. R. l'Anno 1740. Venice: Occhi, 1740.

ALBRIZZI 1740

Albrizzi, Giovanni Battista. *Forestiere illuminato intorno le cose più rare, e curiose, antiche, e moderne della città di Venezia.* Venice: Albrizzi, 1740.

ALBRIZZI 1771

Albrizzi, Giovanni Battista. *L'Etranger plainement instruit des choses les plus rares et curieuses, anciennes et modernes de la ville de Venise et des Isles à l'entour.* Venice: Albrizzi, 1771.

ALLEN 1993

Allen, Brian. "Venetian Painters in England in the Earlier Eighteenth Century." In *Canaletto & England.* Exh. cat. Birmingham Gas Hall, 1993–94. Edited by . Edited by Michael Liversidge and Jane Farrington. London: Merrell Holberton, 1993, pp. 30–37.

ALLEN 2006

Allen, Brian. "The London Art World of the Mid-Eighteenth Century." In *Canaletto in England. A Venetian Artist Abroad, 1746–1755.* Exh. cat. New Haven, Yale Center for British Art; London, Dulwich Picture Gallery, 2006–7. Edited by Charles Beddington. New Haven: Yale University Press, 2006, pp. 30–37.

ALMANACH 1756

Almanach royal. Paris: Le Breton, 1756.

ARCHER 2012

Archer, Ian. "The City of London and River Pageantry, 1400–1856." In *Royal River. Power, Pageantry and the Thames.* Exh. cat. Greenwich, National Maritime Museum, 2012. Edited by Susan Doran. London: Scala, 2012, pp. 80–85.

ARISI 1961

Arisi, Ferdinando. *Gian Paolo Panini.* Piacenza: Cassa di Risparmio di Piacenza, 1961.

ARISI 1986

Arisi, Ferdinando. *Gian Paolo Panini e i fasti della Roma del '700.* Rome: Bozzi, 1986.

ARISI 1993

Giovanni Paolo Panini 1691–1765. Exh. cat. Piacenza, Palazzo Gotico, 1993. Edited by Ferdinando Arisi. Milan: Electa, 1993.

ARISI 2005

Arisi, Ferdinando. "Due inediti di straordinario interesse di Gian Paolo Panini, commissionati dall'ambasciatore francese a Roma nel 1751." *Strenna Piacentina* 2005, pp. 113–17.

ARNAULD 1668

Arnauld, Antoine. *Remarques sur la requeste présentée au Roy par Monseigneur l'Archevesque d'Ambrun contre la Traduction du Nouveau Testament imprimé à Mons.* N.p: n.p., 1668.

ARNAULD 1776

Arnauld, Antoine. *Oeuvres.* Vol. 7. Paris: D'Arnay, 1776.

ARNOLD AND ARNOLD 1985

Arnold, Denis, and Elsie Arnold. "Russians in Venice: The Visit of the *Conti del Nord* in 1782." In *Slavonic and Western Music. Essays for Gerald Abraham.* Edited by Malcolm Hamrick Brown and Roland John Wiley. Ann Arbor: UMI Research Press, 1985, pp. 123–30.

ATERIDO 2004

Aterido, Ángel, et al. *Inventarios reales. Colecciones de pinturas de Felipe V e Isabel Farnesio.* 2 vols. Madrid: Fundación de Apoyo a la Historia del Arte Hispánico, 2004.

AUBERT 1910

Aubert, Marcel. "L'Hôtel-Dieu et l'incendie de 1772." *Société d'Iconographie Parisienne* 3 (1910), pp. 13–24.

BAETJER AND LINKS 1989

Baetjer, Katharine, and Joseph Gluckstein Links. *Canaletto.* New York: Metropolitan Museum of Art, 1989.

BALLARINI 1870

Ballarini, Luigi. *I Conti del Nord a Venezia. Due lettere di Luigi Ballarini a Daniele Dolfin ambasciatore di Venezia a Parigi 1782.* Venice: Visentini, 1870.

BALTEAU 1933–

Dictionnaire de biographie française. Edited by Jules Balteau et al. Paris: Letouzey et Ané, 1933–.

BANIER 1741

Banier, Antoine. Histoire générale des cérémonies, moeurs et coutumes religieuses de tous les peuples du monde. 7 vols. Paris: Rollin, 1741.

BARCHAM 2002

Barcham, William. "Luca Carlevarijs e la creazione della veduta veneziana del XVIII secolo." In Gaspare Vanvitelli e le origini del vedutismo. Exh. cat. Rome, Chiostro del Bramante; Venice, Museo Correr, 2002–3. Edited by Fabio Benzi. Rome: Viviani Arte, 2002, pp. 57–67.

BASSI 1976

Bassi, Elena. Palazzi di Venezia. Admiranda Urbis Venetae. Venice: Stamperia di Venezia, 1976.

BATTAGIA 1844

Battagia, Michele. Cicalata sulle cacce di tori veneziane. Venice: Merlo, 1844.

BECATTINI 1790

Becattini, Francesco. Storia del regno di Carlo III di Borbone Re Cattolico delle Spagne e dell'Indie. 2 vols. Turin: Società de' Librai, 1790.

BECK SAIELLO 2010

Beck Saiello, Emilie. Pierre Jacques Volaire (1729–1799) dit le Chevalier Volaire. Paris: Arthena, 2010.

BEDDINGTON 2006

Beddington, Charles, ed. Canaletto in England. A Venetian Artist Abroad, 1746–1755. Exh. cat. New Haven, Yale Center for British Art; London, Dulwich Picture Gallery, 2006–7. New Haven: Yale University Press, 2006.

BEDDINGTON 2010

Beddington, Charles. Venice. Canaletto and His Rivals. London: National Gallery Company, 2010.

BENZI 2002

Gaspare Vanvitelli e le origini del vedutismo. Exh. cat. Rome, Chiostro del Bramante; Venice, Museo Correr, 2002–3. Edited by Fabio Benzi. Rome: Viviani Arte, 2002.

BERNIS 1878

Bernis, François-Joachim de Pierre de. Mémoires et lettres de François-Joachim de Pierre, Cardinal de Bernis (1715–1758). Edited by Frédéric Masson. 2 vols. Paris: Plon, 1878.

BERTI 2011

Berti, Michela. "Un caso di committenza dell'Ambasciatore francese a Roma. Il Componimento Dramatico di Jommelli e il quadro Fête musicale di Pannini per le nozze del Delfino di Francia (1747)." Fonti Musicali Italiane 16 (2011), pp. 93–125.

BETTAGNO 1997

Venezia da stato a mito. Exh. cat. Venice, Fondazione Giorgio Cini, 1997. Edited by Alessandro Bettagno. Venice: Marsilio, 1997.

BETTAGNO AND KOWALCZYK 2001

Canaletto. Prima maniera. Exh. cat. Venice, Fondazione Giorgio Cini, 2001. Edited by Alessandro Bettagno and Bozena Anna Kowalczyk. Milan: Electa, 2001.

BLANNING 2007

Blanning, Tim. The Pursuit of Glory. Europe 1648–1815. London: Allen Lane, 2007.

BOCK 1980

Bock, Henning. "Largillière—Panini—Gainsborough. Neue Bilder in der Gemäldegalerie." Jahrbuch Preußischer Kulturbesitz 17 (1980), pp. 205–19.

BOCK 1985

Bock, Henning, et al. Gemäldegalerie Berlin. Geschichte der Sammlung und ausgewählte Meisterwerke. Berlin: Staatliche Museen Preußischer Kulturbesitz, 1985.

BOCK 2010

Bock, Henning, et al. Gemäldegalerie Berlin. 200 Meisterwerke der europäischen Malerei, 3rd ed. Berlin: Nicolai, 2010.

BOITEUX 1989

Boiteux, Martine. "Il carnevale e le feste francesi a Roma nel Settecento." In Il Teatro a Roma nel Settecento. 2 vols. Rome: Istituto della Enciclopedia Italiana, 1989. Vol. 1, pp. 321–71.

BOITEUX 2010

Boiteux, Martine. "Feste e vita a palazzo tra XVI e XVIII secolo." In Palazzo Farnèse. Dalle collezioni rinascimentali ad Ambasciata di Francia. Exh. cat. Rome, Palazzo Farnese, 2010–11. Edited by Francesco Buranelli. Florence: Giunti, 2010, pp. 233–47.

BOITEUX 2014

Boiteux, Martine. "Piazza Navona: De l'usage de la fête pour la construction d'un lieu." In "Piazza Navona, ou Place Navone, la plus belle la plus grande." Du stade de Domitien à la place moderne, histoire d'une évolution urbaine. Edited by Jean-François Bernard. Rome: École Française de Rome, 2014, pp. 699–721.

BONET CORREA 1992

Bonet Correa, Antonio. "Vida artística y retrato auténtico de Carlos Broschi 'Farinelli.'" In Carlo Broschi, Fiestas Reales. Edited by Antonio Bonet Correa and Antonio Gallego. Madrid: Turner, 1992, pp. ix–xxiv.

BONET CORREA 2012

Bonet Correa, Antonio, et al. Real Academia de San Fernando, Madrid. Guía del museo. Madrid: Real Academia de Bellas Artes de San Fernando, 2012.

BONET CORREA AND BLASCO ESQUIVIAS 2002

Un reinado bajo el signo de la paz. Fernando VI y Bárbara de Braganza 1746–1759. Exh. cat. Madrid, Academia de San Fernando, 2002–3. Edited by Antonio Bonet Correa and Beatriz Blasco Esquivias. Madrid: El Viso, 2002.

BOTTINEAU 1986

Bottineau, Yves. L'art de cour dans l'Espagne des Lumières 1746–1808. Paris: De Boccard, 1986.

BOUCHOT 1901

Bouchot, Henri. "L'Ambassade de France à Rome en 1747. Portraits-charges par Pier-Leone Ghezzi." *L'Art* 60 (1901), pp. 197–217.

BOUTRY 1895

Boutry, Maurice. *Choiseul à Rome. Lettres et mémoires inédits 1754–1757*. Paris: Lévy, 1895.

BOWRON 1991

Bowron, Edgar Peters. "'The Most Wonderful Sight in Nature': Volaire's *Eruption of Vesuvius*, Commissioned by Henry Blundell." *North Carolina Museum of Art Bulletin* 15 (1991), pp. 2–12.

BOWRON 2001

Bernardo Bellotto and the Capitals of Europe. Exh. cat. Museum of Fine Arts, Houston, 2001. Edited by Edgar Peters Bowron. New Haven: Yale University Press, 2001.

BOWRON AND RISHEL 2000

Art in Rome in the Eighteenth Century. Exh. cat. Philadelphia Museum of Art; Museum of Fine Arts, Houston, 2000. Edited by Edgar Peters Bowron and Joseph Rishel. London: Merrell, 2000.

BRIMONT 1913

Brimont, Thierry de. *Le cardinal de La Rochefoucauld et l'ambassade de Rome de 1743 à 1748*. Paris: Picard, 1913.

BROSCHI 1992

Broschi, Carlo. *Fiestas Reales*. Edited by Antonio Bonet Correa and Antonio Gallego. Madrid: Turner, 1992.

BRUSON AND LERIBAULT 1999

Bruson, Jean-Marie, and Christophe Leribault. *Peintures du Musée Carnavalet. Catalogue sommaire*. Paris: Paris-Musées, 1999.

BRUZEN DE LA MARTINIÈRE 1726–39

Bruzen de La Martinière, Antoine Augustin. *Le Grand Dictionnaire géographique et critique*. 9 vols. The Hague: Gosse, Alberts, de Hondt, 1726–39.

BULL 2003

Bull, Duncan. "The Artist." In Eveline Sint Nicolaas, et al. *Jean-Baptiste Vanmour. An Eyewitness of the Tulip Era*. Istanbul: Koçbank, 2003, pp. 25–39.

BURANELLI 2010

Palazzo Farnèse. Dalle collezioni rinascimentali ad Ambasciata di Francia. Exh. cat. Rome, Palazzo Farnese, 2010–11. Edited by Francesco Buranelli. Florence: Giunti, 2010.

BURKE 2001

Burke, Peter. *Eyewitnessing. The Uses of Images as Historical Evidence*. Ithaca: Cornell University Press, 2001.

BURROWS 2012

Burrows, Donald. *Handel*. Oxford: Oxford University Press, 2012.

BURROWS AND HUME 1991

Burrows, Donald, and Robert Hume. "George I, the Haymarket Opera Company and Handel's *Water Music*." *Early Music* 19 (1991), pp. 323–38.

BUTLER 2009

Butler, Margaret. "'Olivero's' Painting of Turin's Teatro Regio: Toward a Reevaluation of an Operatic Emblem." *Music in Art* 34 (2009), pp. 137–51.

CADOGAN 1991

Wadsworth Atheneum Paintings II. Italy and Spain. Fourteenth through Nineteenth Centuries. Edited by Jean Cadogan. Hartford: Wadsworth Atheneum, 1991.

CAEREMONIALE 1680

Caeremoniale episcoporum Clementis VIII. primum, nunc denuo Innocentii Papae X. auctoritate recognitum. Lyon: Societatis Bibliopolarum, 1680.

CAREY 2008

Carey, Juliet. "New Paintings at Waddesdon Manor. Recent Acquisitions for the Rothschild Collection." *Apollo* 168, no. 557 (2008), pp. 52–57.

CARR 2013

Carr, Dawson. "Canaletto's *The Feast Day of Saint Roch*." In *Art and Music in Venice. From the Renaissance to the Baroque*. Exh. cat. Montreal Museum of Fine Arts; Portland Art Museum, 2013–14. Edited by Hilliard Goldfarb. Paris: Hazan, 2013, pp. 87–91.

CARR 2015

Carr, Dawson, et al. *Seeing Nature. Landscape Masterworks from the Paul G. Allen Family Collection*. Exh. cat. Portland Art Museum, 2015–16. Portland: Portland Art Museum, 2015.

CASELLATO 2009

Casellato, Lucia. "Mauri (Mauro)." In *Dizionario Biografico degli Italiani*. Vol. 72. Rome: Istituto della Enciclopedia Italiana, 2009, pp. 357–61.

CASSIDY-GEIGER 2014

Cassidy-Geiger, Maureen. "Gold Boxes as Diplomatic Gifts: Archival resources in Dresden." *Journal of the Silver Society* 31 (2014), pp. 48–62.

CHAPMAN AND LACHENMANN 2011

Chapman, Hugo, and David Lachenmann. *Italian Master Drawings from the Wolfgang Ratjen Collection, 1525–1835*. Exh. cat. Washington, D.C., National Gallery of Art, 2011. London: Holberton, 2011.

CHRACAS 1716–1836

Chracas, Luca Antonio, et al. *Diario ordinario*. Rome: Chracas, 1716–1836.

CHRACAS 1744

Chracas, Luca Antonio. *Relazione della venuta in Roma della Maestà di Carlo Rè delle due Sicilie*. Rome: Chracas, 1744.

CIRCO AGONALE 1729

Circo Agonale di Roma, restituito all'antica forma con illuminazioni, e machine artifiziali dall'E.mo e R.mo Signor Cardinale di Polignac…per celebrare il felice nascimento del Delfino. Rome: Caporali, 1729.

CLAYTON 2005

Clayton, Martin. *Canaletto in Venice*. London: Royal Collection, 2005.

COCHIN 1991

Cochin, Charles-Nicolas. *Le Voyage d'Italie de Charles-Nicolas Cochin (1758)*. Edited by Christian Michel. Rome: École Française de Rome, 1991.

COGGIOLA PITTONI 1915

Coggiola Pittoni, Laura. "Il viaggio di Pio VI negli stati veneti e nella Dominante." *Nuovo Archivio Veneto* 29 (1915), pp. 167–208.

COLA 2012

Cola, Maria Celeste. "L'inventario di Francesco Pannini. Dipinti, disegni e contorni nello studio di Palazzo Moroni." *Rivista dell'Istituto Nazionale d'Archeologia e Storia dell'Arte* 67 (2012), pp. 199–223.

COLE 1733

Cole, Christian. *Memoirs of Affairs of State: Containing Letters, Written by Ministers employed in Foreign Negotiations, From the Year 1697, to the latter End of 1708*. London: Woodfall, 1733.

COLLEVILLE AND SAINT-CHRISTO 1925

Colleville, Ludovic de, and François Saint-Christo. *Les ordres du Roi. Répertoire général contenant les noms et qualités de tous les chevaliers des ordres royaux militaires et chevaleresques ayant existé en France de 1099 à 1830*. Paris: Jouve, 1925 (reprint Versailles: Mémoires & document, 2001).

COLOMBO 2013

Colombo, Emanuele. "Orsini d'Aragona, Domenico." In *Dizionario Biografico degli Italiani*. Vol. 79. Rome: Istituto della Enciclopedia Italiana, 2013, pp. 719–21.

CONSTABLE AND LINKS 1989

Constable, William George, and Joseph Gluckstein Links. *Canaletto. Giovanni Antonio Canal, 1697–1768*. 2 vols. Oxford: Clarendon, 1989.

CORBOZ 1985

Corboz, André. *Canaletto. Una Venezia immaginaria*. 2 vols. Milan: Alfieri Electa, 1985.

CORP 1997

Corp, Edward. "Maurice Quentin de La Tour's Portrait of Prince Charles Edward Stuart." *Burlington Magazine* 139 (1997), pp. 322–25.

CORP 2009

Corp, Edward. "Prince Charles or Prince Henry? Maurice Quentin de La Tour's Portrait of a Stuart Prince." *British Art Journal* 10 (2009), pp. 51–57.

CORP 2011

Corp, Edward. *The Stuarts in Italy, 1719–1766. A Royal Court in Permanent Exile*. Cambridge: Cambridge University Press, 2011.

COTARELO Y MORI 1917

Cotarelo y Mori, Emilio. *Orígenes y establecimiento de la opera en España hasta 1800*. Madrid: Revista de Archivos, Bibliotecas y Museos, 1917.

CRAIEVICH AND PEDROCCO 2012

Francesco Guardi 1712–1793. Exh. cat. Venice, Museo Correr, 2012–13. Edited by Alberto Craievich and Filippo Pedrocco. Milan: Skira, 2012.

DA CANAL 1809

Da Canal, Vincenzo. *Vita di Gregorio Lazzarini* [1732]. Edited by Giannantonio Moschini. Venice: Palese, 1809.

DEAN AND KNAPP 1987

Dean, Winton, and John Merrill Knapp. *Handel's Operas 1704–1726*. Oxford: Clarendon, 1987.

DEBRIE AND SALMON 2000

Debrie, Christine, and Xavier Salmon. *Maurice-Quentin de La Tour. Prince des pastellistes*. Paris: Somogy, 2000.

DE BROSSES 1991

De Brosses, Charles. *Lettres familières*. Edited by Giuseppina Cafasso. 3 vols. Naples: Centre Jean Bérard, 1991.

DE CRESCENZO AND DIOTALLEVI 2008

De Crescenzo, Simona, and Alfredo Diotallevi. *Le "Effigies nomina et cognomina S.R.E. cardinalium" nella Biblioteca Apostolica Vaticana*. Vatican City: Biblioteca Apostolica Vaticana, 2008.

DE GRAZIA AND GARBERSON 1996

De Grazia, Diane, and Eric Garberson. *Italian Paintings of the Seventeenth and Eighteenth Centuries. The Collections of the National Gallery of Art Systematic Catalogue*. Washington, D.C.: National Gallery of Art, 1996.

DE MARTINI 2012

Antonio Joli tra Napoli, Roma e Madrid. Le vedute, le rovine, i capricci, le scenografie teatrali. Exh. cat. Caserta, Palazzo Reale, 2012. Edited by Vega de Martini. Naples: Edizioni Scientifiche Italiane, 2012.

DE MARTINI AND MORILLAS ALCÁZAR 2001

De Martini, Vega, and José María Morillas Alcázar. *Farinelli. Arte e spettacolo alla corte spagnola del Settecento*. Rome: Artemide, 2001.

DESEINE 1699

Deseine, François Jacques. *Nouveau voyage d'Italie. Contenant une description exacte de toutes ses Provinces, Villes, & lieux considerables, & des Isles qui en dépendent*. Lyon: Thioly, 1699.

DISTINTA RELAZIONE 1729

Distinta relazione delle feste celebrate in Roma per ordine dell'Eminentissimo, e Reverendissimo Signore il Signor Cardinal di Polignac Ministro di Sua Maestà Cristianissima in occasione della felice nascita del Real Delfino di Francia. Rome: Bernabò, 1729.

DORAN 2012

Royal River. Power, Pageantry and the Thames. Exh. cat. Greenwich, National Maritime Museum, 2012. Edited by Susan Doran. London: Scala, 2012.

DORATI DA EMPOLI 2008

Dorati da Empoli, Maria Cristina. *Pier Leone Ghezzi. Un protagonista del Settecento romano*. Rome: Gangemi, 2008.

DRAPER 1969

Draper, James David. "The Lottery in Piazza di Montecitorio." *Master Drawings* 7 (1969), pp. 27–34.

DUBIN 2010

Dubin, Nina. *Futures & Ruins. Eighteenth-Century Paris and the Art of Hubert Robert*. Los Angeles: Getty Research Institute, 2010.

DUPARC 1958

Recueil des Instructions données aux Ambassadeurs et Ministres de France depuis les Traités de Westphalie jusqu'à la Révolution Française. Vol. 26. Venise. Edited by Pierre Duparc. Paris: Centre National de la Recherche Scientifique, 1958.

EGLIN 1999

Eglin, John. "Venice on the Thames: Venetian vedutisti and the London View in the Eighteenth Century." In Italian Culture in Northern Europe in the Eighteenth Century. Edited by Shearer West. Cambridge: Cambridge University Press, 1999, pp. 101–15.

ENTICK 1766

Entick, John. A New and Accurate History and Survey of London, Westminster, Southwark, and Places Adjacent. 4 vols. London. Dilly, 1766.

FALOMIR FAUS 2014

Falomir Faus, Miguel, et al. Italian Masterpieces from Spain's Royal Court, Museo del Prado. Exh. cat. Melbourne, National Gallery of Victoria, 2014. Melbourne: National Gallery of Victoria, 2014.

FARGE 1908

Farge, René. "L'incendie de l'Opéra en 1781." Société d'Iconographie Parisienne 1 (1908), pp. 9–26.

FASTENRATH VINATTIERI 2003

Fastenrath Vinattieri, Wiebke. "Sulle tracce del primo Neoclassicismo. Il viaggio del principe ereditario Friedrich Christian di Sassonia in Italia (1738–1740)." Zeitenblicke 2, no. 3 (2003), http://www.zeitenblicke.de/2003/03/fastenrath.htm.

FAUCHER 1777

Faucher, Chrysostome. Histoire du Cardinal de Polignac. 2 vols. Paris: D'Houry, 1777.

FAUCHEUX 1969

Faucheux, Louis Étienne. Catalogue raisonné de toutes les estampes qui forment l'oeuvre d'Israel Silvestre, précédé d'une notice sur sa vie. Paris: De Nobele, 1969.

FELDMAN 2007

Feldman, Martha. Opera and Sovereignty: Transforming Myths in Eighteenth-Century Italy. Chicago: University of Chicago Press, 2007.

FENLON 2007

Fenlon, Iain. The Ceremonial City. History, Memory and Myth in Renaissance Venice. New Haven: Yale University Press, 2007.

FORD AND INGAMELLS 1997

Ford, Brinsley, and John Ingamells. A Dictionary of British and Irish Travellers in Italy 1701–1800. Compiled from the Brinsley Ford Archive. New Haven: Yale University Press, 1997.

FOTHERGILL 1958

Fothergill, Brian. The Cardinal King. London: Faber and Faber, 1958.

FRANZINI 2012

Franzini, Elio. "Imitare ed emulare: a partire dal 'caso Tiepolo.'" In I colori della seduzione. Giambattista Tiepolo e Paolo Veronese. Exh. cat. Udine, Castello, 2012–13. Edited by Linda Borean and William L. Barcham. Udine: Civici Musei, 2012, pp. 51–61.

FRATI 1908

Frati, Lodovico. "Il principe Filippo Hercolani ambasciatore cesareo a Venezia." Ateneo veneto 31, no. II/1 (1908), pp. 27–48.

FRIEDRICHS 2006

Friedrichs, Cornelia. Francesco Guardi—Venezianische Feste und Zeremonien. Die Inszenierung der Republik in Festen und Bildern. Berlin: Reimer, 2006.

GABILLOT 1895

Gabillot, Cyrille. Hubert Robert et son temps. Paris: Librairie de l'art, 1895.

GABBRIELLI 2004

Palazzo Sansedoni. Edited by Fabio Gabbrielli. Siena: Protagon, 2004.

GACETA DE MADRID

Gaceta de Madrid. Madrid: Imprenta de la Gaceta, 1697–1934.

GAIER 2003

Gaier, Martin. "San Marco in maschera. Papst Pius VI. besucht Venedig (1782)." Studi veneziani n.s. 45 (2003), pp. 127–39.

GARNIER 1900

Garnier, Arthur Edmund. The Chronicles of the Garniers of Hampshire During Four Centuries, 1530–1900. Norwich: Jarrold, 1900.

GAVIGLIA 2005

Gaviglia, Amilcare Quirino. "Monsignor cardinal Melchior de Polignac, 'stupor Urbis.'" In La contesa de' numi di Pietro Metastasio e Leonardo Vinci. Una cantata a palazzo Altemps per la nascita del Delfino di Francia. Edited by Rinaldo Alessandrini and Laura Pietrantoni. 2 vols. Rome: Accademia Nazionale di Santa Cecilia, 2005. Vol. 1, pp. 21–44.

GENTLEMAN'S MAGAZINE

The Gentleman's Magazine (London, 1731–1833).

GEPHYRALOGIA 1751

Gephyralogia. An Historical Account of Bridges, Antient and Modern, From the Most Early Mention of Them by Authors, Down to the Present Time. London: Corbett, 1751.

GILLIO 2006

Gillio, Pier Giuseppe. L'attività musicale negli ospedali di Venezia nel Settecento. Quadro storico e materiali documentari. Florence: Olschki, 2006.

GIRARDOT 1871

Correspondance de M. de la Rochefoucauld ambassadeur à Rome 1744–1748. Edited by August-Théodore de Girardot. Nantes: Mellinet, 1871.

GOETHE 1932–33

Goethe, Johann Caspar. Viaggio in Italia (1740). Edited by Arturo Farinelli. 2 vols. Rome: Reale Accademia d'Italia, 1932–33.

GOMBRICH 1982

Gombrich, Ernst Hans. The Image and the Eye. Further Studies in the Psychology of Pictorial Representation. Ithaca: Cornell University Press, 1982.

GORI SASSOLI 1994

Gori Sassoli, Mario. *Della Chinea e di altre "Macchine di gioia." Apparati architettonici per fuochi d'artificio a Roma nel Settecento*. Exh. cat. Rome, Villa Farnesina, 1994. Milan: Charta, 1994.

GOZZI 1782

Gozzi, Gasparo. *Arrivo, soggiorno, e partenza da Venezia del Sommo Pontefice Pio VI*. Venice: Benvenuti, 1782.

GRADENIGO 1942

Gradenigo, Pietro. *Notizie d'arte tratte dai Notatori e dagli Annali del N. H. Pietro Gradenigo*. Edited by Lina Livan. Venice: Reale Deputazione Editrice, 1942.

GRASSELLI AND JACKALL 2016

Grasselli, Margaret Morgan, and Yuriko Jackall. *Hubert Robert*, Washington, D.C.: National Gallery of Art, 2016.

GREVEMBROCH 1981

Grevembroch, Giovanni. *Gli abiti de veneziani di quasi ogni età con diligenza raccolti e dipinti nel secolo XVIII*. 4 vols. Venice: Filippi, 1981.

GROSLEY 1764

Grosley, Pierre-Jean. *Nouveaux mémoires, ou observations sur l'Italie et sur les Italiens*. 3 vols. London: Nourse, 1764.

GROSVENOR 2008

Grosvenor, Bendor. "The Restoration of King Henry IX. Identifying Henry Stuart, Cardinal York." *British Art Journal* 9 (2008), pp. 28–32.

GUICHARD 2008

Guichard, Charlotte. *Les amateurs d'art à Paris au XVIIIe siècle*. Seyssel: Champ Vallon, 2008.

HAGER 1939

Hager, Werner. *Das geschichtliche Ereignisbild. Beitrag zu einer Typologie des weltlichen Geschichtsbildes bis zur Aufklärung*. Munich: Neuer Filser-Verlag, 1939.

HALLETT 1993

Hallett, Mark. "Framing the Modern City: Canaletto's Images of London." In *Canaletto & England*. Exh. cat. Birmingham Gas Hall, 1993–94. Edited by Michael Liversidge and Jane Farrington. London: Merrell Holberton, 1993, pp. 46–54.

HANOTEAU 1913

Recueil des instructions données aux ambassadeurs et ministres de France depuis les traités de Westphalie jusqu'à la Révolution française. Vol. 20. *Rome (1724–1791)*. Edited by Jean Hanoteau. Paris: Alcan, 1913.

HARRISON 1991

Harrison, Jefferson. *The Chrysler Museum. Handbook of the European and American Collections. Selected Paintings, Sculpture and Drawings*, Norfolk, VA: Chrysler Museum, 1991.

HARTJE 2002

Hartje, Nicole. "'Aus Liebe eines zu Venedig bis ins hohe Alter gewohnten […] Berliners'. Sigismund Streit als Sammler zeitgenössischer venezianischer Malerei." In *Blick auf den Canal Grande. Venedig und die Sammlung des Berliner Kaufmanns Sigismund Streit*. Exh. cat., Berlin, Gemäldegalerie, 2002–3. Edited by Nicole Hartje. Berlin: Gemäldegalerie, 2002, pp. 17–35.

HASKELL 1956

Haskell, Francis. "Stefano Conti, Patron of Canaletto and Others." *Burlington Magazine* 98 (1956), pp. 296–300.

HASKELL 1980

Haskell, Francis. *Patrons and Painters. A Study in the Relations between Italian Art and Society in the Age of the Baroque*. New Haven: Yale University Press, 1980.

HAUSMANN 1950

Hausmann, Friedrich. *Repertorium der diplomatischen Vertreter aller Länder seit dem Westfälischen Frieden (1648)*. Vol. 2. Zurich: Fretz and Wasmuth, 1950.

HENNING ET AL. 2011

Bernardo Bellotto. Der Canaletto-Blick. Exh. cat. Dresden, Gemäldegalerie Alte Meister, 2011. Edited by Andreas Henning, Sebastian Oesinghaus, and Sabine Bendfeldt. Dresden: Sandstein, 2011.

HOGWOOD 2005

Hogwood, Christopher. *Handel: Water Music and Music for the Royal Fireworks*. Cambridge: Cambridge University Press, 2005.

IMBRUGLIA 2000

Imbruglia, Girolamo. "Enlightenment in Eighteenth-Century Naples." In *Naples in the Eighteenth Century. The Birth and Death of a Nation State*. Edited by Girolamo Imbruglia. Cambridge: Cambridge University Press, 2000, pp. 70–94.

INGERSOLL-SMOUSE 1926

Ingersoll-Smouse, Florence. *Joseph Vernet, peintre de marine 1714–1789. Étude critique suivie d'un catalogue raisonné de son oeuvre peint*. 2 vols. Paris: Bignou, 1926.

JACOB 1975

Jacob, Sabine. *Italienische Zeichnungen der Kunstbibliothek Berlin. Architektur und Dekoration 16. bis 18. Jahrhundert*. Berlin: Staatliche Museen Preußischer Kulturbesitz, 1975.

JOHNS 2015

Johns, Christopher. *The Visual Culture of Catholic Enlightenment*. University Park: Pennsylvania State University Press, 2015.

JOHNSON 2011

Johnson, James. *Venice Incognito: Masks in the Serene Republic*. Berkeley: University of California Press, 2011.

JONARD 1978

Jonard, Norbert. *La vie quotidienne à Venise au XVIIIe siècle*, 2nd ed. Geneva: Famot, 1978.

JOUGLA DE MORENAS 1975

Jougla de Morenas, Henri. *Grand armorial de France*. 7 vols. Paris: Frankelve, 1975.

KERSLAKE 1977

Kerslake, John. *Early Georgian Portraits*. 2 vols. London: Her Majesty's Stationery Office, 1977.

KIENE 1990

Kiene, Michael. "Musique, peinture et fête. Une fête au théâtre Argentina de Rome à l'occasion du mariage du dauphin de France en 1747." *Revue de l'art* 88 (1990), pp. 21–30.

KIENE 1991

Kiene, Michael. "L'image du Dieu vivant. Zum 'Aktionsbild' und zur Ikonographie des Festes am 30. November 1729 auf der Piazza Navona in Rom." *Zeitschrift für Kunstgeschichte* 54 (1991), pp. 220–48.

KIENE 1992

Kiene, Michael. *Pannini*. Exh. cat. Paris, Musée du Louvre, 1992–93. Paris: Réunion des Musées Nationaux, 1992.

KIEVEN 2007

Kieven, Elisabeth. "Die Verwandlung der Stadt. Römische Festarchitekturen des 18. Jahrhunderts." In *Bild/Geschichte. Festschrift für Horst Bredekamp*. Edited by Philine Helas et al. Berlin: Akademie Verlag, 2007, pp. 275–86.

KINGZETT 1982

Kingzett, Richard. "A Catalogue of the Works of Samuel Scott." *Walpole Society* 48 (1982), pp. 1–134.

KLEINERTZ 2003

Kleinertz, Rainer. *Grundzüge des spanischen Musiktheaters im 18. Jahrhundert: Ópera, Comedia und Zarzuela*. 2 vols. Kassel: Reichenberger, 2003.

KNEZEVICH 1986

Knezevich, Michela. "L'incoronazione." In *Il Serenissimo Doge*. Edited by Umberto Franzoi. Treviso: Canova, 1986, pp. 97–102.

KOWALCZYK 2005

Canaletto. Il trionfo della veduta. Exh. cat. Rome, Palazzo Giustiniani, 2005. Edited by Bozena Anna Kowalczyk. Cinisello Balsamo: Silvana, 2005.

KOWALCZYK 2008

Canaletto e Bellotto: L'arte della veduta. Exh. cat. Turin, Palazzo Bricherasio, 2008. Edited by Bozena Anna Kowalczyk. Cinisello Balsamo: Silvana, 2008.

KOWALCZYK 2012

Canaletto à Guardi. Les deux maîtres de Venise. Exh. cat. Paris, Musée Jacquemart-André, 2012–13. Edited by Bozena Anna Kowalczyk. Brussels: Fonds Mercator, 2012.

KOWALCZYK 2015

Canaletto. Rome, Londres, Venise. Le triomphe de la lumière. Exh. cat. Aix-en-Provence, Caumont Centre d'Art, 2015. Edited by Bozena Anna Kowalczyk. Brussels: Fonds Mercator, 2015.

KOZAKIEWICZ 1972

Kozakiewicz, Stefan. *Bernardo Bellotto, genannt Canaletto*. 2 vols. Recklinghausen: Bongers, 1972.

KRAGELUND 2010

Kragelund, Patrick. "Popes, Kings and the Medici in the Eighteenth-Century *Fasti* of the Palazzo Mocenigo di S. Stae in Venice." *Journal of the History of Collections* 22, no. 2 (2010), pp. 207–21.

KULTZEN AND REUSS 1991

Kultzen, Rolf, and Matthias Reuss. *Bayerische Staatsgemäldesammlungen, Alte Pinakothek München. Venezianische Gemälde des 18. Jahrhunderts. Vollständiger Katalog*. Munich: Bayerische Staatsgemäldesammlungen, 1991.

LABELYE 1751

Labelye, Charles. *A Description of Westminster Bridge*. London: Strahan, 1751.

LAIGUE 1913

Laigue, Louis de. "Le Comte de Froullay, ambassadeur a Venise (1733–1743)." *Revue d'histoire diplomatique* 27 (1913), pp. 65–138.

LALANDE 1769

Lalande, Joseph Jérôme Lefrançois de. *Voyage d'un François en Italie, fait dans les années 1765 & 1766*. 8 vols. Yverdon: n.p., 1769.

LANZI 1809

Lanzi, Luigi. *Storia pittorica della Italia dal risorgimento delle Belle Arti fin presso al fine del XVIII Secolo*. 6 vols. Bassano: Remondini, 1809.

LAUNAY 1940

Launay, Louis de. *Une grande famille de savants. Les Brongniart*. Paris: Rapilly, 1940.

LAVALLE 1981

Lavalle, Denis. "Une décoration à Rome, au milieu du XVIIIe siècle: Le choeur de l'église Saint-Louis-des-Français." In *Les fondations nationales dans la Rome pontificale*, conference papers, Rome, 16–19 May 1978. Rome: École Française de Rome, 1981, pp. 249–331.

LE BRUN 1787

Le Brun, Jean-Baptiste Pierre. *Suite et supplément au catalogue de M. le Duc de Ch****. Paris: Le Brun, 1787.

LEVEY 1971

Levey, Michael. *National Gallery Catalogues. The Seventeenth and Eighteenth Century Italian Schools*. London: National Gallery, 1971.

LEVEY 1986

Levey, Michael. *Giambattista Tiepolo. His Life and Art*. New Haven and London: Yale University Press, 1986.

LEVEY 1991

Levey, Michael. *The Later Italian Pictures in the Collection of Her Majesty the Queen*, 2nd ed. Cambridge: Cambridge University Press, 1991.

LIMOJON DE SAINT-DIDIER 1680

Limojon de Saint-Didier, Alexandre Toussaint. *La Ville et la République de Venise*. Paris: Barbin, 1680.

LINKS 1998

Links, Joseph Gluckstein. *A Supplement to W. G. Constable's Canaletto. Giovanni Antonio Canal, 1697–1768*. London: Pallas Athene, 1998.

LIVERSIDGE AND FARRINGTON 1993

Canaletto & England. Exh. cat. Birmingham Gas Hall, 1993–94. Edited by Michael Liversidge and Jane Farrington. London: Merrell Holberton, 1993.

LO BIANCO AND NEGRO 2005

Il Settecento a Roma. Exh. cat. Rome, Palazzo Venezia, 2005–6. Edited by Anna Lo Bianco and Angela Negro. Cinisello Balsamo: Silvana, 2005.

LOIRE 2004

Bernardo Bellotto. Un peintre vénitien à Varsovie. Exh. cat. Paris, Musée du Louvre, 2004–5. Edited by Stéphane Loire et al. Milan: 5 Continents, 2004.

MAGNIFICENZA VENETA 1709

La magnificenza veneta nella pomposa Comparsa delle Sontuose Peote, che scorsero il Canal Grande nella Regata seguita il dì 4 Marzo 1709. à divertimento di Sua Maestà Federico IV. Rè di Danimarca, Norvegia, &c. Venice: n.p., 1709.

MANZELLI 1999

Manzelli, Mario. Antonio Joli. Opera pittorica. Venice: Studio LT2, 1999.

MARIUZ 1994

Mariuz, Adriano. "Luca Carlevarijs: 'L'ingresso solenne dell'Abate de Pomponne.'" Arte Veneta 46 (1994), pp. 49–53.

MARIUZ 2004

Mariuz, Adriano. "Entrées solennelles et cérémonies nuptiales: Les commanditaires français de Carlevarijs, Canaletto, Guardi." In Venise en France. La fortune de la peinture vénitienne. Des collections royales jusqu'au XIXe siècle, conference papers, Paris, 5 February 2002. Edited by Gennaro Toscano. Paris: École du Louvre, 2004, pp. 77–97.

MARTINEAU AND ROBISON 1994

The Glory of Venice. Art in the Eighteenth Century. Exh. cat. London, Royal Academy of Arts; Washington, D.C., National Gallery of Art, 1994–95. Edited by Jane Martineau and Andrew Robison. New Haven: Yale University Press, 1994.

MARX 2005

Gemäldegalerie Alte Meister Dresden. Edited by Harald Marx. 2 vols. Cologne: König, 2005.

MASSUE DE RUVIGNY 1904

Massue de Ruvigny, Melville, Marquis de Ruvigny and Raineval. The Jacobite Peerage, Baronetage, Knightage and Grants of Honour. Edinburgh: Jack, 1904.

MCCLYMONDS 2001

McClymonds, Marita. "Jommelli, Niccolò." In New Grove Dictionary of Music and Musicians. Edited by Stanley Sadie. London: Macmillan, 2001. Vol. 13, pp. 178–86.

MENA MARQUÉS AND MAURER 2014

Goya en Madrid. Cartones para tapices 1775–1794. Exh. cat. Madrid, Museo del Prado, 2014–15. Edited by Manuela Mena Marqués and Gudrun Maurer. Madrid: Museo Nacional del Prado, 2014.

MERCURE DE FRANCE

Mercure de France (Paris, 1724–1791).

METASTASIO 1951–54

Metastasio, Pietro. Tutte le opere di Pietro Metastasio. Edited by Bruno Brunelli. 5 vols. Milan: Mondadori, 1951–54.

MICHEL 2016

Michel, Olivier. "Un auditeur de Rote incommode: L'abbé de Canilliac. Le mécène et le collectionneur." In L'Académie de France à Rome. Le Palais Mancini: Un foyer artistique dans l'Europe des Lumières (1725–1792). Edited by Marc Bayard et al. Rennes: Presses Universitaires de Rennes, 2016, pp. 109–42.

MICHEL AND ROSENBERG 1987

Subleyras 1699–1749. Exh. cat. Paris, Musée du Luxembourg; Rome, Académie de France, 1987. Edited by Olivier Michel and Pierre Rosenberg. Paris: Réunion des Musées Nationaux, 1987.

MIDDIONE 1995

Middione, Roberto. Antonio Joli. Soncino: Edizioni dei Soncino, 1995.

MIJNLIEFF 1997

Mijnlieff, Ewoud. "Een vroege vedute van Luca Carlevarijs." Bulletin van het Rijksmuseum 45 (1997), pp. 190–203.

MILLON 1999

The Triumph of the Baroque. Architecture in Europe 1600–1750. Exh. cat. Turin, Palazzina di Caccia di Stupinigi, 1999. Edited by Henry Millon. New York: Rizzoli, 1999.

MONMERQUÉ 1843–65

Monmerqué, Louis. "Pompone (Henri-Charles Arnauld, dit l'abbé de)." In Biographie universelle ancienne et moderne. Edited by Louis-Gabriel Michaud. 45 vols. Paris: Desplaces, 1843–65. Vol. 34, p. 38.

M. MONTAGU 1965–67

Montagu, Lady Mary Wortley. The Complete Letters of Lady Mary Wortley Montagu. Edited by Robert Halsband. 3 vols. Oxford: Clarendon, 1965–67.

W. MONTAGU 1864

Montagu, William Drogo. Court and Society from Elizabeth to Anne. Edited from the Papers at Kimbolton. 2 vols. London: Hurst and Blackett, 1864.

MONTAIGLON 1887–1912

Correspondance des directeurs de l'Académie de France à Rome avec les surintendants des bâtiments. Edited by Anatole de Montaiglon. 18 vols. Paris: Charavay, 1887–1912.

MONTAIGU 1904

Montaigu, Auguste de. Démêlés du comte de Montaigu, ambassadeur à Venise, et de son secrétaire, Jean-Jacques Rousseau, 1743–1749. Paris: Plon-Nourrit, 1904.

MONTECUCCOLI DEGLI ERRI AND PEDROCCO 1999

Montecuccoli degli Erri, Federico, and Filippo Pedrocco. Michele Marieschi. La vita, l'ambiente, l'opera. Milan: Bocca, 1999.

MONTESQUIEU 2012

Montesquieu, Charles-Louis de Secondat, Baron de La Brède et de. Mes voyages. Oeuvres complètes de Montesquieu. Vol. 10. Edited by Jean Ehrard and Gilles Bertrand. Lyon: ENS, 2012.

MOORE 1995

Moore, John. "Prints, Salami, and Cheese: Savoring the Roman Festival of the Chinea." Art Bulletin 77 (1995), pp. 584–608.

MOORE 1998

Moore, John. "Building Set Pieces in Eighteenth-Century Rome: The Case of the Chinea." Memoirs of the American Academy in Rome 43/44 (1998/1999), pp. 183–292.

MORALES VALLEJO AND RUIZ GÓMEZ 2001

The Majesty of Spain. Royal Collections from the Museo del Prado and the Patrimonio Nacional. Exh. cat. Jackson, Mississippi Arts Pavilion, 2001. Edited by Javier Morales Vallejo and Leticia Ruiz Gómez. Jackson: Mississippi Commission for International Cultural Exchange, 2001.

MORASSI 1958

Morassi, Antonio. *Dessins vénitiens du dix-huitième siècle de la collection du Duc de Talleyrand.* Milan: Guarnati, 1958.

MORASSI 1973

Morassi, Antonio. *Guardi. Francesco e Antonio Guardi.* 2 vols. Venice: Alfieri, 1973.

MORELLI 1955–84

Le lettere di Benedetto XIV al Card. de Tencin. Edited by Emilia Morelli. 3 vols. Rome: Storia e Letteratura, 1955–84.

MORONI 1840–61

Moroni, Gaetano. *Dizionario di erudizione storico-ecclesiastica da S. Pietro sino ai nostri giorni*, 103 vols. Venice: n.p., 1840–61.

MOSTEFAI 2016

Mostefai, Ourida. *Jean-Jacques Rousseau écrivain polémique. Querelles, disputes et controverses au siècle des Lumières.* Leiden: Brill Rodopi, 2016.

MUIR 1981

Muir, Edward. *Civic Ritual in Renaissance Venice.* Princeton: Princeton University Press, 1981.

MUTINELLI 1831

Mutinelli, Fabio. *Del costume veneziano sino al secolo decimosettimo.* Venice: Commercio, 1831.

NANI 1702

Nani, Giovan Battista. *Histoire de la République de Venise. Seconde Partie.* 2 vols. Amsterdam: Schelte, 1702.

NICOLINI 1960

Nicolini, Fausto. "Acquaviva d'Aragona, Troiano." In *Dizionario Biografico degli Italiani.* Vol. 1. Rome: Istituto della Enciclopedia Italiana, 1960, pp. 198–99.

NIDERST 1998

Niderst, Alain. "Jansénisme et politique: Le cas, Arnauld de Pomponne." In *Religion et politique. Les avatars de l'augustinisme*, conference papers, Saint-Étienne, 4–7 October 1995. Edited by Jean Jehasse and Antony McKenna. Saint-Étienne: Université de Saint-Étienne, 1998, pp. 267–74.

NIOVA E DESTINTA RELAZIONE 1735

Niova, e destinta relazione di quanto deve seguire li giorni 7., e 9. Febraro 1735. In occasione dell'Ingresso, & accompagnamento delle 72. Peotte, che faranno li Reverendi Capitoli per il nuovo eletto Monsig. Illustriss., & Reverendissimo. F. Francesco Antonio Correr dell'Ordine de' Capucini. Patriarca di Venezia, Primate della Dalmazia. Venice: Valvasense, 1735.

NONNI 1782

Nonni, Angelo. *Descrizione degli spettacoli, e feste datesi in Venezia per occasione della venuta delle LL. AA. II. il Gran Duca, e Gran Duchessa di Moscovia, sotto il nome di Conti del Nort nel mese di Gennajo 1782.* Venice: Formaleoni, 1782.

O'CONNELL 2003

O'Connell, Sheila. *London 1753.* Exh. cat. London, British Museum, 2003. London: British Museum Press, 2003.

ORLANDINI 1903

Orlandini, Giovanni. *La Gondola.* Venice: Scarabellin, 1903.

OVID 1977

Ovid. *Metamorphoses, Books 1–8.* Translated by Frank Justus Miller. 3rd ed. Cambridge: Harvard University Press, 1977.

PALMER 1997

Palmer, Kenneth Nicholls. *Ceremonial Barges on the River Thames. A History of the Barges of the City of London Livery Companies and of the Crown.* London: Unicorn, 1997.

PANHARD 1868

Panhard, Félix. *L'Ordre du Saint-Esprit aux XVIIIe et XIXe siècles. Notes historiques et biographiques sur les membres de cet ordre depuis Louis XV jusqu'à Charles X 1715–1830.* Paris: Dumoulin, 1868.

PARKER 1990

Parker, Karl Theodore. *The Drawings of Antonio Canaletto in the Collection of Her Majesty the Queen at Windsor Castle.* Bologna: Nuova Alfa, 1990.

PASK 1992

Pask, Kelly. "Francesco Guardi and the Conti del Nord: A New Drawing." *J. Paul Getty Museum Journal* 20 (1992), pp. 45–52.

PAUL 1922

Paul, Pierre. *Le cardinal Melchior de Polignac (1661–1741).* Paris: Plon Nourrit, 1922.

PAVANELLO 1981

Pavanello, Giuseppe. "Per Gaspare Diziani decoratore." *Arte Veneta* 35 (1981), pp. 126–36.

PAVANELLO AND CRAIEVICH 2008

Canaletto. Venezia e i suoi splendori. Exh. cat. Treviso, Casa dei Carraresi, 2008–9. Edited by Giuseppe Pavanello and Alberto Craievich. Venice: Marsilio, 2008.

PEDROCCO 2002

Pedrocco, Filippo. *Giambattista Tiepolo.* Milan: Rizzoli, 2002.

PEDROCCO 2003

Pedrocco, Filippo. "Feste e cerimonie all'aperto nelle opere dei vedutisti veneziani del Sei e del Settecento." In *Teatro nel Veneto. La scena del mondo.* Edited by Carmelo Alberti. Milan: Motta, 2003, pp. 9–31.

PENZO 1999

Penzo, Gilberto. *La gondola. Storia, progettazione e costruzione della più straordinaria imbarcazione tradizionale di Venezia.* Venice: Istituzione per la conservazione della gondola e la tutela del gondoliere, 1999.

PÉREZ SÁNCHEZ 1992

Madrid pintado. La imagen de Madrid a través de la pintura. Exh. cat. Madrid, Museo Municipal de Madrid, 1992–93. Edited by Alfonso Pérez Sánchez. Madrid: Museo Municipal de Madrid, 1992.

PÉREZ SÁNCHEZ 2006

Corrado Giaquinto y España. Exh. cat. Madrid, Palacio Real, 2006. Edited by Alfonso Pérez Sánchez. Madrid: Patrimonio Nacional, 2006.

PERRIN AND VASCO ROCCA 1999

Thesaurus des objets religieux. Meubles, objets, linges, vêtements et instruments de musique du culte catholique romain. Edited by Joël Perrin and Sandra Vasco Rocca. Paris: Éditions du Patrimoine, 1999.

PIÉPAPE 1917

Piépape, Léonce de. "Lettres de Mme de Pompadour au Comte de Stainville (Choiseul), Ambassadeur 1754–1757." *Revue de l'histoire de Versailles et de Seine-et-Oise* 19 (1917), pp. 5–30.

PIETRANGELI 1961

I Francesi a Roma. Residenti e viaggiatori nella Città Eterna dal Rinascimento agli inizi del Romanticismo. Exh. cat. Rome, Palazzo Braschi, 1961. Edited by Carlo Pietrangeli. Rome: Istituto Grafico Tiberino, 1961.

POVOLO 1998

Povolo, Claudio. "Correr, Francesco Antonio." In *Dizionario Biografico degli Italiani*. Vol. 50. Rome: Istituto della Enciclopedia Italiana, 1998, pp. 42–44.

PRODI AND FATTORI 2011

Le lettere di Benedetto XIV al marchese Paolo Magnani. Edited by Paolo Prodi and Maria Teresa Fattori. Rome: Herder, 2011.

RAMBAUD 1964

Rambaud, Mireille. *Documents du Minutier Central concernant l'histoire de l'art (1700–1750)*. Vol. 1. Paris: S. E. V. P. E. N., 1964.

REALE 1994

Reale, Isabella. "Per divertimento di Sua Maestà: appunti sulla regata di Federico IV." In *Luca Carlevarijs e la veduta veneziana del Settecento*. Exh. cat. Padua, Palazzo della Ragione, 1994. Edited by Isabella Reale and Dario Succi. Milan: Electa, 1994, pp. 107–14.

REALE AND SUCCI 1994

Luca Carlevarijs e la veduta veneziana del Settecento. Exh. cat. Padua, Palazzo della Ragione, 1994. Edited by Isabella Reale and Dario Succi. Milan: Electa, 1994.

REATO 1988

Reato, Danilo. *Le maschere veneziane*. Venice: Arsenale, 1988.

REDFORD 1996

Redford, Bruce. *Venice and the Grand Tour*. New Haven: Yale University Press, 1996.

REED 2015

The Edible Monument: The Art of Food for Festivals. Edited by Marcia Reed. Los Angeles: Getty Research Institute, 2015.

RELACIÓN DE LOS ARCOS 1760

Relación de los arcos, inscripciones y ornatos de la carrera por donde ha de passar el Rey nuestro señor D. Carlos Tercero en su entrada publica el dia 13 de julio de 1760. Madrid: Ibarra, 1760.

RELATION DES FÊTES 1730

Relation des fêtes données à Rome par Monseigneur le Cardinal de Polignac, à l'occasion de la Naissance de Monseigneur le Dauphin, au mois de Novembre 1729. Paris: Delespine, 1730.

RENIER MICHIEL 1829

Renier Michiel, Giustina. *Origine delle feste veneziane*. 6 vols. Milan: Annali universali delle scienze e dell'industria, 1829.

RÉTIF DE LA BRETONNE 1788–94

Rétif de La Bretonne, Nicolas Edme. *Les Nuits de Paris, ou Le Spectateur Nocturne*. 8 vols. London: Guillot, 1788–94.

REYNOLDS 1975

Reynolds, Joshua. *Discourses on Art*. Edited by Robert Wark. New Haven: Yale University Press, 1975.

RICHARD 1766

Richard, Jérôme. *Description historique et critique de l'Italie, ou Nouveaux mémoires sur l'état actuel de son gouvernement, des sciences, des arts, du commerce, de la population et de l'histoire naturelle*. 6 vols. Dijon: Des Ventes, 1766.

RICHERT 1987

Ambasciatori di Francia a Venezia, XVI°–XVIII° sec. Exh. cat. Venice, Fondazione Querini Stampalia, 1987. Edited by Marie Laure Richert. Venice: Associazione Culturale Italo-Francese, 1987.

RINALDI 1978

Rinaldi, Mario. *Due secoli di musica al Teatro Argentina*. 3 vols. Florence: Olschki, 1978.

RITZLER 1952

Ritzler, Remigius. *Hierarchia catholica medii et recentioris aevi sive summorum pontificum, S. R. E. cardinalium ecclesiarum antistitum series*. Vol. 5: *A pontificatu Clementis pp. IX (1667) usque ad pontificatum Benedicti pp. XIII (1730)*. Padua: Il Messaggero di S. Antonio, 1952.

ALD. RIZZI 1967

Rizzi, Aldo. *Luca Carlevarijs*. Venice: Alfieri, 1967.

ALB. RIZZI 1995

Rizzi, Alberto. *Bernardo Bellotto. Dresda Vienna Monaco (1747–1766)*. Venice: Canal Stamperia, 1995.

ROCCHI COOPMANS DE YOLDI 1996

San Pietro. Arte e storia nella Basilica Vaticana. Edited by Giuseppe Rocchi Coopmans de Yoldi. Bergamo: Bolis, 1996.

ROLLAND AND ROLLAND 1967

Rolland, Victor, and Henri Rolland. *V. & H. V. Rolland's Illustrations to the Armorial Général by J.-B. Rietstap*. 3 vols. London: Heraldry Today, 1967.

ROMANELLI 1983

Romanelli, Giandomenico, et al. *Venetiaanse tekeningen uit de 18de eeuw*. Exh. cat. Brussels, Paleis voor Schone Kunsten, 1983. Brussels: Paleis voor Schone Kunsten, 1983.

ROMANELLI AND PEDROCCO 1980

Romanelli, Giandomenico, and Filippo Pedrocco. *Bissone, peote e galleggianti. Addobbi e costumi per cortei e regate.* Exh. cat. Venice, Museo Correr, 1980. Venice: Alfieri, 1980.

ROSENBERG 1782

Rosenberg, Giustiniana Wynne Orsini. *Du sejour des comtes du Nord à Venise en Janvier 1782. Lettre de Mme la comtesse Douarière des Ursins et Rosenberg à Mr. Richard Wynne son frère à Londres.* Vicenza: Turra, 1782.

ROSTIROLLA 2001

Rostirolla, Giancarlo. *Il "Mondo novo" musicale di Pier Leone Ghezzi.* Milan: Skira, 2001.

ROSTIROLLA 2009

Rostirolla, Giancarlo. "Il 'Mondo novo' accresciuto. Trenta nuovi disegni di Pier Leone Ghezzi dal Museo dell'Ermitage di San Pietroburgo." *Recercare* 21 (2009), pp. 229–87.

RUSSELL 1988

Russell, Francis. "Canaletto and Joli at Chesterfield House." *Burlington Magazine* 130 (1988), pp. 627–30.

RUSSELL 2006

Russell, Francis. "Patterns of Patronage." In *Canaletto in England. A Venetian Artist Abroad, 1746–1755.* Exh. cat. New Haven, Yale Center for British Art; London, Dulwich Picture Gallery, 2006–7. Edited by Charles Beddington. New Haven: Yale University Press, 2006, pp. 38–47.

SANI 2007

Sani, Bernardina. *Rosalba Carriera 1673–1757. Maestra del pastello nell'Europa ancien régime.* Turin: Allemandi, 2007.

SAVAGE 1998

Savage, Roger. "A Dynastic Marriage Celebrated." *Early Music* 26 (1998), pp. 632–35.

SCARPA 2008

Da Canaletto a Tiepolo. Pittura veneziana del Settecento, mobili e porcellane dalla collezione Terruzzi. Exh. cat. Milan, Palazzo Reale, 2008–9. Edited by Annalisa Scarpa. Milan: Skira, 2008.

SCARSELLI 1747

Scarselli, Flaminio. *Componimento dramatico per le felicissime nozze di Luigi Delfino di Francia con la Principessa Maria Giuseppa di Sassonia da cantarsi per ordine dell'Eminentissimo Signor Cardinale de la Rochefoucauld Ministro di Sua Maestà Cristianissima presso la Santa Sede.* Rome: de' Rossi, 1747.

SCHUHMANN 1962–63

Schuhmann, Günther. "Mit Markgraf Wilhelm Friedrich von Brandenburg-Ansbach nach Venedig. Ein Reisebericht aus dem Jahre 1709." *Jahrbuch des Historischen Vereins für Mittelfranken* 80 (1962–63), pp. 94–177.

SEIPEL 2005

Bernardo Bellotto genannt Canaletto. Europäische Veduten. Exh. cat. Vienna, Kunsthistorisches Museum, 2005. Edited by Wilfried Seipel. Milan: Skira, 2005.

SELFRIDGE-FIELD 2007

Selfridge-Field, Eleanor. *A New Chronology of Venetian Opera and Related Genres, 1660–1760.* Palo Alto: Stanford University Press, 2007.

SESTIERI 2015

Sestieri, Giancarlo. *Il capriccio architettonico in Italia nel XVII e XVIII secolo.* 3 vols. Rome: Etgraphiae, 2015.

SEYDL 2012

Seydl, Jon. "Decadence, Apocalypse, Resurrection." In Victoria Gardner Coates, Kenneth Lapatin, and Jon Seydl, *The Last Days of Pompeii: Decadence, Apocalypse, Resurrection.* Los Angeles: J. Paul Getty Museum, 2012, pp. 15–31.

SHIELD 1908

Shield, Alice. *Henry Stuart Cardinal of York and His Times.* London: Longmans, Green, 1908.

SIMONSON 1904

Simonson, George. *Francesco Guardi 1712–1793.* London: Methuen, 1904.

SOLKIN 1982

Solkin, David. *Richard Wilson. The Landscape of Reaction.* Exh. cat. London, Tate Gallery, 1982–83. London: Tate Gallery, 1982.

SØRENSEN 2002

Sørensen, Bent. "Panini and Ghezzi: The Portraits in the Louvre 'Musical Performance at the Teatro Argentina.'" *Burlington Magazine* 144 (2002), pp. 467–74.

SOTTILI 2010

Sottili, Fabio. "Giuseppe Zocchi per Orazio Sansedoni. Un vedutista fiorentino 'sul gusto del Canaletto'." *Paragone. Arte* 61 (2010), no. 91, pp. 64–72.

SPADOTTO 2011

Spadotto, Federica. *Giovan Battista Cimaroli.* Rovigo: Minelliana, 2011.

SPENCE 1975

Spence, Joseph. *Letters from the Grand Tour.* Edited by Slava Klima. Montreal: McGill-Queen's University Press, 1975.

STOCK 1980

Disegni veneti di collezioni inglesi. Exh. cat. Venice, Fondazione Giorgio Cini, 1980. Edited by Julien Stock. Vicenza: Neri Pozza, 1980.

STORIA DEL VIAGGIO 1782

Storia del viaggio del Sommo Pontefice Pio VI. colla descrizione delle accoglienze, cerimonie, e funzioni seguite in tutti i luoghi, dove si fermò, e spezialmente nello Stato Veneto nell'Anno 1782. Venice: Formaleoni, 1782.

STOSCHEK 1999

Stoschek, Jeannette. *Das "Caffeaus" Papst Benedikts XIV. in den Gärten des Quirinal.* Munich: Scaneg, 1999.

SUCCI 1989

Marieschi tra Canaletto e Guardi. Exh. cat. Gorizia, Castello, 1989. Edited by Dario Succi. Turin: Allemandi, 1989.

SUCCI 1994

Succi, Dario. "'Que la fête continue': ospiti illustri e feste straordinarie nelle vedute da Carlevarijs a Guardi." In *Luca Carlevarijs e la veduta veneziana del Settecento*. Exh. cat. Padua, Palazzo della Ragione, 1994. Edited by Isabella Reale and Dario Succi. Milan: Electa, 1994, pp. 59–90.

SUCCI 2011

Bernardo Bellotto. Il Canaletto delle corti europee. Exh. cat. Conegliano, Palazzo Sarcinelli, 2011–12. Edited by Dario Succi. Venice: Marsilio, 2011.

SUCCI 2013

Succi, Dario. *La Serenissima nello specchio di rame. Splendore di una civiltà figurativa del Settecento. L'opera completa dei grandi maestri veneti.* 2 vols. Castelfranco Veneto: Cecchetto Prior, 2013.

SUCCI 2015

Succi, Dario. *Luca Carlevarijs*. Gorizia: LEG, 2015.

SUCCI AND DELNERI 1993

Marco Ricci e il paesaggio veneto del Settecento. Edited by Dario Succi and Annalia Delneri. Milan: Electa, 1993.

TAMASSIA MAZZAROTTO 1980

Tamassia Mazzarotto, Bianca. *Le feste veneziane. I giochi popolari, le cerimonie religiose e di governo*, 2nd ed. Florence: Sansoni, 1980.

TASSINI 1891

Tassini, Giuseppe. *Feste, spettacoli, divertimenti e piaceri degli antichi Veneziani*, 2nd ed. Venice: Fontana, 1891.

TEMANZA 1963

Temanza, Tommaso. *Zibaldon*. Edited by Nicola Ivanoff. Venice: Istituto per la Collaborazione Culturale, 1963.

TIPTON 2010

Tipton, Susan. "Diplomatie und Zeremoniell in Botschafterbildern von Carlevarijs und Canaletto." *RIHA Journal* 8 (2010), http://www.riha-journal.org/articles/2010/tipton-diplomatie-und-zeremoniell.

TOLEDANO 2006

Toledano, Ralph. *Antonio Joli. Modena 1700–1777 Napoli*. Turin: Artema, 2006.

TORRIONE 1998

Crónica festiva de dos reinados en la Gaceta de Madrid (1700–1759). Edited by Margarita Torrione. Toulouse: C.R.I.C., 1998.

TOVAR MARTÍN 2002

Tovar Martín, Virginia. "Arquitectura áulica y urbanismo público en el reinado de Fernando VI." In *Un reinado bajo el signo de la paz. Fernando VI y Bárbara de Braganza 1746–1759*. Exh. cat. Madrid, Academia de San Fernando, 2002–3. Edited by Antonio Bonet Correa and Beatriz Blasco Esquivias. Madrid: El Viso, 2002, pp. 149–62.

UNIVERSAL MAGAZINE

The Universal Magazine of Knowledge and Pleasure (London, 1747–1803).

URBAN PADOAN 1988

Urban Padoan, Lina. *Il Bucintoro. La festa e la fiera della "Sensa" dalle origini alla caduta della Repubblica*. Venice: Centro Internazionale della Grafica, 1988.

URBAN PADOAN 1998

Urban Padoan, Lina. *Processioni e feste dogali. "Venetia est mundus."* Vicenza: Neri Pozza, 1998.

URREA FERNÁNDEZ 1977

Urrea Fernández, Jesús. *La pintura italiana del siglo XVIII en España*. Valladolid: Departamento de Historia del Arte, 1977.

URREA FERNÁNDEZ 2006

Urrea Fernández, Jesús. *Relaciones artísticas hispano-romanas en el siglo XVIII*. Madrid: Fundación de Apoyo a la Historia del Arte Hispánico, 2006.

URREA FERNÁNDEZ 2012

Urrea Fernández, Jesús. *Antonio Joli en Madrid, 1749–1754*. Madrid: Fondo Cultural Villar Mir, 2012.

VALESIO 1977–79

Valesio, Francesco. *Diario di Roma*. Edited by Gaetana Scano. 6 vols. Milan: Longanesi, 1977–79.

VENTURI 1973

Venturi, Franco. "1764 & Napoli nell'anno della fame." *Rivista storica italiana* 85 (1973), pp. 394–472.

VÉRON-DENISE AND DROGUET 1998

Peintures pour un château. Cinquante tableaux (XVIe–XIXe siècle) des collections du château de Fontainebleau. Exh. cat. Musée National du Château de Fontainebleau, 1998–99. Edited by Danièle Véron-Denise and Vincent Droguet. Paris: Réunion des Musées Nationaux, 1998.

VERTUE 1934

Vertue, George. "Vertue Note Books, Volume III." *Walpole Society* 22 (1934), pp. 1–162.

VILLAREAL DE ALAVA 1964

Villarreal de Alava, José María de Palacio y de Palacio, Marquis de. *La Maison royale des Deux Siciles. L'Ordre Constantinien de Saint Georges et l'Ordre de Saint Janvier*. Madrid: Altamira, 1964.

VOSS 1924

Voss, Hermann. *Die Malerei des Barock in Rom*. Berlin: Propyläen, 1924.

WALKER 1979

Walker, R. J. B. *Old Westminster Bridge. The Bridge of Fools*. Newton Abbot: David and Charles, 1979.

WALPOLE 1937–83

Walpole, Horace. *The Yale Edition of Horace Walpole's Correspondence*. Edited by Wilmarth Sheldon Lewis. 48 vols. New Haven: Yale University Press, 1937–83.

WEICHERDING 2001

Weicherding, Sabine. "Faut-il brûler l'Opéra? Hubert Robert et l'incendie de l'Opéra de 1781." In *L'art et les normes sociales au XVIIIe siècle*. Edited by Thomas Gaehtgens et al. Paris: Éditions de la Maison des sciences de l'homme, 2001, pp. 477–92.

WILDENSTEIN 1961

Wildenstein, Georges. "Un amateur de Boucher et de Fragonard. Jacques-Onésyme Bergeret (1715–1785)." *Gazette des beaux-arts* 58 (1961), pp. 39–84.

WISE AND WARNER 1996

Wise, Susan, and Malcolm Warner. *French and British Paintings from 1600 to 1800 in the Art Institute of Chicago. A Catalogue of the Collection.* Chicago: Art Institute of Chicago, 1996.

WITKOWSKA 1996

Witkowska, Alina Zorawska. "Federico Cristiano in Italia. Esperienze musicali di un principe reale polacco." *Musica e storia* 4 (1996), pp. 277–323.

WYNNE 1986

Wynne, Michael. *Later Italian Paintings in the National Gallery of Ireland. The Seventeenth, Eighteenth and Nineteenth Centuries.* Dublin: National Gallery of Ireland, 1986.

ZIMMERMANN 1954

Zimmermann, Hermann. "Über einige Bilder der Sammlung Streit im Grauen Kloster zu Berlin." *Zeitschrift für Kunstwissenschaft* 8 (1954), pp. 197–224.

ZUGNI-TAURO 1971

Zugni-Tauro, Anna Paola. *Gaspare Diziani.* Venice: Alfieri, 1971.

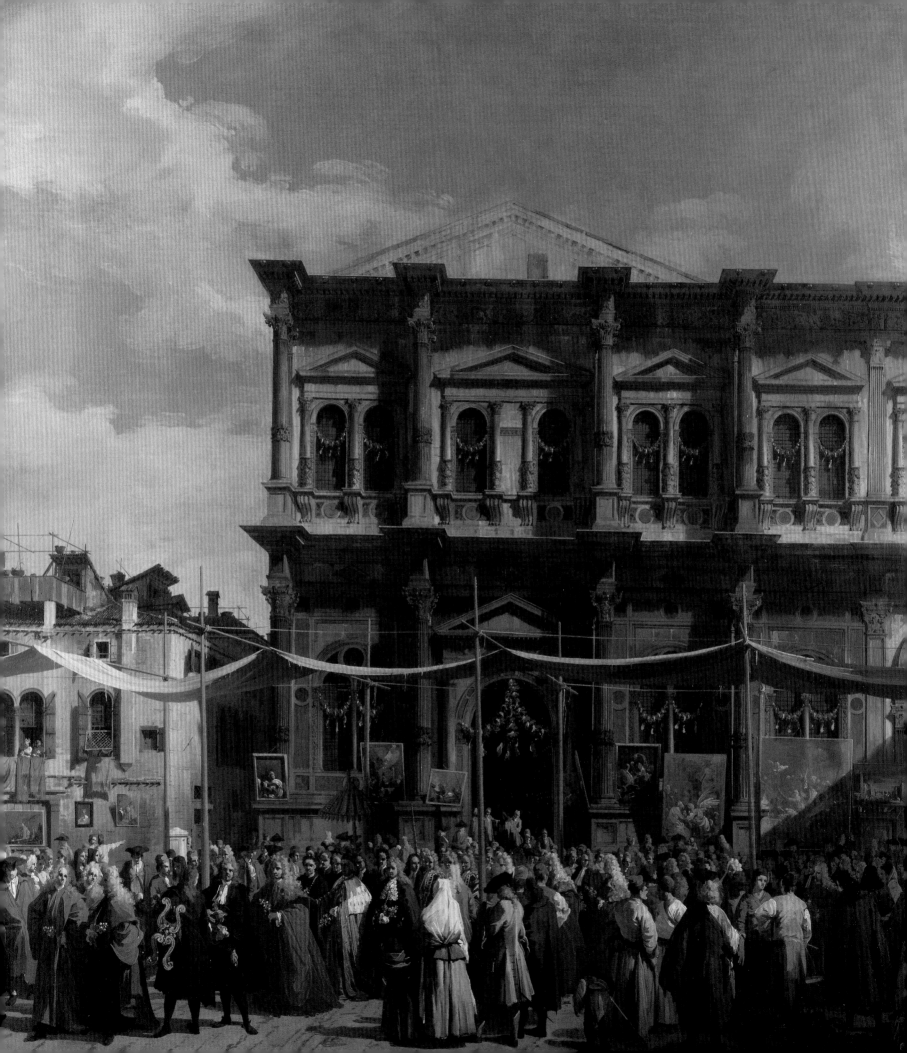

INDEX

�⁊·⁊

ILLUSTRATION CREDITS

✄·✄